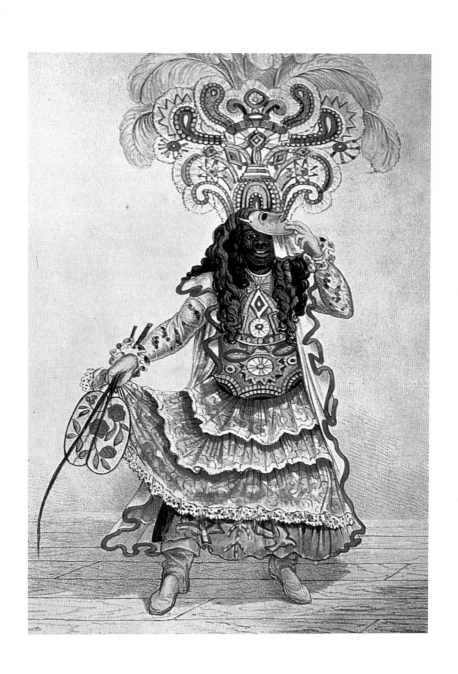

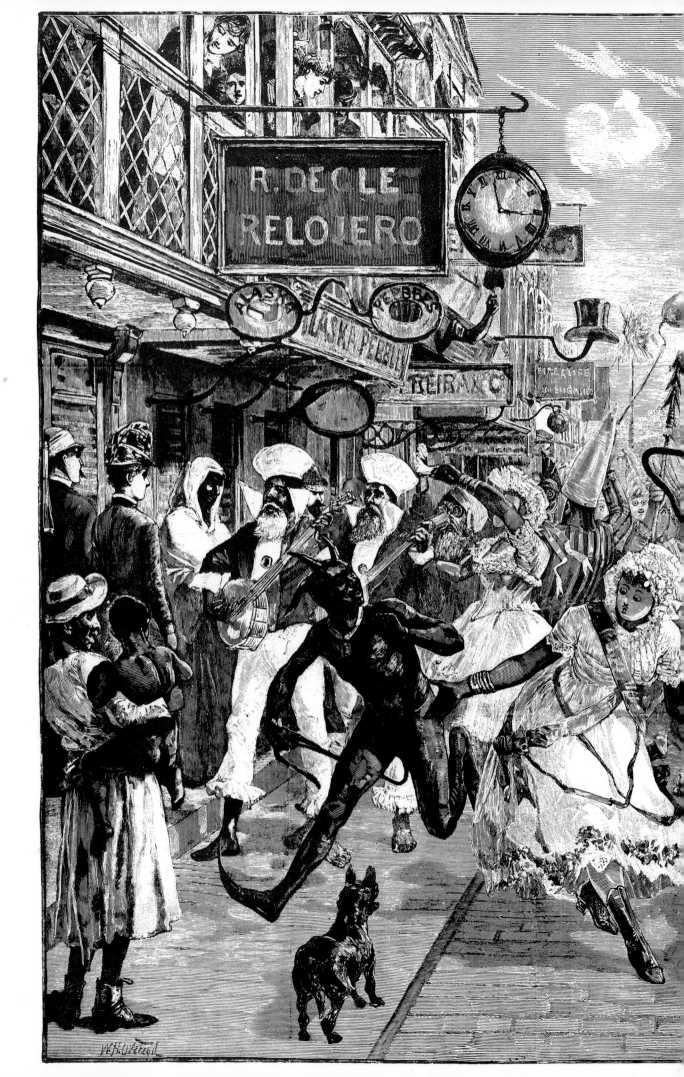

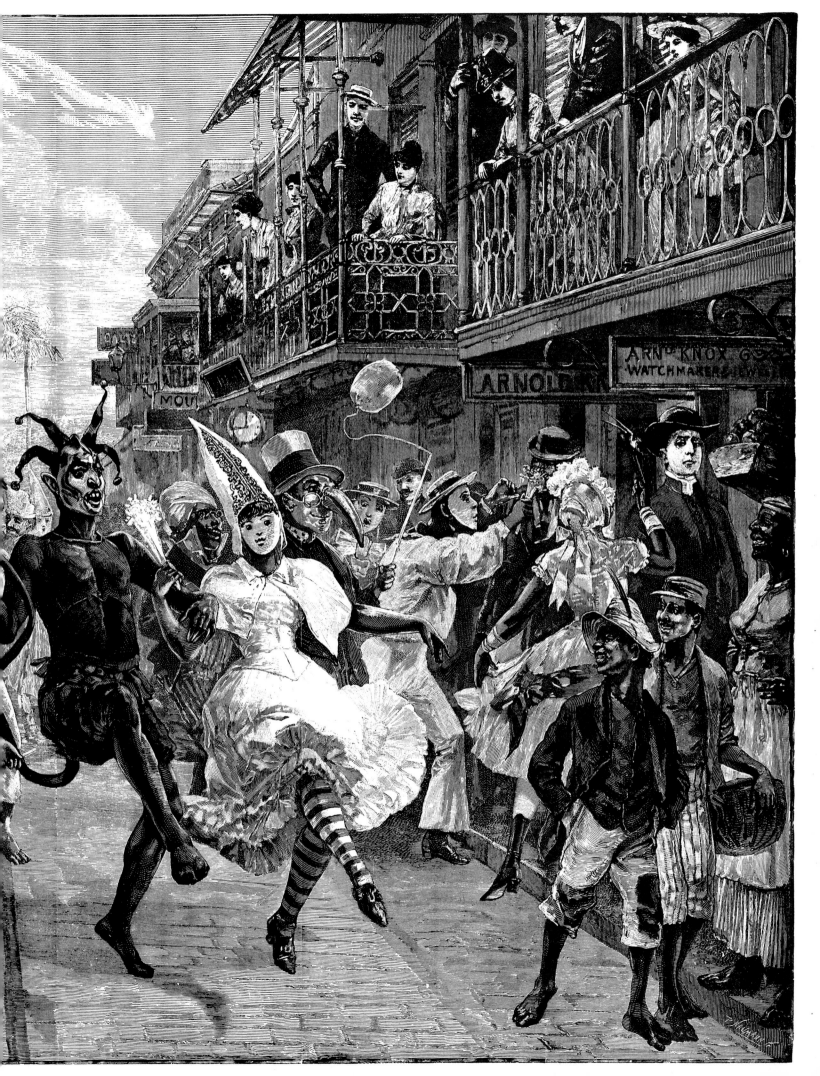

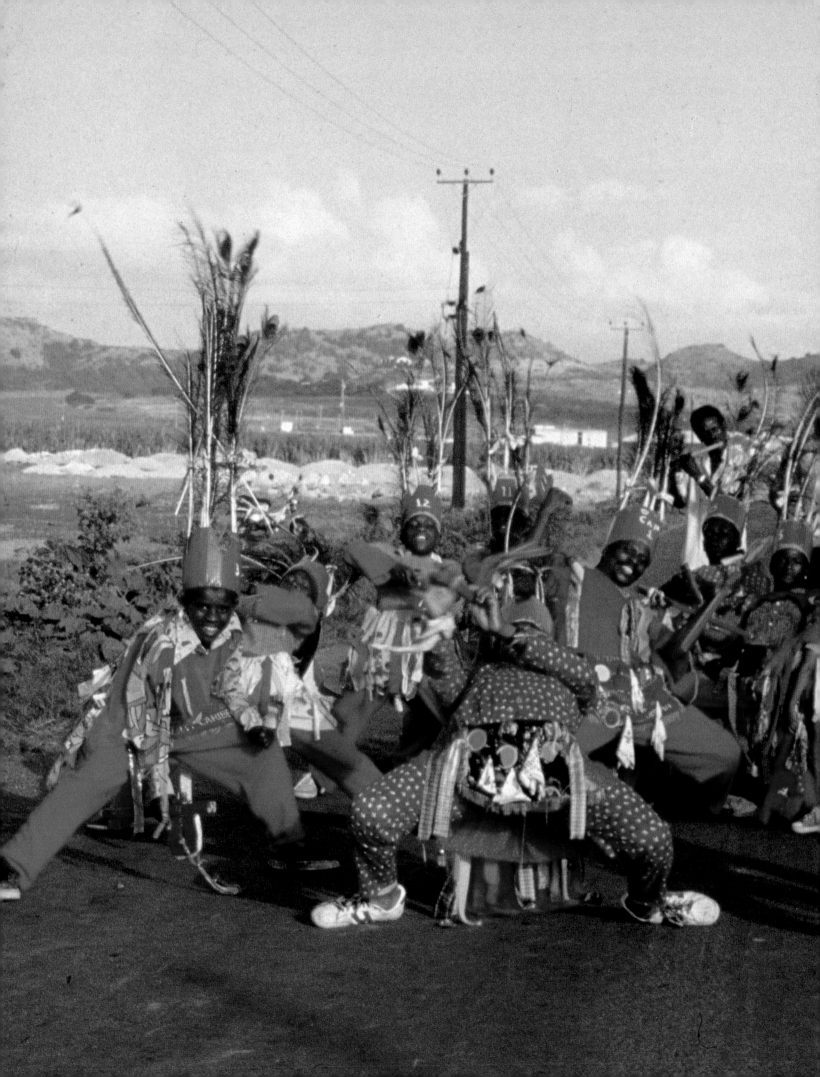

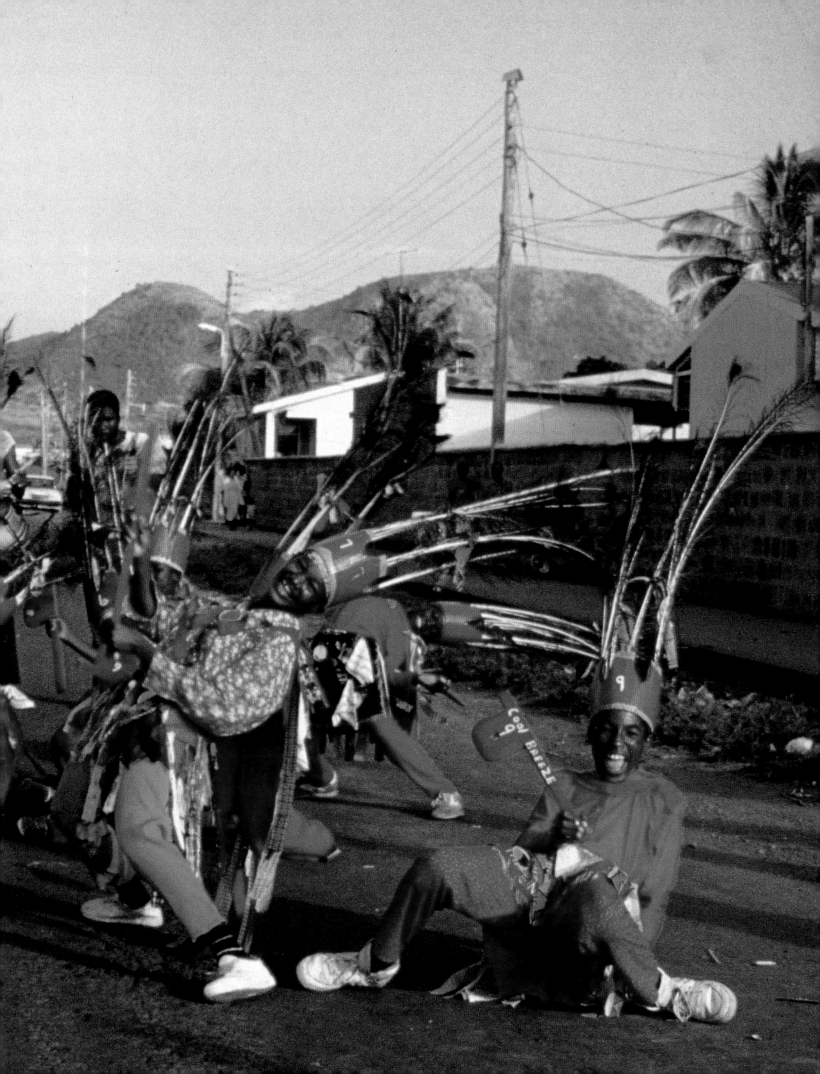

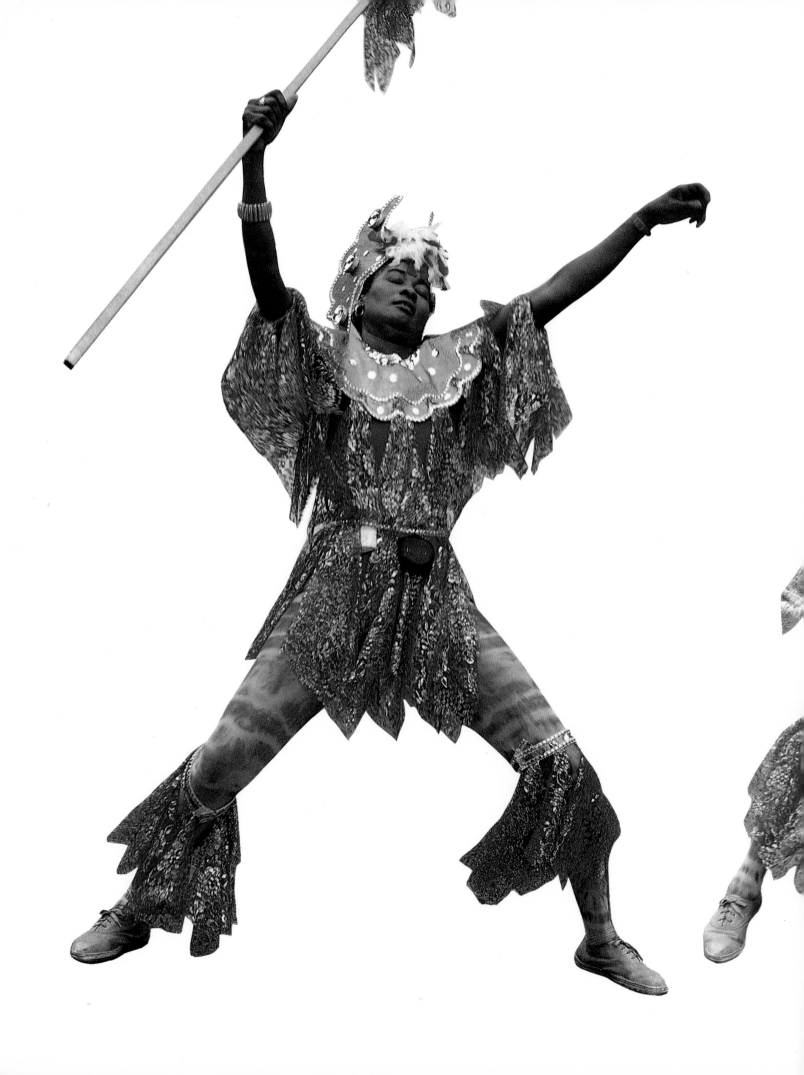

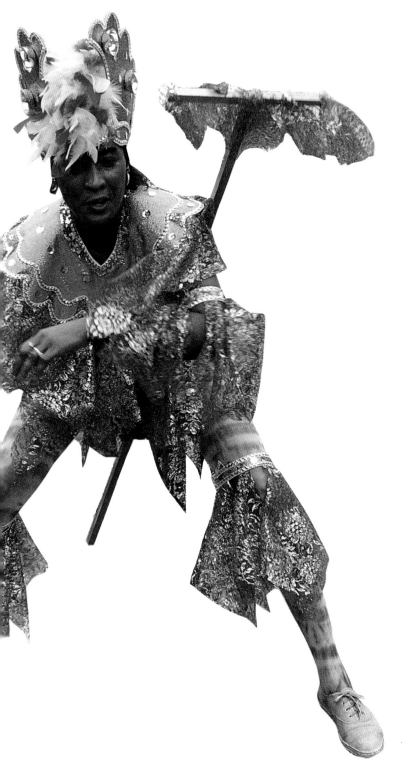

CARIBBEAN

each and every bit

FESTIVAL

of difference

ARTS

John W. Nunley
Judith Bettelheim

Special consultant
Rex Nettleford

With contributions by
Barbara Bridges
Rex Nettleford
Robert Farris Thompson
Dolores Yonker

The Saint Louis Art Museum
in association with
University of Washington Press
Seattle and London

Page 1 *Koo-Koo or Actor-Boy John-Canoe* by Isaac Mendes Belisario, 1836 *(see Figure 22).*

Pages 2–3 *Carnival* by Melton Prior, 1888 *(see Figure 86).*

Pages 4–5 Masqueraders from the Valon troupe in the limbo position of the Wild Mas Dance, St. Kitts-Nevis, January 1, 1987.

Pages 6-7 Clad in a Trinidadian-style costume with plumed headdress, this masquerader dances to the beat of soca music in Brooklyn Carnival, 1987.

Library of Congress Cataloging-in-Publication Data

Nunley, John W. (John Wallace), 1945–
 Caribbean Festival Arts.

 Bibliography: p.
 Includes index.

 1. Festivals—Caribbean Area—Exhibitions.
2. West Indians—Social life and customs—Exhibitions.
I. Bettelheim, Judith, 1944– II. St. Louis Art Museum. IV. Title.
GT4823.N85 1988 394.2'5'07409729 88-20602
ISBN 0-295-96702-1

Published on the occasion of the exhibition *Caribbean Festival Arts,* organized by The Saint Louis Art Museum, December 1988.

Edited by Mary Ann Steiner and Suzanne G. Tyler

Book design by Alex and Caroline Castro

Table of Contents

Foreword

The present enthusiasm for all things Caribbean might persuade one that this exhibition and the book that accompanies it respond to that interest. In fact, the idea for Caribbean Festival Arts emerged in 1982, when John Nunley, Curator of the Arts of Africa, Oceania, and the Americas at The Saint Louis Art Museum, and Judith Bettelheim, Professor of Art History at San Francisco State University, first discussed the possibility of just such an exhibition. The ensuing interval has been invested in overcoming the considerable logistical hurdles of a project of this magnitude.

Caribbean Festival Arts examines the processes that brought the cultural expressions of European, African, and Asian peoples into the region. Combining artistic, political, and religious points of view, festivals provided a solid identity for Old World migrants in what was a new and alien environment. The Caribbean festivals express, on a large scale, the Old World cultural traditions transformed within new surroundings into a unique Caribbean aesthetic.

We are especially grateful to the artists and lenders to this exhibition. Their creativity and generosity in sharing these wonderful works and their flexibility amid complicated arrangements give special meaning to the presentation of festival arts at each museum in the tour.

The response of the museum community to the prospect of this exhibition has been particularly gratifying. We especially owe our thanks to the directors of the Smithsonian Institution, The Seattle Art Museum, The Brooklyn Museum, and the Royal Ontario Museum, who have enthusiastically joined the tour of this exhibition. The commitment of these institutions furthers the opportunities to consider these important cultural movements in new and provocative ways.

In the life of any exhibition, individuals invariably distinguish themselves. The vision and creativity, not to mention the perseverance, of John Nunley and Judith Bettelheim in bringing this project to fruition are laudable. Among those involved in producing the book, we are particularly indebted to Robert Farris Thompson and Rex Nettleford, for contributing the introduction and the epilogue respectively, as well as for their lively support and suggestions throughout the project. Mary Ann Steiner, Director of Publications, and Suzanne G. Tyler, Assistant Editor, have guided the development of the book with dedication and energy. Susan Patterson, Information Services, and Libby Martin and Kathleen Schodrowski, secretaries, grappled with the many versions and transformations of the manuscript.

Alex and Caroline Castro of Hollowpress merit praise for their admirable designs of both the book and the exhibition. Nick Ohlman, Registrar, has coordinated the details of shipping the works of art with patience and good humor. Marge Lee, Director of Public Relations, kept the enthusiasm high nationally as well as locally. Barbara Bridges, Curatorial Assistant, routinely devoted herself to ensuring that

innumerable matters were resolved, and coordinated the illustrations for the book as well. Bonnie McKenna aided the effort to manage illustrations and permissions. Zoe Annis-Perkins, Textile Conservator, spent untold hours preparing objects for the exhibition. And Sidney M. Goldstein, Associate Director of the Museum, shepherded the project through its many challenges.

The project has been immeasurably enhanced by the support of the Rockefeller Foundation, which has lent not only funding but also counsel and encouragement to our efforts. In their respective capacities as Director and Associate Director of the Arts and Humanities programs, Alberta B. Arthurs and Steven D. Lavine have expressed the Foundation's willingness to sponsor an exhibition like this one that tests the prevailing stereotypes and expands our understanding of what art truly is.

Additional funding has been given this exhibition by the National Endowment for the Humanities, the National Endowment for the Arts, and the Missouri Arts Council. We are grateful not only for this financial help, but also for their keen interest in ensuring that so unusual a project would be possible.

James D. Burke
Director
The Saint Louis Art Museum

Acknowledgments

This work began as a doctoral dissertation for the Department of Art History at Yale University. I would like to thank my mentor, the director of my doctoral studies, Robert Farris Thompson, for his support and inspiration. My first trip to the Caribbean in 1975 was supported by the Department of Art History, and subsequent fieldwork was supported by the Social Science Research Council in 1976 and the National Endowment for the Humanities through The Saint Louis Art Museum intermittently from 1984 through 1988. Travel funds for research in Cuba were provided in part by the Art Department, School of Creative Arts, San Francisco State University. Since my first trip to Jamaica, I have been generously assisted by Rex Nettleford of the University of the West Indies, who also has provided editorial wisdom in the preparation of this volume. I respectfully acknowledge the assistance and support of members of the Jamaican National Dance Theatre; Sheila Barnett of the Jamaica School of Dance; Beverley Hall, Director, and Cheryl Ryman, Director of Development, as well as the staff of the Institute of Jamaica; Joyce Campbell and the staff of the Jamaican Cultural Development Commission; Lukshmi and Ajai Mansingh; the staff of the Bermuda Library in Hamilton; Dr. Gail Saunders and the staff of the Department of Archives, Nassau; the staff of the Musée d'Ethnographie, Port-au-Prince; and the helpful people at the Ministerio de Cultura in Havana. I am especially grateful to the staff of the Casa de Caribe in Santiago de Cuba for inviting me to Festival and Carnaval, and to licenciado Julián Mateo Tornés and Felicia Meizoso Puig for their assistance and hospitality.

I especially thank the following individuals who produced costumes and masks for this exhibition: John "Pickles" Spence of Bermuda; Edgar J. Richards of St. Thomas; Don Bucknor, Winston Cole, and Audrey Mantock of Jamaica; Pedro Jorge Pozo, Concepción Gonzalez Bestard; Ludvik Perez Renginfo, Gerardo "Yayo" Del Rio Gomez, and Leonardo La Badí Garcia of Cuba; Fabian Cayetano and Patrick Bernard of Belize; Manuel de Jesus Jimenez of the Dominican Republic; and Violet and Icilma Leader of St. Kitts-Nevis.

The following individuals facilitated the negotiations for costumes and assisted in the numerous details of collection, and I thank them: Robert Burns, Jeanne Cannizzo, Barbara Briggs, Phyllis Little, Aston Spence, Cheryl Ryman, Julián Mateo Tornés, Felicia Meizoso Puig, Israel Moliner Castañeda, Ricardo Alegria, Helmut Kopp, Hubert Auer, and Jacoba Atlas.

I would like to acknowledge the enormous intellectual inspiration provided by the feminist movement and feminist art historians in particular. The initial statement of their position coincided chronologically with my decision to become a student of Afro-American festivals. I have been rewarded consistently by their example and their writings.

Over the years my colleagues have provided me with helpful critical discourse and astute commentary. Many have shared fieldwork information and loaned

photographs for this volume. I extend a heartfelt thanks to Daniel and Pearl Crowley, Robert Dirks, Monica Schuler, Franklin Knight, Doran Ross, and Dolores Yonker. I also thank John Nunley and The Saint Louis Art Museum for asking me to participate in this exciting project. A special warm thank you to D. E. whose intelligence, warmth, and support have strengthened me.

Benjamin Bettelheim Edwards accompanied me during fieldwork, learned to shoot photographs, and provides me with humor and love. One day I hope he will want to read this book. Thank you, son.

Judith Bettelheim

I express my thanks to Daniel Crowley, whose presentation on Trinidad Carnival at the 1977 African Art Triennial Symposium in Washington, D.C. persuaded me to experience Carnival. I also thank the Ode-lay boys of Freetown, Sierra Leone, whose interest in Caribbean music and culture strengthened that resolution in 1978, and the anonymous Trinidadian expatriate who told me in 1983 that I must witness the 100th anniversary of Carnival.

Christine Galt of the Trinidad and Tobago Tourist Board introduced me to Trinidad's leading *mas* men and in the order of those introductions I thank Wayne Berkeley, Peter Minshall, Lionel Jagessar, Rosemary Carew, Andrew Joseph, Jim Harding, Ken Morris, Stephen and Elsie Lee Heung, Keith Lovelace, Dr. David Picou, and Todd Gulick. I thank Karen Morell and Roy Watts for their participation in the project, and Noel and Mary Norton, Napier Pillai, Gerard and Sheelagh Besson, and Roy Boyke for their assistance. When it was time to relax and consider the great Carnival experience, Allan and Cynthia Clovis and Boscoe and Sheila Holder were there for fun and friendship. For sharing friendship and literary experiences, I am grateful to Raoul Pantin. And I acknowledge the assistance of Junia Brown, who arranged appointments and transport, courtesy of The Tourist Board. Special thanks go to Hassin Joey Muller and his team who organized the Hosay portions of the project, and to Jenen Charlie Ramlal, who designed the *tadjah*.

The spiritual and intellectual guidance of Rex Nettleford and Robert Farris Thompson have shaped this project and encouraged us in the most challenging times. Thanks to Noel Audain, Neil Arthur Hodge, David Robeson, Arthur Peters, and Larry Bannock, respectively from Toronto, the Bronx, Brooklyn, London, and New Orleans, for completing costumes. I join Albert Hodge and Beryl Parson in praise of their son Neil, whose death prevented his seeing this exhibition. The memory of the late Clement Bethel lives on as well, a man whose good friendship and generosity opened for me the world of Bahamian Junkanoo and its leading artists, Winston R. Cooper and Percy "Viola" Francis and his associate, Jackson Burnside III.

A special credit to Barbara Bridges who, along with daily Museum business, kept track of the detailed aspects of the project and contributed the New Orleans section. Special thanks to Judith Bettelheim who joined me in this project and for weathering its difficult moments.

Special thanks are also due Linda Horsely-Nunley and our children, Avery and Boyd, who endured my absences for long periods, including family holidays.

John W. Nunley

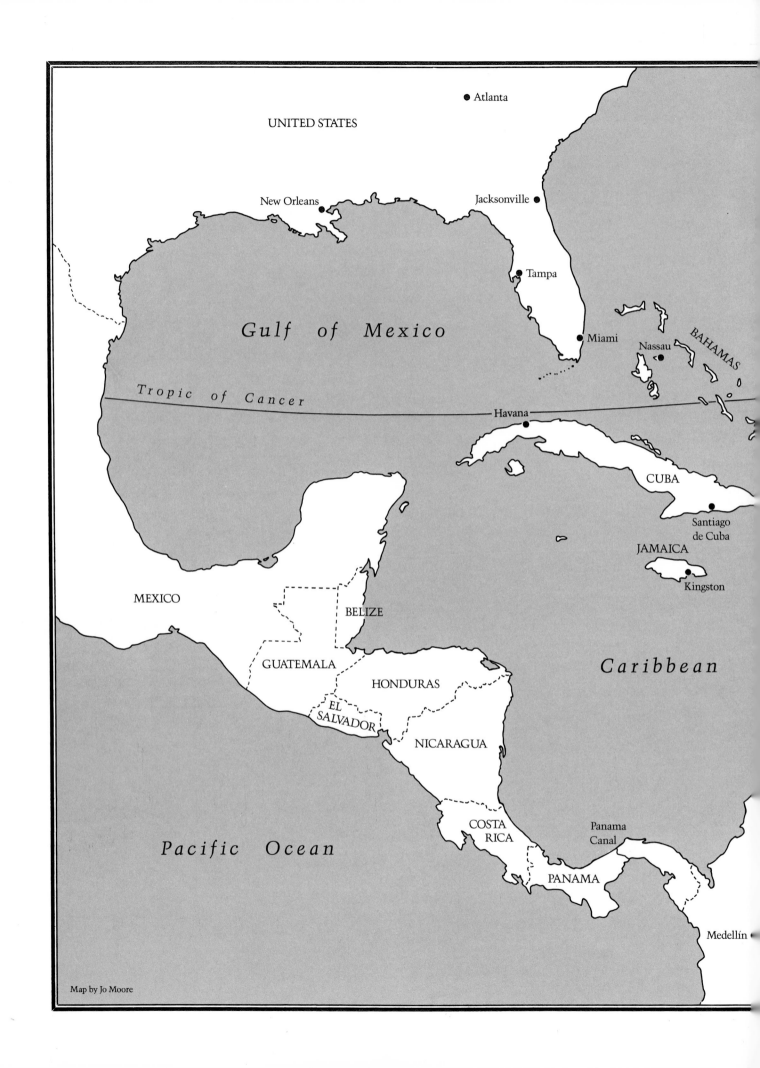

Atlanta

UNITED STATES

New Orleans

Jacksonville

Tampa

Gulf of Mexico

Miami

Nassau

BAHAMAS

Tropic of Cancer

Havana

CUBA

Santiago
de Cuba

JAMAICA

Kingston

Caribbean

MEXICO

BELIZE

GUATEMALA

HONDURAS

EL
SALVADOR

NICARAGUA

Pacific Ocean

COSTA
RICA

Panama
Canal

PANAMA

Medellín

Map by Jo Moore

BERMUDA

New York, Toronto

London

EUROPE

ASIA

AFRICA

HAITI

DOMINICAN
REPUBLIC

VIRGIN
ISLANDS

San Juan

PUERTO
RICO

ST. KITTS
NEVIS

ANTIGUA
MONTSERRAT
GUADELOUPE

DOMINICA

MARTINIQUE

ST. LUCIA

BARBADOS

ST. VINCENT

GRENADA

TOBAGO

Port of Spain

TRINIDAD

Santo
Domingo

Port-au-
Prince

Sea

ARUBA

CURAÇAO

Atlantic Ocean

Maracaibo

Caracas

Georgetown

VENEZUELA

GUYANA

Paramaribo

Cayenne

COLOMBIA

SURINAM

FRENCH
GUIANA

Bogotá

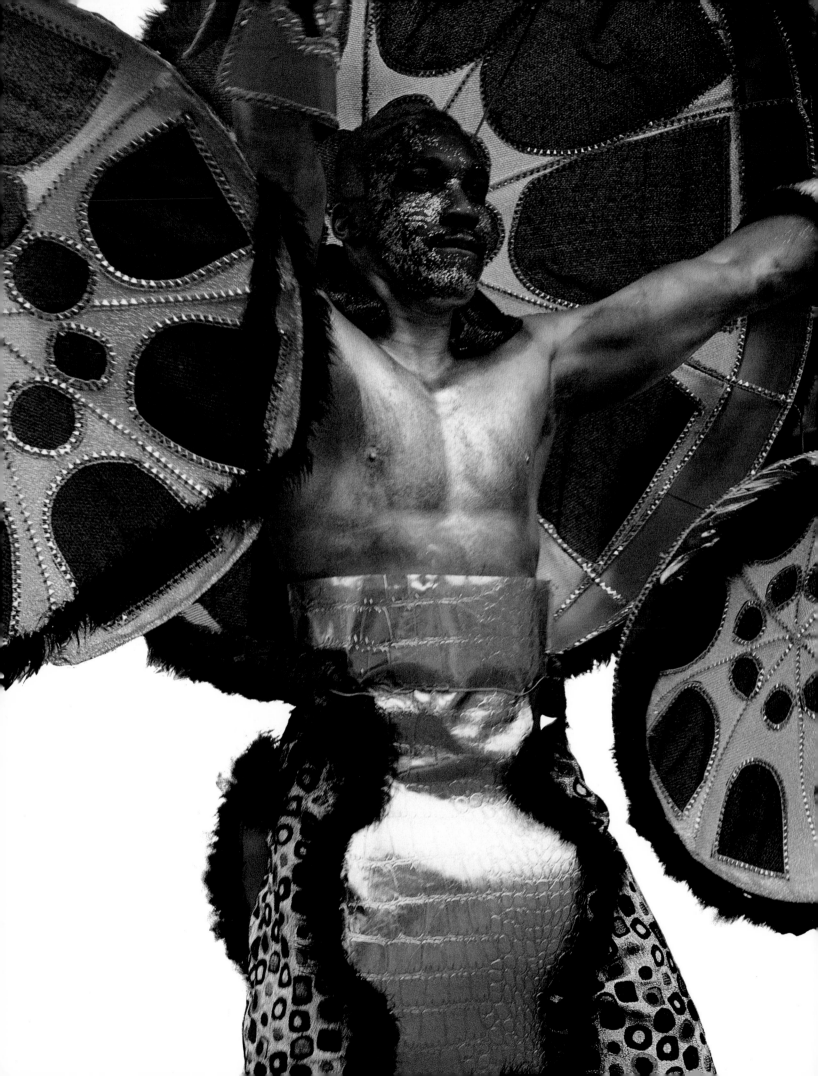

Robert Farris Thompson

Everytime I come to giant city
Hear tambores

Victor Hernández Cruz, *Tropicalization,* 1976

Recapturing Heaven's Glamour: Afro-Caribbean Festivalizing Arts

World Break-Out: The Cultural Impact of Caribbean Migration

In Brooklyn, Toronto, and London taste a star apple/akee/patty/roti feast; hear in New York salsa/merengue/compas/skanking/soca music; dance in Paris a cadence/ compas/reggae/songo/mambo universe in motion *(Figure 1)*. This exhibition is just in time. A new art history, a new visual tradition, based on beads and feathers and masks and percussion-dominated street-marchers, permeates certain neighborhoods of our major cities. To repeat: a whole lot of shaking, drumming, chanting, feathering, beading, multi-lappeting, and sequinning is going on. How did it happen? Immigration, mon.

In city after city, but especially in New York, Washington, and Miami, more and more conversations are conducted in Caribbean-accented Spanish or Caribbean-accented English. The phenomenon started with the first wave of Puerto Rican migration between 1945 and 1955, but has increased dramatically in the last two decades with the arrival of persons from virtually all the islands.

In London, in 1958, novelist Colin MacInnes found himself immersed again and again in a distinctively black cultural configuration: "prodigious . . . sound, rare in purely English gatherings—a constant movement of person to person, and group to group."[1] MacInnes was recording West African/Afro-American responsoriality, calling and responding, basic structures of black song and speech. This he noted in his novel, *City of Spades.* He was plainly impressed by West Indian cultural confidence:

> This English gentleman, he say to me,
> He do not appreciate calypso melody,
> But I answer that calypso has supremacy
> To the Light Programme music of the BBC.[2]

Moreover, MacInnes discovered a telling reason for the black diaspora to London: "The world has broken suddenly into my country; and we are determined to break out equally in the world."[3]

Figure 1 This masquerader in the 1987 Brooklyn Labor Day Festival acknowledged the musical significance of Trinidad's steel bands with a costume representing steel drums. Each black compartment on the drumhead signifies a different note on the diatonic scale.

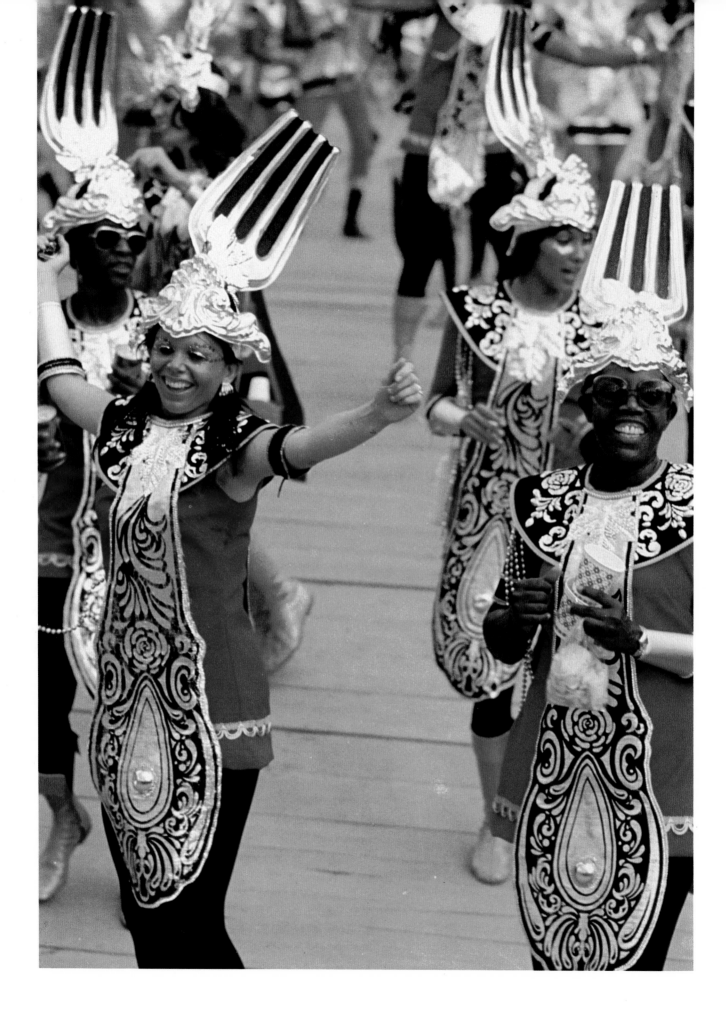

Between 1955 and 1962, some 201,540 immigrants "broke out" from the Caribbean and headed towards Britain. Of these, 178,270 came from Jamaica. Eventually, Jamaicans transformed Brixton Market in London into the Caribbean every Saturday. And by 1982 their reggae had inspired the rise of one of the more powerful figures in world popular music, Sting.[4]

With all this going on in London, it is not surprising to find an emerging African-Caribbean festival of masking emerging there as well. The situation in that other quintessential European capital, Paris, is equally acute: "People figure that if you include [Africans, especially Malians and Senegalese, with] the Antillais [francophone black Caribbeans], who have French passports and can come and go as they want to, there are at least a million, and more likely a million and a half, blacks living in Île-de-France."[5] Hence French popular singers like Serge Gainsbourg sing reggae in French; hence certain Parisian boîtes specialize in cadence music from Martinique or balafon music from Mali; hence black Caribbean—and African-born—painters and sculptors in Paris. The formerly colonized now aesthetically colonize their former masters.

As the world moves towards the millennium, it seems a dramatic reworking of art and art history is taking place in cities that operate under Afro-Caribbean aesthetic pressure. The appearance of self-creolized Kongo spike figures, zinkondi, and the Caribbean botánica trickster image, Echú, in the painting of James Brown; the rise of the young black painter, Jean-Michel Basquiat, himself half-Haitian, half-Puerto Rican; the theme of Afro-Brazilian martial art and the image of the Brazilian-Yoruba goddess of the sea, Iemanjá, in the paintings of Keith Haring—these events are emblematic of what is going on today in New York alone.[6] To exhibit festival arts from the black Caribbean in a museum setting, therefore, is a landmark action that brings tomorrow and the next century to today.

No matter what special bursts of improvisation govern a given creole masking situation, ongoing allegiance to certain cultural basics (like cooking with yams and peppers and tossed greens, staples of West and Central African cuisine that have become givens in Caribbean cooking) will betray descent from African-influenced aesthetics *(Figure 2)*. We know what these principles are: dominance of a percussive concept of performance; call-and-response; battles of aesthetic virtuosity between two singers, or two dance groups; and so forth.[7] But we will know them better, know their atomic weight, as it were, if we seek the popular aesthetic vocabularies in which they lie embedded. This is especially true in those portions of Africa, notably the Yoruba of Nigeria and Benin, and the Bakongo of Congo, Bas-Zaïre, and Angola, from which so much African influence on aesthetics in the Americas derives.

It is a research imperative I cannot fully initiate, let alone complete, in these few pages. Nevertheless, I will at least speak of a few basic African/Afro-American aesthetic principles, in Yoruba and Ki-Kongo terms. I will then examine a few elements of West Indian festival aesthetics.

Yoruba and Kongo Concepts of Parading and Processioneering

The Yoruba verb *pagbo*, "to parade," combines concepts of joining things together [*pa*, bring things in contact with one another], and circularity [*agbo*, circle]. Dejo Afolayan explains the implications of this social geometry among the Yoruba in terms of masking: "When itinerant, entertainer-Egungun maskers, *alaarinjo*, go

Figure 2 This section from the band A la Carte, produced by Stephen Lee Heung in 1975, features dancing forks while other sections included members masquerading as appetizers and other national foods of Trinidad and Tobago.

about entertaining the town or village in an open place, people form an appreciative circle about their moves and gestures."[8] But the appreciative circle is but one aspect of the social geometry generated by masks and parading maskers. There is another basic verb for moving in procession, *yide*, which refers to the circular perambulation of a major entertainer and his or her entourage. *Yide,* to parade in a circle, derives from *yi,* to roll. This is a deeply rooted, and variously nuanced, Yoruba aesthetic concept. In modern Yorubaland, for example, Christopher Alan Waterman shows how the superior juju orchestra in Lagos is expected to *yi* a performance, i.e., changing a rhythm pattern or song's direction, the plotting of its course within the flow of musical tradition, but without altering the essential character of tradition.

Oyo and Ijesha Yoruba describe the distinctly circular emphasis of maskers rolling through a town. Explicitly, they say, Egungun maskers do not enter a town in straight lines; they enter in a circular manner, they roll into the city, to roll away discord, death, and terror. Here is a sanctioning verse:

> Ajelanke [a masker], roll away my death
> Ajelanke roll away my illness
> Let both death and illness stay away
> away in the bush [where they belong]
> Father, roll on home
> Ajelanke, roll all fortunes to my house
> Unlike the beetle, rolling its substance,
> To no avail
> It is fortune of every sort you should
> Roll, roll, roll into my house.

A classic example of the rolling, circling parade of the masker in Yorubaland is the annual Beere festival in Oyo. At that time the great brass-faced Alakoro masker, said to represent King Shango's own Egungun, makes a circular perambulation of the palace walls of the Alafin, or King of Oyo. Gesturing forcefully to heaven and then to earth at each main gate that dramatically punctuates the palace walls, Alakoro symbolically starts the new year by rolling evil away from the boundaries of the palace; he also imbues the entrances with invocations of perfect fortune and good luck, descending from above, like the meteorites with which he is deeply associated.[9]

Kongo traditional notions of the structure and function of masked parades dovetail nicely with Yoruba beliefs. It is more than likely that the two belief systems reinforced themselves, in creole collision, in the black Caribbean. In any event, to parade, with or without masks, was a serious matter in Kongo. Bakongo believe that ritual processioneers ideally carry fortune and spiritual rebirth to a village that they circle. It is further believed that processioneering around a village can mystically heal its hidden problems, can "cool" the entire settlement with circling gestures of felicity and good faith.

Figure 3 African masking motifs often appear on Carnival costumes. In this example from the 1987 Brooklyn Labor Day Festival, a face mask in the Chokwe style from Angola and an African gourd instrument with beaded surface symbolize the African heritage of Caribbean peoples.

Just as it is important to Yoruba that the Egungun maskers "roll away" bad luck and other impurities with their ceremonial visitation, so Bakongo believe that an entire village can be ritually circumscribed by a band of maskers or celebrants. Circling the village brings the ancestral, otherworldly power back to the center. Sometimes maskers circle the council hall at the heart of the village, rather than the whole settlement, in socially geometric shorthand.

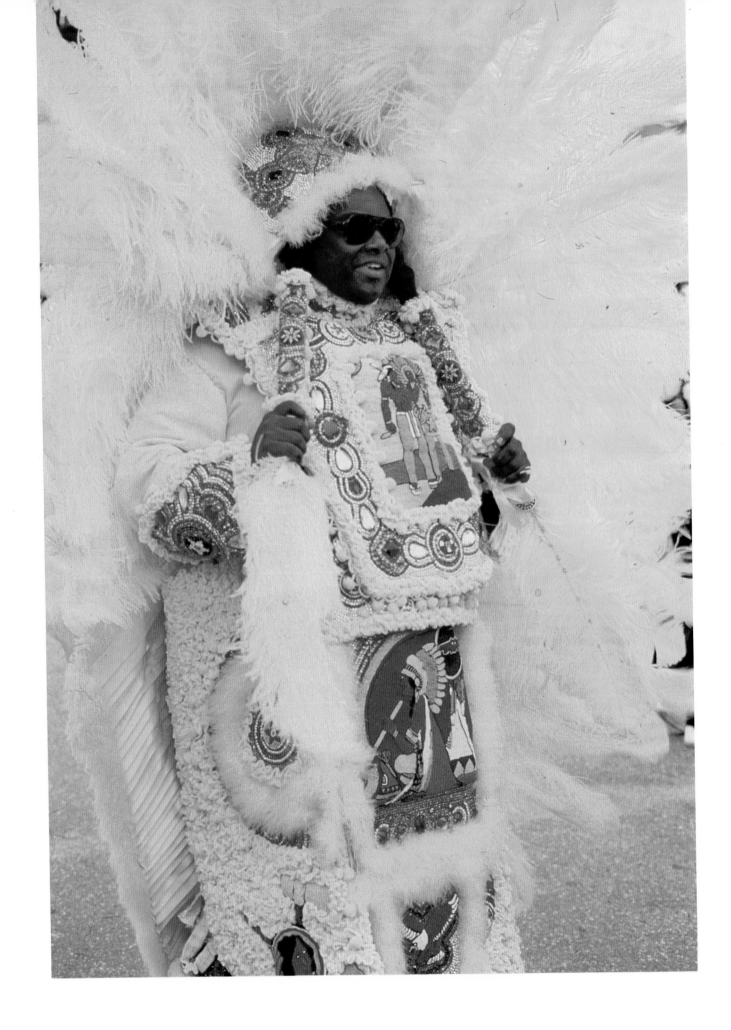

As Yoruba and Kongo artistic culture eventually fuse in creole combinations in certain cities in the Americas, notably Rio de Janeiro, one wonders if, despite immersion in the grid-plan of Western urban planning, Rio festival art echoes something of the ancient valences—ritual circular cleansing and the quest for luck and fortune. Thinking of Victor Turner's assertion that the way persons play profoundly reveals their culture,[10] one wonders if the ancient values, the quest for fortune and luck embedded in parading, were conceptually "loan-translated" into the samba school world. The leadership of samba schools, significantly, is said to be connected with operators of a local kind of lottery called *jogo de bicho*.[11] One thinks also of an old-time "spasm-band," perambulating the streets of New Orleans in the 1940s: ghost-raffia at the cuffs of their pants, shiny pieces of chrome and other metal struck in the center of their circle, and playing cards, symbolic of chance and gambling and luck, affixed to their dancing costumes.

At the very least, we should attend masked performances in the streets of the West Indies and Latin America, as well as in the cities of Miami, New Orleans, and New York, to see if the original symbolism and aspiration connected with circling as an Afro-Atlantic form explicitly remain *(see Figure 3)*. It is implied in the perambulations festival maskers make in Santería and Candomblé and Abakuá and la Regla de Mayombé within Afro-Cuban or Afro-Brazilian public masking; it is also implied in the search for renown, luck, and fortune in specific "morally reflexive" festival floats and costumes in Brazil. Given the powerful fusion of Kongo ancestorism, the quest for power through contact with the world of the dead, and lily-white Alan Kardec spiritualism, which takes place in the Umbanda religion of Rio de Janeiro, one must question the extent to which the circling of the samba schools through the streets of Rio conceals some trace of the ancient Kongo belief that circumscribing the town or council hall unrolls, unlocks, and releases the luck and the power of the ancestors. Such power can be conceptually hidden in a shell or in the quartered circle of the Kongo cosmogram. Not surprisingly, Umbanda is replete with numerous ritual cosmograms and blazons of the spirits, all called *pontos riscados*. One must note the connection between writing cosmograms and sacred signatures around the centerpost of the Haitian sanctuary in *vodoun*; the ultimate blessing there is in witnessing the circling, parading persons who are possessed by the very spirits so signed on the earth around this point.

Fu-Kiau Bunseki, founder of the Kongo Academy in Kumba in Bas-Zaïre, suggests that parades in Kongo are a sort of three-dimensional song of allusion: "Festivals are a way of bringing about change. People are allowed to say not only what they voice in ordinary life but what is going on within their minds, their inner grief, their inner resentments. They carry peace. They carry violence. The masks and the songs can teach or curse, saying in their forms matters to which authorities must respond or change. Parades alter truth. Parades see true meaning."[12]

Finding the House of Consciousness and Activating Heaven: Kongo and Yoruba Interpretations of West Indian Festival Art

When we listen to Fu-Kiau describing West Indian festival masks with feathers, we begin to comprehend why the theme of the Amerindian feathered bonnet is such a haunting constant in black Caribbean masking. The intensity of the feathering of such costumes, especially among the Black Indians of New Orleans, is completely

Figure 4 The use of colorful feathers in this costume made and worn by Larry Bannock for the 1986 New Orleans Mardi Gras derives from native American and African religions whose use of feathers symbolized spiritual flight and the sacred space of heaven.

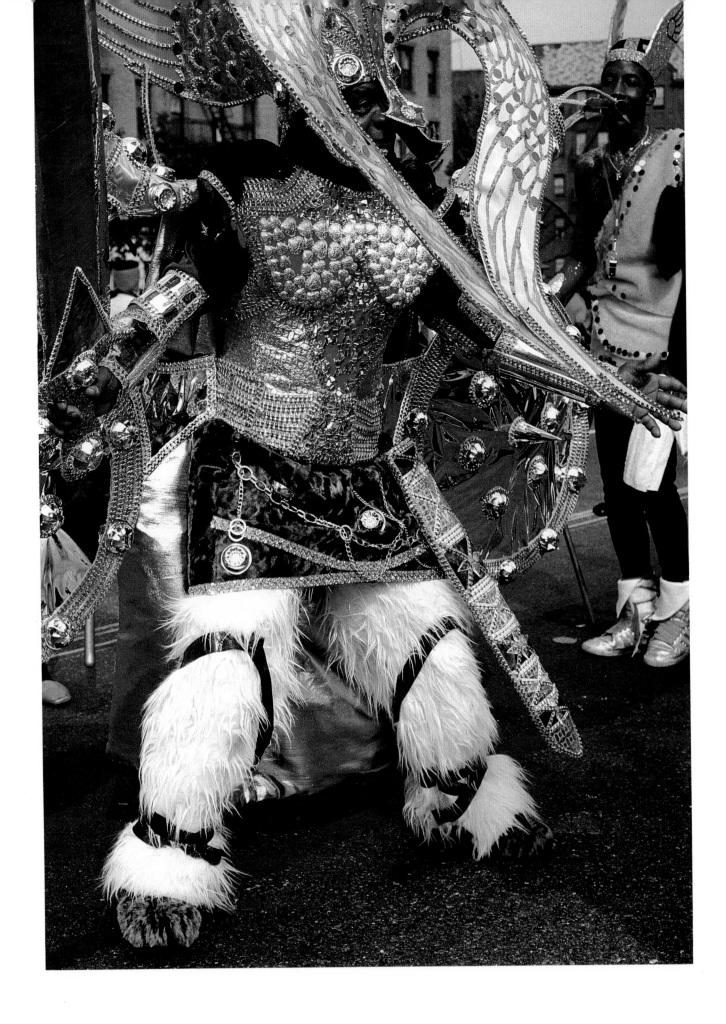

out of proportion to the number of feathers used among Plains Indians in making their famous bonnets *(Figure 4)*. In black Caribbean festivals, feathers often spread from the top of the head to the sides, to the shoulders, to the entire body, becoming what has been called among black celebrants in Brooklyn "feather explosions." Now compare Fu-Kiau reacting to color photographs of Wild Indian black masking in New Orleans and to cognate masks from Trinidad and Haiti: "Masks with feathers symbolize flying beings. A feathered person is a tangible being and a spiritual force. Although the feathered masker is walking or parading, the inner person, within that feathered radiance, flies in his mind to other worlds." (One thinks of the brilliant winged furniture of James Hampton of Washington, who not only conceptually "feathered" chairs with revetments of tin foil, but also gave them literal flashing foil-covered wings.) "As long as the person is conceptually flying within such masks," Fu-Kiau continued, "it is impossible for him to contract sickness that can lead to death. Illness leads to death only if the inner person stops flying, an expression for the loss of his soul."

In other words, feathers on masks or headdresses in Kongo are medicines, referring to confidence and strength built into the vaunting of the power to fly. They teach that it is possible to cure illness by rising out of ourselves, emerging from our physical situation into full spiritual awareness and potentiality. Then, by means of radiant sky-implying feathers, heaven can speak of cures we need, heaven can suggest leaves that can be combined to assuage a burning fever. Traveling among the Vili and other northwestern Kongo groups in the nineteenth century, Adolf Bastian was made aware of the links between spirit-possession and healing. He reported that a certain person took a magic medicine that made him fall, as if struck down by death. Later he arose, ritually renascent, at which point he revealed the herbs and medicines which were disclosed to him in a state of ritual ecstasy.[13] Feathered masks are thus medicines in Kongo. The special persons who wear them are called "the ones who show God" or "the ones who wear God's shadows."

Of Afro-Trinidadian festival "soldiers," dressed in armor reminiscent of ancient Rome and Chokwe-looking "African" masks with radiant white plumes, Fu-Kiau said, "White feathers over metal masks represent the call of the ancestors. By wearing such masks, it seems to me, the Blacks on that island convey the need of the presence of their forebears. The European armor relates to war and warriors. But the white feathers above their masks, I think, means they wish to fly back to Africa and fight there with their armor what is evil, *apartheid* or pockets of colonialism *[Figure 5]*." John Nunley tells me that Fu-Kiau's impression is not that far from the original maker's intentions. The findings of Carol Scotton, who has sounded the meaning of linguistic shifts on both sides of the Atlantic, where Blacks switch languages in a single conversation, suggest, to me, that wearing African feathers and masks over Roman-looking armor invokes "safe return" from a double voyage. And double voyaging is what the Caribbean is all about.

In 1983 Peter Minshall, the famed Trinidadian festival costume maker, made a giant metal Mancrab for the Trinidad Carnival of that year. A part of the artist's intention was aesthetic defiance: "By opposing yourself to such a horrific vision, you fight it, you contest it, yet at the same time you ironically identify with its intimidating structure and power of motion below the waves."[14] Now compare an impression by Fu-Kiau:

Figure 5 Since the introduction of the cinema, West Indians have been inspired to depict gladiators, medieval knights, Vikings, and other heroic figures in their Carnival bands. In this 1987 Brooklyn Labor Day Festival costume, armored chest plates, fur, leggings, and a fanciful winged nordic helmet are combined.

First of all, this mask proclaims the power of life within the ocean. Using this metal crab, we descend beneath the waves by means of the power of the whites' machines. So doing, we can talk to our ancestors, and they can bless our technology. The mask proclaims a machine for descending below the waves, a machine built on the premise of a crab. By using this metal machine crab we can show the modern world both our modernity and antiquity, and our power to fight and win our space within both worlds.

The silver on the crab we translate as white, the ancestral color, the world of the ancestors. A crab colored with the sparkle of the dead therefore becomes their blessing. Without their benison, no machine, not even this one, can work.

Traditional Yoruba, with rich associations linking masking to the power and presence of the dead, would probably nod in agreement with Fu-Kiau's insistence on finding the power of the other world implied in the fantasy and flash of modern masks made for Afro-Caribbean festivals.

First of all, a basic term for Egungun costuming, *ago*, derives from a root verb, *go*, which means to be visually mysterious. In other words, when the *ago* is on you, you're ritually covered; viewers will not see beyond the immediate. We are not talking about "mask" or "costume" in Western terms. We are really talking about creating visual misinformation for blocking profane vision. These abstract apparitions "mask" the entire body, not only the head. Over the face of such constructions goes not a mask but an embedded veil, *awan*, a netted shield. As one mask-wearer told me: "Behind the *awan* everything you can see, outsiders see nothing." The *ago* with *awan* is also called *eku*, which refers to something death-connected. This is because in the contexts of royal and ancestral visitations, Yoruba refer to virtually any sacred object that has to be covered as "death." There is a saying about this belief: "We dare not open cloth of life and death."

Yoruba sacred body-coverings with netted viewing-shields are death-connected sacred objects *(Figure 6)*. We pierce or lift up their lappeted structures at our peril. The danger lies in the fact that, for the Yoruba, such "masking" philosophically keeps secret the distinction between the spiritual world and the world of the living. Therefore we are not talking about the mere wearing of cloths and lappets. We are talking about the ritual wearing of thresholds. Birth is an obvious threshold. It is interesting that if a child is born with an *ago*-like sack covering its face and neck, it is born a child of Egungun, ancestral inquisitors and entertainers.

This sacred facelessness defines Egungun masking. The cloths which shape this dissolving of the face take on awesome powers. They are cloths of the end, cloths of the beginning, the fatal garb. As a liminal, conceptual "heavy" thing, it can be used as a charm against evil. Certain persons sleep on pieces of red Egungun cloth to protect them from visitations by "our mothers" in the night. Others lick such crimson cloth pieces for immediate activation of a prayer or invocation.

As sacred boundary-marking, boundary-hiding devices, Egungun masking costumes can be compared to altars, called "the face of the gods" in liturgical Yoruba. An altar can similarly be veiled from improper viewing by cloth, and can be protectively shielded by fringes of raffia, correlated with the aggression and power of the iron and war god, Ogun. I might add, parenthetically, that Yoruba links, between altar and masking, hint that Caribbean masking should be compared with local altar configurations.

Figure 6 This enigmatic face mask appeared in the 1988 Trinidad band by Peter Minshall entitled Jumbies. The white mesh mask makes direct reference to the old time wire screen masks, once prevalent in the pre-Lenten festival. In this case, the mask represents the past looking into the future.

26

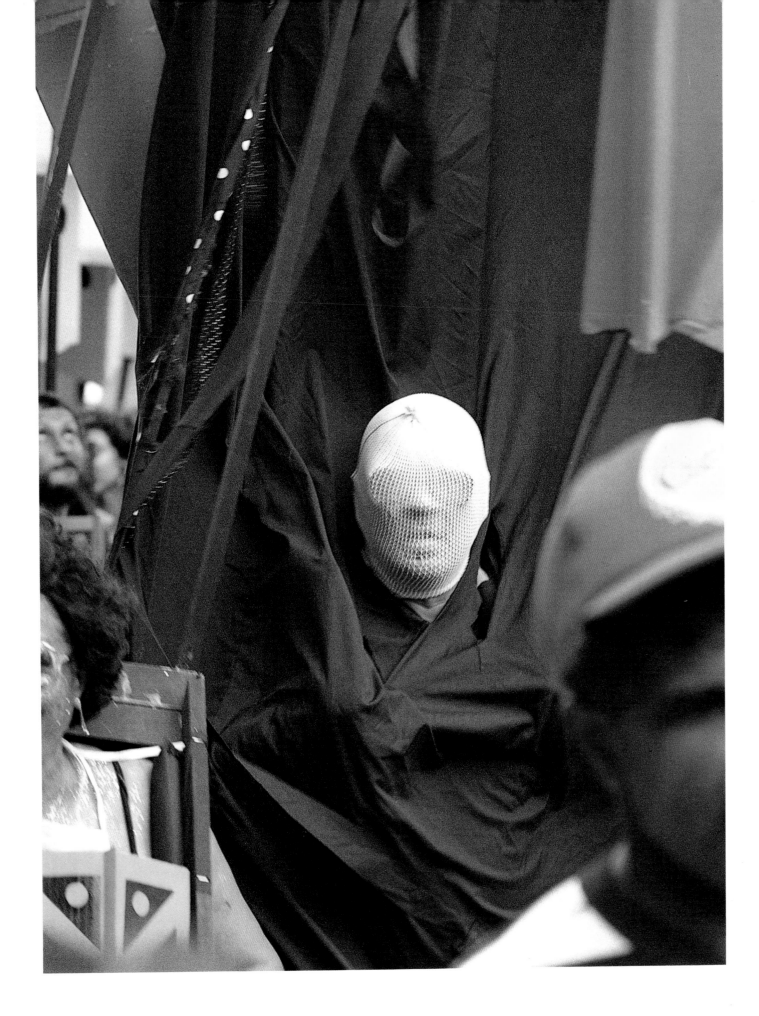

Whereas casual outsiders in black New Orleans, for example, might see only fun and fantasy in the brilliantly plumed costumes of the Black Indian groups, Africans, and Yoruba in particular, read religious devotion into the intensive blocking of ordinary viewing of the body with feathers, beads, sequins, and other elements. In fact the Wild Indian maskers kneel to pray at altars for successful parading of their costumes. We suspect there is a connection between the Rosicrucian altar made by Willy Best, a maker of Jonkonnu masks in Port Antonio, Jamaica, and the power and glitter of his masks.[15] And there is definitely a link between protecting the altar of the deity of creativity and intellectual assertion in Yorubaland, and in the worship of a cognate deity in Benin, with a white cloth and a shield of protective raffia, and the dressing of *kanzo* initiates in Haiti—and Haitian New York, as I witnessed above the banks of the Hudson in the west Bronx in the spring of 1987. *Kanzo* initiates emerge with a straw hat over their head-ties, raffia fringe falling over their faces protectively, just like the fall of the veil over an Egungun masker or a Yoruba king in state.

Recalling the Yoruba idea that circling the town in Egungun costumes rolls away all evil, and brings good fortune, consider similar Yoruba themes of symbolic fortune by means of feather-symbolism or feather-signing. For example, sometimes a red feather and a blue feather appear together in a masquerade context. The red feather symbolizes waves of good fortune from the sea. The blue feather symbolizes waves of fortune from the lagoon. In short, feathers are considered a very strong medium for attracting heaven in Yoruba artistic culture, for attracting the positive attention of the ancestors and their wealth beneath and beyond the watery boundaries of the sea.

Now let us consider two possibly Yoruba-influenced costumes in Caribbean festival masking. The first example is a Junkanoo costume worn by John Wesley, local star athlete and Junkanoo performer on the island of Eleuthera, the Bahamas, on Christmas and Boxing Day in 1978.[16] His costume, cut in long lappets of cardboard covered with bright strips of gold and red crêpe paper, recreates the multi-lappeting of many Egungun costumes. Such cascading lappets, called *alabala* in Yorubaland, are meant to be wheeled in a brilliant spinning motion. There are songs about this quality:

> thundergod dancer, if you don't spin
> you've covered your body in shame

John Wesley, the Yoruba would be glad to know, always covers himself in glory by using the lappets in dramatic turns and spins when he performs Junkanoo. But his multiple lappets are *open*, proclaiming apparent quasi-secularization of a tradition that came to the Bahamas, differing dramatically from that of Yorubaland. Among key Yoruba maskers, the lappets, even when they whirl apart and open, reveal nothing but further lappeting, and lappeting beneath that, protecting the wearer from profane observation.

The Trinidad Carnival of 1971 included a most interesting masker.[17] His costume embodied several Yoruba-looking touches. First, the front of his body was emblazoned with numerous multiple lappets, very much in the style of western Yoruba Egungun *alabala* or *irepe*, a word meaning "strips of cloth." Disguising was partial, however, for the hands of the masker were visible at the sides and the lappets did not radiate out from all directions, as they do in the most spectacular western Yoruba Egungun. Nevertheless, the manner by which each lappet was fringed and

framed and decorated with bright sequins was very similar to Egungun seen today on the coast of Benin and Nigeria between Ouidah and Badagri. To Dejo Afolayan, who studied this photograph, the masker seemed to be wearing "the ritual skirt of heaven," traditional Egungun garb. But traditional Yoruba would be shocked by the fact that the Trinidad masker was dancing bare-faced, without a face-shield. This defines his dress as vaguely Egungunizing, but really something else, something creole, fanciful, different.

Nevertheless, white-chalked marks on the face of this masker and on that of a colleague in the same photograph indicated to Afolayan that the dancers were honoring spirits, however informally, however out of sacred context. Afolayan's attention was riveted upon a circular device, filled with brilliant blue glass, that flashed over the chest of the masker. He immediately related this device to the Yoruba image:

> [Heart], house of consciousness
> Deep seat of thought and the decision-making process

Finally, the flash of white plumes, part of the costumes of the two maskers with multi-lappeting, was visually exciting to Afolayan. These are "feather signs": "It is thought that beautiful feathers in elegant arrangements easily touch the heart of departed relatives. It is said that 'when heaven hears the visual voice of the peacock's feathers, heaven is activated.'"

The Kongo vision of persons mystically taking flight in colors and feathers under the pressure of a totalizing percussion, and the Yoruba image of heaven's own activation by the blazing beauty of the peacock's plumes, explains, I think, why the image of the Amerindian in feather-bonnet is one of the recurrent themes of black Caribbean festival masking. Certainly the Blacks are honoring the nobility of the original inhabitants of the lands and islands to which their ancestors were brought in bondage centuries ago. But they are also honoring themselves.

This double homage, to the nobility of the Amerindians and to the Afro-Atlantic quest for possession by the spirit, has become a perennial occasion by which the artists of the black Caribbean demonstrate that several art histories, not one, flourish today upon our planet. The creole thing to do is to mix them. Gone is the notion of a single canon. Bring on the Callaloo.

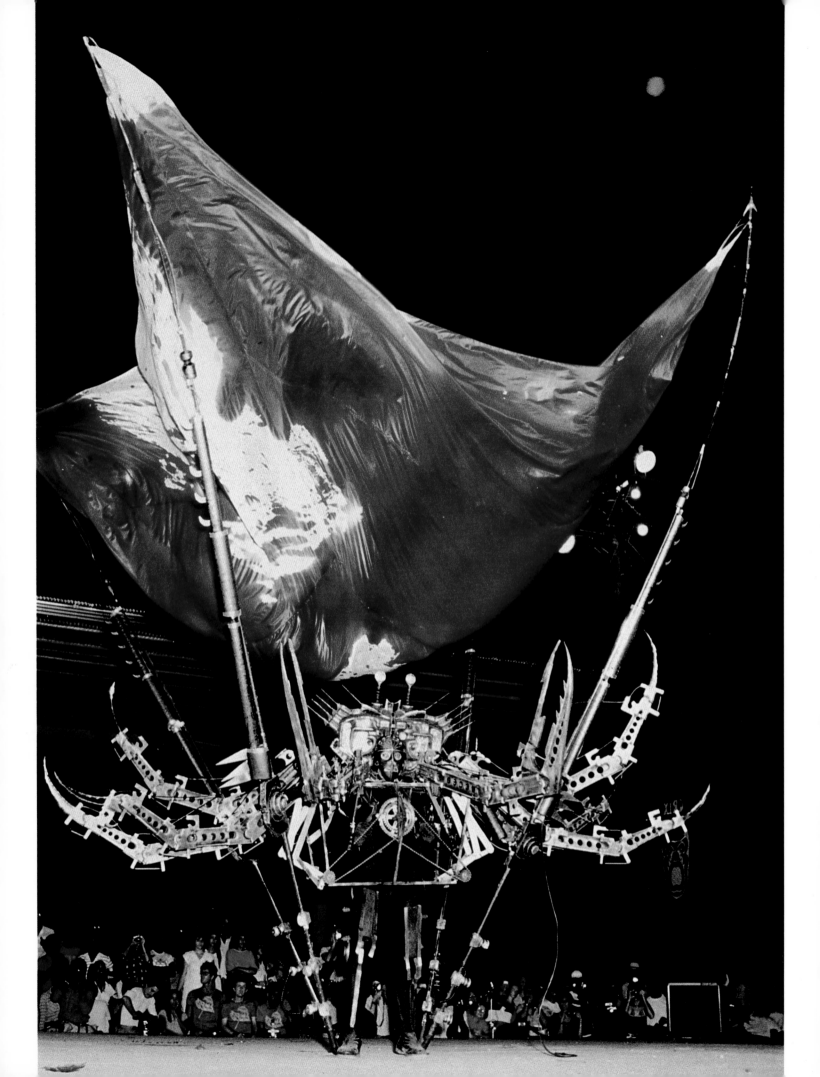

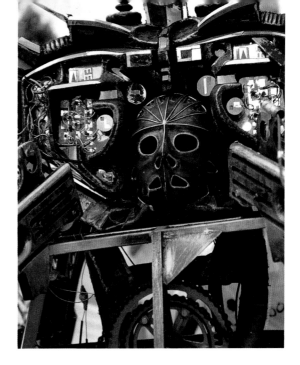

Judith Bettelheim
John Nunley
Barbara Bridges

1

Caribbean Festival Arts: An Introduction

Figure 7 As Mancrab dances across the stage to the rhythm of *tassa* drums, the silk suspended from the poles flashes its white brilliance with the movements of the dancer. Slowly the dye begins to stain the corners of the silk until the sheet is completely blood red, symbolic of Mancrab's destructive powers.

Figure 8 This detail of Peter Minshall's King Mancrab, performing in Carnival 1983, Port of Spain, illustrates the automaton nature of the creature.

Soft-shell crab, the meat and milk of the coconut, curry, hot peppers, and the ground green leaf of the tropical dasheen plant combine to make Callaloo, a soup that has become the national dish of Trinidad and Tobago. To the inhabitants of the Caribbean, it is a metaphor for the racial diversity of their nations, containing "every little piece of difference." The more diverse the ingredients, the sweeter the soup; the more diverse its people's racial and cultural backgrounds, the stronger, the better the nation. The dasheen leaf, the primary ingredient of Callaloo, is heart-shaped; it proclaims the goodness or heartfulness of us all.

"Callaloo" is also the name of a character in a story by Ma Elise, an Afro-Trinidadian storyteller from Maracas Beach. Inspired by her tale of good and evil, Peter Minshall, a leader of a Carnival theme band, embellished it with costumes for his Carnival bands in Trinidad between 1983 and 1985. Slithering in the polluted slime of the island, Mancrab, King Evil himself, represents technology's dark side, its promise of environmental destruction. On each night at the King and Queen competitions of Carnival 1983, in Trinidad's capital of Port of Spain, this hideous dancing mobile moved to the violent music of East Indian *tassa* drums. Menacing pincers clawed the air threateningly as the multi-armed monster spun its dance of destruction beneath a canopy of white silk. The automaton's face stared without emotion at spellbound spectators *(Figure 8)*. At the climax of the dance, a compressor pumped red paint up tubes attached to four poles, slowly staining the silk at the corners. Before the dance was done, the pure white silk had turned blood red *(Figure 7)*. Twisted by the winds, the dancing mobile stunned the crowds.

Mancrab's enemy was Washerwoman, that year's Queen, whom the demon finally murdered in the masquerade. This snow white beauty danced soca-samba

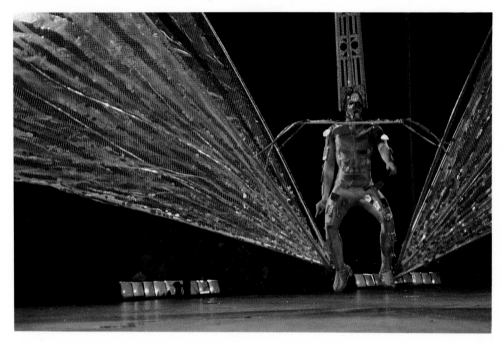

Figure 9 King Callaloo, designed by Peter Minshall in 1984. In the story, Callaloo walks on water; as the King danced, the wing-like forms attached to his ankles created a splashing sensation.

across the stage, battling her adversary. To Washerwoman and Papa Bois, the spirit of the forest, a son named Callaloo was born. Those who are black see themselves black in him; if they be brown, they see themselves brown; if white, then white.[1] Callaloo's sequined costume glowed in the stage lights as if he were walking on glittering water *(Figure 9)*. Armed with moral strength and ethnic diversity, Callaloo subdued the Mancrab and saved the river people from destruction.

Thus the multi-racial Caribbean people, represented by the triumphant image of Callaloo and his edible namesake, fight evil in the contaminating forces of technology. The Callaloo metaphor embodies the pan-Caribbean aesthetic, with its mixture of media and themes, and defines the flavor of the Caribbean character: a blend of ethnicities, religions, and political orientations intrinsic to the color, themes, music, and spirit of festival arts.

The festivals and the artists that are the focus of this book and the accompanying exhibition come from different backgrounds and produce art under different circumstances. They are charismatic individuals whose training and backgrounds are as diverse as the festivals themselves. Valentine "Willy" Best of Port Antonio, Jamaica, who designs his own costumes, has been playing Jonkonnu for about thirty-five years *(Figure 10)*. Jonkonnu players like him are part of a Jamaican tradition: they learned by apprenticing with other performers. Some of these men have never left Jamaica, or even traveled as far as the other side of the island. They may have seen other festival performers at local competitions, during national festivals, or more recently on television. Their inventive aesthetics derive entirely from what is at hand, from what they have seen. They are not trained in a beaux-arts tradition but neither are they aesthetically isolated. They do not participate in that particularly nostalgic European attitude toward the "handmade." As anthropologist Nelson Graburn points out, "Most classes of people are now exposed to national and international traditions and tastes, through radio, travel, marketing networks, and increasing worldwide standardization."[2] Nevertheless, these artists maintain an independent sense of approbation and value. Asked how he prefers to design his Jonkonnu costume, Willy Best said, "What I really like is for us to get the

cloth and operate it the way we like. Each man likes to make his own suit. He don't like the committee to make it and give it to us."[3]

The West Indian islands encompass the land masses along the eastern border of the Caribbean Sea, extending from Florida to the mouth of Venezuela's Orinoco River on the South American continent. The Caribbean Basin includes the islands of Cuba, the Bahamas, Jamaica, Haiti, Puerto Rico, the Virgin Islands, Montserrat, St. Kitts, Nevis, Antigua, Guadeloupe, Dominica, Martinique, St. Lucia, St. Vincent, Barbados, Grenada, Tobago, Trinidad, and the culturally related countries of Bermuda, Belize, and Guyana *(see map, pp. 14–15)*. Once Columbus encountered the Indians who lived on these islands, it was only a matter of time before colonial settlements and immigrants altered the cultural nature of the region, establishing an even greater mix.

Figure 10 Valentine "Willy" Best, Port Antonio, Jamaica, August 1984. Willy Best plays Wild Indian in the Port Antonio Roots Jonkonnu band. His costume usually consists of fringed trousers, overskirt, and shirt. Here, he wears a feathered headdress adorned with mirrors, a wire screen mask, and his special signature, a heart-shaped chest shield, and is playing a rattling drum.

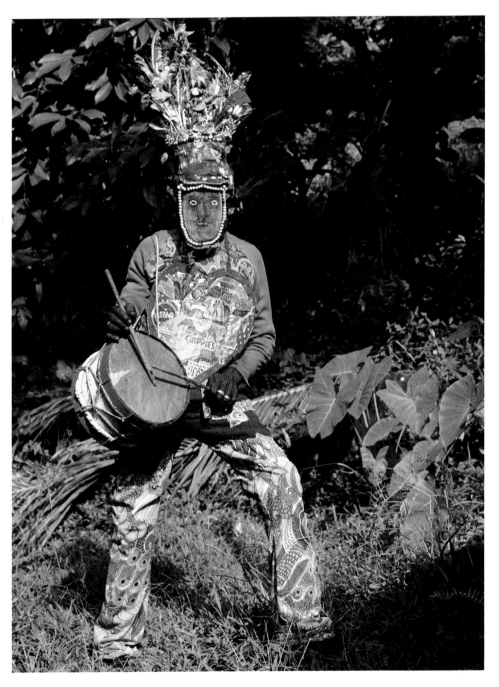

Spanish explorers dominated the Caribbean for several decades, conquering the surrounding mainland civilizations and establishing the Roman Catholic religion throughout the region. Later the English, French, and Dutch colonized the smaller Caribbean islands and introduced large-scale sugar cane cultivation. Driven by the lure of huge profits, Barbados, Jamaica, and Haiti soon became plantation colonies operating under a feudal system that utilized slave labor, with all its attendant evils, for the profit of white landowners. The English entered the slave trade in the 1560s, and throughout the seventeenth century the Dutch and French also took part, bringing slaves to West Indian plantations from West and Central Africa. The establishment of plantation economies in the West Indies, and the trade associated with them, dictated the need for cheap, plentiful labor which would eventually form the ethnic fabric of the Caribbean islands. Furthermore, white settlers from the Old World took the roles of middlemen and overseers to seek their fortunes.

During the seventeenth and eighteenth centuries, sugar plantations thrived in the West Indies, as did the slave trade. By the early nineteenth century, some six million slaves had been brought to the Caribbean. By then, however, Britain had moved to abolish its slave trade, and had established apprenticeship systems to compensate for the labor loss.

> The slave trade was abolished by Denmark in 1802, by England in 1808, by Sweden in 1813, by Holland and France in 1814, and by Spain in 1820; it continued "illegally" until after the middle of the nineteenth century. Slavery itself ended by revolution in Haiti, 1791–1804 (though plantation production on European-owned estates continued until substantially later); in the British colonies in 1834–1838; in the French islands in 1848; in the Dutch islands in 1863; in Puerto Rico in 1873–1876; in Cuba in 1882–1886; and in Brazil in 1888.[4]

Between 1836 and 1917, indentured workers from Europe, West and Central Africa, southern China, and India were brought to the Caribbean as laborers. Though it was a complicated system, indentureship basically required individuals to work according to the stipulations of contracts, though the documents often were of dubious worth. Many workers originally settled in Jamaica, Trinidad, Surinam, and Guyana, but by 1890 continued economic decline increased migrations from island to island, as well as to Central America, Canada, London, and the United States. In many of these places, festival celebrations modeled after those in the Caribbean take place today.

Presently, West Indians are of African, East Indian, Carib, Anglo, Spanish, French, Chinese, and Middle Eastern origin. They practice Vodoun, Rastafarianism, Santería, Pukkumina, Obeah, and Shango as well as Catholicism, Islam, Hinduism, and varieties of Protestantism.

The Caribbean's ethnic complexion, as well as its dynamic economic and political history, are the ingredients of its festival arts. Religion, costumes, musical traditions,[5] and the friction created by slavery and perpetuated by racial inequities, all contribute to the dates on which festival celebrations occur, their themes, social and satirical commentary, and the forms, color, and music they celebrate. At the heart of festival arts in the Caribbean are three major celebrations—Carnival, Hosay, and Jonkonnu—which typify a public attitude toward celebration and which, except for the Hosay festival in Trinidad, do not incorporate systematic religious rituals. Carnival, Hosay, and Jonkonnu draw on Old World traditions. Derived from the combining of European pre-Lenten festivals with traditional African masquerades,

Figure 11 Coiffure, ou le Triomphe de la Liberté. During the eighteenth century, European courtly masqueraders often incorporated fanciful and elaborate elements into their costumes.

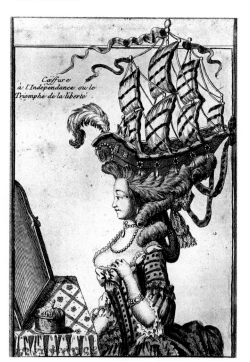

Carnival is celebrated in Trinidad during the week before Ash Wednesday and during summer months in London, Toronto, New York, and other metropolises of the west. Jonkonnu grew out of African dance and masquerades combined with English folk festivals such as mumming,[6] and is usually celebrated around the Christmas and New Year's holidays. Hosay, occurring in the Muslim month of Muharram, commemorates the martyred grandsons of Mohammed, named Husain and Hasan, with the building of large tomb-like structures. In the West Indies it is celebrated by East Indians of diverse faiths. Festival costumes and music take on the sweetness and spice of many cultures, forming a pan-Caribbean aesthetic, a truly Caribbean quality, in the tradition of Callaloo.

Festival Aesthetics and Aesthetic Sources

Caribbean festivals embody an aesthetic formally rooted in the early European, African, and Asian traditions brought to the West Indies between the fifteenth and nineteenth centuries, as well as from twentieth-century publications, broadcasts, and artistic movements. Caribbean festival arts are evidence of the transformation worked by a creole aesthetic.[7] During colonial expansion, European sensibilities encompassed a Romantic aesthetic that sought the new, the novel, and often combined it without the restraint of historical accuracy. In a popular European masquerade costume of the late eighteenth century, for instance, a French woman might dress in a fancy gown while donning an elaborate coiffure with a full-masted ship forming the crest *(Figure 11)*. Similarly, an ingenious black masquerader, Joseph Johnson, paraded the streets of London in the early 1800s wearing on his head a model of "the Ship Nelson [which] . . . he can, by a bow of thanks . . . give the appearance of sea-motion"[8] *(Figure 12)*. In English folk theater this penchant for the historical, drawing on Shakespearean dramas, became part of mumming performances. These themes also were featured in Caribbean *tea meetings* and similar small theatrical traditions. In the parish of Westmoreland, Jamaica, a band of Actor Boys used to perform a version of the misadventures of King Henry II, while many nineteenth-century chroniclers recorded black bands presenting condensed versions of Richard III. Historical themes are still part of many Carnival celebrations, although now historical accuracy is of primary concern.

The African sensibility of masquerade is also a major focus of festival arts. Despite their different tribal origins, Africans in the Americas understood and practiced the masquerade, which combined music, dance, costume, sculpture, and drama in a single performance. Traditional African aesthetics also can be characterized as assemblage. In the motherland, animal and human bones, raffia, beads, shells, horns, metal, and imported cloth might all appear on a single masquerader.

The slaves brought these well-tested artistic institutions with them, and despite the break-up of families and tribal affiliations, they retained this aesthetic dimension, adding European objects to the costume assemblages. Reports of early Jamaican masquerades describe Africans and their descendants dressed in animal costumes with feathers, mirrors, animal horns, shells, and glitter. Later in Carnival and Jonkonnu, animal parts, along with Christmas tree bulbs, sequins, beach balls, plastic whistles, beads, and magazine cutouts, would be incorporated into costume making.[9]

East Indian Islam brought to the Caribbean another aesthetic that downplayed naturalistic representation and stressed abstract, geometric, colorful, and all-over

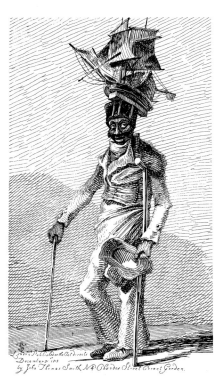

Figure 12 Joseph Johnson's headdress may be derived from a Senegambian tradition. Johnson wore a model of the ship *Nelson* and paraded during the Christmas season, accepting donations from appreciative spectators. From an image by John Thomas Smith, London, 1815.

35

patterns. This aesthetic is most magnificently expressed in the *ta'ziya* made for the Hosay festival. Since the mid-nineteenth century, East Indians of all backgrounds have embraced the Hosay festival; large, tomb-like structures with domes, decorated with glittering paper, mirrors, flowers, and other colorful objects in assemblage, were paraded for all to see. With Hosay, another ingredient was added to the aesthetics of Callaloo.

Caribbean festival arts still revolve around the aesthetics of assemblage. The makers of festival arts attach items both fabricated and found in the urban environment, and natural vegetal and animal materials, to superstructures in layers, resulting in a plethora of textures, colors, and collage-like forms. Mirrors are frequently placed over the layers to break up the surfaces by reflecting light onto dark areas.

Another quality common to the three festivals is that which art historian Robert Farris Thompson has called a "high-affect" aesthetic. While this quality is enhanced by the modern technology of an urban environment, its source is really the individual's desire to stand out in a crowd. Wherever large buildings, the sounds of automobiles, machinery, and people all compete with the costumes and music, high-affect aesthetics result. One costume in the 1985 Toronto Caribana festival loomed like a twenty-foot-long jellyfish, its mylar-skinned surface reflecting the buildings on University Avenue, literally reducing and absorbing them onto the costume.

Initially, the first encounters of such diverse populations in public festivals were characterized by both unity and disruption, solidarity and intense competition. In some cases, festivals have even harbored rebellions. Despite newspaper condemnation and the restrictions placed on festivals by governments, participants have held fast to the belief that public festivals are the right of the people, and they have shared their artistic and aesthetic foundations, developing a new iconography.

Festivals are no longer regarded as mere rites of reversal, when class struggles and repression can find a public forum, nor as politically neutral expressions.[10] Though they do provide an arena for negotiations in political power, they simultaneously codify and package vibrant arenas of cultural production. As cultural products, they "have superceded traditional social relations as a basis of shared values and sensitivities. Cultural productions have become the generative basis of myths, life styles, and even worldviews."[11] Rex Nettleford, Jamaican scholar and founder of The National Dance Theatre Company, has called the artists of the Caribbean "cultural brokers," collectively mediating internal and external influences in a festival environment, adapting to multi-cultural circumstances. At different points in the twentieth century, these festival artists have expressed new or renewed interest in Africa, creolizing traditions gleaned from photographs or publications or movies or travel, blending sources and meanings *(Figure 13)*. Nettleford describes festivals as "a culture of options." The aesthetics of acculturation, so integral to festival arts, provide the basis for longevity and dynamic expansion.

There is real potential for historical inaccuracy, however, in claiming one-to-one correspondences between twentieth-century Caribbean cultural expressions and their African counterparts.[12] Recent research has clearly proven the tribal heterogeneity of the Africans transported to the Americas. In fact, as so many of the

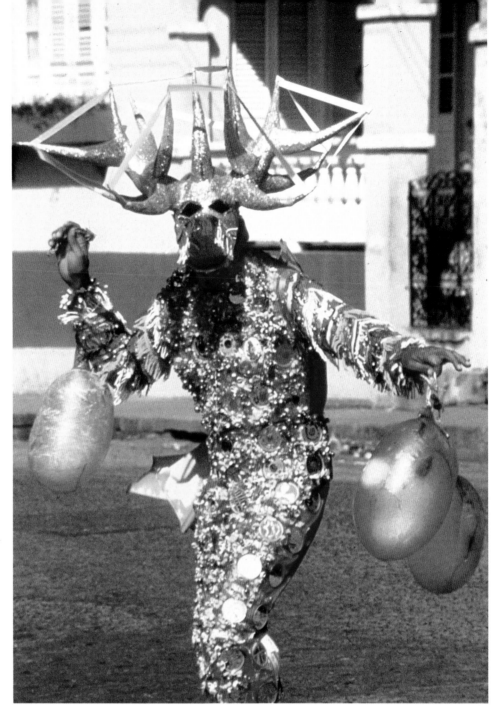

Figure 13 Body costumes decorated with sequins and mirrors and complemented by multiple horn headpieces distinguish the Carnival of Santiago, the Dominican Republic. The horn headdress of this 1984 costume has antecedents in African festivals, while the custom of swinging bladders at passersby derives from European Carnival. The blending of these disparate elements is indicative of the creolization process. c. 1986

cultural forms in the Caribbean indicate, renewed interest in African culture has often inspired new forms, distinct from those based on traditional, or tribal, retentions. This renewed interest derives from the power of aesthetic expression to codify and enunciate individuality while simultaneously declaring solidarity with a people, with a place, with a concept. Using a perceived African or East Indian image or aesthetic form, perhaps a musical instrument or a rhythm, provides a viable link with roots, a restatement of historical depth.

Most festival arts are ephemeral. Ideas for these arts, however, are carried forward from year to year, as they were during the first immigrations to the Americas. More recently, photographs and art exhibitions have spurred this process. After each festival, sated celebrants still look forward to the next year when "every little piece of difference" will again be assembled and prepared in the artistic kitchens of the Caribbean. The ingredients, like the people, are distinctive, yet together they create a sweet, pungent pan-Caribbean aesthetic.

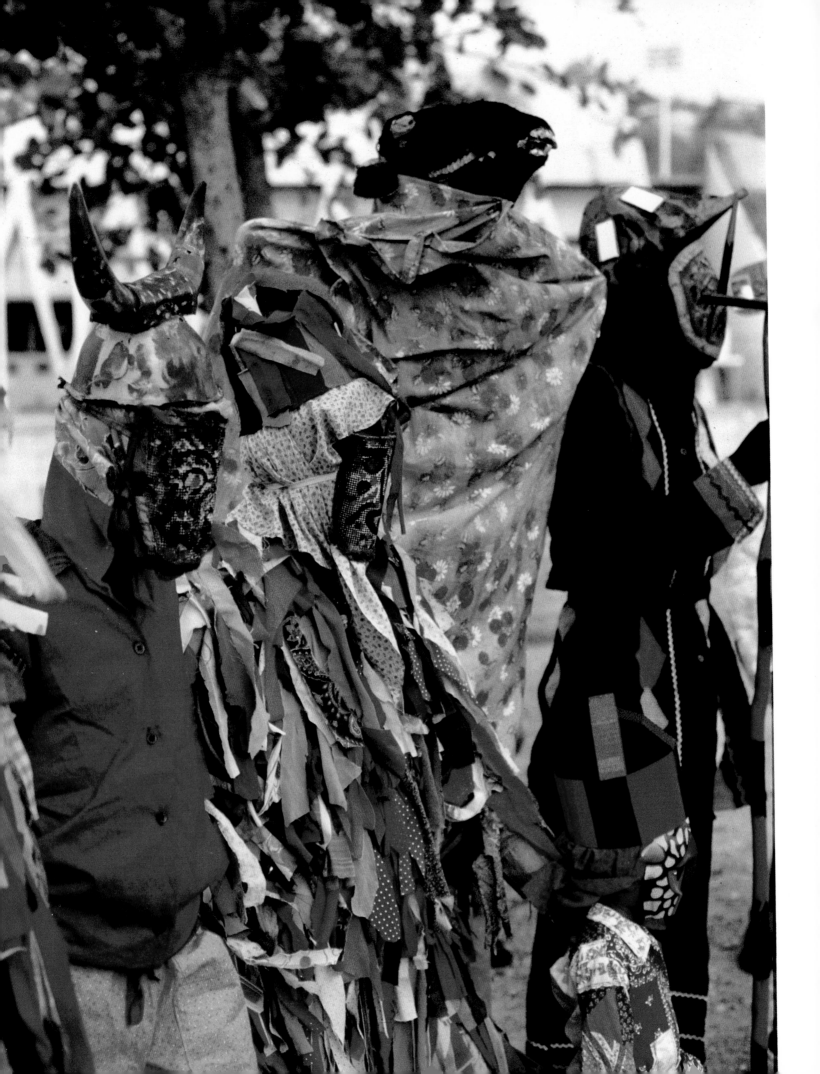

Judith Bettelheim

2

Jonkonnu
and Other Christmas Masquerades

Jonkonnu is a Jamaican street festival characterized by an entourage of wire screen masked and costumed male dancers, performing mimed variations on an established repertoire of dance steps and accompanied by small musical corps. They perform sometimes at Christmas, but more often on important state occasions *(Figure 14)*. Since at least the beginning of the eighteenth century in Jamaica, masked and costumed performers have paraded the streets during the Christmas season and have given performances, originally before Great Houses, and subsequently before the residences or offices of people important in the community.[1] Variations on this festival occur in many British-influenced Caribbean nations, including Belize, St. Kitts-Nevis, Guyana, and Bermuda in the South Atlantic. In no two places are the festivals exactly the same. In Belize the custom seems to have a direct Jamaican connection, while contemporary Bahamian Junkanoo shares only a nomenclature with the Jamaican practice.

In Jamaica today, Jonkonnu consists of all-male entourages who are either Roots Jonkonnu maskers or members of Fancy Dress bands. The Roots masquerades include such characters as Cowhead, Horsehead, Pitchy Patchy, Devil, Warrior, and Amerindian. These bands tend to be located in the eastern region of Jamaica and are strongly Neo-African in style.[2] Fancy Dress bands mainly come from the western Jamaican parishes of St. Elizabeth, Westmoreland, and Hanover. The costumes of Fancy Dress bands show strong European influence, incorporating the courtly attire of such characters as kings, queens, and courtiers, but in wildly colored prints, embellished with plastic flowers and Christmas ornaments that are

Figure 14 The Spanish Town Road Jonkonnu Band, Kingston, Jamaica, August 1984, performing for National Festival. Characters typical of a Roots Jonkonnu band are (left to right) Cowhead, Pitchy Patchy, Horsehead, Devil, and a young apprentice in front.

Figure 15 Pitchy Patchy from the Spanish Town Road Jonkonnu Band, performing at National Festival in Kingston, Jamaica, August 1984. This wire screen mask is typical of a Roots style, since the features are painted over a surface decorated with highly contrasting specks, dabs, and lines.

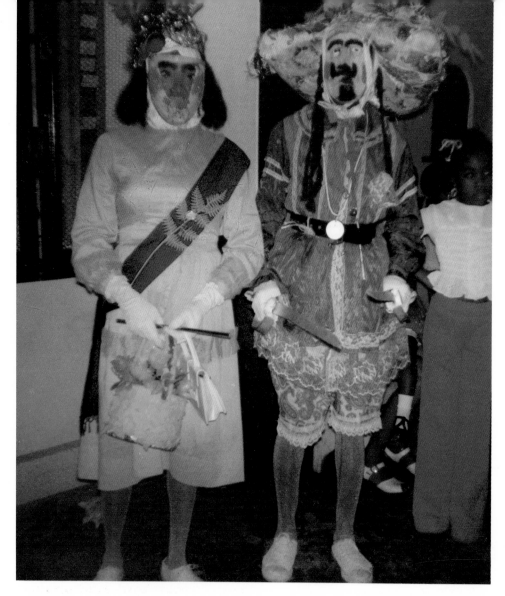

Figure 16 Flower Girl and King, Savanna la Mar, Jamaica, Christmas 1975. Both these members of a Fancy Dress Jonkonnu band wear costumes derived from a European courtly entourage, complete with white stockings, knickers, and wire screen masks painted rosy pink. Their headdresses are decorated with Christmas ornaments, and the King wears a special decorated straw sombrero.

evidence of the transformation worked by a creole aesthetic *(Figures 15 & 16)*. Other characters in the bands include the Sweeper, Jockey, and Sailor. Today most Jonkonnu bands perform on a stage.

Many have assumed that because it is a Christmas celebration, Jonkonnu is religious in character.[3] The evidence suggests, however, that Jonkonnu is a secular festival. To say a festival is secular means, above all, that it does not systematically address gods or spirits in a uniform or codified manner. To say that a festival as a whole is secular does not, of course, preclude a deeply religious motivation, almost a personal mysticism, on the part of individual performers. The explanation of Valentine "Willy" Best, who has played Wild Indian in the Port Antonio band for at least twenty years, reflects his deep spirituality and personal mysticism:

> Because I am AMORC—a member of the Ancient Mystical Order of Rosicrucians. Other people, they know who I am when I wear these things. It makes me pretty near to them, if they are foreigners too[4] *(Figure 17)*.

Jim Robinson, who lives in the hills of Westmoreland and plays the character of Horsehead, has a different motivation. Asked why he had decided to play Horsehead in the 1940s, Robinson said he had never had a trade and that playing Horsehead had become a regular profession for him. He used to perform in front of businesses and shops during the holiday season as well as with Jonkonnu bands. In

fact, playing Horsehead had become his major source of income, his only other cash job being occasional road work.

Presently, Jonkonnu is most often seen on such important state occasions as the second celebration of Carifesta, the Caribbean Festival of Arts, held in Jamaica in the summer of 1976.[5] Two major resurgences of Jonkonnu took place in the twentieth century. The second took place during the mid-70s, when Michael Manley's People's National Party actively supported many grass-roots cultural forms, and when parish chapters of the official Jamaican Festival Commission, called the Jamaican Cultural Development Commission since 1978, provided the patronage necessary for public performances.[6]

During Carifesta 1976, about eight different Jonkonnu bands performed. The core members of each band had been performing for at least ten to twenty years, and many had worked with the Jamaican Cultural Development Commission since its inception in the early 1960s, coinciding with Independence in 1962. The performing artists all expressed pleasure at being recognized in a public forum. Jonkonnu has always been closely associated with, and therefore influenced by, patronage, so a shift in the last few decades from private sponsorship to sponsorship by such government-funded organizations as the Jamaican Cultural Development Commission has produced, and probably will continue to produce, changes in the festival.

1976 was also an election year. Michael Manley had come to power in 1972, instituting a progressive program of cultural, social, and economic reform. Carifesta 1976 was vitally important to the image of Jamaica that the People's National Party wanted to project: in the realm of culture, Jamaica was thriving and healthy, and its people were contributing to a new vibrant populist cultural ethos.

> Food, music, and dress all excite the senses, provoke the deepest human passions, and tell much about the character of a people. It is therefore not surprising that Manley should have made them instruments of national policy. In his support of reggae music as a national voice, he understood the importance of aesthetics in forming national consciousness and international image.[7]

But the recognition and support provided by the Manley government and Carifesta 1976 could not override the rapidly increasing social unrest of the late 1970s. In the latter half of the 1970s social unrest was so marked that Jonkonnu performers were reluctant to appear on the streets. The Jonkonnu band from Port Antonio, Portland, on Jamaica's north coast, has not performed publicly at Christmas since 1973, although members have danced for a fee at official occasions, such as those sponsored by the Tourist Board. Many band members welcomed this shift in patronage since it provides formal recognition under structured situations.

> In the shilling days they sometimes threw money on the streets for us. Now in the more civilized days we don't want them to just throw it on the ground. For we are humans, like yourself.[8]

Figure 17 A practicing Rosicrucian, Willy Best decorated his home altar according to the same assemblage aesthetic as his Jonkonnu costumes. Port Antonio, Jamaica, July 1976.

After the election of 1976, many Jonkonnu bands admitted to the consequences of street violence on their performances and only participated in local competitions or special showcases such as Independence celebrations. After the violent election of 1980 and the coming to power of Edward Seaga, Jonkonnu as a street festival was surely on the decline. Since the 1960s, the younger generations have embraced Rastafarian culture and politics.[9] With Rastafarianism, they found newer reconnections with Africa for, as Rex Nettleford has said, there is a cultural readiness to

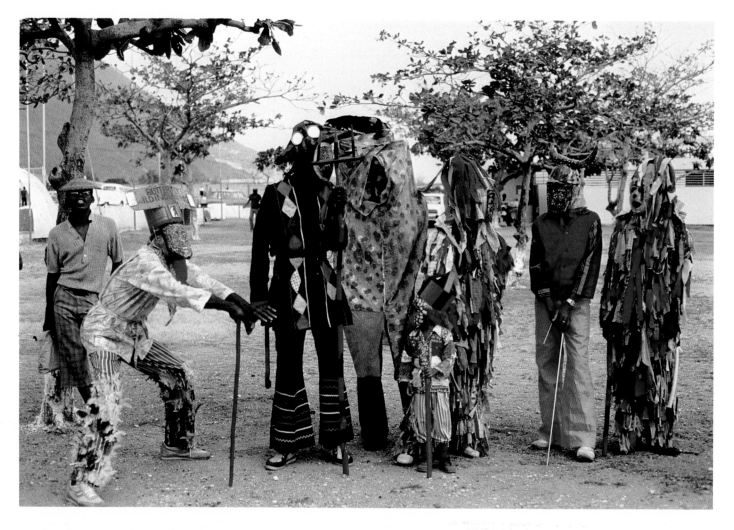

reconnect with a Roots culture. Nonetheless, the image of Jonkonnu remains firm in the socio-cultural history of Jamaica. Its presence mirrors Jamaican history and its aesthetics recombine today in a constant spiral of cultural production. In general, Jonkonnu has become more and more a performance of paid participants rather than a participatory event within a neighborhood, although it is still a focus for national identification as well as neighborhood solidarity among older Jamaicans.

At least until the turmoil of the 1970s, performing Jonkonnu conveyed social status for many Jamaicans. Ranny Williams, the late Jamaican folklorist, admirably summed it up:

> The gentry of the time used to treat Jonkonnu real good. They didn't work in the field; they got special food and special clothes, and they taught them mummery and some English things like War of the Roses; so they were a special people.
>
> All of these groups are from the poorer classes; they are from run-down areas in the city, and because of this when they go out and perform and ask for money, people get the idea that they are all beggars. But on the whole, they are much better behaved than the ordinary lot in the area. They have a social standing; they are Jonkonnu men.[10]

The most important resurgence of the Jonkonnu Festival dates to the 1950s, when *The Daily Gleaner*, Jamaica's largest newspaper, sponsored all-island competitions. The driving force behind these competitions was Theodore Sealy, chief editor of the *Gleaner* from 1952 to 1975, who began working for the paper during the 1940s. Sealy's direct inspiration for the 1951 all-island Jonkonnu competition

Figure 18 The Spanish Town Road Jonkonnu band, Kingston, Jamaica, August 1984, performing for National Festival. Typical of a Roots Jonkonnu band are these characters, from left to right: "Butterfly" Wild Indian; Devil; Horsehead; four-year-old apprentice Kevin; Pitchy Patchy #1; Cowhead; and Pitchy Patchy #2.

was Trinidad's Carnival whose costumes he had viewed during a trip to Trinidad in 1949. Sealy was impressed by Carnival as an embodiment of national pride and strength; when Carnival resumed after World War II in 1946, the Trinidad *Guardian* newspaper had become partial sponsor of the Dimanche Gras revue of folk dance and folk music held on Sunday night.[11] When Sealy returned to Jamaica, he began encouraging interest in what he felt was the Jamaican equivalent.

In both countries, media support of cultural activities was and is crucial to their success. The *Gleaner* approached its project in a strong, didactic fashion. The December 12, 1951 issue carried special instructions on how to obtain a police permit, the requirements for entry, and the categories to be judged. Following the announcement of the 1951 competitions, the *Gleaner* published a series of articles designed to publicize Jonkonnu. This was the first time that Jonkonnu had received national press attention. The lead article on October 6, 1951 was titled "I remember John Canoe." It asked:

> Has this tradition of street dancing and burlesque shows in costume—the main features of the Christmas holidays in Jamaica in the old days—died out completely? Have our people forgotten the lore of John Canoe with its innocent merriment and simple joy? This Christmas will tell . . .

On October 31, 1951 the *Gleaner* ran another lengthy article written by a Kingston resident who had seen Nassau's Junkanoo parade on three consecutive Boxing Days. In order to stimulate Jamaican competition, the article emphasized the tourist attraction Junkanoo created and the cooperation of Nassau's business community in organizing the parade and awarding prizes. Other *Gleaner* articles published before the competition itself covered different aspects of Jamaica's own

Figure 19 The Clarke's Town, Trelawny, Jamaica, Jonkonnu band, performing at the 1952 national Jonkonnu competitions sponsored by *The Gleaner*. From left to right are Uncle Sam, Actor Boy, Queen, Cowhead, Actor Boy #2 (portrayed by Victor Mendez who won a first prize) with bandoliers, Horsehead, several musicians, and Saint Nicholas. All characters wear wire screen masks.

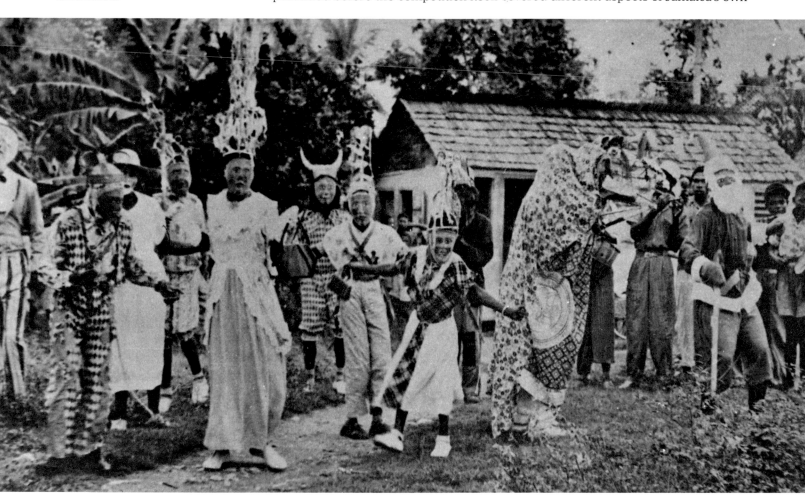

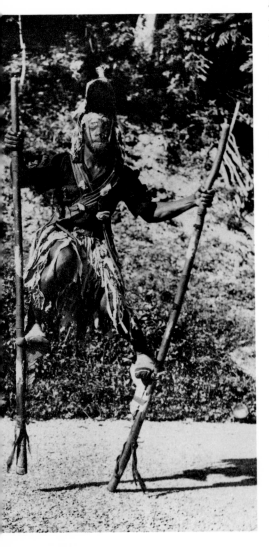

Figure 20 A stilt dancer performing for the national Jonkonnu competitions of 1952, sponsored by *The Gleaner*. This performer wears crisscross bandoliers and a skirt made from cloth strips.

Jonkonnu celebrations. During December 1951, many articles compared historical celebrations with those seen by the authors. One might assume that these printed accounts, appearing so close to the date of the competition, would have influenced the choice of costumes or characters portrayed by the participating Jonkonnu bands. Indeed, if a costume closely resembled one in the Jamaican artist I. M. Belisario's 1837 illustrations,[12] one can assume a connection with the printed accounts. The costumes from the 1951 and 1952 competitions, however, do not appear to have been inspired by descriptions in historical accounts *(Figures 19 & 20)*. This indicates not only that Jonkonnu had changed considerably since the early nineteenth century, but also that the *Gleaner* was recognizing an existing tradition, rather than reviving a dormant one.

The *Gleaner's* 1951 propaganda campaign appears to have been highly successful, for not only were the competitions held again the following year, but the judges also helped incorporate Jonkonnu, or Jonkonnu elements, into the more visible cultural scene. Individual judges wrote articles about their experiences. Thus a nationalistic impulse directed at Jamaican self-esteem and cultural visibility in the Caribbean, plus dissemination of vital information through print, prompted a renaissance of the Jonkonnu tradition.

In Jamaica, there are two distinct opinions about the traditional heritage of the present celebrations. Some claim that the festivals had begun and continue in rural communities; others declare that the tradition had been interrupted from time to time, manifesting new syncretic forms with each renaissance. Most likely, both views are correct, the one referring to the continuous but less publicized rural performances, the other to urban events. Jonkonnu was born in an urban environment; the plantation was, after all, a miniature city. The process of creolization was already maturing by the time Jonkonnu moved to rural areas, an event occasioned by the breakdown of the plantation system and the development (after the period of apprenticeship from 1834 to 1838) of an independent black peasantry. In the twentieth century, the demand for labor frequently brought rural and urban into contact. The 1951 and 1952 national competitions formally reunited both strands of the Christmas festival tradition.

The complexity of Jonkonnu's history is mirrored in the complexity of its twentieth-century art history; in particular, it is mirrored in the regional differences that exist, or existed, around the island. The most dramatic of these, of course, is the difference between Roots and Fancy Dress traditions, which is still basically a geographic distinction. The most important information on the regional differences came out of the 1951 and 1952 national competitions.[13] Since these contests marked the first national recognition of Jonkonnu, the already existing bands that performed in them may be considered the result of the development of Jonkonnu as a predominantly regional tradition.

Jonkonnu has always reflected the changing socio-political climate of Jamaica, making it difficult to pinpoint a typical Jonkonnu performance. In the 1950s Jonkonnu bands were most often organized by neighborhood. Each city had three or four bands and rural villages may have each supported a single one. At Christmastime each band paraded from house to house in its own neighborhood, gathering an appreciative audience of friends and neighbors as it went. The procession then advanced to the centers of patronage or authority in the neighborhood, where the actual performance took place. There the line of performers began the "Break

Out," the central portion of any performance, in which characters interacted, usually one on one, in narrative mimes, comic bits, or stick fights. The sequence of characters in the procession was unpredictable, for then, as now, it depended on the individual band, on the finances and feelings of its members at any given moment, and on a host of other factors. After the Break Out, the performers accepted donations before marching on in procession.

In earlier times, all the bands from within a town, together with their separate entourages, would often converge on the town square, where a danced territorial competition would take place, the performers attempting to outdance or out-maneuver each other. In the city, bands from different districts would converge at special intersections where certain members would battle for right of way. The rules of the game required the team captains to step out in front and spar verbally. "And they decide who can pass. Me don't go to your town, and you don't come here. Then the captain makes a sign and you can pull through. And that's the rules of it."[14] The conflict was never bloody, nor has anyone been reported to have actually won, but the crowd loved the assertion of neighborhood pride in the aggressive, challenging competitions.

The vicissitudes of the economic and socio-political climate determine whether Jonkonnu can take place in public. Under certain circumstances, marches and processions are illegal in Jamaica, and the Christmas season can be regulated by special ordinances. Law enforcement officials often grow weary of large crowds, so they may break up a Jonkonnu parade or prohibit any event, like a Jonkonnu performance, that might attract a crowd. Originally, Christmas was considered the appropriate season for festivities because all business activity on the island was halted by official decree, and also because all free white males were called up for military service, swelling the larger towns with transients. The urban populations have always been the principal spectators at Jonkonnu parades, although there is a less publicized rural tradition as well. Information on that tradition comes mostly from recollection of Jonkonnu participants about rural performances in the 1920s, a period from which virtually no written record survives.

During the time of slavery, the Christmas holiday on most estates included three days of free time—Christmas Day, Boxing Day, and New Year's Day. As Reverend H. M. Waddell remarked in 1829, "It was hoped that the result of this free time and license would prepare slaves for another year of toil."[15] To be sure, these occasions assumed the character of ritualized freedom, or at least ritualized unrestraint. Many Great Houses were opened and the slaves invited to a banquet that often included a dance or theatrical event. These performances must have provided controlled outlets for aggression and hostility, as well as for theatrical skills. Jonkonnu also could incorporate role reversal.

> Scenes were exhibited in Falmouth . . . that were highly entertaining—a description of masquerade in procession . . . in which his Lordship, with several other distinguished characters, were personated by negroes in full costume, as imitated their models in this respect as possible . . . they had lost sight of one grand requisite to complete the resemblance, viz.—ease of manner, and consequently their deportment being strangely at variance with that of their originals, rendering such mimic actions truly amusing.[16]

During these opportunities for theater and festivity, the Jonkonnu tradition developed, incorporating such African-based characters as the Cowhead, and

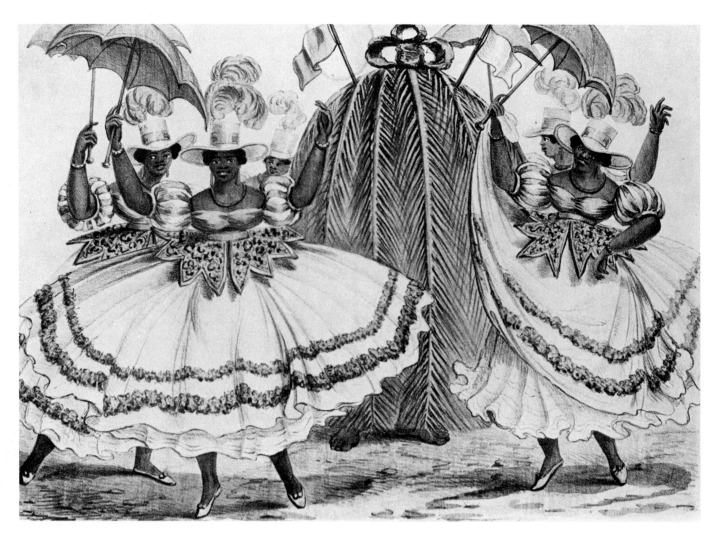

African instruments such as the *gumbay* drum, as well as such British-based characters as the King and Queen or the Squire and the Lady. In the dance itself, the merging of African-based steps like the *hip scoop* or *legs* and European-based steps such as the *quadrille balance* also probably reflects these occasions when all classes were able to observe, and even to criticize, one another's theatrical skills, and to gather aesthetic information.

Traditionally celebrated during the Christmas–New Year season, Jonkonnu bears testimony to the process of creolization so typical in the Caribbean. In the Americas, culture does not reflect a total separation between the free and slave (or Euro-American and Afro-American) sectors. "In fact, the interpenetration of these sectors poses one of the most interesting and enigmatic questions to be weighed in examining the growth and character of so-called creole societies."[17] Yet it is wise to think of Jonkonnu as Afro-creole: "The African influence remained, even if increasingly submerged, as an important element in the process of creolization. European adaptations or imitations could never be whole-hearted or complete. There might be apparent European forms, but the content would be different."[18] A structured public event such as Jonkonnu could incorporate elements and energies from many traditions and rituals, white as well as black. Even within the black community, one must assume diversity, for Blacks in the Americas do not share a single cultural ancestry, but rather reflect a multifarious African heritage. Thus the festival developed as a diverse and complex melange of many traditions. Historically it has incorporated masquerade from disparate African nations together with

Figure 21 The Red Set Girls and Jack-in-the-Green, drawn at Christmas 1836, in Kingston, Jamaica by Isaac Mendes Belisario, lithographed by Duperly in 1837, and published in Kingston as one of a series of twelve. Belisario reported that rival groups of female sets used to perform at Christmas, "the Reds representing the English, the Blues representing the Scotch, and the French Set comprised of immigrants from Haiti." This Jack, covered with palm fronds, is the predecessor of the modern-day Pitchy Patchy, who wears a cloth strip costume.

versions of British mumming plays and *tea meetings*, and even with excerpts from Shakespearean monologues.

Most eyewitness accounts of Jamaican Jonkonnu celebrations date from between 1800 and 1850. The few seventeenth and eighteenth-century accounts mention animal costumes almost exclusively. In 1688 Hans Sloane reported seeing dancers with rattles tied to their legs and waists and "Cowtails to their Rumps, and add such other things to their bodies in several places, as gives them a very extraordinary appearance."[19]

Edward Long's account, dated to his first-hand observations in Jamaica during the 1750s and '60s, is graphic: "In the towns, during the Christmas holidays, they have several tall or robust fellows, dressed up in grotesque habits, and a pair of ox-horns on their heads, sprouting from the top of a horrid sort of vizor, or mask, which about the mouth is rendered very terrific with large boar tusks."[20] By the beginning of the nineteenth century, elements of British folk theater had been incorporated into the festival celebrations, and the Christmas parade seems to have grown to an organized spectacle. From ten eyewitness accounts, one finds these categories of performers: house-headdress performers; sets of females dressed in fine clothes; actor groups performing mini-dramas; kings and/or queens; mimic military men; musicians; performers named Jack-in-the-Green *(Figure 21)*, who dressed in palm fronds or similar vegetal fiber; occasional bull or cow figures; and "John Canoe."

Lady Nugent, wife of the governor, who resided in Jamaica from 1801 to 1805, wrote one of the earliest nineteenth-century accounts. Her diary entry for December 25, 1801 reads: "After Church, amuse myself very much with the strange processions, and figures called Johnny Canoes. All dance, leap and play a thousand antics. Then there are groups of dancing men and women . . ."[21]

Lady Nugent first reported bonafide British influence, for what she witnessed was actually an Afro-Jamaican rendition of a British Hero/Combat play. After describing the procession of dancers, she remarked upon a group of actors who represented Tippo Saib's[22] children and Henry the IV of France. "All were dressed very finely, and many of the blacks had really gold and silver fringe on their robes."

Estate owner Matthew Gregory "Monk" Lewis arrived in Jamaica at the port of Black River, St. Elizabeth, on January 1, 1816; among the masqueraders at the New Year's festival there, he saw a character known as "John Canoe":

> The John Canoe is a Merry Andrew dressed in a striped doublet and bearing upon his head a kind of paste-board house-boat, filled with puppets, some representing sailors, others soldiers, others again slaves at work on a plantation. The Negroes are allowed three days for holidays at Christmas, and also New Year's Day.[23]

Lewis also confirmed the existence of distinct groups of performers who today are remembered as the "Actor Boys."

> A play was now proposed to us, and, of course, accepted. Three men and a girl accordingly made their appearance; the lady very tastefully in white and silver, and all with their faces concealed by masks of thin blue silk.[24]

Another Actor Boy appeared in a series of lithographs by I. M. Belisario in 1837. "Koo Koo or Actor Boy" is depicted lifting off a white face mask to reveal a black face under a wig of heavy long curls. His fancy headdress, complete with jewels, feathers, and glittery materials, offset with the small face mask and combined with an elaborate European-style tiered skirt with frock coat, completes the masquerade *(Figure 22)*.

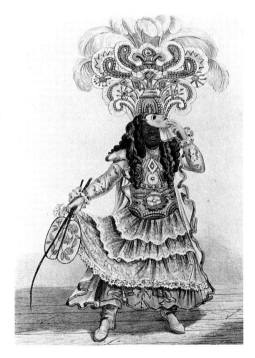

Figure 22 Koo-Koo or Actor-Boy John-Canoe, drawn by Isaac Mendes Belisario at Christmas 1836 in Kingston, Jamaica and published by Duperly in 1837. These Actor Boys roamed the street competing for prizes for their costumes and their performances of monologues, often based on Shakespeare. The term "koo koo" seems to derive from the name of a West African dish; an attendant chorus chanted this phrase as the Actor Boy requested donations.

The actual identity of the character Jonkonnu was a matter of some confusion, as these accounts demonstrate:

a man dressed up in a mask with a grey beard, and long flowing hair, who carried the model of a house on his head. This house is called Jonkanoo and the bearer of it is generally chosen for his superior ability in dancing. He first saluted his master and mistress, and then capered about with an astonishing agility and violence.[25]

Cynric Williams, 1823

[the sets] have always one or two Joncanoe men, smart youths fantastically dressed, and masked so as not to be known.[26]

Alexander Barclay, 1823

companies of young men paraded the estates carrying a fanciful and gaily painted structure called a Johnny Canoe and followed by a crowd singing and bearing the gombey.[27]

Reverend H. M. Waddell, 1829

The prominent character was, as usual, the John Canoe or *Jack Pudding*. He was a light, active, clean young Creole Negro, without shoes or stockings; he wore a pair of light jean small clothes, all too wide, but confined at the knee below and above, by bands of red tape . . . He wore a splendid blue velvet waistcoat . . . His coat was an old blue artillery uniform one, with a small bell hung to the extreme points of the swallow-tailed skirts and three tarnished epaulets; (one on each shoulder, one at his rump) . . . He had an enormous cocked hat on, to which was appended in front a white false-face or mask. . . .

The John Canoe, who was the work house driver, was dressed up in a lawyer's cast-off gown and bands, black silk breeches no stockings or shoes. But with sandals of bullock's hide strapped on his great splay feet, a small cocked hat on his head, to which were appended a large cauliflower wig, and the usual white false face.[28]

Michael Scott, 1833

The most conspicuous of those who *annually* attract public notice, are the "Koo-Koo" or "Actor-Boy" and the "Jaw-Bone John Canoe" . . . the latter, non-descript compound, in half-military, half-mountebank attire, comes under present consideration. His regimental coat and sash, are invariably retained, whatever changes may take place in the other parts of his costume, he (in common with the whole of the John Canoe fraternity) always wears a mask . . . The house is usually constructed of pasteboard and colored papers—it is also frequently highly ornamented with beads, tinsel, spangles, pieces of looking glass, etc. and being firmly fixed on a board, the bearer is enabled to balance it, whilst going through many strange contortions of body and limbs [Figure 23].[29]

I. M. Belisario, 1837

Figure 23 House John-Canoe drawn by Isaac Mendes Belisario at Christmas 1836 and lithographed by Duperly in Kingston, Jamaica in 1837.

Belisario's rather complete description of the Christmas-New Year's festivities includes companies of costumed performers, who offered renditions of reinterpreted mummings: "Richard the Third was a favorite tragedy with them; but selections were only made from it without paying the slightest regard to the order in which the 'Bard of Avon' had deemed it proper to arrange his subject."[30]

These reports seem to show that an African theatrical element slowly was being transformed, or at times even replaced, by a European one, as the original Jonkonnu with his ox-horned and boar-tusked mask was replaced by a performer in

a white face mask, with "half-military, half-mountebank" costume. The phrases used by early chroniclers—"extraordinary appearance," "dressed in grotesque habits," or "horrid sort of vizor . . . rendered very terrific"—suggest through their emphasis on the bizarre and grotesque that the observers were confronting a culturally foreign form. As the transformation to an amalgam of British and African prototypes progressed, however, chroniclers' reactions were likewise transformed; confusion in the face of an alien model shifted to acceptance of a new form that contained recognizable imagery in costumes and play structure. The performers, for example, are said to be "fantastically dressed," "dressed very finely," or "dressed like the tumblers at Astley's." As for the performances, chroniclers seem to have justified a genuine enjoyment, however condescending or confused, by interpreting the spectacles as "farcical" and subsuming them under the general rubrics of fun and amusement. Belisario, for example, was able to recognize the bits performed by Blacks as derived from the "Bard of Avon" and clearly enjoyed himself while watching them, although he was quite in the dark as to the principles guiding the artistic selection of the episodes and their order.

Belisario's account—and his confusion—show that even within a performance structurally related to a British prototype, Blacks could maintain a degree of aesthetic control and character interpretation by introducing innovations that manipulated and transformed their models. Within the European-influenced imagery, moreover, one can mark the retention of an aggressive African element in the dance style—witness the persistence of the "strange" and "astonishing," in such comments as "capered about with an astonishing agility and violence," or in Belisario's "many strange contortions of body and limbs."

All these describe festivals held on plantations or in major towns. It is indeed unfortunate that no reports of festivals in the rural areas have survived, for if twentieth-century festivals can help one understand the past, it is more than likely that African elements maintained themselves in areas remote from direct white patronage. In 1828, Marly reported that "during the course of Christmas day the country negroes came into town with their own gumba [gumbay] and fife."[31] Marly's "country negroes" may have been field slaves, who worked in areas of cultivation away from plantations or towns and lived in rural villages with an overseer, but with no real Great House structure. Since no visitor was bold enough to venture outside the towns and plantations, and no resident thought to do so, there exists no record at all of the composition or performances of such rural bands. Today more traditionally African, or, more appropriately Afro-Jamaican, bands include aggressive animal characters; one can hypothesize, given the very early documentation of animal characters as part of Jonkonnu, that it was in outlying districts that they survived and developed as a distinctive part of the Jonkonnu tradition. Barclay, in 1823, summed up the situation:

> About twenty years ago [1800] . . . the different African tribes, forming a distinct party, singing and dancing to the gumbay . . . Now the fiddle is the leading instrument; they dance Scotch reels and some of the better sort (who have been house servants) country dances.[32]

Barclay notes the adoption of British customs by Blacks who had the closest contact with whites; so one can surmise that those related to "the different African tribes" would retain their traditions in a purer form.

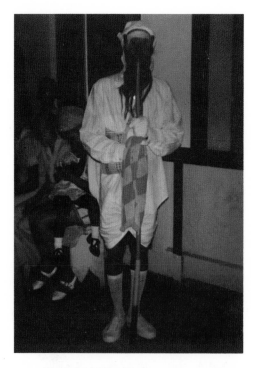

Figure 24 Babu, the East Indian cowherd, performing at Christmas, 1975, in Savanna la Mar, Jamaica. Western parish bands often include a Babu, as many East Indians became plantation workers on the large estates.

Figure 25 Pitchy Patchy, performing at Christmas, 1975, in Savanna la Mar, Jamaica. Pitchy Patchy appears in all types of Jonkonnu bands; here he exposes his multi-layered costume in an exuberant dance.

The Cast of Characters

In Jamaica today, there are two kinds of Jonkonnu bands, "Roots Jonkonnu" and "Fancy Dress," or Masquerade. The word *Roots* is in keeping with the Jamaican vernacular, connoting "peasant" to some and "lower class" to others, but always emphasizing a strong black presence; reggae music and Rastafari religion are both considered Roots Jamaican. The performances of both types of bands are structurally the same—they use the same basic steps and follow the same performance pattern of a procession followed by a Break Out. But the quality of motion, the identity of the characters, and the costumes differ.

In a Fancy Dress performance, Courtiers perform steps in a contained fashion, emphasizing movements that are straight up and down and to the side, and hip swings that cause their short skirts to flare out *(see Figure 40)*. The Amerindians in a Roots Jonkonnu performance do the very same steps, but with a different rhythm, a more pulsating movement of the hips and hands, and more syncopation with the feet and knees. A typical procession of a Fancy Dress band begins with Courtiers followed by a King and Queen, sometimes preceded by a Flower Girl. Sailor Boy runs around the outside of the line, wielding a whip to keep the audience in line; Babu, the East Indian cowherd who carries a long cattle prod, may accompany him *(Figure 24)*. Pitchy Patchy also runs outside of the procession; like Sailor Boy and Babu, he is more exuberant than the courtly entourage *(Figure 25)*.

Pitchy Patchy's costume is made of layered strips of brightly colored fabric sewn onto pants and a shirt, and a headdress that varies in style. He dances with rapid, small jumps, raising and lowering his shoulders and sweeping his arms. His movements are accentuated by the layered costume, which swings in large, circular patterns. According to oral tradition, Pitchy Patchy's costume is derived from the vegetal costumes that the Maroons wore for camouflage during guerrilla warfare. Formerly, he also wore scraps of straw and shrub attached to a burlap sack.

Vegetal costumes that have appeared in Jamaican masquerade bands in the past may have been the ancestors of the modern Pitchy Patchy. One of the characters portrayed by Belisario in 1837 was called Jack-in-the-Green, after the character that led May Day parades in England.[33] Like Jonkonnu, these were all-male performances. The man who played Jack was concealed within a tall frame, three feet in diameter, covered with green foliage and flowers.[34] The Jack-in-the-Green who performed in London in the mid-1800s was accompanied by a jester, a "maiden," and chimney sweeps who collected money *(Figure 26)*.[35]

In Belisario's lithograph, palm fronds have replaced the evergreen boughs worn by the London Jacks. The substitution of palm fronds for evergreen branches echoes a strong West African masquerade tradition. Throughout Africa leaf and bark figures perform in masquerades. Thus, the planter-class onlookers may have thought these costumes represented Jack-in-the-Green, although in the beginning, at least to those who made and wore them, they probably echoed African vegetal figures. The fact that a Jack-in-the-Green was observed only in the Kingston area strengthens the likelihood that an African forebear was as important, probably more important, than its British counterpart. Only in urban areas, it seems, did nineteenth-century patronage wield enough influence to transform the African vegetal masquerader into a British "Jack."

A transformation from vegetal matter to cloth or paper has been documented for masquerade costumes in Great Britain by Margaret Dean-Smith.

Figure 26 Upper Lisson Street, Paddington, from Chapel Street, ca. 1837–1847. This May Day parade in London included an all-male entourage: a Jack-in-the-Green wearing evergreen boughs, a jester, a maiden, a chimney sweep who collected money, a military man, and a drummer.

Straw and greenery are intractable materials: to substitute paper or strips of cloth would seem in process of time to be a natural development, having some relation to the distribution of such materials in country districts and an increase in wages and prosperity amongst the labouring classes permitting the use of purchasable goods.[36]

Many of the Mummers, especially those performing Hero/Combat plays, formerly dressed in straw disguises; likewise, an Irish group known as the Strawboys wore tall straw hat/masks and straw skirts. By the 1870s, however, ribbons and paper strips began to be substituted for straw, and by the early 1900s, some groups were wearing complete costumes of paper or cloth strips cut to resemble straw; others simply attached a few paper streamers to their clothes. Perhaps the best examples of these costumes are those worn by the Marshfield Paper Boys and the Hackwood Park Mummers. The cut paper-strip costumes of Nassau's Junkanoo echo this same tradition. In the paper-strip disguises, as in the straw costumes or the period courtier costumes from Jonkonnu in Savanna la Mar, the characters were barely distinguishable from each other.

The transition from natural materials to paper or cloth has not been investigated in Africa. However, Robert Farris Thompson has seen Egungun masqueraders in country districts in Ekiti, Yorubaland, clothed in vegetal matter rather than cloth.[37] Thus, Pitchy Patchy may be a twentieth-century transformation of the Jack-in-the-Green, enhanced by echoes from his African counterparts—or vice versa. His cloth costume may once have been vegetal. The transition from a costume of layered straw or palm fronds to one of layered cloth or paper strips would not only reflect the increased distribution of such materials and an increase in prosperity, but might also embody an urban image rather than a rural one.

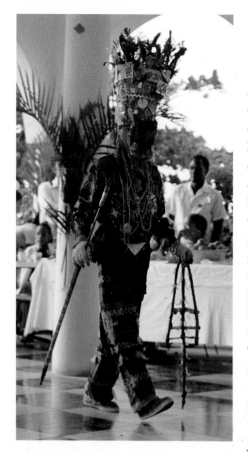

Figure 27 Willy Best's costume, from Christmas 1975, incorporates an assemblage aesthetic common to Roots Jonkonnu.

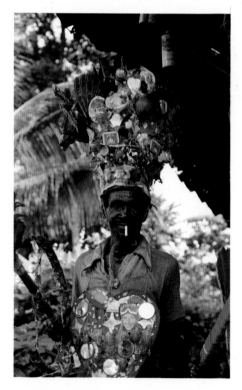

Figure 28 Willy Best rehearsing for Carifesta 1976 in Port Antonio, Jamaica. His feathered headdress is decorated with mirrors, cutouts, Christmas balls, and playing cards.

In Roots Jonkonnu, the Courtiers are replaced by Amerindians and Warriors, the Amerindians being more expressive than the Warriors, who are forceful but dignified. Valentine "Willy" Best from the Port Antonio band designs his Amerindian costume *(Figure 27)* in a style found throughout the Caribbean, a feathered headdress and an apron and/or skirt over long fringed pants. He also always carries a bow and arrow. Best's headdress varies from performance to performance, but it always has a long blonde rope braid attached to it. The braid is black on most Wild Indian costumes, but this is Willy Best's way of being different. The headdress he wore in 1975 had a regular circle of black and white feathers attached to the upper edge and was decorated with patterned wrapping paper, cutouts, playing cards, mirrors, and ricrac. The headdress he wore for a performance in 1976 was more irregular in shape, with longer and larger feathers extending from the cardboard brim. It was ornamented with white feathers, store-bought pink peacock feathers, black fowl feathers, plastic flowers, Christmas tree balls and lights, plastic fruit, and various images, including food advertisements cut from magazines *(Figure 28)*. The most exotic element was a cutout image of a blonde woman in ski clothes and large ski goggles. Sometimes Best sews white feathers to his pants and shirt. During one performance in 1976, he wore short pants, and his lower legs from the knee to the ankle were wrapped in cords that had feathers and bells attached to them. Best's personal collage aesthetic emphasizes unusual and thought-provoking juxtapositions. Caught in the motion of dance, blurred black and white text forms a variegated background for magazine images that spotlight single figures in color, just as one headdress covered with gold and silver foil creates a shimmering background for cutouts of food, female faces, and Christmas bulbs.

Jamaican Wild Indians are linked through the use of glitter, tinsel, feathers, mirrors, and high-contrast, "high affect" color and design combinations by bands from the easternmost parish of St. Thomas and the adjacent areas of Kingston and Portland. These elements probably reflect a more recent input of African aesthetics. Whereas the aesthetic of western-parish masquerade bands was formed under the prolonged influence of British patronage, an influx of liberated African laborers probably affected developments in the east. Between 1840 and 1860, 26,000 liberated Africans were transported to the Caribbean, and at least 8,000 arrived in Jamaica. A large percentage settled in St. Thomas Parish and developed new sociopolitical structures among the farmers there. Historian Monica Schuler has written extensively about the impact of Central Africans on Jamaica's eastern parishes. In religious matters, the new leaders were Africans who dominated ritual information. Late arrival, large numbers, and group cohesiveness have all contributed to a strong African-based tradition.[38] Perhaps these same leaders or their colleagues initiated or reinforced a movement away from a European aesthetic model. In Jamaica, at least, a performer could not masquerade as an aggressive African, but he could choose to be a glittery, aggressive Amerindian. Surely glitter, reflective surfaces, and feathers are closer to an African aesthetic than are courtly figures wearing nineteenth-century pantaloons and overskirts. The image of the Amerindian also can be construed as homage to the lost Indian tribes which originally populated the Caribbean.

In Roots Jonkonnu bands, Flower Girl is replaced by Whore Girl, who raises her skirts to titillate the audience, or by Belly Woman, who shakes her belly to the rhythm of the music. Cowhead charges and butts the crowd to keep them back

(Figures 29 & 30). The presence of Cowhead and other animal characters is one of the most important distinctions between Roots Jonkonnu and Fancy Dress; they introduce a strong rural or "uncultured" flavor into the performance. Fancy Dress, on the other hand, seems more closely affiliated with a British plantation model.

"Rural" has certain specific referents in Jamaica. Many revolutionary movements were based in the "unknown" or "untamed" countryside. At the same time, wise people can be found in rural areas. These wise folk are especially revered, for they often have knowledge that relates to traditional African systems. This is not a contradiction. Wisdom and courage, the tamed and untamed, complement one another. Cowhead and Horsehead are rural, but because of their untamed power they also are revered. They scare, but they also amuse. They invoke both fear and courage.[39]

This distinction of rural and urban developed from plantation life; from here, the individuals associated with the Great House became urban, the field workers became rural, and individuals who supervised the plantation became the middlemen. In many cases the plantation functioned as a miniature city, with different social strata, classes, ethnic groups, and religions. Maroon settlements or field workers living in outlying villages, or mountain people, are considered the rural population in present-day Jamaica, whereas the residents of parish capitals or major towns are considered the urban population.

Roots Jonkonnu springs from villages removed from major coastal towns. Luther Cooper, a Masquerade participant from Savanna la Mar, Westmoreland, commented: "Yes, there is people who play Cowhead but not in town here. You don't play Cowhead in town. The masks from the country generally play Cowhead and Horsehead."[40] Since some town bands do include the Cowhead and Horsehead, Luther Cooper is actually referring to the fact that the western parishes of West-

Figure 29 Cowhead from the Port Antonio, Jamaica Jonkonnu band performing at Christmas 1975. Animal characters are central to Roots Jonkonnu bands. This Cowhead wears a calabash with two horns, a wire screen mask, and a tail.

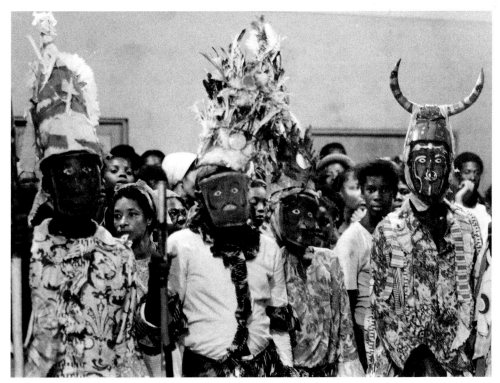

Figure 30 The Jonkonnu band from Duheney Pen, St. Thomas, during a rehearsal for Carifesta 1976. Three Wild Indians are accompanied by a Cowhead whose wire screen mask has a ring in the nose.

moreland and Hanover support Fancy Dress or Masquerade bands, and Savanna la Mar patronage tends to favor bands closely aligned with the British courtly model. In these locations, which he associated with the urban tradition in general, animal characters are not present.

Jamaicans associate the Horsehead and Cowhead characters with rural life, with Roots Jamaican traditions. The Horsehead and Cowhead characters seem more directly African, for they incorporate aggressive dance behavior, less refined posturing, and often even break ranks to chase members of the audience. By Jamaican popular interpretations, these characters incorporate an African fierceness rather than a British reserve.

The current Cowhead attire is made of a pan or half a calabash, with holes cut for real horns. The headdress is worn over a headwrap and wire screen mask. The performer also attaches a tail, made of wire wrapped with cloth, to his rump. The rest of the costume is usually left to the individual performer's discretion. It often includes tennis shoes, pants, and a shirt in contrasting colors and patterns.

Although there are rare horned figures in British masquerade, such as the Horn Dancers, who carry deer horns,[41] the Cowhead, which appears only in Roots Jonkonnu bands, is almost certainly derived from an African source. The particular form of Cowhead headdress found in Jamaica today, the cap with two real horns inserted into it, is also found in other Afro-Caribbean and black South American masquerades.[42] In the Americas, this headdress form may represent a culmination of a process of transformation in masking styles, a shorthand version of a full face mask with horns, originally made of wood and later of papier-mâché. On the other hand, this headdress type, used in black masquerades all over the Americas, may be derived from a similarly ubiquitous West African type.

The earliest examples of the use of real horns in West African masquerade are from the Tassili in the Sahara, in paintings that date from at least 3,000 to 7,000 B.C. There, as elsewhere, the headdress takes the form of a horned cap or horned helmet. Today, this headdress type is found among West Atlantic, Manding, and Voltaic groups.[43] This form, including the wearing of real horns and often a tail, refers specifically to circumcision ceremonies and subsequent adulthood.

Despite—or perhaps because of—many parallels, an African counterpart to the horned headdress in the Americas cannot be specifically pinpointed. Thus the horned headdress is a prime example of the difficulties in finding direct sources for Afro-American cultural motifs.

The Jamaican Horsehead is made of a mule's skull, equipped with an articulated jaw and attached to a pole. It is painted, eyes are added, and the player covers himself with a piece of cloth[44] *(Figures 31 & 32)*. Zora Neale Hurston recorded the opinion of Colonel Rowe, the leader of the Accompong Maroons, and a local "medicine man," about the Horsehead. He explained that the three-legged Horse manifests himself right before Christmas. "If he chases you, you can only escape by running under a fence. If you climb over it, he will jump the fence after you." But he usually appears just to enjoy himself:

> When the country people masque with the Horsehead and Cowhead for the parades, the Three-legged Horse wrapped himself up in a sheet and went along with them in disguise. But if one looked close he could be distinguished from the people in masques because he was two legs in front and one behind.[45]

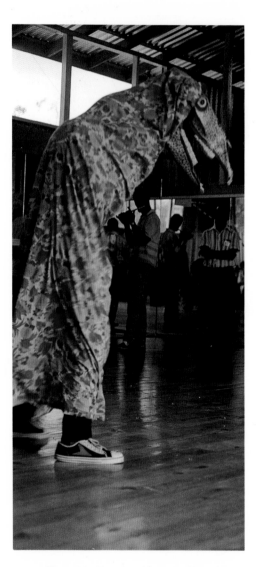

Figure 31 Horsehead from the Three Mile area Jonkonnu Band, rehearsing at the Jamaica School of Dance, Kingston, November 1976.

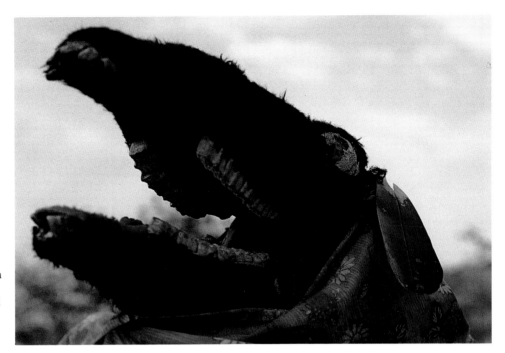

Figure 32 The Horsehead from the Spanish Town Road Jonkonnu Band, Kingston, Jamaica, August 1984, performing for National Festival. Made from a mule's skull, the Horsehead is equipped with an articulated jaw and attached to a pole.

The African counterpart to the Jamaican Horsehead is found in nuclear Mande country and culturally contiguous areas of Mali. One type of horse costume and mask is used in the *duga* class of the *kore* society among the Bamana peoples. When the initiates dress as the *kore duga*, they masquerade as a horse. Each brotherhood within the *kore* owns two or three horses, and they go from village to village, clowning, begging food, and eating continuously. The *kore duga* represents a summation of the universe, incorporating intelligence, initiation, the spirit of life, and the wisdom of the creator. As the initiate plays his role, he holds the horse stick between his legs, grasps a sword in his right hand, and wears a horse mask. His dancing consists of jumps, kicks, and runs, interpreted as an enactment of man's struggle and search for a life without end. During his ride, the initiate receives gifts and food; each type of food has a specific significance. As Dominique Zahan, the ethnographer, describes it, "The universe is consumed in the guise of food."[46] The *kore duga* is at the same time a clown and an incarnation of the struggles and accomplishments of *kore* members. Zahan also reports that in their role as clowns, the *kore duga* used to go to the town of Segou for certain festivals, especially to entertain groups of Europeans.[47]

Technically, the Jamaican Horsehead is closest to a British skull-and-pole variety. In Britain, this Horsehead is considered an old, traditional form. In Cheshire County, England, the Horsehead formerly performed alone, but joined the Soulers' masquerade group in the early twentieth century because he could not collect enough money in his solo performances. His costume was made from a real horse's skull, attached to a pole and equipped with snapping jaws, as is the Jamaican model. The pole was grasped by a stooping man covered by a blanket or sheet.[48] In Jamaica, too, the Horsehead often joined a Jonkonnu band, for he could not afford to perform alone.

Other British Horsehead characters may have influenced the survival of the character in Jamaica. One common type is the hobbyhorse, distinctive because this costume is designed to give the appearance of a horse and rider. The Padston, Cornwall "Old Oss," and the Minehead, Somerset Snapping Horse are both hob-

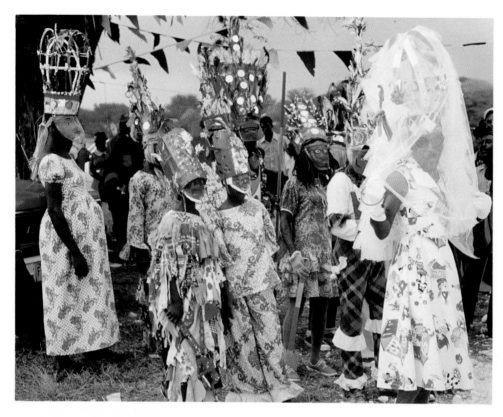

Figure 33 A Jonkonnu band from Duheney Pen, St. Thomas performing at Carifesta 1976 in Westmoreland, Jamaica. At the extreme left is Belly Woman wearing a fancy crown and a wire screen mask in the older whiteface style. Other characters include five Indians, Whore Gal, who carries a hatchet and wears a short dress, and Bride.

byhorses that appear on May Day.[49] The horse that appears with the Morris dancers or Mummers is also usually a hobbyhorse.[50]

Although Horsehead is an important masquerade character in both Great Britain and part of Mali in West Africa, and now appears with some very traditional Jonkonnu bands in the Caribbean, no mention of this character before the twentieth century seems to exist. Twentieth-century reports indicate that the Horsehead often performed alone. It is possible that nineteenth-century performers, both white and black, played Horsehead, but that it never was incorporated into performances sponsored by the planter and merchant classes.

All band members, regardless of their origin or the character they play, wear wire screen masks, cloth headwraps, and headdresses. Present-day Jonkonnu masks are limited by the use of wire screen, but within these bounds there is enormous variety and ingenuity. In the whiteface masking tradition, the features are usually schematically rendered, conforming to the pattern of black eyebrows, moustaches, and beards, with red cheeks and lips. These masks are crudely constructed, being flat and square, and they do not conform to the facial structure. They are actually painted a rosy pink, rather than white. The whiteface tradition is usually associated with Fancy Dress bands from the western parishes, but there are no hard and fast rules in Jamaican Jonkonnu.

The mask of a 1976 Belly Woman from the eastern town of Duheney Pen, St. Thomas may be a reproduction of an older, commercially produced type *(Figure 33)*. The wire screen is definitely white; the black eyebrows and moustache are drawn with fine lines and the lips are red. The nose is even realistically modeled. Belly Woman is the only member of the Duheney Pen band to wear a whiteface mask; as a group the band may be termed aggressive, flashy, and glittery. Most of its members

wear feathers and mirrors on their headdresses, whereas Belly Woman wears an oversized crown. Although her mask is unique, the band members insist that it suits her character, and is therefore acceptable. In contrast, members of the West Kingston Jonkonnu band in 1984 wore masks with the wire screens roughly cut to fit over the facial area, not modeled to its contoured surface *(see Figure 15)*. Parts of the masks are left unpainted so that the performer's skin shows through. Specific facial features are schematically represented, with no attempt to portray a definite racial type. The masks' surfaces are painted in primary colors, with specks, dabs, and vague geometric patterns. The eyes may be circles, triangles, or slits. This mask type is tied more clearly to an Afro-Caribbean style.

The historical evidence indicating that the whiteface wire screen variety of mask was available commercially by the early twentieth century also tells us that the masks were imported, some from the Tyrol region of Austria[51] *(Figure 36)*. This connection is underscored by reports of a German-Austrian influence on Caribbean costumes. The Port of Spain, Trinidad *Gazette* of February 1882 carried an advertisement for fancy costumes. Included were Turks, Chinese Dress, Jockeys, Highlanders, and Tyrolese. When in 1906 the first "Jab Jab" or "Devil Mas" was organized for Trinidad's Carnival, band members wore some masks imported from

Figure 34 This Courtier was played by Wilfred Hibbert, who won second prize in the 1952 national Jonkonnu competitions sponsored by *The Gleaner.* Courtiers wear whiteface masks, pantaloons with overskirts, white gloves and light-colored stockings.

Figure 35 Members of the Savanna la Mar #1 Jonkonnu Band at Carifesta 1976 in Westmoreland, Jamaica. In the background is a Queen and a Sailor Boy, while in the foreground is a Courtier whose costume typifies Fancy Dress, based on a European model and rendered with strong colors and juxtaposed contrasting patterns.

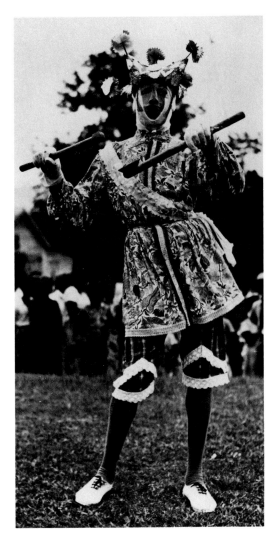
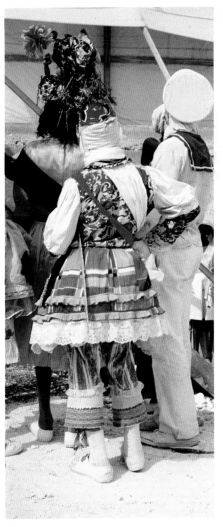

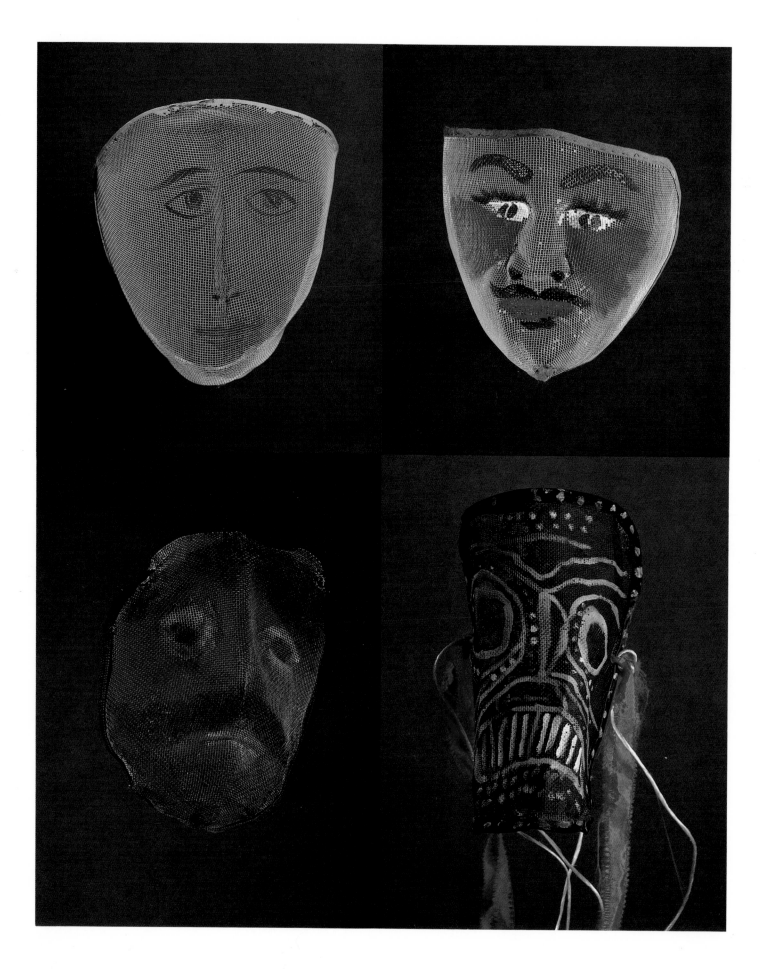

Germany and purchased "from Waterman Brothers, a firm of merchants whose store was on Frederick Street in the City of Port-of-Spain."[52] Furthermore, Emory Whipple reports that John Canoe players in Belize used to import their wire screen masks "from Germany."[53]

In the 1950s, many Jamaican and Trinidadian masqueraders continued to use whiteface wire screen masks. In the historical masques of Trinidad Carnival, the wire screen masks had pink-painted skin, blue eyes, a coif around the face and head, and were worn with a turban or hat *(Figure 37)*. As in Jamaica, the face, neck, and hair of the performer had to be covered. Daniel Crowley indicates that some were made from fencing masks, while others were bent and painted kitchen sieves. In the 1950s the Carnival Jab Jab bands were still wearing wire screen masks.[54] In both Jamaica and Trinidad, these masks were sometimes called "sifter masks," because they were fashioned from mesh flour sifters.

During the 1951 and 1952 Jamaican national Jonkonnu competitions, many Jamaican performers wore whiteface wire screen masks with black eyebrows and thin black moustaches *(see Figure 34)*. Some donned the mask, whether it was appropriate to their costume or not. The Wild Indian made his mask Amerindian simply by adding black braids, as is done in Bermuda. Among certain performers, wearing a whiteface mask is a tradition not perceived to be associated with individuals or racial types. Presumably these masks originally were designed to resemble Caucasian faces; but those who wear them no longer regard them so.

In urban areas, store-bought whiteface wire screen masks may have been prevalent in the early twentieth century, but this certainly was not, and is not, the only masking tradition. Masks per se are no longer part of Trinidad Carnival, while Jamaican and Belizean Jonkonnu members wear wire screen masks. The mask form and its applied details vary considerably from band to band and from character to character, reflecting an older tradition.

Figure 36 Wire screen masks were originally exported to the Caribbean and South America in the late 1800s from the Tyrol region of Austria. Today the masks are made by local performers. Those more Afro-Caribbean in style are evidence of the transformation worked by a creole aesthetic. Top left: Tyrolean Carnival mask from the turn of the century. Top right: mask used during the July festival for Santiago, Loiza, Puerto Rico, 1987. Bottom left: Bermuda Gombey mask used for the Amerindian masquerade, 1986. Bottom right: Jamaican Jonkonnu mask in a Roots style, Kingston, 1987.

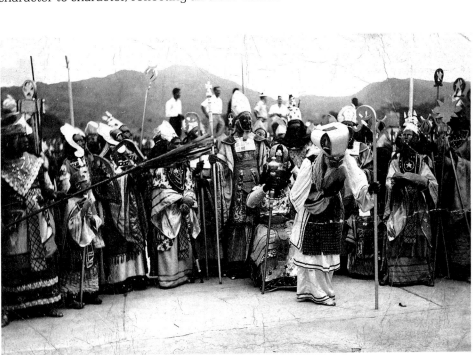

Figure 37 The Coronation of King David, Trinidad Carnival, c. 1947, produced by Fitzroy and Fitzgerald Hoyte at Savannah Park, Port of Spain. The central group of characters are wearing wire screen masks.

59

Varieties of Jonkonnu headdresses conform not to divisions in band aesthetics, but to the aesthetic demands of a particular character. All headdresses are called crowns, although only certain styles are actually derived from a crown form. Although it is difficult to determine which character will wear which headdress, some generalizations are possible. The Cowhead wears two horns attached to half a calabash or inserted in the base of a metal pan (see Figures 29 & 30). The Horsehead is made from the decorated skull of a mule (see Figures 31 & 32). The Amerindian headdress, most commonly made by attaching a vertical band of feathers to a wide brim, has more applied decoration than any other headdress form. A popular type of crown incorporates an intricate openwork pattern of bent wood, resembling the framework for a hoop skirt. This skeletal form may be decorated with applied feathers or paper flowers, or the frame itself may be wrapped with patterned paper or foil. The width of the circular brim varies with individual design, and it may be left plain or adorned with cutouts or mirrors (see Figure 28). Any number of individual creations, such as tall peaked hats or four-pointed caps, are also worn.

Although many Jonkonnu performers from the parish of Westmoreland have claimed their designs were modeled after patterns found in a large, unnamed book, this source remains elusive. The official seamstress for the band from Savanna la Mar, Westmoreland that competed in the 1951 and 1952 national competitions was Mistress Porter, who was about sixty years old in 1976. For most of her life she had been a dressmaker, having learned the profession from her mother, who was the official seamstress for the famous Westmoreland band of the 1930s. In 1976 Mistress Porter, who ran a small, roadside general store, would not verify the existence of a pattern book. Aston Spence, the local patron of the one remaining Savanna la Mar masquerade band and former foreman at the Westmoreland Sugar Refining Company, remarked,

> Well, you're not going to see this book. What I'm saying to you is that this costume making is an art. And she [Mistress Porter] would never tell you about that book because she's fearful of losing the book.[55]

Costume designing is an art distinguished by improvising on a norm. In Westmoreland this norm is typified by the courtier characters who wear short overskirts, blousy tops, pantaloons, white stockings, and white gloves (see Figure 35). The players are proud of this Fancy Dress style and insist that their skirts be hooped and stiff. Much of their aesthetic resembles that of other Jamaican bands, but they all improvise certain costume elements frequently; the aesthetic core, however, remains constant. At Christmastime in 1975, the Captain of the Savanna la Mar band substituted a broad-brimmed straw hat for his usual bent-wood openwork crown. The hat was completely covered with cutouts, artificial flowers, Christmas tree balls, white feathers, and tinsel paper. In 1976 another member of the courtly entourage wore a skirt made from a plaid print and an overblouse in a contrasting paisley. Sometimes the front of the overblouse is cut from one fabric, and the back from another. Although Westmoreland-style wire screen masks are usually painted white or pink, the Policeman's mask from Carifesta 1976 deviated from this. It was typical in that it incorporated a moustache and beard, but atypical in its handling of the outlined eyes, starkly drawn nose, and diamond-shaped red cheek patterns (Figure 38). The Westmoreland bands are the most conservative in Jamaica today,

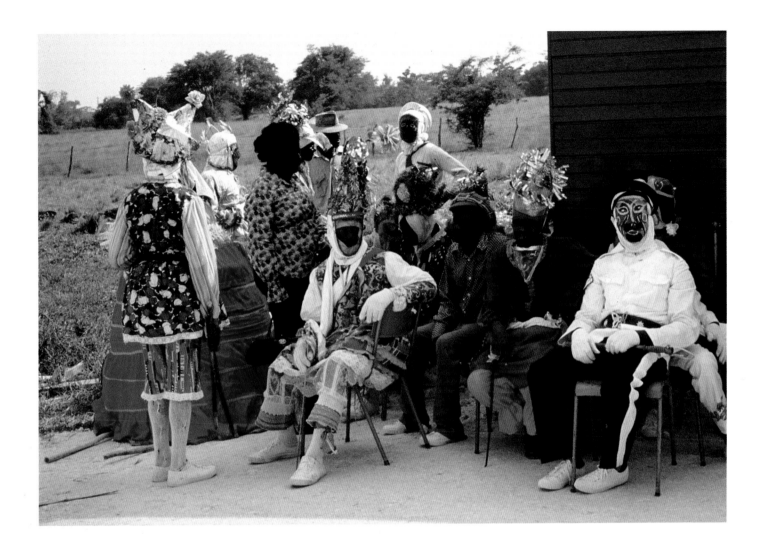

Figure 38 Savanna la Mar #1 Jonkonnu band at Carifesta 1976 in Westmoreland, Jamaica. To the left are grouped Courtiers; Policeman sits at the right. With its outlined eyes, starkly drawn nose, and diamond-shaped cheek patterns, his mask deviates from the Fancy Dress whiteface wire screen style.

both in their insistence on maintaining a particular tradition of costume style and in their use of a European courtly model. But within this tradition performers frequently experiment and substitute in ingenious ways.

The aesthetic of Jonkonnu may submit to the complicated interweaving and echoing of different traditions in its history, so that pinpointing a single source for any given element is very difficult. In many cases, parallels between British and African masquerades are striking, suggesting a conflux of influences; in others, the issue is clouded by insufficient research in Africa. Jonkonnu displays the fundamental contemporary Afro-Caribbean aesthetic: a high-affect collage combining strongly contrasting elements. Words such as *mosaic*, *collage*, and *contrast* repeatedly come to mind. A typical Jonkonnu mask uses colors offset by the brown skin showing through and is accentuated by unexpected, loosely drawn blotches of color. In headdresses, the feathers, glitter, mirrors, cutouts, and ribbons are placed side by side to produce contrasts in color, texture, and pattern. A band of black and white feathers, for example, will encircle the upper circumference of the supporting structure, which can be further decorated with patterned wrapping paper, cutouts, playing cards, mirrors of varying shapes and sizes, and ricrac.

As for the body of the costume, the Roots tradition varies considerably from character to character, but basically the participants wear pants and a shirt. Checks

are juxtaposed against diamonds, or rhythmic narrow-line wide-band patterns are placed beside swirling patterns with dots and undulations. High-affect embellishments, such as mirrors, beads, paper cutouts, or feathers, are added to the fabric base *(see Figure 18)*.

In the Fancy Dress tradition, courtier-style costumes are the rule. Laced, mid-calf length pants are topped by a short, stiff overskirt, and a blousy shirt. If the character wears a modern-style dress over stockings, the fabric is invariably a shiny synthetic. In contrast to the Roots tradition, these Fancy Dress costumes are punctuated with white stockings and white gloves. Yet within this tradition, an Afro-Jamaican aesthetic shines through, for even within conservative traditions people are not static.

Thus both Roots and Fancy Dress traditions exhibit the Afro-Jamaican aesthetic of mosaic and collage: stripes against checks, floral patterns against stripes, diamonds against a swirl, all heightened by an assortment of embellishments. Even in Fancy Dress, these high-contrast patterns underlie a superficially British style.

Basically this aesthetic typifies that of most such creole patterns, either in Africa or the Caribbean. Combinations are employed that are unusual, that stand out. The goal is high visibility within an urban mix, the opposite of the urban melting pot. Any added flair increases notoriety and visibility. Hand in hand with high visibility is the desire to demonstrate that one is of the city, not just country folk. Thus the added elements often reflect mass production rather than handicraft.

The sources for Jonkonnu and other anglophone Christmas masquerade characters appear to be a mosaic of theatrical traditions, including various parallels that probably influenced the festival, even though they cannot be pinpointed as exact and exclusive sources. Tentatively, working-class British folk theatrical conventions appear to have merged with parallel African examples. Although some characters, like the Cowhead, may reflect a direct and exclusive African heritage, to tilt the equation toward either Africa or Britain would distort the historical record. One must be satisfied with a complexly interwoven history, which has given birth to a vibrant, important, and creative Afro-Jamaican festival tradition.

Jonkonnu as Performance

Jonkonnu music is known as fife and drum music *(Figure 39)*. The band actually includes two drums, a fife, and a scraper, often called a grater. Sometimes a banjo, a tambourine, triangle, or *shak shak* (shakers or shakka) will be added to the ensemble. Two types of drums are used in Jonkonnu bands. A large bass drum, which is played with a padded stick, sustains a steady beat. The smaller drum, called by some bands a rattling (rattler) drum and by others a kettle drum, is higher pitched. The rattling drum executes the more complex rhythms, and is more often played with two sticks.

Jonkonnu music is divided into sections. All performances begin with a slow procession, sometimes called the "stop and go." After this the music changes to a faster, upbeat tempo. This section is called "jig music" by some bands, and "drillin" by others. One or two bands from the Kingston area also include a special fast section called the "open cut out." Sometimes a special slow section, "a marchin

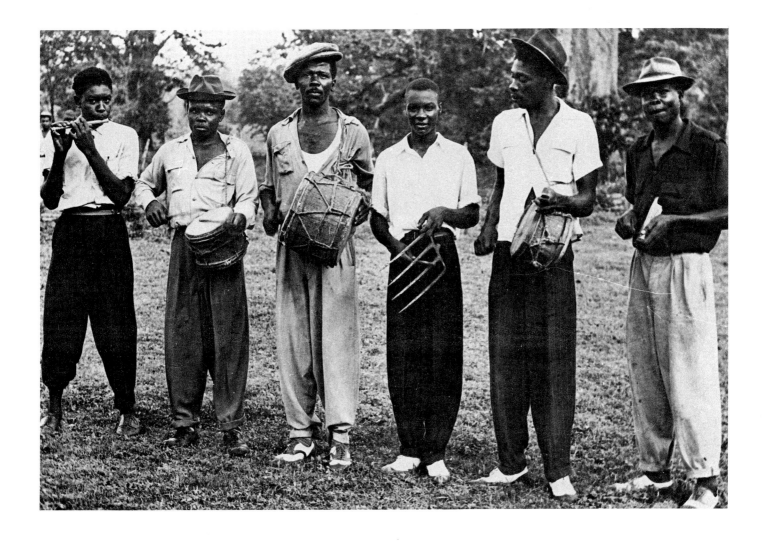

Figure 39 A Jonkonnu band from the 1951 national competitions sponsored by *The Gleaner.* From left to right the musical instruments are a fife, rattling drum, bass drum, fork, rattling drum, and scraper.

tune," is included in the repertoire and provides the dancers with a change of pace and a rest, although the performers never stop dancing.

Jonkonnu dancing involves the knees, pelvis, and shoulders moving separately, even as they move in unison.[56] Furthermore, distinct aspects of each motion are accentuated. This genre of movement—distinct body parts moving simultaneously, or multi-metric movement—is basic to African and Afro-Caribbean dance. In many respects, Jonkonnu dancing is a version of African dance. The body parts act as separate and distinct units capable of moving independently of one another. There is, for example, a variety of steps that use hip and back isolations also common in African dance. In addition, these isolations are done without breaking a basic fluidity of body movement. That the body is flexible and that its parts can move as distinct units is the basis of African dance. A second characteristic of this African-derived dance style is the use of staccato movements at the end of a movement phrase. For example, as the hips swing, the final part of each swing backward or forward is accentuated slightly.

Observers often comment on the "get down" quality of Jonkonnu dancing. Jonkonnu dancers are not afraid to touch the earth. Many steps are executed in a low, deep knee bend position, similar to steps in African dance. In terms of rhythm, the downbeat of each movement is accentuated. There is a very real relationship to

the earth in this style of dancing. The body is never made to look weightless, even when it is achieving great heights, because it is the meeting with the earth that is accentuated.

Jonkonnu dancing is also creole dancing, which can best be demonstrated by a European step called the *quadrille balance*. Ordinarily, there is a delicate, toe-tapping quality to this step. In European and American dance classes it is done without any back or hip movement, with the torso rigid, and with elegant leg extensions. The Jamaicans perform this step differently. They dip or scoop their hips (a down-under movement, with a forward contraction), rotate their shoulders, knee bounce on the supporting leg, and sometimes even shimmy their shoulders. The spirited approach to the dance gives the step a quality more reminiscent of jazz dancing than the European quadrille; it creolizes the movement.

Mintz and Price suggest that instead of explaining similarities of form considered in isolation, one should compare broad aesthetic ideas.[57] In most cases it is impossible to pinpoint a direct African source for a specific step, but when one watches a Jonkonnu performer dance, one is sure of an African heritage. Specific steps are the result of an Afro-Caribbean blending within a specific socio-aesthetic climate. These steps share similar qualities "more in terms of deep-level cultural rules or principles than in terms of formal continuities."[58] Dance movements, such as the hip scoop, the pelvic roll and the shoulder rotation, become the principles that unite the dance into an Afro-American creolized whole.

The Procession

Almost every Jonkonnu performance begins with a formal procession, a type of danced walk. If the band is performing in town, the participants usually begin by dancing down a main street and then lining up in procession at the actual perform-ance site. Or they may dance in a circle on a stage as part of the choreographed introduction. They may also use the steps of the procession to regroup after moving in and out of more complex integrative patterns. The performers usually execute the steps in single file. Each performer holds some type of prop in his hand: a stick, a bow, a wooden sword, or a hatchet. The performers move forward, or toward an audience, either in a straight line or in small alternating diagonal lines. The basic step is a walk in the pattern of step right, step left, step right, close left.

The main section of any Jonkonnu performance is called the Break Out or Break Away.[59] This section is comprised mostly of solo dances, all performed simul-taneously. For the most part, each performer chooses a sequence of steps that he feels is comfortable and most suited to his character. The exact choreography of this section varies considerably from band to band.

The Major Steps

One of the most popular of the Break Out steps is called a "jig" by most Jonkonnu bands. It is a distinct step also used in other Jamaican dances. In this travelling hopping step, the knees are turned out as the free leg is passed from the front to the back, or the back to the front. As one leg passes the other, it is then placed on the ground, replacing the standing leg, which in turn passes the support leg. The hands

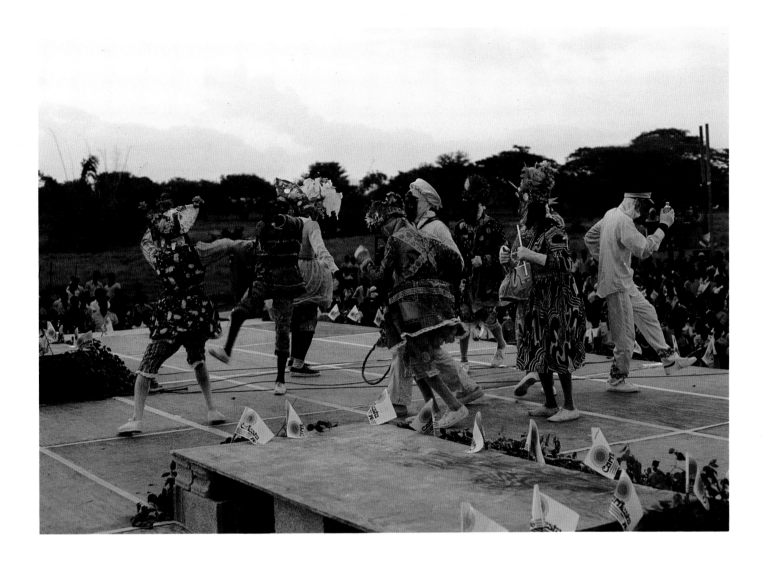

Figure 40 Savanna la Mar #1 Jonkonnu band, performing during Carifesta 1976 in Westmoreland, Jamaica. The four Courtiers wear knee-length pantaloons, short over-skirts, white stockings, and blousy long-sleeved tops, all typical of Fancy Dress bands. The troupe also includes a Queen, a Flower Girl, and two Sailor Boys.

are most often on the hips. A variation on the jig step so closely resembles Belisario's description of the House John Canoe dancing in the 1830s that one is tempted to believe it is the same step.

> The position in which he is drawn will convey a tolerably accurate idea of one of his favorite steps, consisting of small rapid crossings of his legs, several times repeated, and terminating in a sudden stoppage *[see Figure 23].*[60]

As performers execute this distinctly European-derived step, one might suspect satire in the choreography, but this is not so. Jonkonnu performers execute this motif with exquisite technique. The performers and the audience appreciate the expertise and skill necessary for any dynamically danced sequence, regardless of its origin. A good performer is expected to show off and execute all steps well. For the Jamaican public and for the performers, the contradictions and complexities inherent in the tradition are certainly understood and accepted. The performance is hybrid and discontinuous; it is Afro-Caribbean.[61]

The Courtiers from Westmoreland Parish often execute a choreographed step to emphasize their hoop skirt costume. They twist their hips from side to side to set the skirts in motion, while shuffling their feet and fighting one another with swords and sticks. The mock battle itself is also choreographed, as the opponents cross

their respective sticks and swords in a patterned movement. The steps are performed in a contained fashion, emphasizing movements that are straight up and down and to the side *(Figure 40)*.

Certain of the Break Out steps are most frequently performed by the more athletic band members, or by characters whose role incorporates unpredictable aggressive behavior. These steps would not be included in the repertoire of the courtly entourage bands from Westmoreland, but might be danced by a Pitchy Patchy from Westmoreland who is not actually a part of the entourage.

Since Jonkonnu choreography is made up of a number of steps that can be combined in almost any order, many steps appear throughout the dance as individual units. These solo steps are combined in various patterns by individual characters. For the most part, however, all the performers are dancing simultaneously. In Westmoreland complete skits are incorporated into a section of the Break Out, while the band members from Port Antonio, Portland, rarely interact, except to reject the advances of the Devil. Out of the repertoire of at least twenty-five steps, some are rests between periods of intense physical exertion, and others are transitions between more complicated movement patterns. Certain generic steps also seem to be the special movements of specific characters. Very athletic steps that involve going "high-high" or "getting way down" may be performed by Warriors, Amerindians, or the Devil, but would probably not be included in the repertoire of a King, Queen, or Policeman, for these characters must maintain a more dignified appearance. A good deal of improvisation goes on in any Jonkonnu performance, so the variety can never be completely documented.

Observations

Jonkonnu in Jamaica today both parallels and diverges from the aesthetics and structure of the tradition in the earlier twentieth century. First and foremost, the control by the Jamaican Cultural Development Commission has produced changes and innovations. Along with the change in sponsorship has come a change in emphasis. The all-island festivals of the 1950s awarded the highest prizes to Fancy Dress bands, which reflected the more sedate, British-influenced image appropriated by middle-class Blacks of that time. In contrast, national sponsors now emphasize African influence and sources, at times to the detriment of the fullest understanding of the genius of Jonkonnu—the melding of a whole range of influences, European and African, into a distinctively creole mix, one version of the flexibility, syncretism, and intermixing of multi-ethnic elements that make the Caribbean so exciting.

But the contribution of national patronage to the survival of Jonkonnu cannot be ignored. As the elderly fifeman of the Duheney Pen band said in 1976, "And now it good, when decent respectable people come look at it [Jonkonnu]; now we have more faith to do it and to train, you know."[62] To which the Devil from the West Kingston band added in 1984: "In Portland they don't dance no more at Christmastime. Nobody give them any money to help them. But we is dancing. The Commission, they give us money to make costumes."[63] The number of performing Jonkonnu bands has diminished; the patronage is for the most part in the hands of government agencies or industry, but innovations indicative of the festival's rich heritage persist.

Pia Manadi and John Canoe in Central America and Belize

The Central American area inhabited by the Garifuna, formerly known as Black Caribs, shares a masquerade tradition common to the Caribbean[64] *(Figure 41)*. The terminology in descriptive accounts, however, is sometimes misleading; it seems that early travellers used the classic Jamaican nomenclature "John Canoe" to describe masked performances, often with no real historical relationship to the Jamaican tradition. By the early twentieth century, however, costume and performance elements shared by other Caribbean masquerades were implanted in Belize. A magnificent early photograph from Punta Gorda Town, c. 1907–1914, labeled "John Canoe men" and "Xmas dancers," makes this quite clear[65] *(Figure 42)*. Of the nine masqueraders pictured, two are dressed as women with fashionable floor-length, long-sleeved dresses, white gloves, veiled headdresses, and whiteface masks. The remaining dancers wear white shoes, dark stockings, knee-length breeches with knee rattles, long-sleeved white jackets, white gloves, and head-dresses with a circular rim decorated with pom-poms, tassels, flowers, and tall upright feathers. Some wear crisscross bandoliers, while others wear wide streamers attached to the jacket collar and falling to knee length. All masqueraders wear whiteface masks with delicate black moustaches. This male costume is strikingly similar to the one worn today. The specific tradition of Central American John Canoe most closely resembles masquerades from the British Caribbean at the turn of the century, especially in terms of costume style.

Figure 41 A John Canoe performance in Seine Bight Village, Belize, 1974. Present-day performers in Belize still use the older style of imported wire screen mask, but they make their own.

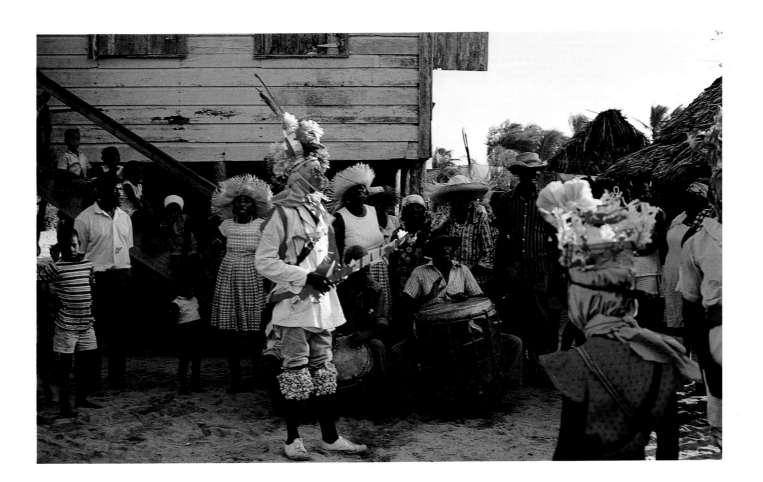

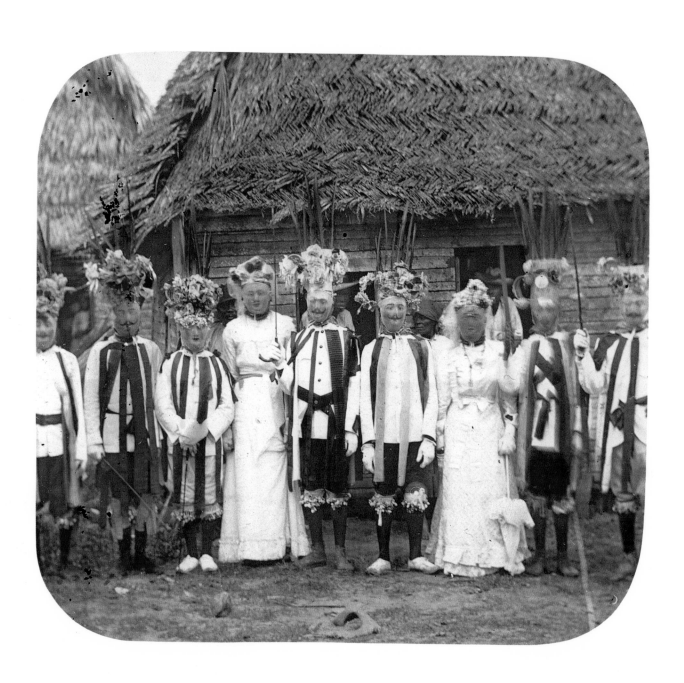

Today in Belize and neighboring areas of Guatemala, John Canoe is a favorite Christmas masquerade of the Garifuna, although it is not the only masquerade performed during the Christmas-New Year season. This masquerade is most popular among the Garifuna, but it is also enjoyed by non-Carib Blacks.

The John Canoe appear on Christmas Day and Boxing Day.[66] They dance house to house to the music of two drums and the songs of a female chorus. The John Canoe performers dance individually, do not perform mimed dramas, and do not differentiate characters by costume elements, although one performer is usually a King, who acts as master of ceremonies as he signals others to perform solo.

Although there are both male and female types of John Canoe costumes, the male quasi-military costume is worn exclusively by the official touring John Canoe troupe sponsored by the National Arts Council of Belize. Within the male category, there also seem to be a formal costume and a rural version. All John Canoe dancers wear cloth headwraps, wire screen masks, colored stockings or long socks, knee rattles, and white or black canvas shoes. They also carry a stick or a wooden sword. Belizean wire screen masks are painted either white or rosy pink, with staring eyes, red lips, and black eyebrows; the male masks include an additional thin black moustache *(Figure 43)*. These masks are based on a style and type that was popular throughout the Caribbean in the nineteenth and early twentieth centuries and were available commercially. Present-day John Canoe performers have continued this whiteface masking tradition, although they now make their own masks.

The formal male style of John Canoe costume consists of a long white belted jacket and matching knee-length white pants *(see Figure 41)*. The dancer also wears black or white long socks and white canvas shoes. Across the chest are worn crisscross bandolier-style red and blue ribbons. The Belizean performers at Carifesta 1976 in Kingston, Jamaica wore white squarish cardboard headdresses covered with colored pom-poms and surmounted by upright peacock feathers. Photographs from Seine Bight Village show that turkey or parrot feathers are used as well. This costume seems to be the "official" Belize John Canoe outfit and bears little total resemblance to other Jonkonnu costumes around the Caribbean, although it probably resembles turn-of-the-century Jamaican Jonkonnu. The less formal male costume style consists of brightly colored knee-length pants, jackets or overblouses, knee socks, and a different style of headdress.

Female John Canoe costumes consist of store-bought blouses with puffed sleeves worn over knee-length skirts or street dresses and light-colored stockings. The headdresses vary. Some resemble tall hats completely covered with paper flowers, mirrors, and sequins, while others resemble crowns and include streamers and feathers. This latter style of female costume is ubiquitous in the Caribbean.

Another variation of Christmas masquerade called *Pia Manadi* is actually a mimed and danced drama that can take place at any time during the Christmas-New Year season. The action is accompanied by fife and drum music. Two drums are used, a bass and a snare. Douglas Taylor states that *Pia* means "a man, and is also the name of forest spirit," while *Manadi* is derived from "*manattee*," meaning a man dressed as a woman.[67] The characters in *Pia Manadi* are distinguished by their costumes and their mimed action. In many respects *Pia Manadi* resembles the Afro-Caribbean versions of English Doctor plays so popular throughout the Caribbean.[68]

Figure 42 John Canoe performers from Punta Gorda Town, Belize, photographed at Christmas between 1907 and 1914. All these black male masqueraders wear whiteface wire screen masks, and their costumes resemble those worn by other masqueraders in the British Caribbean at the turn of the century. Male characters still wear knee-rattles and tall feather headdresses in Belize today.

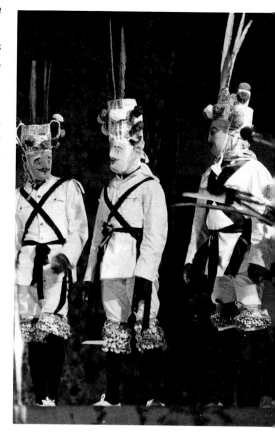

Figure 43 John Canoe dancers from Belize performing at Carifesta 1976 in Kingston, Jamaica. These costumes resemble a style popular in Jamaica during the 1950s competitions, and probably most strongly resembles turn-of-the-century Jonkonnu.

To discern the relationship of Belizean and Central American John Canoe to the broader Caribbean tradition, one must consider both John Canoe and *Pia Manadi*. The structure of Belizean John Canoe does not resemble Christmas masquerades around the Caribbean, and the costume resemblances might be incidental. The structure of *Pia Manadi* parallels other Caribbean traditions that include a British mumming prototype.

A majority of black non-Carib people along the Central American Atlantic coast are of Jamaican origin. It seems likely that the thousands of Jamaican laborers who migrated to the area for plantation work, for the building of the Panama Canal in the last half of the nineteenth century, and for construction work in the first quarter of the twentieth century substantially influenced Belizean festival customs.[69]

At the turn of the century, whiteface wire screen masks were most popular in Jamaica and in other areas of the Caribbean. The quasi-military uniform worn by the official Belize troupe was popular in Jamaica in the early 1900s, and some Jamaican performers at the 1951–1952 *Gleaner* competitions also wore this outfit. Even the John Canoe dance style reflects this earlier Jamaican connection. Thomas Young recorded a Garifuna performance in the middle of the nineteenth century in which "a dancer appears, who after throwing his body into all conceivable postures, now jumping up and down . . . he kicks about with great energy, till at length he gives a whirl, a bow, and retires; another taking his place. . . ."[70]

Compare this with descriptions of 1933 and 1974 John Canoe dancing in Belize.

There were leaps straight up in the air with the feet criss-crossing one another rapidly. Nearly all the positions were taken with the feet off the ground, and the accent gesture, so to speak, was to snap the whole body backwards . . . Warrin concluded his dance in a tremendous aerial whirl, and stopped entirely.[71]

below the waist the body is in perpetual motion. Often dancers remain in a stationary position as their feet churn the sand. At times the body is propelled backward and forward by sudden kicks. This is interspersed with skips and hops in one direction or another and frequently climaxed with a quick violent spin. Dance completed, a John Canoe may walk up to a householder and shake hands.[72]

Indeed, one of the dance styles of the Garifuna has remained constant since the early nineteenth century. It is interesting to compare these descriptions with Belisario's 1837 account of Jonkonnu dancing in Kingston, Jamaica. The character House John-Canoe had a favorite step,

consisting of rapid crossings of his legs, several times repeated, and terminating in a sudden stoppage, at which point, it requires all the ability of this Posture-Master, to poise his body at one and the same moment.[73]

While the acrobatic nature of Jonkonnu dancing has remained constant, other elements of the dance have developed differently. Belizean John Canoe performers today dance quite differently than their Jamaican counterparts. The Belizean John Canoe performance at Carifesta 1976 in Jamaica demonstrated some variations on the dance observed by early visitors to Belize. The performers danced solo, each solo composed of vigorously executed, rapid small steps and ranging from one to three minutes in length. The posture was stiff and very frontal, with the upper torso held rigid and pitched slightly forward. The knees were flexed, and the dancer bounced on the balls of the feet. The hands were often held up with palms facing the audience, and elbows were bent. Sometimes a wooden sword was held, pointed upward. Below the waist, the legs remained rigid and the feet executed rapid, tiny

steps. The dancers tended to remain in one spot, as the basic bouncing movement did not propel them back or forth. Often the dance climaxed with a quick, violent spin and a bow. None of these performances included mimed drama or a narrative.

This Afro-Caribbean masquerade tradition was not introduced to Belize or any other Central American area at any specific time in history. The popularity of masquerading has been documented all over the Caribbean. The indigenous residents of the Central American coast also had their own masquerade traditions. Perhaps the Black Caribs arrived from St. Vincent with a tradition of Christmas masquerading, but in terms of costume style the influences seem to date to migrations in the latter 1800s, not the earlier part of the century. Today the Garifuna of Belize appear to be the caretakers of a tradition that is as much creole as it is Garifuna. The exact heritage of the tradition is diverse, and problematic; it demonstrates a variety of influences, as does any Afro-Caribbean festival.

The Junkanoo Festival in Nassau, the Bahamas

Although masquerade in the Bahamas has a longer history, the Junkanoo Festival, per se, has retained the same structure since the early twentieth century. By the 1920s most performers covered their bodies with shredded strips of colored paper, while incidental paraders imitated clowns, horned animals, or European court dress. Participants joined bands that represented particular neighborhoods or districts. They performed a choreographed marching step, accompanied by a drum ensemble. This pattern persists to this day. Despite the resemblance in the names of Jamaican Jonkonnu and Nassau's Junkanoo, similarities between the two are generic rather than specific.

The use of the term "Junkanoo" by Bahamian officials seems to have been adopted for publicity purposes, most probably by people aware of the Jamaican festival. The music, the musical instruments, the organization, and the structure of the bands are all different. Bahamian bands no longer include distinct costumed characters, nor do they wear masks. Instead they depict a central theme. To be sure, the histories of Christmas festivals in the Bahamas and in Jamaica share similarities, resulting from a similar historical mix—a British colonial society and a black African slave population, followed by a colonial administration and a creole population. Historically, both festivals may have been an amalgamation of African and British sources. But today the Nassau parade and the Jamaican festival share only a name.

The *Nassau Guardian* has been publishing reports of Christmas and New Year's festivities for over a century.[74] These articles indicate that the performers and musicians who paraded on Christmas Day were Blacks celebrating Christmas according to their own traditions. They came from "over the hill" in Grant's Town, where most black Bahamians have always lived, to parade on Bay Street, the main street of the then all-white Nassau. Since the newspaper reporters presumably never ventured "over the hill," no reports exist of Christmas celebrations, or of any celebration, for that matter, in Grant's Town. Furthermore, there is no explanation of why, in the 1860s or 1870s, Blacks from "over the hill" began parading on Bay Street.

An intriguing article in the December 25, 1875 *Nassau Guardian* juxtaposes the Blacks' Christmas celebration with that of the whites. At a white Nassau grammar

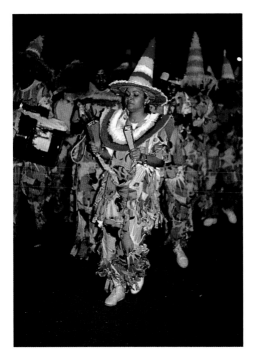

Figure 44 Small Bahamian scrap bands of 1986 wear less elaborate costumes in order to dance more easily.

school that year, students performed a Christmas masquerade, a burlesque of St. George and the Dragon, with the characters Maid Marian, the Turkish Knight, and the Grand Master. The article offers a clue to the development of a British folk-drama tradition among Blacks in the Caribbean: schoolchildren performing mummers' plays could have introduced costumes and characters to the black population. According to Roger Abrahams, the same plays were performed by Blacks in St. Kitts, but there is no record of Bahamian Blacks performing these dramas in the nineteenth century. Whites seem never to have performed in the masquerade on Bay Street, choosing instead to spend Christmas strolling on Bay Street and attending choir recitals and dances at the Nassau hotels.

Another nineteenth-century report mentions a different kind of Christmas celebration. Louis Diston Powles, who was in Nassau in 1886, noted that tribal distinctions among the Blacks still remained and that they divided themselves into groups, especially for the holidays.[75] Every August the Yorubas, Egbas, Ebos, and Congos [sic][76] elected a queen, "who ruled on certain matters." At Christmas "they march about with lanterns and bands of music." Many of the groups that Powles saw were not parading in Nassau, so their celebration of the Christmas holiday differed from that of urban Blacks.

In the early 1920s the Nassau street parade became known as John Canoe, and by the mid-1920s, the number of John Canoe participants had increased substantially. The December 28, 1927 *Nassau Guardian* reported that visitors, eager to see John Canoe, had flocked to Nassau. That year the procession of masqueraders was seen both on Christmas Eve and on Christmas morning. Due to popular acclaim, another parade was scheduled for January 2.

By piecing together these reports, one can visualize what these Bahamian John Canoes looked like. In 1924, Alan Parson witnessed a Christmas evening parade on Bay Street.[77] Although he does not call this parade by a particular name, he does comment that the participants all wore whiteface masks or whitened their faces. He also describes some prominent costumed participants, including a performer dressed like an Englishman in the Boutique, another in red velvet Shakespearean costume, and another dressed in flour bags, wearing a clown's cap on his head. Other notables included three Highlanders and a group of men dressed as women in the latest Paris fashions. Most participants in the Nassau Christmas parade seem to have been men dressed in costumes based on European models *(Figure 45)*.

Robert Curry noted in 1928 that "colored folk" paraded on Bay Street on Christmas Day and New Year's morning, suggesting that this celebration was creole. This practice was known as the "Johnny Canoes properly and colloquially as Junkanoos."[78] Most of the masked participants carried musical horns and cowbells, covered their bodies with shredded strips of colored paper and wore a structure, often in the shape of a ship covered with shredded paper, on their heads *(Figure 46)*. This is one of the first written descriptions of the costume type which provided the basis for Junkanoo costumes today. Now costumes are made from imported crepe paper, hand-sheared to achieve a layered fringed effect *(see Figure 44)*.

In 1929, Amelia Defries wrote that male masqueraders dressed in knee-length skirts, their legs covered by light-colored tights.[79] Many wore British-style safari hats, and all wore "machine-made masks" in imitation of whites. She also saw a man in a loose-fitting polka-dotted clown suit, another covered from head to foot in

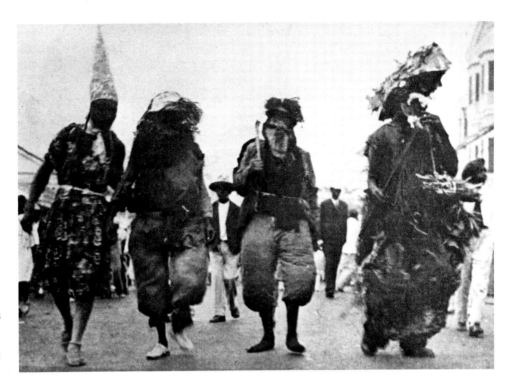

Figure 45 Junkanoo performers in Nassau, the Bahamas, 1934. The three masqueraders to the left are dressed in European-derived costume styles, including full pantaloons. The right-hand figure wears a fiber costume; all are masked.

shredded paper or cloth and wearing a tall pointed cap, and others parading as a white policeman, a "kiltie," and a British master of arts. Several solitary men with closed umbrellas danced in a style that resembled the "cake-walk." Other characters wore dresses that Defries called variations on the "Pantaloon," with remarkable color combinations. This particular description is reminiscent of the performers from Westmoreland, Jamaica.

Most of these masqueraders were divided into bands representing "over the hill" neighborhoods. The leaders danced with a "one step forward and two steps back" pattern, a step still executed by many performers today. These dancers were accompanied by musicians playing small, open-ended drums strung over the

Figure 46 Junkanoo performers parading at Christmas, 1941 in Nassau, the Bahamas. By the 1940s paper fringe costumes were the norm, as were ship headdresses.

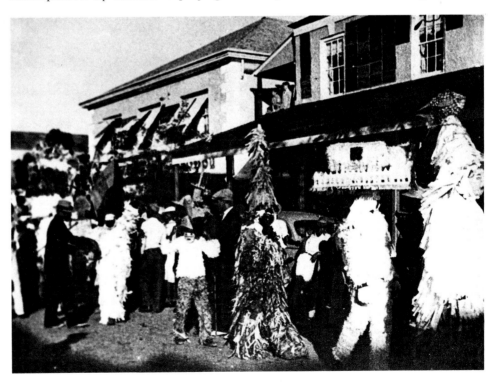

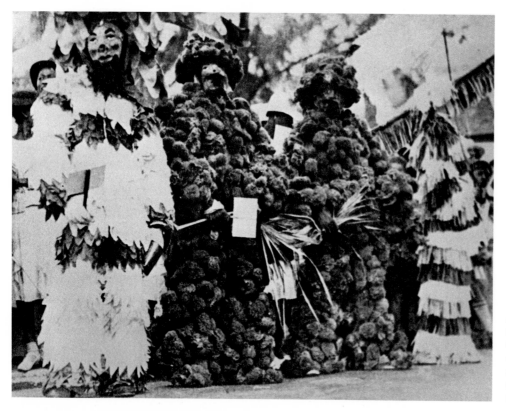

Figure 47 Junkanoo performers parading at Christmas in Nassau in the late 1930s. The center masqueraders are wearing sponge costumes. When the supply of sponge was depleted by the 1940s, the most acceptable costume style became shredded paper strips.

shoulders. "You might walk the length of [Bay Street]," Defries remarked, "and from end to end you would hear no variation in the rhythm."[80]

Evidence indicates that formerly Junkanoo performers wore masks which varied considerably. Some were created by powdering the face with flour, and others were purchased ready-made. "Some people would wear soft wire," said Charles Storr, Jr. "We'd call them 'silver face,' and they'd come painted. The shop keepers would have them ordered."[81] Another name for the "silver face" mask is "sifter mask." In these pre-1930 reports there is no mention of the collecting of money, or of characters with particular names. Only occasionally are animal characters mentioned. Performers never acted out dramas or played specific roles.

In 1976, Charles Storr, then eighty-five years old, remembered men parading on stilts and others who wore sponge costumes at the turn of the century.[82] By the end of the 1930s, when the sponge supply had been depleted, the most accepted and popular style of costume became shredded paper strips *(Figure 47)*.

The 1930s saw a demarcation in the history of the Nassau festival, when the Development Board, now known as the Tourist Board, assumed much of the patronage of the festival, organizing, regulating, and awarding prizes in categories of its own choosing. A parallel occurred in Jamaica during the *Gleaner* competitions of the 1950s, when Fancy Dress bands received awards. Official government patronage often changes festivals into events that will bring in tourists, giving prizes to costumes that tourists would like to see.

By the 1930s, the Development Board held Nassau's "Johnny Canoe Parade" on New Year's Day to placate those who felt that a raucous parade was inappropriate on Christmas Day. To encourage delaying the parade from Christmas to New Year's morning, the Development Board offered cash prizes for original costumes and also took on some of the artistic direction of the parade. The *Nassau Guardian* on January 2, 1934 called "the mummers heads which had been specially imported . . . for the occasion . . . very effective." These heads included a John Bull, a Wolf, a

Deathshead, and a Pierrot. Starting in 1935, the John Canoe parade was held regularly on New Year's morning. The *Nassau Guardian* of January 2, 1937, included an article and editorial on the parade which sums up its character to this day.

> The object of offering prizes is to encourage more and better costumes to be worn in the parade, which will reflect more credit to Nassau generally . . . A few of the citizens got together and decided that perhaps offering prizes would be an incentive to a better turn out of masqueraders, and last year the Business Men's Weekly canvassed for funds for prizes . . . it was decided to offer prizes again this year and as was seen, the parade was a decided improvement.

By the 1940s, the Junkanoo parade was an established feature of New Year's celebrations in Nassau. Costume references to World War II were quite popular, as were ship headdresses *(see Figure 46)*. In 1944, Junkanoo parades were suspended, on account of "hooliganism." In actuality, neighborhood bands had developed such a keen sense of competition that they were often involved in "friendly" combat. Though public Junkanoo celebrations were officially revived in 1947, they were temporarily halted again from 1953 to 1955. There is no doubt that the extent of militant competition among neighborhood groups was considerable by the 1940s. "In the old days we'd buy whips from the hardware . . . long whips. You see, people would be from different areas—and maybe we'd be enemies," said Charles Storr.[83] "At first, a while ago, they used to just rush. The south group would put on a dare . . . to rush into the west group. They maybe held chains or even whips. If you were west you'd try to mess with the east," said Percy Francis, a group leader since the 1960s.[84]

"Before the government support, it was rough and tumble," Chippy Chipman added. "Now it's progressive and they've organized it. Now the people stand aside for us to pass."[85] Despite these interruptions in public performance, the celebrations themselves did not cease, nor did occasional cancellation of Bay Street festivities dampen the spirits of the participants. "When I was a youngster we used to go 'over the hill' and we'd masquerade all night long, because we couldn't go into town until 3 or 4 o'clock in the morning," said A. B. Malcolm, a white resident of Nassau and masquerade enthusiast. "During the war they stopped Junkanoo, but they still did it 'over the hill.' If we came out in town they would put the fire hose on us to stop us."[86]

Today, Nassau's Junkanoo rivals Trinidad's Carnival in scope and structure. Many older Bahamians express regret at this; they feel such structure limits participation and restricts personal creativity. They also resent the official limitations placed on the participants. A. B. Malcolm, seventy-five years old in 1976, had been dancing Junkanoo since about 1910. He was adamant in his dislike for regulations.

> Back in those days you could just "jump in." In those days coming out meant coming out with a uniform on . . . then nobody knows you and that was the beauty of it. These days they all come out in big groups, but no masks. In these days the government gives them money. Now they get money. It's not right. They should have one morning for the real Johnny Canoes.[87]

Government regulations have changed the character of Junkanoo, and modified and transformed the festival elements. Junkanoo participants are divided into groups, and each group represents a theme. These groups are supported by local businesses and real estate interests. The larger groups receive from $1,000 to

Figure 48 Members of the band Saxon Superstars, which competed in the 1986 Boxing Day Festival, working on the costume of a giant wild boar, one of several endangered animals in the Bahamas.

$1,500 in support and cash prizes in return. In essence, Junkanoo groups comply with guidelines: the groups must be organized and registered with Festival Committee; the costumes are made from hand-sheared crepe paper molded with wire and pasted onto a cardboard frame not more than eleven feet in height; all participants must report to Bay Street by 4 a.m. and receive official entry numbers; all groups march down Bay Street and each has its own musical accompaniment provided by *goombay* drums, trumpets, whistles, and cowbells.[88] Contemporary groups number from one to two hundred. Out of this, there may be fifteen to twenty goatskin drummers, thirty horn and bugle players, thirty cowbell players, and many whistle players. Everybody wears costumes and everybody dances.

Because of government sponsorship of Bahamian Junkanoo, and the tourism it attracts, costumes have become larger, resembling those of Trinidad Carnival. Government officials and artists from Nassau have attended Carnival, adapting techniques and styles from Trinidadian artists. Two of the leading costume builders of the Bahamas, Winston "Gus" Cooper and Percy "Viola" Francis, in 1983 attended Carnival in Port of Spain, where they were singularly impressed by both the Mancrab *(see Figure 7)* and Diana Goddess of the Hunt *(see Figure 79)*. Attracted by the scale and sculptural qualities of both costumes, the artists introduced to Nassau a style that they called three-dimensioning, wherein costumes extend into space, making them visually interesting from every angle.[89]

By December 1986, Cooper's and Francis's studios or shacks were a flurry of activity. Francis's Junkanoo group, Saxon Superstars, had partitioned its large space into rooms where the leader costumes were assembled *(Figure 48)*. Thousands of wrappers and cardboard boxes that had held the imported Austrian crepe paper were strewn about. Saxon Superstar artists, apprentices, and volunteers assembled wood and metal substructures of the costumes, while others carefully cut colored crepe paper and glued the strips to the gessoed-cardboard surfaces. Giant frogs, bats, snakes, and lizards peered from their stalls.

Figure 49 Members of a 1986 Nassau drum ensemble heating drum heads to obtain the correct pitch.

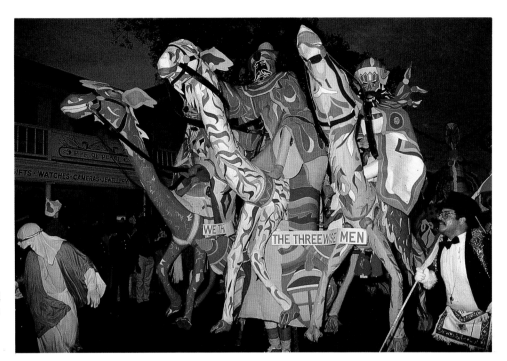

Figure 50 The Valley Boys group organized their 1986 Boxing Day masquerade around a Christmas theme. Here the three wise men move in syncopated rhythm down Bay Street, Nassau.

The primary competitors, Valley Boys, led by Winston Cooper, located its shack across town in an equally impressive structure subdivided for the various leader costumes. Members ate and slept at the shack, to meet the deadline for the celebration. Artists in each camp occasionally shouted, "Number one!" anticipating the first place prize they hoped to win. Meanwhile, the newspapers carried stories about all the bands, fueling the expectation of Bahamians and tourists.

Small groups of revelers walked down Bay Street at 3 a.m. on December 26, 1986, Boxing Day. A few supporters of Junkanoo groups gathered and the town slowly stirred to the tuning of the *goombay* drums which, like the *tassa* drums of Hosay, were heated next to paper fires to obtain the proper pitch *(Figure 49)*. Within the hour, the leader costumes of each group were delivered to the designated area. The music became louder. With the press and judges assembled in front of the densely packed crowd, Boxing Day Junkanoo began. Out of the night came the Saxon Superstars, their banner announcing their theme of "SOS—Save Our Species." Behind followed the giant leader costumes, each depicting an endangered species from the Caribbean—the wild boar, giant frogs, an alligator, iguana, parrots. All were in polychrome colors moving to the syncopated rhythm of the music. In between the big costumed bands, small scrap bands picked up the beat with their musically hot ensembles *(see Figure 44)*.

The competition stiffened as the Valley Boys band, "A Magnificent Celebration of Christmas," made its appearance on Bay Street. It featured characters such as Santa and his sleigh, Rudolph, Frosty the Snow Man, the Three Wisemen, Christmas Turkey, and a manger scene, in a living and dancing visualization of the Christmas story *(Figure 50)*. Large, athletic young men danced, not without difficulty, under costumes that weighed as much as 150 pounds. To the tempo of the music they spun, swayed side to side, and rushed down the street.

Other entries for the year included a new group called Fox Hill Congoes, whose theme, "The Myths and Legends of Fox Hill" treated the subject of *obeah*, i.e., Afro-Caribbean medicine. Skull motifs, as well as a larger group of Black Indians dressed

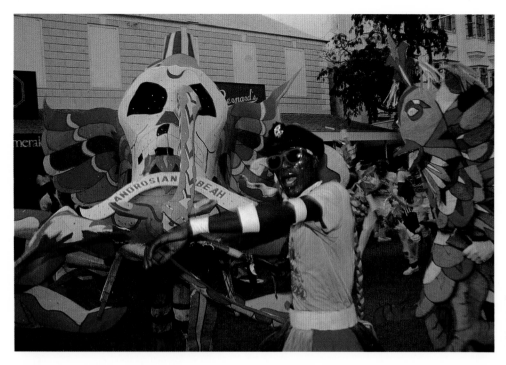

Figure 51 A section of the 1986 Nassau Boxing Day band Fox Hill Congoes. The skull in the background refers to *obeah,* an African-derived medicinal system common in the Caribbean.

as Hopi Kachinas, illustrated this theme *(Figure 51)*. Individual costumes, produced by Philip Miller using vegetal materials in the old style, were reminiscent of the . Jamaican Jack-in-the-Green character drawn by Belisario in 1836.

The Vikings band depicted seashells while the Music Makers, who would attend the Caribbean Festival in Toronto the following year, presented "Exploring Splendors of Dysterioques." By 6:30 a.m. the bands filled the half-mile circular procession route. Sound merged into sound, and visual image into visual image. The soft morning light dissolved the separate units, leaving a wave of visual sensation that breathed with the music.

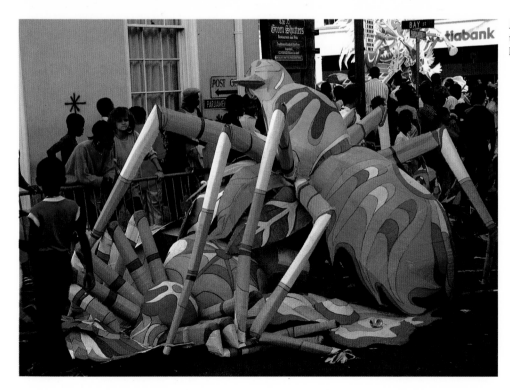

Figure 52 Bahamian Junkanoo animal costume discarded after the Boxing Day celebration, December 26, 1986.

The crowds and participants began to disperse at 10 a.m. Some had abandoned their costumes and returned home. Giant crabs as well as the first-place leader costume, *Away in the Manger*, along with countless other costumes, were left in the open. Thus for a short time, these perishable works of art stood as public sculpture *(Figure 52)*. Band leaders of both camps and their supporters went back to the shacks and prepared to work around the clock until New Year's, when entirely new costumes would be presented.

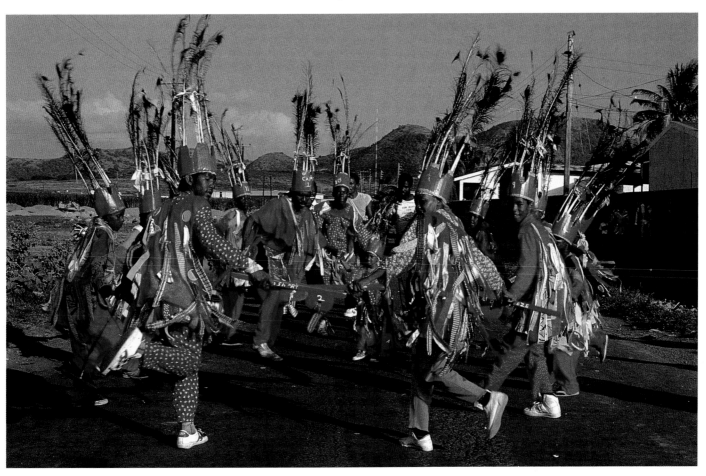

The Amerindian Masquerade of St. Kitts-Nevis and Bermuda

Figure 53 The style of this 1986 Amerindian costume for Masquerade on St. Kitts-Nevis has not changed since the turn of the century. Today long-sleeved shirts, trousers, short aprons, and capes decorated with mirrors, beads, and colored ribbons are worn with tall peacock feather headdresses.

Masquerade from St. Kitts-Nevis has influenced festivals on many other Caribbean islands, and most specifically festivals in the Dominican Republic and Bermuda. This area seems to have fostered a very strong and mature festival tradition. In the late 1890s, Alfred Williams saw masqueraders impersonating Amerindians in St. Kitts. He noted that they wore feathered headdresses and leggings and carried tomahawks.[90]

Antonia Williams's 1908–09 Christmas-New Year snapshots from Nevis are some of the earliest visual evidence of Caribbean festival traditions *(Figures 54 & 55)*. Some masqueraders wore tall peacock-feathered headdresses, whiteface masks, trousers, and long-sleeved shirts, "sewn all over with penny glasses and post cards, and any other tinsel." Other masqueraders had "paper cake frills as their headgear, all very tawdry, and paper frills sewn on their clothes."[91] Antonia Williams also documented an Amerindian masquerade in which the male Amerindians wore

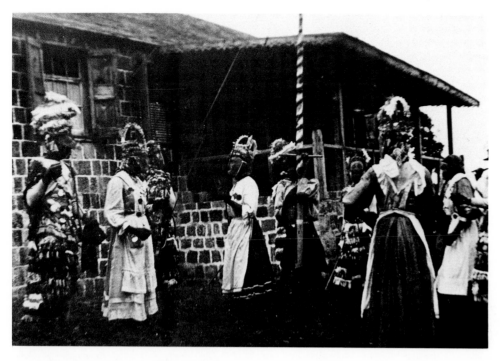

Figure 54 Masqueraders from Russell's Rest, Nevis, Christmas 1908. The black male masqueraders impersonating women are performing a Maypole dance. To the left is a costumed Amerindian decorated with bangles, mirrors, and ribbons; all these performers wear whiteface wire screen masks.

fringed leggings and solid light-colored long-sleeved shirts. Over the leggings were skirt-aprons that were completely fringed and reached to just above the knees, while bandolier-style or multiple-strand necklaces were worn over the shirt. The entire costume was decorated with bangles, mirrors, and ribbons. Although these masqueraders also wore "white masks and headdresses of peacock's feathers about three feet high," Antonia Williams did not photograph them.[92]

The details of these costumes underscore the similarity of St. Kitts-Nevis traditions to those on other islands, especially the anglophone smaller islands. Interestingly, few of these costume elements have been reported from Jamaica, and only incidentally does the dramatic tradition resemble Jonkonnu.

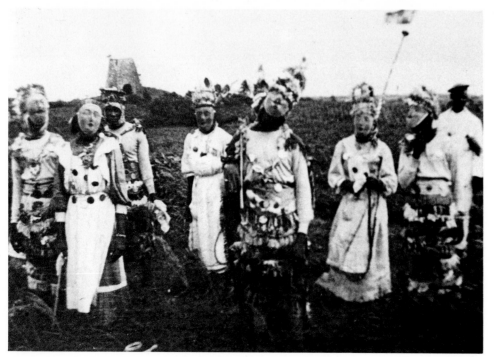

Figure 55 Christmas masqueraders from Russell's Rest, Nevis, December 25, 1908. This is one of the earliest photographs of black masqueraders, including men wearing long dresses or the prototypical Amerindian costume with fringed pants, short skirt-aprons, and white tops. Their clothes were "sewn all over with penny glasses and post cards, and any other tinsel." All also wear the typical imported whiteface wire screen masks.

Some older residents still recall the Christmas festival traditions at mid-century and before. The troupes performed Giant Despair from Bunyan's *Pilgrim's Progress,* David and Goliath, the Wild Bull and his trainer Mock Jumbie [sic] on stilts, Negra Business,[93] and Masquerade. The specific performers known as Masquerade were the most exciting. They were dressed as "Red Indians,"

> their outfits decorated with tiny tinkling bells and small mirrors. These Nevisian Red Indians performed very credibly, urged on by the almost maddening music of the fife. The best dancers are able to leap high into the air one minute, then stretch backwards till their headdresses touch the ground.[94]

Today the basic Masquerade troupe includes eight to twelve performers and three musicians playing the bass drum, kettle drum, and the fife.[95] Certain costume elements appear to have remained constant since at least 1909: colorful shirts, trousers instead of knee-length breeches, short aprons, and capes decorated with mirrors, beads, and colored ribbons *(Figure 53).* Often small bells also are attached to the border of the costume. The circular headdresses are adorned with tall peacock feathers. Formerly all masqueraders wore wire screen masks, but if one is used today it is attached to the side of the cardboard base of the headdress, as if in homage to a vanished tradition.[96] The troupes still perform during the Christmas-New Year season.

A complete performance observed in 1986 consists of a sequence of six dances: the Quadrille, the Fine, the Wild Mas, the Jig, the Waltz, and the Boillola. Most sequences are led by the Captain who often directs the troupe with a crack from his whip.

This St. Kitts-Nevis masquerade tradition spread to other islands along with emigrant laborers. Christmas dancers and their celebrations in Bermuda are called Gombey. Gombey masqueraders from Bermuda all play Wild Indian and the masquerade also became rooted in the Dominican Republic. Seasonal cane workers from St. Kitts-Nevis spent January through July in Cuba and the Dominican Republic. Roughly ten percent of the inhabitants of St. Kitts-Nevis left and returned annually to the Dominican Republic between 1914 and 1939. In the early twentieth century, labor from St. Kitts-Nevis was used in Bermuda for dockyard and military construction.[97]

The costumes worn by the masqueraders from St. Kitts-Nevis, Bermuda, and the Dominican Republic are identical, attesting to both a recent origin and a common source. Fradrique Lizardo, the Director General of the Ballet Folklorico Dominicano, writes that St. Kitts-Nevis immigrants not only brought with them the Amerindian masquerade, but also introduced others such as The Bull Dance, Macayombi (stilt dance), Momise (the Mummers) and several biblical plays which featured dances between the speeches *(Figure 56).*[98] In the Dominican Republic the performance is called Masquerade, as it is called to this day in St. Kitts-Nevis.

The costume worn by the Dominican Republic Masquerade groups resembles the one worn by the Bermuda Gombeys and the Masqueraders from St. Kitts-Nevis. This same costume has been worn since at least the 1930s. The major difference between it and the costume in Antonia Williams's photographs is that the current uniform includes a decorated cape and often a decorated front flap worn over the short skirt. In Bermuda, two black braids are attached to the plumed headdress *(Figure 57),* while in the Dominican Republic the mask is no longer worn as part of

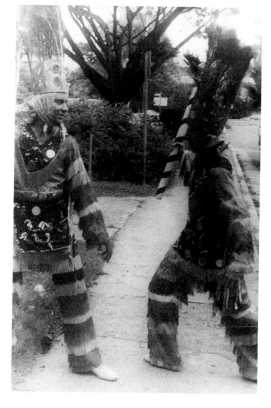

Figure 56 The Amerindian masquerade of the Dominican Republic being performed by members of the Ballet Folklorico Dominicano, 1978, Rio Piedras, Puerto Rico. The masquerade and costumes were introduced from St. Kitts-Nevis by migrant workers between 1900 and 1930.

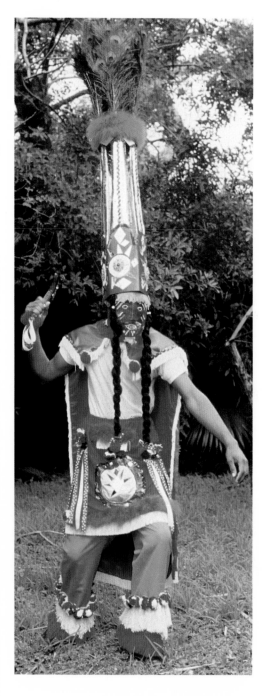

the costume ensemble. One Gombey player from Bermuda adds that the cape is normally decorated with pieces of mirror, or even little bells; but Charles Place said, "You put on your costume what you could afford to put on it. These days they cost a whole lot of money."[99] In Bermuda most Wild Indian performers wear soft shoes, tennis shoes perhaps, a short apron-like skirt, gloves, a headtie, and a wire screen mask. The headdress is made from cardboard covered with tissue paper and mirrors and surmounted by tall, upright feathers; the preferred variety is peacock. "The peacock is a proud bird, so we wear his feathers."[100]

Although Gombey masqueraders in Bermuda traditionally appeared at the Christmas season, they now perform during summer Cup Match,[101] and throughout the year for tourists. These gaily-costumed street dancers have performed since at least the early 1800s, although the costumes and the festival's formal structure have changed considerably. By the 1940s Bermuda Gombey troupes had been transformed by the St. Kitts-Nevis tradition. The earlier troupes consisted of named characters wearing specific costumes. Charles Place remarked that, when he was very young, "Sometimes we even had different costumes, like goatskin capes and all kinds of shapes of hats. It was not like the Gombeys."[102]

Although the Amerindian costumed troupe has become the standard Gombey tradition, other earlier traditions, like the wearing of a house-headdress or performances of David and Goliath dramas presented by a group called Giant and Despair, have died out. These elements, part of the historical tradition of Gombey in Bermuda, have not been seen in festivals on that island since around 1935 because they were so seriously frowned upon by the Church, although an occasional performance may have taken place in the 1940s. Another group, known as the Jumbies (see Moco Jumbie in glossary), performed on stilts; and yet another, known as Masquerade, did a Maypole Dance.

The earlier descriptions of Afro-Bermudian celebrations differ considerably from those described above. It is probable that some elements of the Christmas celebrations were introduced early on from the Caribbean, rather than having developed from an original African source. Today Gombey performers dance mimed routines accompanied by drums, fifes, and whistles. These troupes include acrobatics, splits, and fancy pirouettes in their dance repertoire. The choreographic emphasis is on quick foot and leg movements and the musical accompaniment is rapid and very upbeat.

The Gombeys shown in photographs taken in 1932 strongly resemble those of today. Their capes and trousers are covered with beads, sequins, pieces of mirror,

Figure 57 John "Pickles" Spence playing Amerindian masquerade in Hamilton, Bermuda, January 1985. Introduced from St. Kitts-Nevis in the early twentieth century, this costume style still exhibits many of the attributes of the earlier tradition: the tall peacock feather headdress, a cape, short overskirt, and fringed trousers. In Bermuda, braids are added. This particular wire screen mask is painted in a creolized style, highlighted by multicolor geometric patterns and stark outlining.

ribbons, bells, and fringes. They also wear short, apron-like fringed skirts. The masks of 1932 have white faces with carefully drawn features *(Figure 58)*. Currently the masks are made of wire screen with painted pink cheeks and red lips. The headdresses, consisting of a circular band trimmed with glitter, and surmounted by about four-feet-high peacock feathers, have been part of the Gombey costume since at least the 1930s, but hardly earlier than that. The dancers carry bows, arrows, and hatchets. In fact, the entire costume vaguely resembles the Amerindian type worn throughout the Caribbean, though in Bermuda they also wear white gloves.

As the tradition evolved, some Gombey dancers portrayed specific characters with specific roles. The Captain wore a long cape, carried a whip and blew a whistle. Each time the Captain blew the whistle, it was a signal for something to happen, like a salute or a bow. The Chief wore a long cape too, but he also carried a hatchet. The Chief was like an assistant; when people were not paying attention or someone was dancing poorly, he would say, "On your parade, masquerade." Most of the other dancers wore short capes and carried bows and arrows. Of these, there was always a character called Wild Indian or Chopper, who cleared the way for the other dancers. He often led the troupe to line up for a drill. Then the Captain would blow the whistle, and the Wild Indian would do a solo dance, and then leave. The others would all dance together in a circle.

It is interesting that the Amerindian-style costume was and is so popular, for the most common wire screen mask type is painted a pinky color, with red lips, rosy checks, and bluish eyes. Except for the addition of two long black braids, this mask certainly does not resemble the features of an Amerindian. In fact, until the mid-1970s most masks copied the commercially produced whiteface wire screen variety so popular throughout the Caribbean. More recent masks exhibit a freedom of style and decoration typical of Afro-Caribbean aesthetics.

Only a few Gombey troupes now perform outdoors during the Christmas season. As on other islands, the younger generations do not like the restrictions imposed by costumes that never vary and the masked, choreographed performance. Since the mid-1970s, the main costume attractions have been the mask parades and competitions, that are designed along the lines of Trinidad Carnival and that are incorporated into the Cup Match festival.

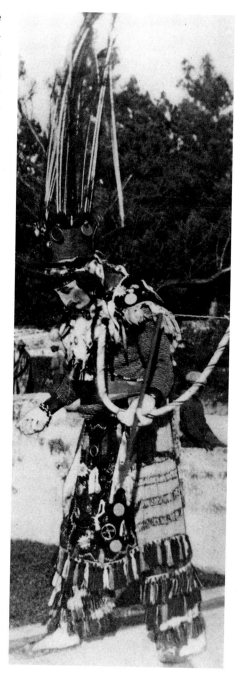

Figure 58 A Gombey dancer from Hamilton, Bermuda, 1931. All Gombey performers play Amerindian masquerade, a tradition introduced from St. Kitts-Nevis in the first decade of the twentieth century. This costume is still the standard style in many West Indian masquerades.

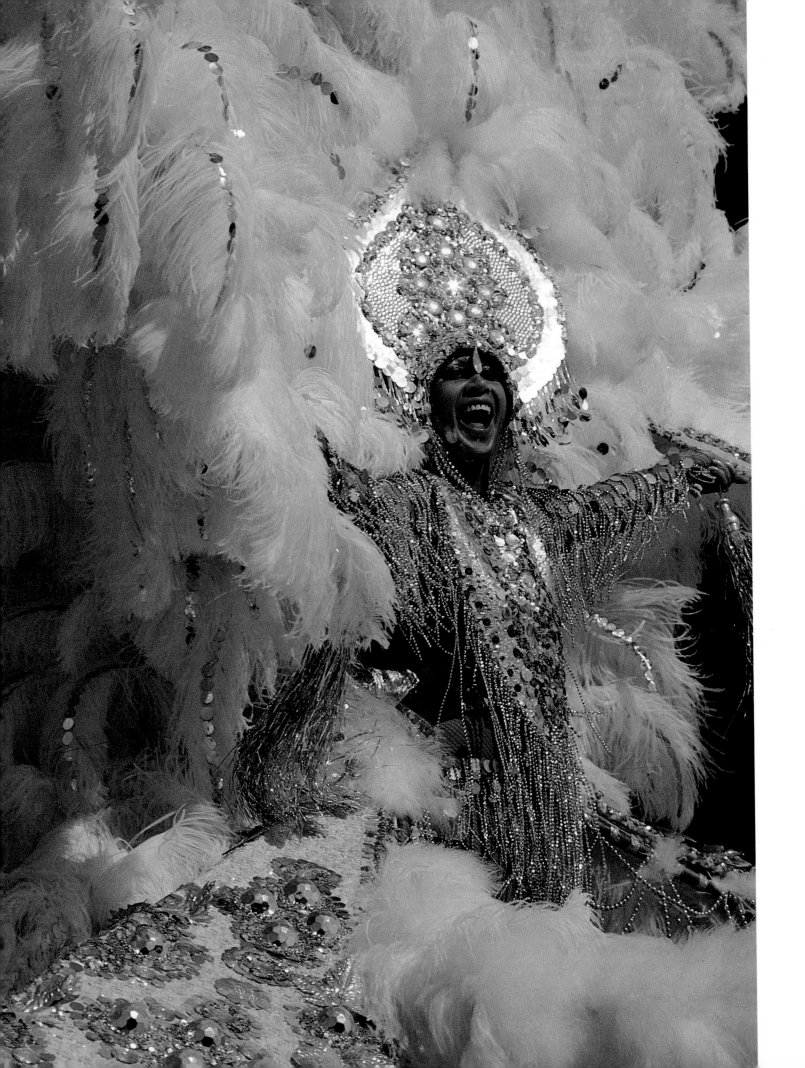

3

Masquerade Mix-up in Trinidad Carnival: Live Once, Die Forever

Neil Arthur Hodge, who migrated to New York from Trinidad in 1970, succinctly explained why he spent so much time, money, and effort on his Carnival costumes: "Live once, die forever."[1] Like life, like the masquerade, the brief beauty of the costumes must recount the traditions of the country. Once their mission is completed, they are left in the streets or discarded on the Savannah, where they collapse and fade before the city disposal units pick them up. Each year new costumes add to the traditions; each Carnival is different; each affirms the past and reaches into the future.

The aesthetic of Callaloo in Trinidad embraces the remarkable sources of Carnival costume motifs, materials, and styles. From the founding of the Spanish colony, and later through the settlement by French and English planters, Europeans celebrated from Christmas through Lent with fancy balls and masquerades. African slaves, repatriated slaves,[2] and Chinese and East Indian indentured laborers brought to the island cultural traditions that the Europeans considered exotic, pagan, and subhuman. Today these disparate traditions blend in Carnival, giving unity and identity to a country characterized in the past by racial tension, cultural bias, and religious bigotry (*Figure 59*). "This is our grand release," said Geoffrey Holder, an artist, choreographer, and set designer born in Trinidad. "We sing, dance, laugh and boogie for two days and nights. We are purified and revitalized through Carnival."[3]

Carnival today is big business. As Carson remarked in Alec Waugh's novel *Island in the Sun*, "They have such capacity for enjoyment too. You'll have a chance of seeing that at Carnival . . . the two days before Ash Wednesday. Three weeks from now. Trinidad is the place to see it, at least people will tell you that it is, but in Trinidad the Carnival's too organized for my taste, too commercial. It's more intimate in a small place like this."[4] Carson had a point; Carnival is well organized and commercial. The profits, however, are not summed up in British pounds, as they were in the 1950s, or as they are currently in T&T dollars. Success is counted in the ethereal realm of ideas, aesthetics, and affective behavior. With over one hundred thousand masqueraders taking to the streets, Carnival must be organized, it must be commercial, but if it did not succeed aesthetically, the business of Carnival would cease.

Figure 59 This 1983 Queen, Day-dreaming, from the Port of Spain band Nicer Things in Life, prepares to cross the Savannah stage. The complete layering of sequins and feathers expresses the quintessence of the Fancy aesthetic in *mas.*

The Shape of Carnival Today

Carnival is alive, powered by its musical breath. The events which help define the festival indicate the nature of its pulse. In September, the biennial steel band classical music competitions in the Jean Pierre Sports Complex are attended by Trinidadians from all over the island; there the audience discusses the previous year's steel bands and the *mas* bands. Later in the fall, the designers and band leaders hold *mas* launchings, where drawings of each band section, Kings and Queens, and band themes are presented. Artists visit each other's camps, and eventually word gets out about who is doing what. The question one inevitably asks a friend up until Carnival is, "What band will you play?" *Fêtes,* or parties, are held each weekend after Christmas in anticipation of Carnival. The steel bands perform several nights a week. The Calypsonians release new recordings in hopes of winning the Carnival Calypso March award. Through January the entire city is a seething workshop. The north stands, the Savannah stage, and portable booths for food vendors are assembled a few weeks before Carnival begins.

Figure 60 These individuals were members of a Jouvay band which danced to Independence Square in 1987. The mud, oil, dirt and paint mask participants as they enter the threshold for this ritual event of Carnival.

Figure 61 A participant in Jouvay, covered with mud and ochre, enters the early morning,darkness. His shining, slippery skin eases his passage into the ritual space of Carnival. Port of Spain, 1988.

Formal events begin about a week before Mardi Gras with the preliminary King and Queen competitions. Designers work until the last minute on their *mas,* while others apply make-up on the King and Queen contestants. The next evening *Ole Mas* competitors wearing simple costumes present skits of political and social satire. The following day is reserved for Calypso competitions. On Friday before Carnival, the semifinals of the King and Queen contests are held. On Saturday over sixty thousand school children masquerade on the streets of Port of Spain. That evening at Pan-o-rama, the grand steel band competitions, sixteen bands roll their instruments out on wheeled carts, preceded by flag girls who dance, grind their hips, and provocatively manipulate the flag poles.

Carnival is pan; pan is hot. The performance continues till early morning. Sunday night, called Dimanche Gras, presents the final Kings and Queens competition and the Calypsonians. By this time people have arrived at strong opinions about the music and costumes. By two in the morning, some have returned home for a shower, a little food and drink, and perhaps an hour's rest, while others remain at the *fêtes* waiting for the steel bands to appear.

Roosters break the pre-dawn quiet; it must be four a.m. A few Jouvay bands from distant parts of the city are heard faintly. Jouvay, from the French *Jour overt* (opening day), gives strength to people who must find their bands and begin the long trip to Independence Square. Participants often cover themselves with mud or ash, soot and oil, while others are dressed in worn, old clothes or dilapidated costumes *(Figures 60 & 61). Soca* musicians, steel bands, and other less organized groups play with a fiery syncopation that breathes movement into the fatigued revelers *(see Figure 90).*

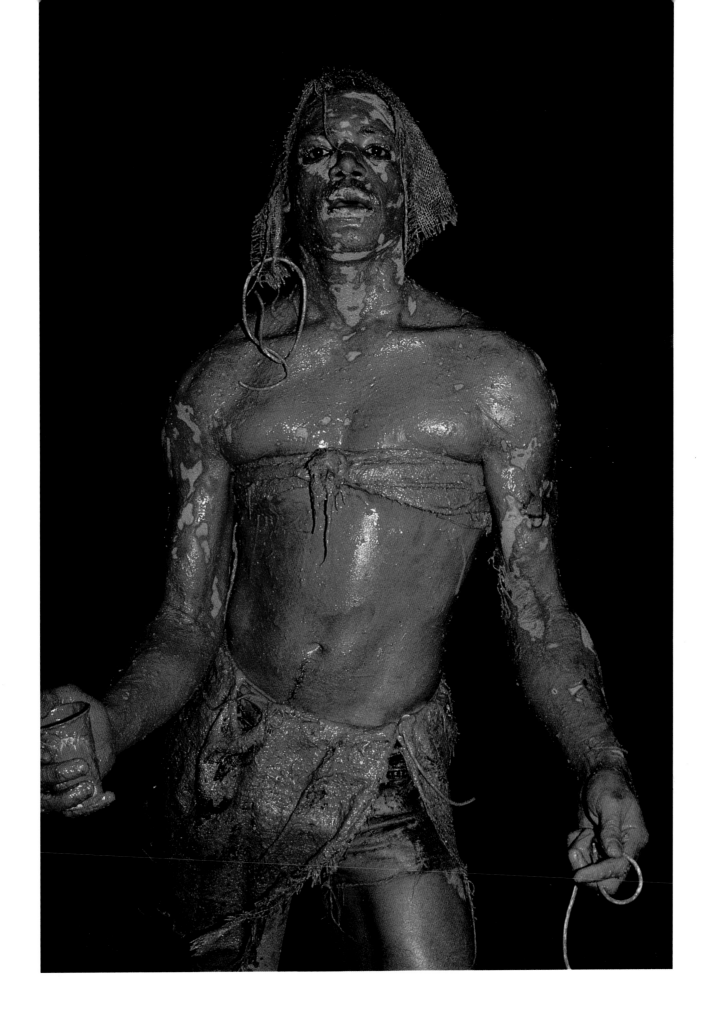

As bands move closer and closer to Independence Square, the music and dance recall the days when black slaves lit the night with their torches. Palm branches are blessed with libations of beer, rum, or the mud and soot worn by the participants. Elsie Lee Heung elaborates:

> And even this year at Jouvay if you see anybody with a green leaf, it means something [*Figure 62*]. The meaning is, years ago, whenever crop time came along and the slaves finished at the plantations of sugar cane and everything and they burned the cane, there was a rejoicing because it was finished in the fields, and the masters would allow them to jump and rejoice. And they would pick up a branch and go merrily after they had burned the others. And this was the meaning. It was Freedom, emancipation, no more work.[5]

The liberation of Jouvay carries participants into Carnival, in which ordinary life is waived (*Figure 63*). The mixture of soot and oil that coats the players symbolizes that passage.

After Jouvay, most people eat a hearty brunch with traditional foods like black pudding and salt fish. Band members return home to dress for *mas,* though still not in their best or complete costumes. This is a day for browsing and spontaneity; perhaps they will ignore the dictates of the band leaders. The groups dance up Frederick Street and parade across the stage, literally ascending the Savannah, once the site of a sugar plantation. What was a symbol of slavery and bondage is now one of liberation (*Figure 64*).

On Monday night people attend parties before retiring for the grand finale on Tuesday. By late morning band members assemble at designated points along the road. Pan bands, *soca* orchestras, and disc jockeys with electronic components and giant speakers on wheeled carts or flatbed trucks mingle among the bands. The mellow, pulsating motion of the dancers is expressed by such *soca* lyrics as "Ah Feeling Nice Now" and "Hot, Hot, Hot." After masquerading in the streets for hours, the last participants cross the stage in late evening. Carnival ends at midnight.

Figure 62 This Jouvay dancer carries a branch, symbolic of the renewal of life, a function of Carnival born of both the ancient European festival and of African planting and harvest festivals, Port of Spain, 1988.

Figure 63 Small steel bands like this one provided rhythmic inspiration for Jouvay participants. Port of Spain, 1988.

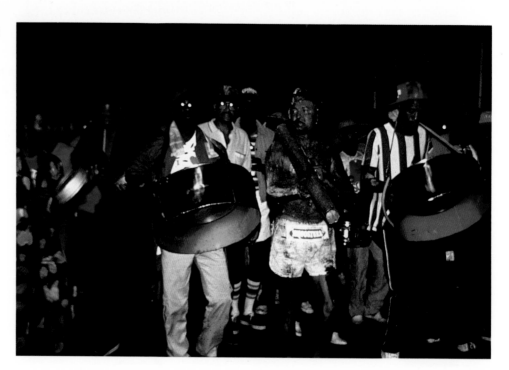

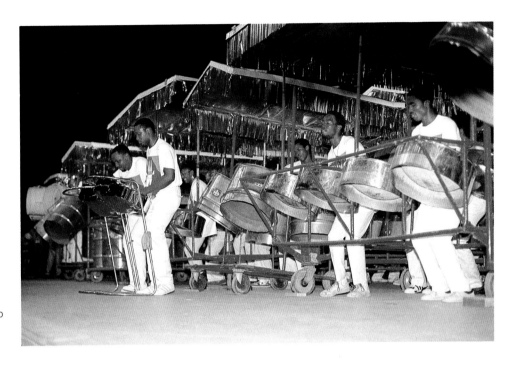

Fiture 64 Each year the steel bands compete fiercely on the Savannah stage. Amoco Renegades is among the top performing bands from Port of Spain, 1988.

Masquerade Sources

Throughout the history of Carnival the schedule of events has been affected by the development of new cultural forms such as the steel band music. However, the costume competitions that have consistently been the core of the festival have thrived, drawing from multiple artistic sources that suggest the richness of the tradition of Carnival artistry.

The French colonists who originally celebrated Carnival took it to a level of debauchery far different in spirit from the Spanish disguised balls. The slaves of French colonists were not permitted to masquerade, but they certainly were influenced by it. Early costume descriptions of black celebrants reveal an emphasis on King and Queen costumes as well as the striped style of English mummer costumes. Through the movement of slaves among the islands and the recruitment and disbursement of black West Africans into the British military, European costume types spread.

> Because it is really the French people who brought Carnival as it is here today. It is from the masked balls of Versailles. So this is when they started playing Kings and Queens. And that is why you have the people performing. They would dress up and play lord this and King Louis XIV and feting to the tent and wear old clothes and say, "Yes my Lord." And that is why you hear the calypso names. He's not Kitchener, he's Lord Kitchener, and the High and Mighty Duke of Albany.[6]

African sources within Carnival are more difficult to pinpoint, because the forms have changed. Yet the underlying aesthetic sensibility remains the same. Like Blacks whose colonial names of Felix and Betsy obscured their Africanness, Carnival costumes derived from African sources assumed different shapes. Their character, however, remained solidly African.

Among historically linked costumes is the stilt dancer or *Moco Jumbie*, whose presence in western Africa is mirrored throughout the Caribbean *(Figure 68)*. Early

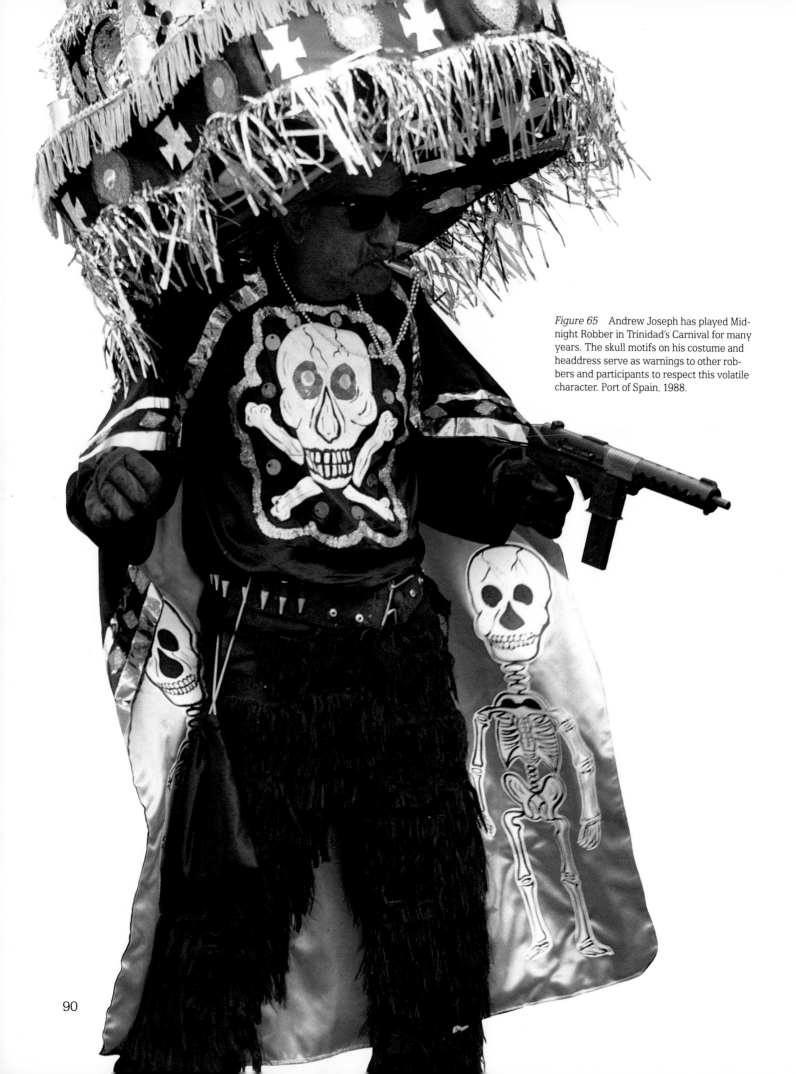

Figure 65 Andrew Joseph has played Midnight Robber in Trinidad's Carnival for many years. The skull motifs on his costume and headdress serve as warnings to other robbers and participants to respect this volatile character. Port of Spain, 1988.

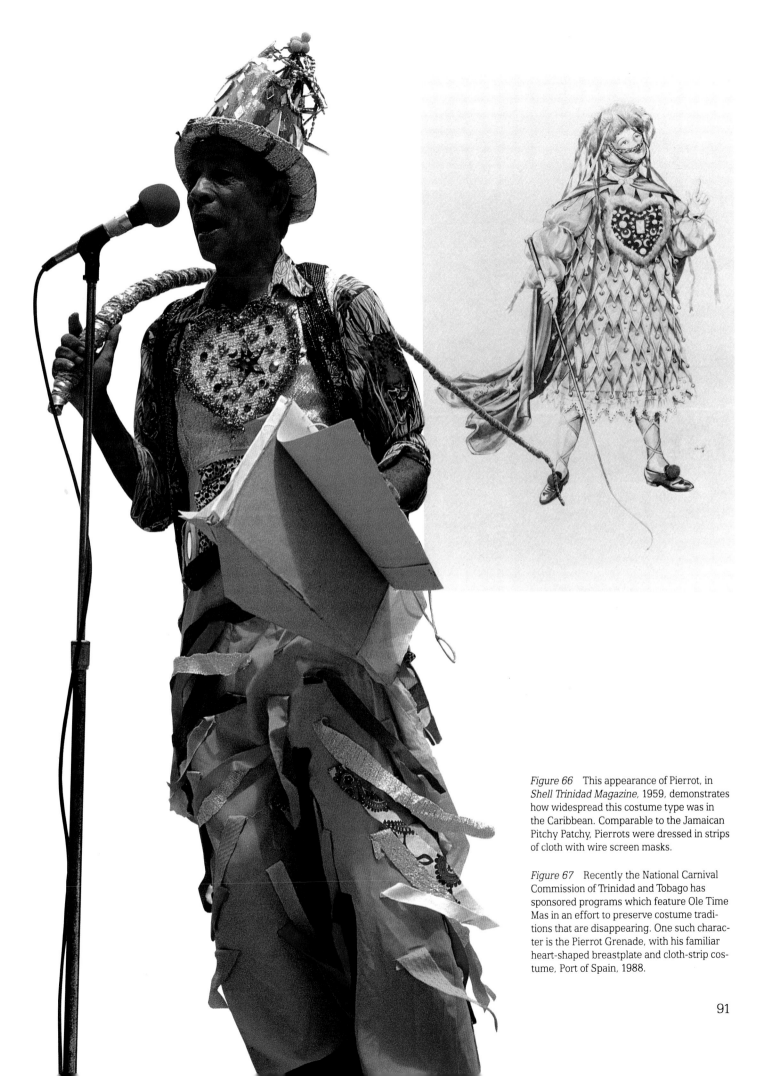

Figure 66 This appearance of Pierrot, in *Shell Trinidad Magazine,* 1959, demonstrates how widespread this costume type was in the Caribbean. Comparable to the Jamaican Pitchy Patchy, Pierrots were dressed in strips of cloth with wire screen masks.

Figure 67 Recently the National Carnival Commission of Trinidad and Tobago has sponsored programs which feature Ole Time Mas in an effort to preserve costume traditions that are disappearing. One such character is the Pierrot Grenade, with his familiar heart-shaped breastplate and cloth-strip costume, Port of Spain, 1988.

sources suggest that the origin of the term is probably Mumbo Jumbo, a Manding phrase, from West Africa.[7]

Although Moco Jombie, or variations thereof, is still found in the Caribbean, the appellation and the practice of stilt dancing reached the Caribbean from distinct African traditions: the phrase Mumbo Jumbo is from West Africa; the name Moko is a Kongo word referring to a doctor or curer;[8] and stilt dancing is ubiquitous to the continent. In Trinidad, only a few stilt maskers remain, but the tradition is still strong in other parts of the Caribbean (*Figure 69*). In contemporary United States vernacular, the term connotes "utter confusion" or "silliness," although by dictionary definition Mumbo Jumbo is a magician who protects his people from evil.[9]

Another traditional character of Trinidad Carnival, the Pierrot Grenade, is probably historically analogous to the Jamaican Jack-in-the-Green in its evolution from vegetal to cloth form. On a purely visual level, it is strongly reminiscent of the Jamaican Pitchy Patchy. His costume was made of old oat bags and numerous strips of colored cloth (*see Figure 66*). Attached to this were bits of odds and ends. He sometimes wore an old hat adorned with shrubbery, or simply tied his head with a colored handkerchief. Formerly his mask either was of wire screen or was an "earth mould mask shaped to amuse."[10] Pierrot Grenade often carried a five-foot stick or branch.

Pierrot Grenades frequently appeared in pairs, just like Pitchy Patchies. They pranced and twirled around, advancing rapidly forward and backward. Traditionally, each Pierrot Grenade had his own territory, which he protected both verbally and physically. Since he often satirized local events and individuals, his identity had to be kept secret. In consequence, his voice was invariably disguised, being low and gruff. Articulate on any subject, Pierrots demonstrated their knowledge and spelling abilities before the crowds as they competed with one another. By the 1950s, Pierrot Grenade had almost disappeared from Trinidad Carnival celebrations (*see Figure 67*). He was eventually replaced by the Midnight Robber who, in baggy pants and fancy shirt, forced his victims to turn over their possessions (*see Figure 65*). Though both characters are rarely seen in Carnival now, one still finds them manifested in Kings and individual masqueraders. Mancrab and the Merry Monarch by Peter Minshall, and Tarantula by Teddy Eustace, derive from these early costumes.

Obeah, the African medicinal system, is often a theme of Carnival bands in Trinidad. *Obeah* objects include skulls, bones, shells, and feathers, the same materials used in African masking traditions. Often bands with *Obeah* themes make costumes with skull motifs and fiber skirts reminiscent of African masquerade dress. Double lightning motifs, such as scepters, are held by masqueraders, a tantalizing reference to the scepter carvings dedicated to the Yoruba god Shango (*see Figure 70*). Those ghosts, demons, wild beasts, and wilder Africans[12] once observed by travelers and colonists have taken on an identity clearly Trinidadian.

Band leaders and costume designers have paid more attention to African sources since Trinidad's Independence in 1962, consciously attempting to link the older African tradition with the creolized one in the Americas. The results have been spectacular. The Callaloo King costume of Peter Minshall's 1984 band makes the point (*see Figure 9*). Its twenty-foot-high superstructure is a reinterpretation of masks of the Dogon peoples of Mali and the Mossi of Borkino Faso. Its open-work

Figure 68 Moco Jumbie character of 1919 in Port of Spain, recalling the African heritage of Carnival.

Figure 69 The costume character Moco Jumbie is found throughout the West Indies and more recently in the metropoles to which Caribbean peoples have migrated. In 1988 in Trinidad, this Moco Jumbie took part in an Ole Mas performance.

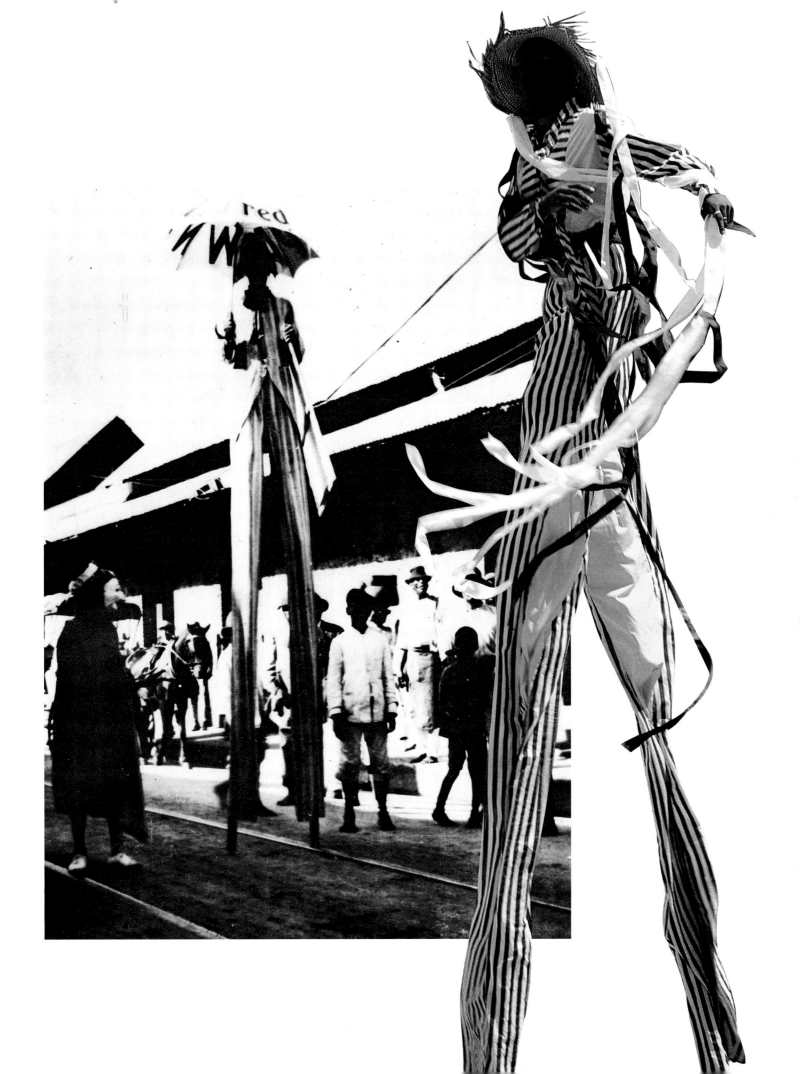

patterns recall carved African prototypes. The rectangular objects on the King's body suit represent amulets, again of African origin. In the masquerade context, magic amulets and the mask itself defend Callaloo against evil. Another King costume illustrating African links was made in 1984; it incorporated contemporary masks sold to tourists in West African markets. A giant version of the African headdress from the Bamana people of Mali—the Chi Wara or antelope mask—has been used in costumes. The source for the motif was probably an African art book. These images have caught the imagination of designers who, like their African counterparts, make the objects dance and move. Every year bands produce African tribal themes and incorporate body paint, coiffures, and shields, all derived from African traditions depicted in books *(Figure 71)*. Contemporary African sources continue to shape the masquerade mix-up.

Figure 70 This section of the 1983 band Rain Forest depicts the climate of the region, commonly subject to thunderstorms. The twin lightning bolts of the standards recall Shango scepters, forming part of the paraphernalia used by Shango worshippers in Trinidad.

Figure 71 Members of this 1983 band express the African heritage in Trinidad. The flaring crested coiffure is an African hairstyle the designer adapted for this band.

Figure 72 The design of this King/Queen from Carnival 1987 was influenced by the wheeled *tadjahs* paraded on the streets of Port of Spain during the Hosay Festival. The incorporation of wheels in costumes has allowed artists to increase the size of their costumes.

Asian influences have had an impact on Carnival through Islamic and Hindu festivals. With the introduction of wheeled Kings and Queens, borrowed from the East Indian Hosay festival, the costumes grew in scale, allowing large *tadjah* structures to be reproduced *(Figure 72)*. Mosque forms also have appeared in masquerade headpieces, like those in the 1983 band River. Influenced by the powerful dancing of the Hosay moon dancers, the crescent-shaped object of this tradition has been adapted by several designers. Most recently in a children's band called Liming, designed by Richard Bartholomew, one section called Hosay Liming included a costume with a moon. Fancy Sailors known for their ithyphallic-nosed headpieces have at times used the elephant trunk shape for the nose. Elephant masks representing *ganesha* are very popular in the Trinidadian festival of *Ramlil*. The *tassa* drum of East Indian Islamic origin is a regular feature of Carnival as well.

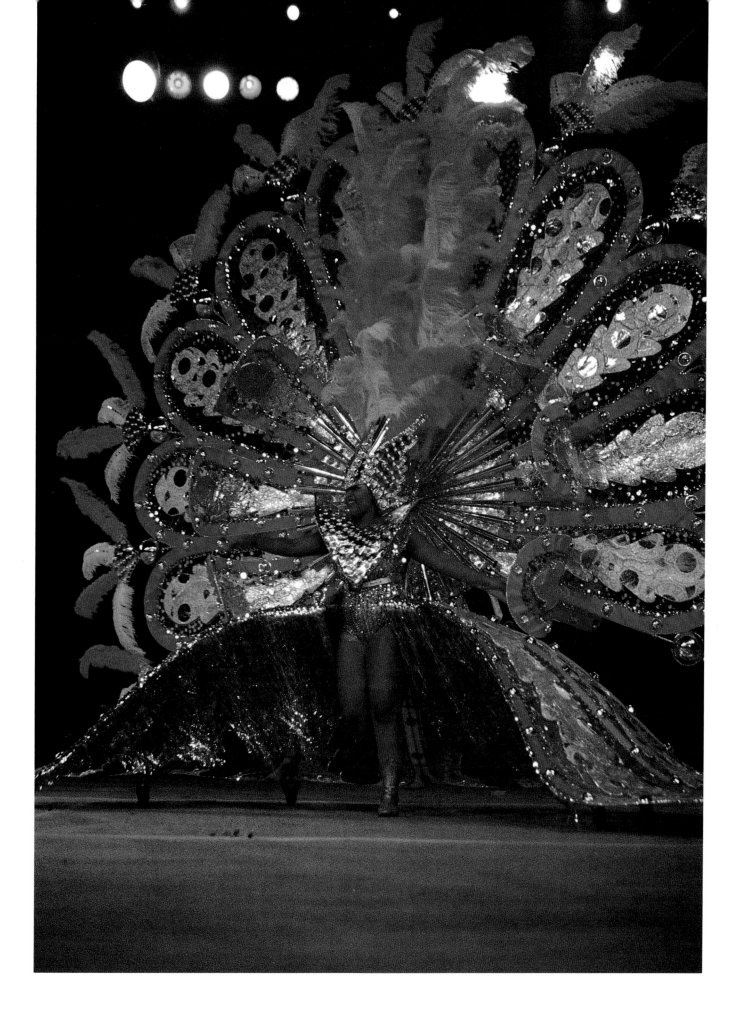

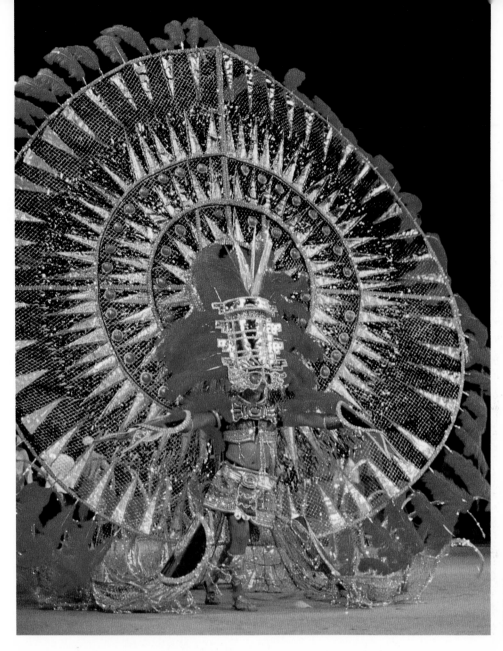

Figure 73 This 1983 King, The Sun King of Eldorado from the band Pomp of the Potentates, represents a Pre-Columbian ruler, indicated by his breast plate, skirt, and headdress, all derived from Aztec costumes.

Motifs from other cultures contribute to the diversity as well. Pre-Columbian motifs include the Rain God, Chac or Tlaloc, and the Plumed Serpent, Quetzalcoatl, both high-ranking deities in Mayan and Aztec religions. Returning from service on cruise ships, Trinidadians also brought back photos of the ancient monuments of Yucatan, Mexico, where images of these gods are carved upon the facades of the great ruins. Interest stirred by this experience was further fed by historical sources *(Figure 73)*.

Adjunct to the Pre-Columbian sources are that of the Amerindian, a costume type found in most festivals; black Trinidadians first dressed as the indigenous Carib and Arawak Indians who came to Port of Spain to trade. Although the earliest photographs of the Amerindian character date from 1908 and 1909, Charles Day noted their appearance in Trinidad Carnival in 1848.[13] He said that Spanish workers, themselves part Indian, would daub themselves with red ochre and personify the Indians from neighboring South America, complete with quiver and bow. By the end of the nineteenth century, the image of the North American Indian had replaced that of the nearly extinct indigenous people. By 1909, in a competition sponsored

by the La India rum shop, an Amerindian masquerade band from the Belmont neighborhood won first place, and other Amerindian bands won again in 1910 and 1911.[14]

The evolution of the Amerindian masquerade tradition has continued in Trinidad. Carniff Bomparte has been involved in Amerindian masking since the 1920s and has led both Fancy and Authentic Indian bands since at least 1961. He is still one of Trinidad's most important band leaders. By the 1960s the Amerindian band was so popular that the Carnival Development Committee established the competition categories of Fancy and Authentic Indian, the former distinguished by fantastic headgear and the latter by "true garments, headgear, etc. of any Indian tribe."[15] During the mid-twentieth century, the Red Indian Masquerade was played by half-Indian peons who were seasonal laborers from South America.[16]

Today the great bands of Lionel Jagessar of San Fernando (*Figure 74*) and Bomparte's bands of Port of Spain specialize in costumes of authentic and fancy Indians. Thus the spirits of the original settlers return each year to Carnival. With particular dancing steps and call-and-response lyrics—more common several years ago than today—they resemble the Mardi Gras Black Indians of New Orleans.

In the 1920s and 30s, Hollywood films influenced masquerade bands. The Three Musketeers, the Mummies of Tutankhamen's Tomb, and the Gladiators produced by Errol Hill were presented between 1928 and 1938.[17] During this period the Wild

Figure 74 This Queen contestant from 1987 Carnival, designed by Lionel Jagessar and Rosemary Carew, reveals the extent to which fantasy Indian designs have been developed.

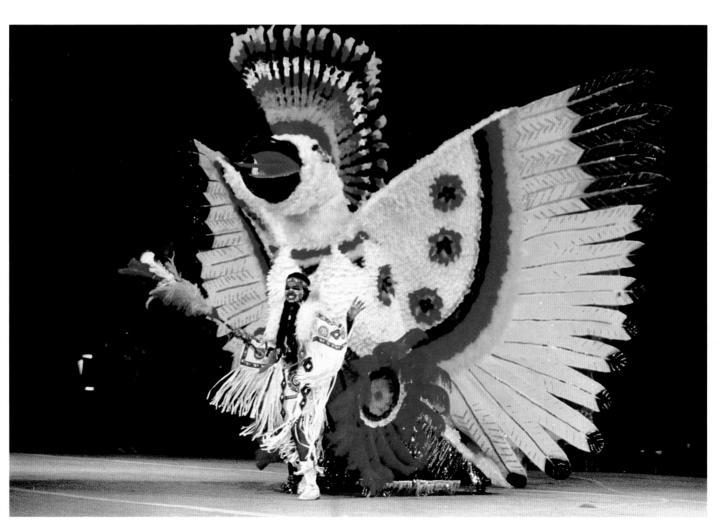

Indian costumes were modeled after those in cowboy films and comic books. Although Carnival was banned during World War II, the presence of American sailors and Seabees stationed at the naval base outside Port of Spain had a profound impact on Jason Griffith, who has since designed sailor costumes, including the wild, scruffy, fancy, extraterrestrial, and Nipponese. After the war, Carnival bands burst back upon the streets, reaching new heights of membership. Themes from films like *Quo Vadis, Samson and Delilah* and *Imperial Rome 44 B.C. to A.D. 96* were produced by Harrold Saldenah, who introduced section bands and bare legs.[18]

The physical surroundings are also great sources of Carnival costume themes and motifs. The red ibis and tropical parrot are among the favorites. Of a haunting quality are the flora and fauna expanded in scale in the costume arts of Hilton Cox. These objects are overpoweringly surreal, exemplified by his giant crayfish of 1981 *(Figure 75)*. Highly colored butterflies, framed by the rich tropical greens of the rain forest, also capture the attention of band designers, who incorporate images of insects into costumes of all sizes *(Figure 76)*.

Besides drawing on all these sources, band leaders and designers watch other bands and buy videotapes of the festival. Viewing these tapes after Carnival, they consider what worked and what did not, often gaining inspiration from the designs of their contemporaries. Drawing upon the historical past, the coexistence of diverse cultural traditions, and the wide-ranging subjects of publications and broadcasts, designers have made Carnival a Masquerade Mix-up, a Callaloo of global dimensions.

Figure 75 The giant crayfish by Hilton Cox from 1981 illustrates the artist's continued interest in the animal world.

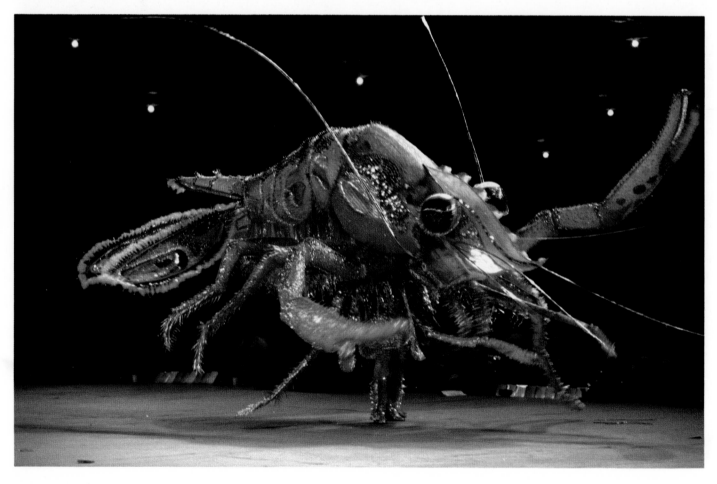

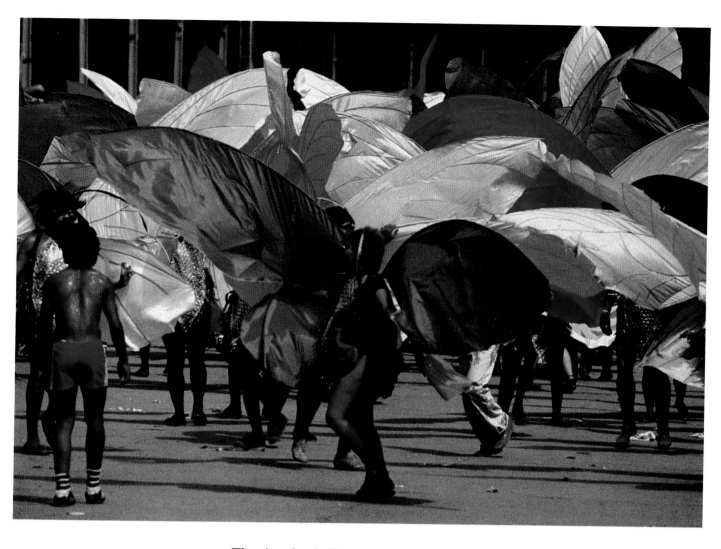

The Aesthetic Force

Figure 76 A section of Peter Minshall's 1982 band entitled Papillon, in which over 2000 butterflies performed. With moving force, Minshall explored the fragility of life.

Carnival feeds upon the principles of assimilation and assemblage. Old World African and Hindu shamanistic religions played significant roles in shaping this aesthetic. In such religions, foreign deities are easily absorbed. Since all things have spirits, the shaman artists controlled or interpreted the animistic world by reorganizing objects into what one calls works of art. These objects in turn reorganize human experience, lifting it to ecstatic states. Manufactured items simply extended the African artist's resources. Thus Christmas tree light bulbs, plastic flowers, and bottle caps are used to make art. The same artistic process occurs in Caribbean countries, particularly in Trinidad, where fiberglass poles, styrofoam, beads, bones, beach balls, rubber fish, and other materials are employed in costume design.

Within the aesthetic of assimilation, color is emphasized with high-affect, richly polychromed schemes. Mirrors attached to costumes enhance reflection. Texture too is important, with large sections of smooth, fuzzy, sticky, soft, and hard surfaces, often all on the same costume. Scale is a quality of itself, for designers continue to build bigger and bigger King and Queen costumes. To accomplish this new scale, poles are attached to the body, increasing the supporting armature to which materials can be added. The result is a fan-like shape.

Bands also absorb current ideas. In a 1987 children's band called R.I.P. Robber, several sections addressed issues including bankruptcy due to the decline in oil prices, disarmament, drugs, and a protest to the way in which wealthier nations

take what they want from Caribbean culture. This section featured several dancers with television headpieces and a larger individual costume with a huge satellite dish on its shoulders, symbolizing the way in which North Americans appropriate Carnival and broadcast it for profit. Less poignantly, a 1983 children's band called Once Upon a Burger featured giant french fries, milkshakes, ice cream cones, hot dogs, and mustard containers—fast food dancing to the festival beat.

Texture, color, scale, and topical concepts all fit into the aesthetics of assimilation. Each masquerade band, however, has its own special appeal, its little piece of difference. It connects one's view of the universe with that of the right masquerade band.

Band Leaders and Bands

Edmond and Lil Hart

During 1984 Carnival, two expatriate Trinidadian women from Miami were among the guests at Stephen and Elsie Lee Heung's *mas* camp. Asked if they were playing *mas,* they whispered, "Yes, but with Edmond Hart," explaining that his costumes showed more of the female body. "Less is more" was apparently the guiding principle. The sensuality centered on the female form extended to the Harts' selection of colors and the stylistic arrangement of each section of their bands which move in undulating soft curves of color that intensify and recede. Impres-

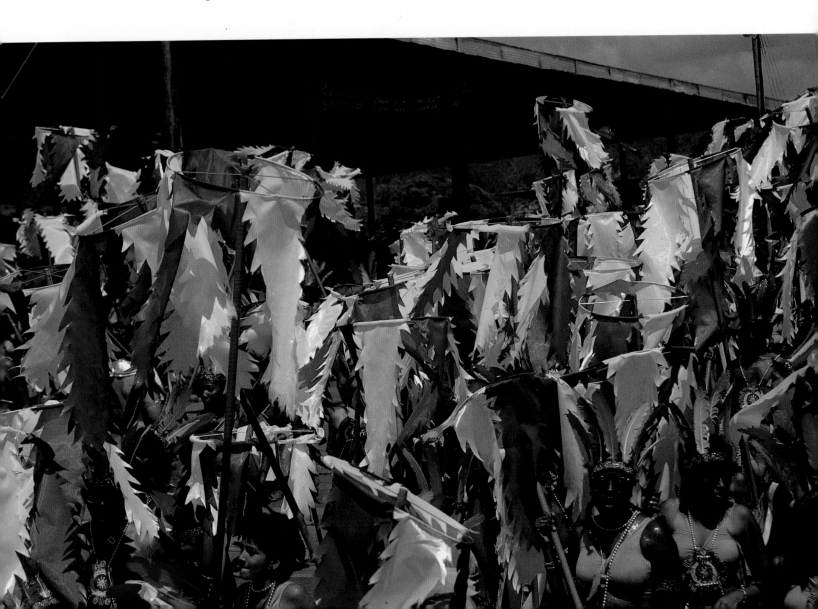

Figure 77 This band section, from Edmond and Lil Hart's 1984 band Tribes, depicted the indigenous inhabitants of the land, the Arawaks and Caribs.

sionistic waves of color, moving curved outlines, and the female form combined to effect the Harts' success.

Their 1981 band, Waves of Color, included hula girls, a girl in every port, and Caribbean Callalou (Callaloo). Callaloo girls, according to one observer, are "livelier, lovelier, and of course, just one more special port in Hart's international voyage."[19] The beauty of the female form was made metaphor in Waves of Color.

Lil Hart is primarily responsible for design and color selection. In the 1986 band Islands in the Sun, she used colors to suggest each Caribbean island's unique character. As Jamaica is the land of springs, its color was shimmering silver; the deep blue waters of Antigua provided its color; the nutmeg of Grenada gave it yellow-brown; Tobago was assigned blue-green for the waters of its popular snorkeling and diving spot, Bucco Reef; and Haiti, stark red and white for its ties to African-based *vodoun* and the deities Shango and Ogun.[20]

The Harts emphasize color by varying the elevation of band sections. To achieve the wave-like action, the accent hue of sections alternates from low to high positions *(Figure 77)*. The *mas* band Tribes of 1984, which contained four thousand people in twenty-three sections, used this arrangement. The front line consisted of individual performers in fancy costumes with synthetic fiber skirts of brilliant color, followed by pink costumes centered low on the body, and then by green, raised high with banners, blue and orange low on shields, pink, high on standards. One group of

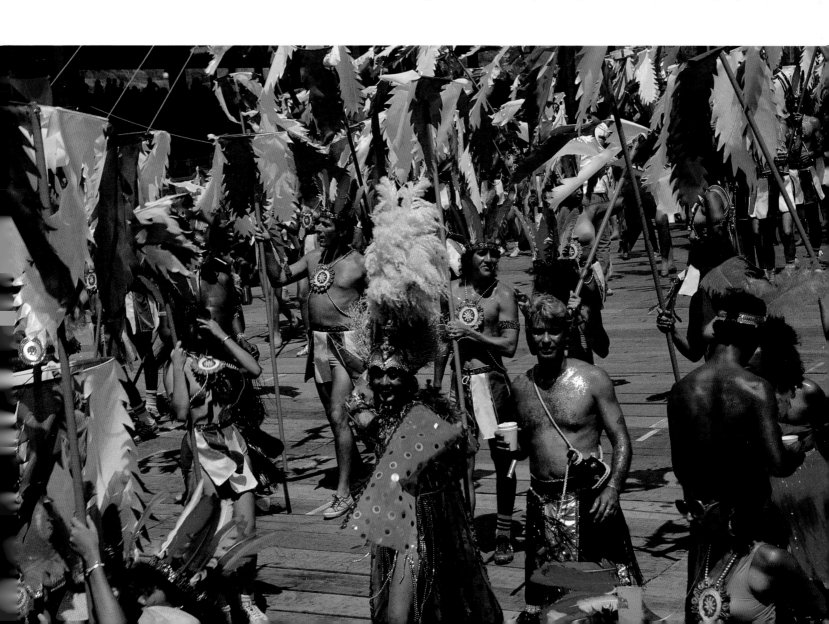

Indians, the Quillancinga tribe of Columbia, swept by in tall sections, carrying streamers in primary colors suspended from beach balls. Then followed the Carib section with massive green standards, and the Arawaks dressed in hot orange costumes with standards of the same color. One Trinidadian critic concluded that this band was simply color, pretty girls, and good times. On the contrary, overriding this superficial criticism is the Harts' commitment to abstract color presentation, and beneath this are the individual performers, the brushstrokes of color whose tropical beauty and feminine form equal the Harts' aesthetic sensibility. Their *joi de vivre* derives from the French part of the Callaloo mix-up.

Jason Griffith

Sailors have been part of Carnival since the nineteenth century. Traditionally, the masqueraders wore long noses in imitation of the English sailor's nose. Since 1949, Jason Griffith and other founders of this group have paraded many kinds of sailors, including sea police, stray sailors, firemen, stokers, drunken sailors, and sea captains. Many uniforms were influenced by the United States Navy, which occupied a base in Port of Spain during World War II. The band moves with sliding steps in a march originated by the West Indian African Regiments stationed on the island in the early nineteenth century.

Griffith's sailor band consists of experienced persons who are well disciplined and pay attention to detail. The themes of the band usually center on travel. In 1984, the band called Extra-Terrestrial Voyage featured two thousand individuals in twenty-four sections, including Stray Sailors, Flying Saucer Sailors, and Launch Pad Columbia spaceship costumes. The 1985 band treated the subject of oceanic exploration.

Beneath the regimented appearance of Griffith's bands runs a strong commitment to individualism. Though sailors buy their headdresses from the *mas* camps, they make their own pants, shirts, and jackets, and each year these parts of the costumes are further embellished with mirrors, sequins, bottle caps, photographs, medals, and naval badges. The result is a well-coordinated band of individuals *(Figure 78)*.

Dancers in one section of Extra-Terrestrial Voyage wore Sputnik-styled headdresses decorated with plumage and glass bulbs. These lost sailor-cosmonauts happened to land in Mexico. Below the Russian space vehicle, the face of the Mayan rain god Chac appeared. Keith Lovelace, who comes from generations of sailor maskers, designed a section for Griffith's Oceanic Exploration which plumbed the depths of the surreal. His dead sailor section included members who wore large coral-shaped shoulder pieces that flared outward three feet. In the center of each was the skull of a sailor. Fishnet covering this section contained model fish and other sea life. A deep-sea diver in heavy canvas suit, steel headpiece, and air hose searched for the bodies of the missing, while dancing to the *soca* beat. As Keith explained it, "Dead sailor is sick, sick ting [thing] E boss e bad." It was too bad it was so good.[21]

The driving force of Griffith's band is the combination of the exotic-surreal themes expressed in headdresses and personal treatment of the body costumes—everyone marches together as sailors, while the unconscious explores the theme of the band.

Figure 78 These performers are members of Jason Griffith's 1988 fancy sailor band, Mystical and Legendary Voyages of Old Fashioned Sailors. These characters are known for the elaborate decoration on their pants and shirts. This sailor carries talcum powder, which he liberally showers on his own face as well as on those of other sailors. His companion carries a corn cob pipe in memory of the old time sailor bands.

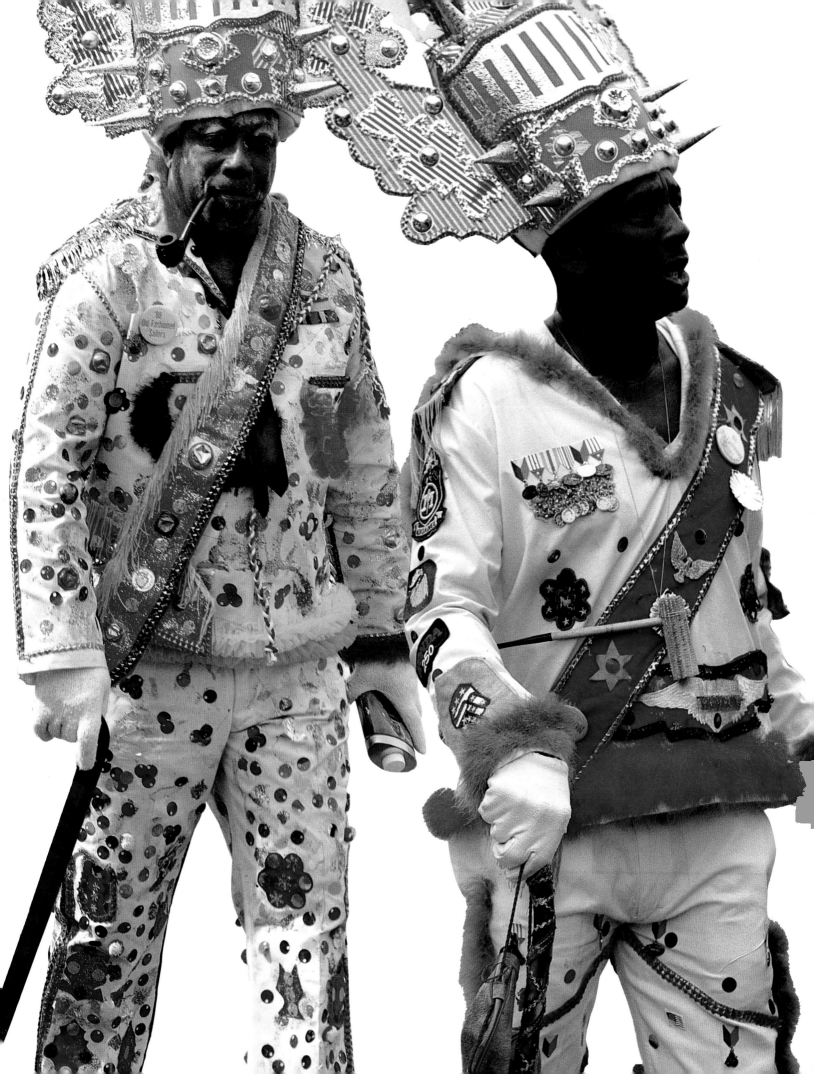

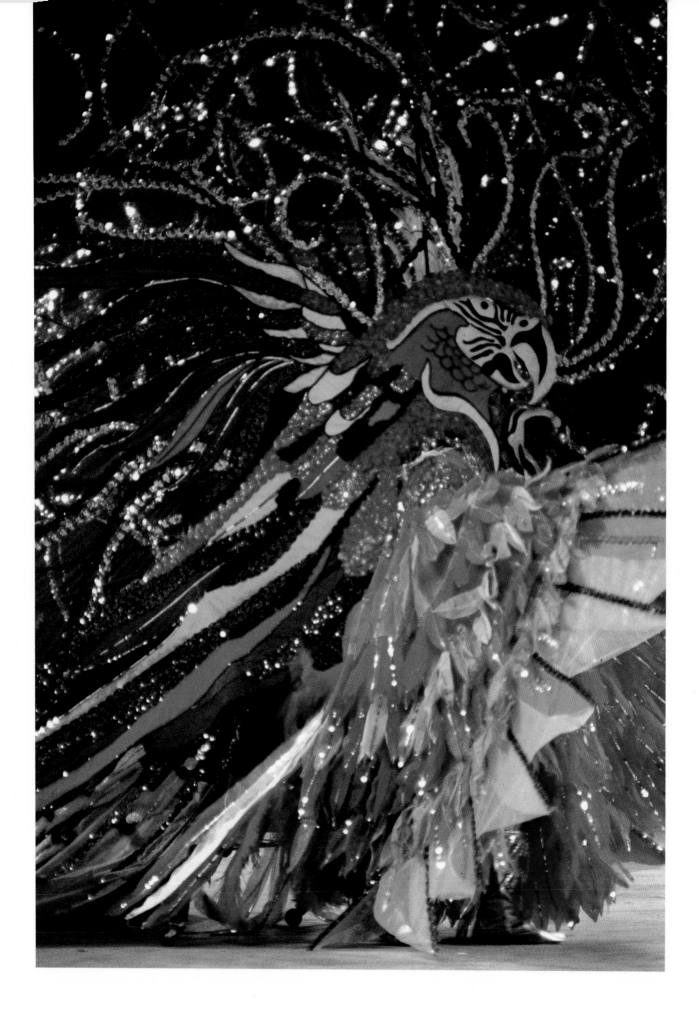

Stephen and Elsie Lee Heung and Wayne Berkeley

The aesthetic of the Lee Heungs may be characterized as delicate, refined, complex, and precise. For many years, the group has hired Wayne Berkeley to design Kings and Queens and band sections. Before this collaboration, Elsie and Stephen's first large-scale band of 1964, called Japan, the Land of the Kabuki, included Japanese costumes with intricate brocade. The couple researched costume design at the Japanese Embassy and interviewed a Japanese captain hospitalized in Port of Spain.

The Rain Forest band of 1983 featured the Queen Diana, Goddess of the Hunt, played by Elsie and designed by Berkeley *(Figure 79)*. The costume had a bent wire substructure decorated with thousands of sequins and other synthetic materials in pale blues and greens. The large structures on each side could be moved like bird wings. One wing portrayed a red ibis and the other a parrot. The branch-like curvilinear forms of the wings served as a tree-filled background for the birds. The rest of the band also portrayed the environment, with a section entitled Morning Mist, wherein participants carried green and white palms. A section carrying scepters with double lightning bolts, one of masquerading suns, and other sections portraying the flora, fauna, and climate of the rain forest completed the theme.

The ingenious manner in which the Rain Forest band transformed the landscape of Port of Spain required imagination of the purest sort. Berkeley showed these skills in his band, A la Carte, of 1975. Its twenty sections of maskers imitated corn on the cob, cocktails, hors d'oeuvres, gin and coconut, salt and pepper shakers, crêpe suzettes, turkey and cranberry sauce, champagne and caviar, crème de menthe frappé, game with mushrooms, and fruit cocktail. The city became a moveable feast, a visual commentary on the real feasting of Mardi Gras. In other efforts the Lee Heung team has carefully researched all aspects of a selected theme to produce the best combination of sections.

The Lee Heung-Berkeley bands attract old, middle-aged, and young followers of all backgrounds. It has produced younger artists like Sean DeFreitas, who in 1987 created a Junior Band with the King Warlord of the Planets. The mask of this costume showed that DeFreitas has the same concern for craftsmanship as Berkeley, his teacher; the headpiece was made with hundreds of sequins, rhinestones, beads, and feathers *(Figure 80)*. Loyal supporters from New York, London, and Toronto return to Carnival to play Lee Heung every year. Lee Heung costumes transform their wearers. "If you're a bird, you're a bird," said Elsie. "If you're Diana, you suddenly become Diana."[22]

Peter Minshall

Peter Minshall's bands attract supporters who identify with the struggle of good and evil, political allegory, and issues such as war and environmental pollution. Each year he weaves motion, theater, and costume together.

Motion is a prime concern in all Minshall's designs. This reflects his interest in Ole Time Mas costumes which, unlike the larger ones of today, move and shake to the music. The serpent costume in the band Paradise Lost moved on poles attached to the ankles and under the thighs. In this way the dancing of the legs directly transferred to the snake form. The Queen's costume in Minshall's 1978 band Phases of the Moon broke where the poles were attached to the dancer's hips. Undaunted,

Figure 79 Diana, Goddess of the Hunt, designed by Wayne Berkeley, was Queen of Carnival 1983. The costume featured a macaw on one side and a red ibis on the other.

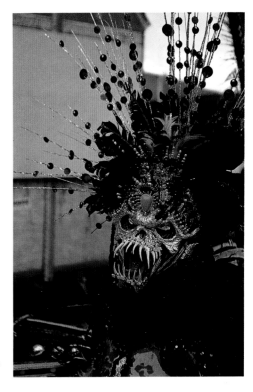

Figure 80 This 1987 Junior King costume entitled Dragon, the Supreme Evil Force of the Galaxy, was designed by Sean DeFreitas. As a student of Wayne Berkeley, DeFreitas combines intricate designs with attention to detail.

the dancer picked up the poles and waved them like flags. The crowd roared its approval, and since then Minshall has been a strong advocate of movement. The Mancrab is another study in motion; as the four poles attached to the legs of King Peter Samuel moved to his dancing, the satin sheet attached to the poles above registered that movement, which was compounded by the wind. The arms of the creature also moved up and down to the beat of *tassa* drums. The dancer jumped on the stage and moved side to side, imitating the motion of the crab. Minshall's King Callaloo was even more successful in this respect; since it was a lighter costume, the King jumped higher off the stage, with the glittering wing-like construction constantly changing, giving the impression that the masquerader was walking on water.

"It's a whole incredible kinetic form . . . it is not mechanical, it is alive," Minshall said. "You can't put Carnival costumes in a museum. Some designs yes. The ideal record for Carnival would be a film library . . . people moving."[23]

Each year Minshall pits good against evil—the Mancrab and Washerwoman in 1983, Callaloo against Madam Hiroshima in 1984, and King Rat of the band Rat Race Versus the People in 1986. Death also is a persistent theme in Minshall's productions. His Papillon band of 1982 included large individual butterfly costumes with portraits of Che Guevera, Marilyn Monroe, and the harbinger of death, the Ayatollah Khomeini, on the wings *(Figure 81)*. Skulls, prevalent in his work, appeared on his gigantic Midnight Robber and Merry Monarch Kings *(Figure 82)*. Death also is dramatically prefigured in his atomic bomb siren, Madam Hiroshima of 1984, and the protest version, which demonstrated in Washington, D.C. on the fortieth anniversary of the bombing of Hiroshima. In this version, the skull face of the demon was flanked by a globe in one hand and missile scepter in the other. To reinforce the death theme, Minshall draws from the traditional Midnight Robber costumes which often displayed a skull on the headpiece. He also draws inspiration from the painter, Francis Bacon. The Mancrab, for instance, demonstrated the horrifying danger of pollution and its deathly consequences in Bacon's style.

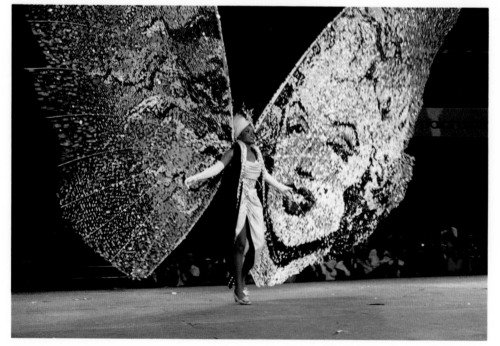

Figure 81 Marilyn Monroe from Peter Minshall's band Papillon. Here the artist combines an image of the actress derived from Andy Warhol with a hairstyle depicted in the artist Sandro Botticelli's *The Birth of Venus*. Blending Renaissance and modern in *mas* dynamically expresses the aesthetics of Callaloo.

Figure 82 The 1987 King of Carnival, The Merry Monarch, is yet another of artist Peter Minshall's treatments of the themes of life and death. Here he draws upon the old *mas* character Pierrot Grenade, whose costume was made of strips of cloth, and the Midnight Robber, with the incorporation of the skull.

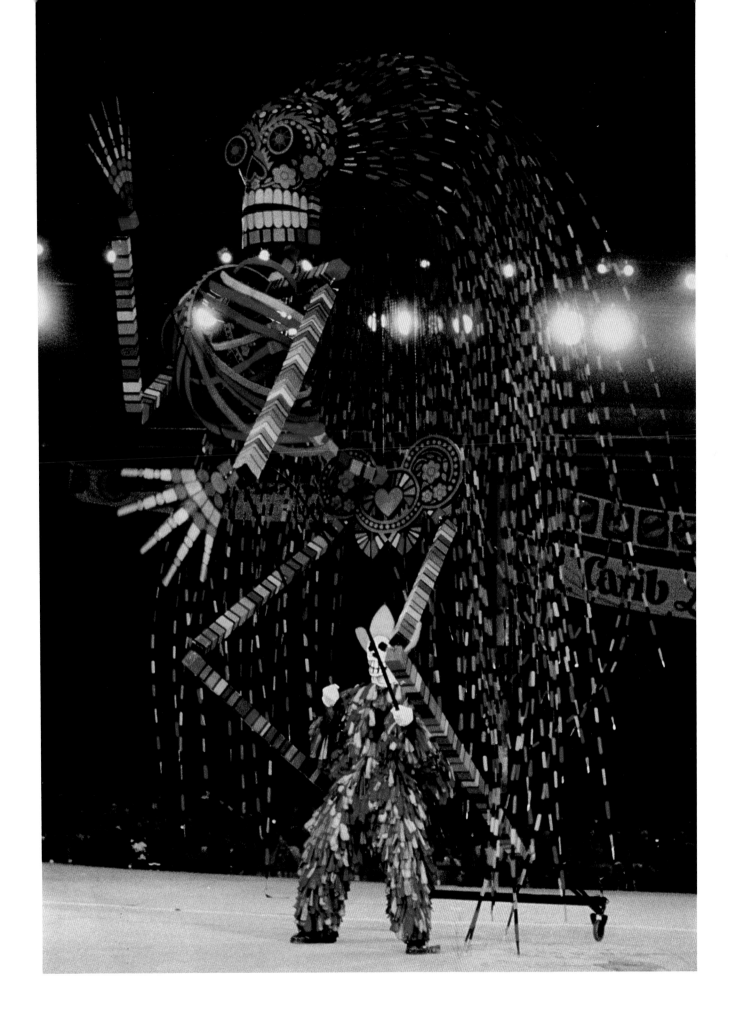

Striving for theatrical effect and asserting that *mas* is theater, Minshall creates what one might call two-act bands. The River band that introduced a trilogy best illustrates the point. The Queen Washerwoman danced on the stage to a gently rolling *soca*, washing the clothes of her people on a washboard. Their clean clothes hung on lines suspended over her head. Each night the Mancrab performed its threatening dance. On Monday of Mardi Gras, the Queen danced across the stage, as did the band sections. Each section formed a tributary to the main river represented by a twenty-five foot wide, half-mile long stretched nylon canopy held on poles over the entire band. The pure waters represented by each section converged in The River above the heads of the participants.

Act Two opened on Tuesday with the parade of Mancrab, his blood-stained shroud, and the dead Queen with her clothes soaked in red. The half-mile river canopy had become a polychrome river, indicating pollution. It was a stunning change. The three thousand-member band reached the Savannah at around 5:30 that afternoon. First, sixteen black priestesses mounted the stage, carrying calabashes. Facing one side of the stands, the priestesses very slowly lifted the calabashes over their heads. Suddenly, they tipped the sacred containers and out poured red bloody liquid, staining their pure white costumes with the pollution of the Crab. They had sold out the environment after the death of their Queen. The dead Queen was carried onto the stage while Mancrab entered in victorious dance, issuing red umbilicus from his gut to symbolize the birth to a new dark age. The tributary sections then crowded together on stage, where compressors of paint doused all with color. Everyone helped the Crab celebrate the destruction of the environment. The costumes, motion, and theater had given the Minshall view to all who would embrace it.

Today, Carnival is big business. Peter Minshall's 1981 band, Jungle Fever, could be taken as an example. It was produced by the Zodiac Committee, a limited liability company consisting of a restaurateur, a broadcasting producer, an accountant, an advertiser, a salesman, and a graphic artist. Shares in the company were offered as a registration fee to participants. The Canadian Imperial Bank of Commerce was elected as the banker, and checks made out to the production staff had to be signed by two members of the Committee. On December 6, 1980, the *mas* launching was held on French Street and the sale of shares was a success, allowing for immediate production.

To create the twenty-five hundred costumes for the band, eight different venues were rented; fifteen seamstresses, twenty-five painters and decorators were employed; and numerous volunteers were promised free costumes. Everyone could indulge in an endless supply of pizza, chicken and chips, Chinese food, cold beer and other drinks. The King's costume, Tiger, Tiger, Burning Bright, which measured fifteen by twenty feet, glittered with 220,000 handstitched sequins.

Wayne Berkeley, one of the Carnival's best designers, takes an entrepreneurial attitude toward masquerade building. "By a process of observation, you discover that some people are particularly neat, so you put them to work with sequins."[24] Such use of labor would have met the approval of Adam Smith. Wayne's five years in banking sharpened his organizational skills and contributed to the success of his bands. Another artist, Ken Morris from Belmont, switched from molding costumes of papier-mâché after World War II to melting down brass flower pots and working

Figure 83 These *mas* men belong to the section River Gods, part of the Port of Spain River band of 1983. Designed and executed by Ken Morris, these superb centurions, dressed in copper armor and carrying African-style masks, compare with the repoussé work the artist is noted for in his public sculptures.

them into shields and breastplates *(Figure 83)*. Currently, he runs a full-time business specializing in copper gilded in silver and gold.[25] He also receives private and public commissions. Large bands designed by Berkeley, the Harts, the Lee Heungs, and Garib have used equal quantities of goods and equally large production staffs. The vast quantities of materials, the demand for imported goods, and the size of the bands demand a business approach, an economy of scale to masquerade production and its aesthetic reward.

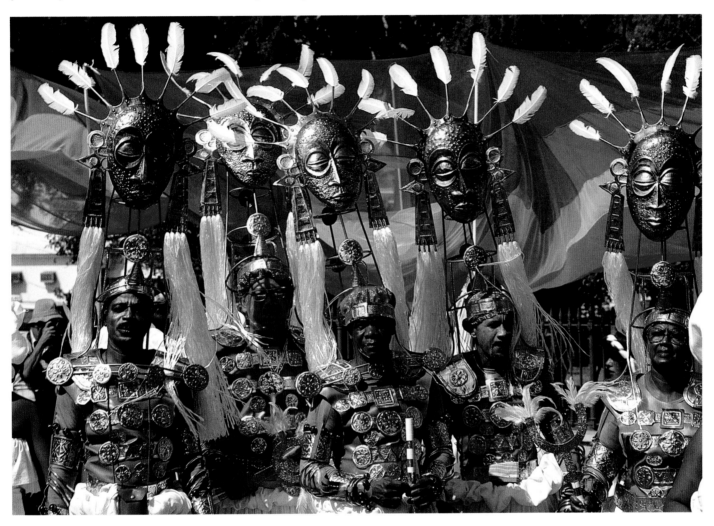

History

That diverse aesthetic origins and thematic conceptions of the *mas* bands derive virtually from around the world is in itself remarkable. More astonishing is the fact that festival arts are organized along sound business practices inherited from the colonial past. Not surprisingly, this combination of aesthetic diversity and business has emerged against a background of a complex social history.

Trinidad and Tobago were inhabited by indigenous Caribbean Indians, the Warahuns, Arawaks, and Caribs *(see Figure 84)*. After Columbus landed there in 1498, the Spanish occupied the territory, controlling it until the colony was transferred to the British in 1797. Short of manpower, the first colonists encouraged the French, with their black slaves, to open new plantations.[26] Englishmen also settled, eventually becoming the dominant European group.

Figure 84 Although nearly extinct by the end of the nineteenth century, the Carib Indians live on in Carnival; from the beginning, participants have worn costumes imitating these fierce tribesmen.

During the first third of the nineteenth century, Carnival was the monopoly of the white creole establishment. The masquerade costumes were of European origin, based on French high court costume designs and English mumming *(see Figure 11)*. House to house visiting, street promenading, practical joking, and small musical bands completed European Carnival, characterized by gentility and what might be termed the Fancy aesthetic.

Little is known about the culture the African slave brought to Trinidad. Though Africans were not permitted to participate in Carnival, slaves probably performed before their masters, as in Jamaica. A dramatic event for the slaves was extinguishing fires on the cane plantations. On such occasions, they carried torches, sang, and marched to the fields in what became known as *canboulay,* from *cannes brulées.*

At Emancipation in 1838, there were some 22,359 slaves and children of slaves on the island, the first of whom were from the Cameroons and the Kingdom of Benin; the latter were called the Moco people.[27] Emancipation profoundly changed the character of Carnival. Though British philanthropy played a role in passing this act, there were certainly economic considerations. Influential leaders such as James Stephen, the Under-Secretary at the Colonial Office, and Lord John Russell,

who became the Colonial Secretary in 1839, encouraged "properly colonized" Africans to migrate to the British West Indies. The two colonies among the British territorial holdings that supplied such an enlightened labor force were Sierra Leone and St. Helena.[28]

The first ship of repatriated slaves from Sierra Leone arrived in Port of Spain on May 9, 1841, with one hundred eighty-one passengers. They had been educated by the Church Missionary Society and the Methodist Missionary Society, and were therefore considered properly trained for the task of improving life on the islands. Subsequent immigrants, however, were not so well acculturated. Increasing numbers of older repatriated Africans in Freetown, Sierra Leone resisted the call for the West Indies; it was the slave who had but six weeks of repatriation in the Queens Yard there who arrived in Trinidad. By 1861, 6,501 such persons had settled on the island. Many African immigrants lived in the Belmont area in northeast Port of Spain, where in the twentieth century Dahomian descendants still worshipped their own gods. In 1858, a Yoruba village grew along the Eastern Main Road. During this period, an African-based therapeutic system known as *obeah* was established.[29]

Worship of the Yoruba deities Shango and Ogun, and traditions from various masquerades came to Trinidad from the Yoruba, and later from repatriated Yorubas from Sierra Leone.[30] An 1845 description of Carnival compares to descriptions of Sierra Leone masquerades of the same period.

Figure 85 A 1919 Carnival band featuring devil bats and a Midnight Robber with skull. In old time Carnival, band members carried chains to keep onlookers away. The chains may allude to slavery.

Now we observe the Swiss peasant, in holiday trim, accompanied by his fair Dulcima—now companies of Spanish, Italians, and Brazilians glide along in varied steps and graceful dance . . . But what see we now?—goblins and ghosts, fiends, beasts and frightful birds—wild men—wild Indians and wilder Africans.[31]

The appearance of ghosts, beasts, and frightful birds *(see Figure 85)* signals the presence of the Fierce aesthetic, similar to the aesthetics of Roots Jonkonnu. Both aesthetics are emphasized in African masquerades. By 1847, masquerades including pirates, Highlanders, Turks, Death, cavalry, infantry, and Indians were played by "peons of Spanish-Amerindian descent."[32]

As Port of Spain swelled with African, Chinese, and East Indian immigrants, Carnival reflected the cultural mix of Trinidad. The lower classes who lived in long barrack ranges behind the city blocks formed yard bands; they danced, sang, and practiced stick fighting, derived from the *canboulay* and the East Indian and West African versions of that sport. These fringe members and gangs, as the press labeled them, had counterparts in turn-of-the-century Freetown. Band members on both sides of the Atlantic boasted of their bravery, verbal wit, drumming, and indifference to law.[33] That new forms of Carnival expression merged in dense black urban settlements is not surprising, as the phenomenon occurred in the Deep South or Kro Jimi area of East Freetown, Sierra Leone, where the crisply drawn grid of the town dissolved into a network of paths, symbolic of African tribal, economic, and kinship networks. Some of the greatest masquerade societies of Sierra Leone have their origins in this Freetown neighborhood.[34]

With the emergence of stick fighting, transvestism, and such sexual masking as the *Pisse en lit* bands, who wore transparent nightgowns and carried menstrual cloths stained with blood, the Victorian upper class withdrew from street Carnival, though it retained the private fancy mask balls *(Figure 86)*. From this time to the end of the nineteenth century, the press generally ridiculed the festival, and from time to time the government sought to control or suppress it.[35]

Newspaper descriptions of masquerades in the 1870s indicated that Carnival was dying, and that many of the mask characters, Fancy and Fierce, were on the decline. In contrast, one report in 1879 cited a float featuring the invasion of Constantinople by Turkish soldiers, complete with fortress and wooden canons. Another report noted a Hosay procession, a party of maypole dancers, schoolgirls, a Venezuelan army, a Chinese couple, a squad of Redcoats, pierrots, and South American Indians. Less acceptable to the Victorian class were the *Pisse en lit* bands, who danced with a rapid shifting side-to-side pelvic motion countered by back and forth movements, all the while singing obscene lyrics.

Though the upper class withdrew from Carnival and the newspapers disapproved of it, a post-emancipation social order was in the making, one which found affective expression in Carnival. As neighborhood bands grew, intense masquerade competition developed. These bands were first formed in the Belmont area, a village of mud and thatched cabins that cradled an African culture. Band participants practiced dancing and drumming, sometimes holding night-long wakes. The early settlers of Belmont called their neighborhood Freetown, in memory of their resettlement in Sierra Leone. In the 1860s, the African secret association-derived bands of Port of Spain took such names as "Mousselins" and "Don't give a damns." A group called "Beka Boys" provoked the wrath of the press with their practice of tossing foul-smelling handkerchiefs into the faces of respectable women and using obscene language.[36] Bands of the same type surfaced in

Figure 86 This 1888 depiction of Carnival by Melton Prior shows how black bands with whiteface masks freely intermixed on Shrove Tuesday. Here devils, prostitutes, minstrels, sailors and the character with an ithyphallic nose derived from Italian Comedia del Arte celebrate together. Bladders filled with water and tethered to sticks were used to hit passersby. Though absent from present-day Carnival, this practice is still found in the Dominican Republic.

early twentieth-century Freetown, the Foot-A-Backers, and A-Burn-Ams, the latter referring to cigarette smoking.[37] Once again, masquerade dress, music, and dance were forging a new cultural base from complex migrations, linking Trinidad fast to Africa.

Port of Spain bands of 1871 included True Blues, Danois, Maribones, Black Ball, Golden City, Alice, and D'jamettes. The male Maribones wore red shirts, white trousers with blue waistbands colored with red, white, and blue, and a Foulah band around each knee, in the *negre jardin* style. Female characters wore trousers to the knee, short red jackets over blouses, aprons, and sailor hats. Each female carried a wooden hatchet painted to resemble the scepter or dance wand used by Shango devotees. Musical ensembles consisted of a small drum, toms-toms, and a triangle. In 1877 there were twelve or more large bands in the city with such names as Bakers, Danois (Danes), Cinnamon Bark (*Peau de Canelle*), and Kites (*Cerf-Volants*). Competition among these bands pointed to the vigorous tradition Carnival was taking on.[38] Several times in the early 1880s the government tried to suppress it, but the festival as a symbol of liberty could not be stopped.[39]

The Carnival Riots of 1881 marked a turning point for the festival. On February 27, 1881, Captain Baker, an Irishman with a stubborn vein, intercepted a group of masqueraders with a group of his soldiers. A woman shouted: "Messieurs, Cap'n Baker au coin laure avec tous l'hommes" [Captain Baker and all his men are at the corner].[40] A battle took place, as the police tried to extinguish the celebrants' torches. By the time it ended, the street was a sea of bottles and smashed glass, and several police and Carnival participants were seriously injured, though no one was killed. "Lay of Canboulay" describes the riot:

> Then down at once the flambeaux went,
> And staves and sticks they drew,
> And in and out and all about
> The stones and bottles flew;
> Hotter and hotter the battle raged
> Till near the break of day;
> Full many a head and many a lamp
> Were cracked in the affray.[41]

By 3 a.m., believing they had crushed the rebellion, the police returned to the barracks to celebrate. Then the Governor of the Colony made a surprising move. On the following day he admitted, "I did not know you attached so much importance to your masquerade." He gave permission for Carnival to begin and ordered the police confined to barracks for the duration of the festival. Thus Carnival survived despite the efforts of colonial authority and the wishes of the upper class.

Stick fighting and *Canboulay* were banned from Carnival by 1885, in accord with the taste of the upper classes who had again begun to participate in the street masquerades.[42] They reintroduced pre-1838 traditions, emphasizing Fancy Dress. With the exception of some East Indian classes, Carnival began to work its magic in all quarters.

> Today it has become a cement of society: its ritualized excitements, the deep competitive feeling of the bands, the blend of tradition and novelty, the saturnalian release of emotions, smother for a time divisions within the body politic and provide an invaluable catharsis for all.[43]

Only a decade before, Carnival had been reduced to a rowdy festival of the urban lower class.

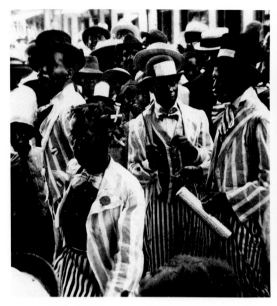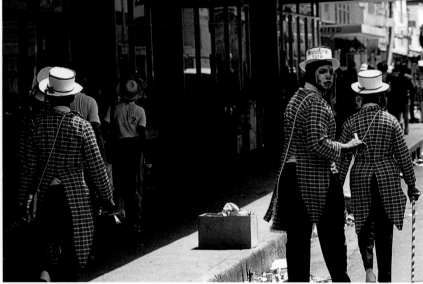

Music

Initially, Carnival music was of European origin, with minstrel bands and court music *(Figures 87 & 88)*. Liberated Africans and slaves introduced drumming and the rhythms of the "chac-chac" (shak-shak) and "toms-toms" (drums) from the homeland, but upper classes condemned this loud disruptive music. From this music would evolve the internationally recognized calypso and steel bands. By the late 1890s performers sang Latin melodies, accompanied by the guitar and chac-chac. The first calypso to be fully sung in English was by Norman le Blanc. Its lyric commentary addressed the abolition of the Borough Council. One verse reads:

Figure 87 This 1919 photograph reveals the popularity of minstrels in early Carnival. One of the members of this band carries a cylindrical metal instrument which, when stroked with a baton, emitted a scraping sound. The scraper is widely dispersed in the West Indies.

Figure 88 Several minstrels representing *Ole Mas* strolling down Frederick Street, Port of Spain in 1983.

> Jerningham the Governor
> Jerningham the Governor
> I say is fastness in you
> To break the laws of Borough Council[44]

From such lyrics rose later and more elaborate calypsos by performers like the Mighty Sparrow, who commented on the British Queen's unannounced visitor in 1982.

> Phillip my dear, last night I thought was you in here
> Where did you go, working for good old England
> Missing out all the action, my dear
> Do you know, there was a man in meh bedroom
> Wearing your shoes
> Trying on royal costume dipping in royal perfume
> Ah telling you true, there was a man in meh bedroom
> Anxious for a rendezvous, and I thought it was you.
>
> CHORUS
>
> He big just like you, but younger
> He thick just like you, but stronger
> He lingay like you but harder
> He lay-lay like you but badder
> A man in meh bedroom
> And I took him for you.[45]

Some of the lower class played music on tambor bamboo drums (like Haitian *vaccines*) and later on "found" instruments, including tin kettles, salt-boxes, biscuit tins, paint containers and kerosene cans, all forerunners of the fifty-five-gallon oil drums of the post-World War II period which were the genesis of the steel bands *(Figure 89)*. The metal artifacts of European manufacture produced new sounds of different timbres and pitches that rhythmically recall those of native African drum ensembles. At a *fête* in the St. Anne neighborhood of Port of Spain in 1984, one of the *soca* ensemble percussionists played two used automobile brake drums that were attached to long pipes planted in the ground *(see Figure 90)*. The highly percussive, rhythmic cadence from this variation of the double gong sounded similar to the Freetown *aggogoo* of West Africa, an instrument consisting of a pair of cowbells attached to the belts of milo jazz music players. Double gongs of various forms are used extensively throughout the Caribbean.

Today the influence of calypso music and *soca* (soul-calypso) spreads with the masquerade. Composer David Rudder is a lead singer with a contemporary Calypso group named Charlie's Roots. Rudder characterizes the new generation in his ability to call on untapped traditions, appealing to new audiences as well as the old. "Bahia Girl" is a calypso that tells of one man's search for African roots through a woman of Bahia, a Brazilian city rich in African heritage. Both woman and city symbolize mother Africa. Throughout the song, chanting backs the chorus. Rudder

Figure 89 Steel band in London, 1951 demonstrates that where steel band music became established in Caribbean communities, *mas* soon followed.

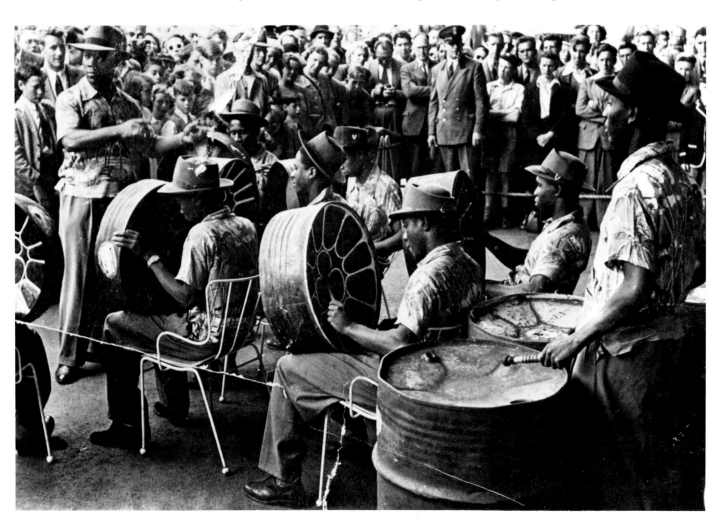

Figure 90 A small Jouvay band plays brake drums on the streets of Port of Spain in 1987.

Figure 91 At the center of the great masquerade bands are the workshops or *mas* camps, where teamwork and organization spell the difference between winning and losing. Established in the last decade, the D'Midas Camp, pictured here in 1988, produced the band Clash of Cultures in 1984.

explained that the chant was drawn from his childhood experiences in the Shouters Church, a Baptist sect with roots in the Trinidadian version of the Shango cult.[46] The Yoruba chant as they prepare for Shango procession. Rudder has integrated the ancient chant into modern music, recreating the power of Shango. It is not uncommon for dancers at Rudder's concerts to become possessed by the sound of "Bahia Gyal."

The development of the steel band, or pan, was central to the growth of Carnival during the post-World War II period and continues to be a unifying force of the festival. The history of pan can be traced from Emancipation, when people of African descent appropriated Carnival and substituted their own music based on sounds of their homeland. This music was always subject to restrictions of government, which was intimidated by the power of the music and its potential for creating a great social force. By 1883 a ban on drums went into effect, but bamboo cylinders replaced them. Based on the Shango drum ensemble, these instruments were of three types, each with a distinctive pitch. Tambour bamboo drumming accompanied the masquerades until the 1930s when young people sought a stronger, louder sound. Scraps of iron, car parts, metal boxes, and dustbins were incorporated into percussion ensembles that satisfied the new musical mood.[47]

The search for new and even more affective sounds in 1948 led to the incorporation of the fifty-five-gallon gasoline oil drum in the bands. Its unique qualities and availability made it very popular and it soon replaced all other instruments. Steel bands adapted well; they played virtually everything from classical European music to calypso and the fox trot. In 1951 a national band toured England. Its success caused the proliferation of steel band groups and formal competitions.[48] Today bands like the Renegades, Invaders, Desperadoes, Pamberi, Phase II Casablanca, Trinidad All Stars, and Samaroo Jets supply the music that is the spirit of Carnival in what is clearly an important musical innovation of the twentieth century.

The forces of the bands which make up Carnival have grown within a national history in which cultural clash, rebellion, liberation, and African heritage were most important. Drawing upon many stylistic and thematic possibilities, Trinidadian artists have produced massive artistic displays based on sound business principles *(Figure 91)*. The differences between these bands inspire competition and unabashed criticism, while composing a general aesthetic of diversity, a Callaloo mix. That aesthetic is based on the principle of individuality in community—the resolution of contrasts in community and, more remotely, the cultural clashes of the past. This aesthetic fusion liberates *mas,* deploying its energy through the individual and the social body simultaneously. Herein lies the magic of Carnival, its mystery. Geoffrey Holder has correctly summarized the experience: "Carnival costumes are the ultimate symbols of liberation"[49]—the liberation of Everyman.

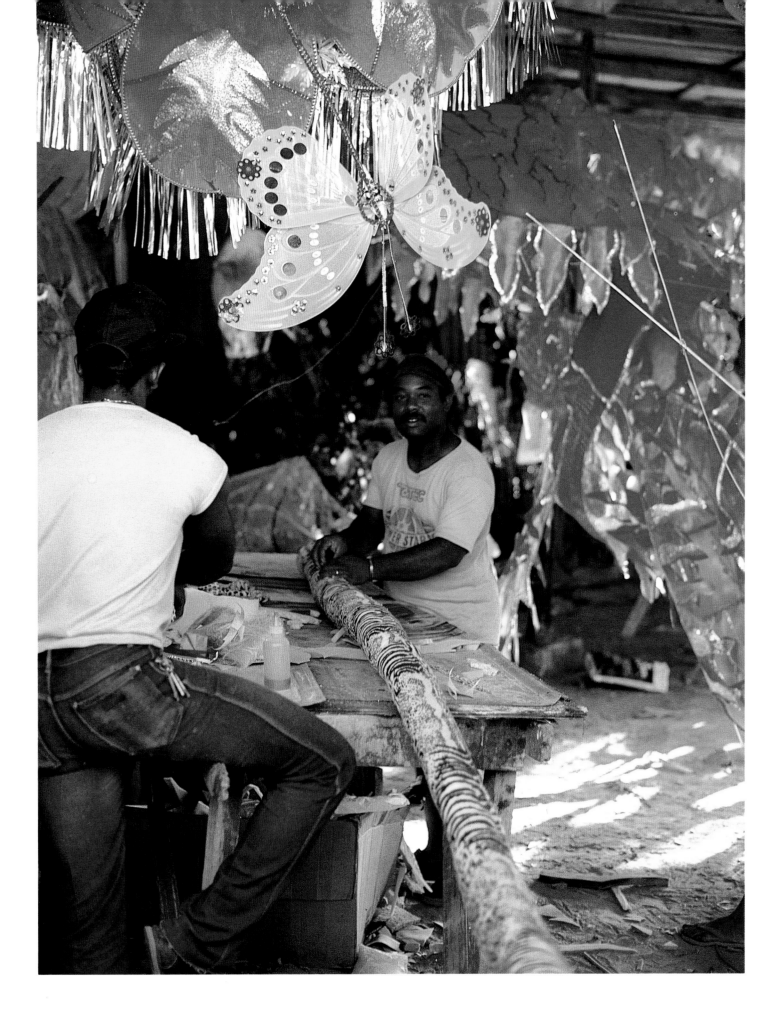

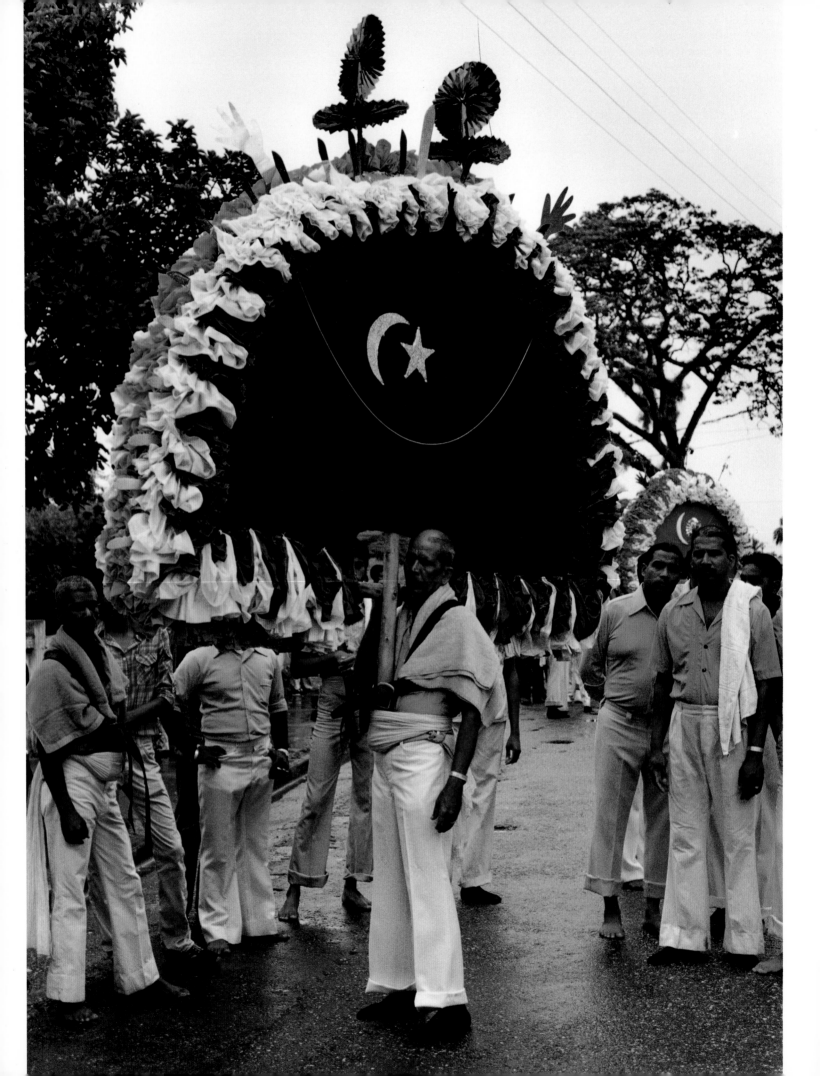

Judith Bettelheim
John Nunley

4

The Hosay Festival

On September 15, 1986, the celebration of Hosay in Port of Spain, Trinidad was ending[1] *(Figure 92)*. Muslim participants, exhausted by the weight of the ritual objects they had carried about for days, stared light-headedly into the distance. The people had quieted down as prayers were offered in front of the moons. The air was slightly cooled now that the sun had moved past its highest point. One elder, dressed in a suit with a gold and blue striped tie, proudly explained how his people, the East Indians and their descendants in Trinidad, had triumphed after many hardships. When Queen Victoria gave permission to Trinidadian East Indians in 1863 to carry their sacred moon objects onto the Queen's Royal College grounds, she granted the festival of the country's newest migrants recognition and status that endure to this day. That September day, the sacred Hasan and Husain moons again rested on the college grounds, confirming that recognition. At 3:30 p.m. dancers raised the objects to their shoulders and circled to the chant of Hosay, Hosay, Hosay, Hosay! The ancient chant echoed from the battle of Karbala, through the historical currents of Trinidad and into the future.

The dancers led the procession back to the St. James neighborhood, where East Indian traditions still thrive, where the festival had begun. Despite ten days of fasting and a long journey with a heavy load, the dancers found the strength to return. Their sacrifice mirrors the price Old World peoples paid when they were brought to the Americas.

The Hosay Festival is part of the broader celebration of Muharram, the first month of the Muslim year. Imam Husain was the second son of Ali and Fatima, the daughter of the prophet Mohammed.[2] His elder brother Hasan was forced to abdicate as the fifth caliph, and at Hasan's death (some believe he was poisoned), Husain attempted to reinstate his family's rule. He led his supporters in a revolt

Figure 92 The moon of Hasan carried by Bato Ali of Port of Spain for the last time in 1980. Weakened by cancer, Mr. Ali continued to attend the festival through 1986 and died in January 1987. His memory is carried forth by each moon presentation.

against the Umayyad caliphs of Damascas. Husain and his supporters were trapped in the desert at Karbala on their way to Syria.

On the 9th of Muharram the commander of the opposition received notice to declare war, and on the 10th war began. Just before the catastrophe, Husain's daughter Fatima married Hasan's son Kasim, but Kasim was immediately killed in the fighting. Many of the supporters were killed, even the two infant sons of Husain and Hasan. Adding to the tragedy, many died of thirst in the desert. Ultimately Husain was killed. His one surviving son carried his severed head (some accounts also mention that his hands were cut off) as he and the few remaining supporters were led to the Caliph Yazid I. Incidents from Husain's life and the tragedy at Karbala have become part of the dramatic cycle of the Hosay festival.

The festival commemorating this event takes place during the first ten days of Muharram. The martyrdom of Husain is observed differently around the world. In Iran, the celebration centers around the ritual theater or *ta'ziya* dramas, in which both spectators and performers reenact the massacre at Karbala and other incidents in Husain's life. Of special significance is the influence of the practice in India on those in the Caribbean, for in many Caribbean and Caribbean-rim nations, East Indians account for much of the population.

As a result of a late seventeenth-century British trade policy which destroyed parts of the Indian economy, India descended into depression, with mass unemployment.[3] This development was to offer the British a ready supply of contract, or indentured, labor which stemmed the labor shortage in the West Indies that had been caused by the abolition of slavery in 1838 and the flight of former slaves from the sugar plantations *(Figure 93)*.

Figure 93 After the abolition of slavery in 1838, black slaves on the great sugar estates were replaced by indentured laborers, mostly from India.

The exact date when East Indians began arriving varied from country to country; in Jamaica migration started in 1845, in Guyana in 1834, and in Surinam, in 1873. By 1865, between 25,000 and 30,000 East Indians had settled in Trinidad. Almost all of the 36,412 East Indian indentured laborers who arrived in Jamaica between 1845 and 1917 came from North India, and 90 percent were Hindus. Jamaican East

Indians in the 1970s comprised approximately 3.5 percent of the population, about 56,000 individuals, of whom only 2,000 identified themselves as Muslims.[4] In 1917 the British Colonial Office finally took serious interest in the evils of the indentured labor system and abolished it, although their primary concern was not the inhumanity of the system, but rather that World War I had made shipping goods and human beings too dangerous. By the mid-nineteenth century, thousands of East Indians became part of a new racial and cultural reality in the Caribbean, adding to the Euro-African mix. They landed with their own traditions, musical instruments, dress and body ornamentation, and language.[5] By the provisions of indenture, these migrants could pursue their customs legally. Foremost among these customs was the Hosay festival.

Whenever East Indians settled in large numbers in the Caribbean, the Hosay festival followed. While it served a religious need in the community, on the larger scale it united Hindus, Muslims, and others who maintained their East Indian identity. Thus East Indian nationalism became a primary focus of the celebration. As is characteristic of the creolization process, however, the participants adapted Hosay specifically to their environment, Jamaican, Trinidadian, Guyanese or another; though the celebration followed a general pattern, artistic considerations and performances differed, allowing for every little piece of difference.

Thus as early as the 1850s, the Muslim festival of Muharram brought Muslims, Hindus, Afro-Jamaicans, Afro-Trinidadians, Afro-Guyanese, and Afro-Surinamese together in ways that suggest a developing solidarity. "Even the collective response of the larger East Indian group to the Mohammedan festival of Hosein, in which both the Hindus and Muslims participated, began to speak to the ethnic solidarity that was emerging," Noor Kumar Mahabir observed, "especially as getting along on their native ground became increasingly difficult."[6] Dr. Ajai Mansingh, a Hindu leader of the East Indian Jamaican community, said that the festival in the Caribbean mirrors his own childhood in India, where his father took him to Muslim households for special festivities and "similarly Muslims used to come to my father's and my home, both men and women, for readings from our culture."[7]

In Jamaica, as in other locations, differences between Muslim and Hindu became secondary to their new status; they were both suddenly in the minority, but they shared a common heritage—India. East Indian Muslims are much fewer than are the Hindu in the Caribbean, as is the case in India. But both groups celebrate Hosay as an occasion for East Indian national and ethnic identity. In Guyana, the Indo-Guyanese community joined the Afro-Guyanese in celebrating *tadja*, as it is called there.[8] In Trinidad the celebration is called Hosay, and it has developed as a multiethnic affair. Even in India, Hindu participation in the Muharram festival underscores the marginal association of the festival with the death of Husain.[9]

In *Trinidad in Transition*, Donald Wood chronicled the vicissitudes of the celebration, observing that its history in Trinidad is as complicated as in India. Yet the festival has endured, and Wood shed light on its popularity throughout the Caribbean when he wrote,

> Both Carnival and Hosein were processions, and the animation of a march has a more exciting effect on a crowd than a function that takes place in one spot. And perhaps most important of all, each had a strong competitive element in it. In Carnival it was, and still is, the rival bands that compete in the ingenuity of their themes and in the magnificence of their costumes. In Hosein it is the rival taziyas

that compete for admiration, and to be first in the procession or first at the edge of the water. The rivalry of Hosein was between estates and it was the working group and not religion or the same home district which determined the allegiance of those who took part.[10]

The parallels between the Caribbean festivals and those in mother India are clear to this day. In India one can distinguish between the *ta'ziya* of different cities by their styles, and within these there are further varieties. Kept in shrines, the permanent *ta'ziya*, or *zareeh*, are generally made of "wood, ivory, glass, silver, brass and many other materials, often in ornate combinations, inlaid or studded with gems. . ."[11] Every Muharram shrine or *Imambara* has its own *zareeh*. An *Imambara* is a shrine, ranging in size from household to major architectural monument, in honor of the *Imams*. *Ta'ziya* also vary in size. Some can be held in the hand, like the small, one-tiered *menhdi* from Delhi. Others may be twenty feet high. Some are carried on bamboo poles, while others rest on platforms supported on the shoulders of four men.

The *ta'ziya* is basically a replica of the domed tomb of Imam Husain at Karbala. Often it is constructed in three sections, the two lower ones resting on a rectangular base and the top crowned by a domed roof. In some cases it may resemble a multi-storied domed house. A *ta'ziya* from India often resembles an ornate miniature shrine, while others are skeletal structures with tiered sections decreasing in size toward the domed tops *(Figure 94)*. The style of most is the same, but their sizes, details, and materials vary, reflecting the wealth or status of those who built them. One *ta'ziya* in Lucknow in 1960 was constructed of six rectangular tiers with a dome above the sixth level. Revolving on the pinnacle of the dome was a bamboo and paper umbrella,[12] a symbol of royalty in India and Africa, and one of stature and authority in the Americas. Another *ta'ziya* was "about twenty feet in height, with four stories below the dome, each having little windows with green shutters, and small doors that could open and shut, and with little electric bulbs to light the interior."[13]

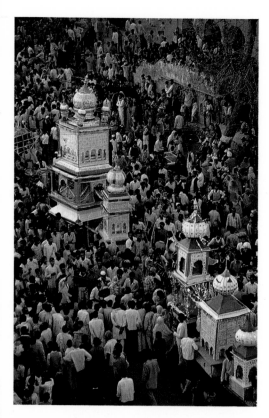

Figure 94 Indian *ta'ziya* from the 1974 Muharram festival in Lucknow, where many migrants to the Caribbean originated. This example, with its four turrets and central dome made of colorful paper, is stylistically similar to those built in Port of Spain.

Depending on its size, the *ta'ziya* can be built from cardboard, bent bamboo frames, or from sugar, like a candy miniature, and it may be covered with any number of materials. The most ornate have metallic decorations, and others are draped with colored scarves and paper. Often tissue paper is cut in filigree patterns, or scroll work on mica is applied, or the *ta'ziya* is covered with glass, plastic bangles and tinsel. In Lucknow, both Hindu and Sunni make *ta'ziya* for sale in the bazaar before Muharram.[14] In the countryside, *ta'ziya* may be made from tree branches and decorated with leaves and flowers. At the end of the Muharram festival, *ta'ziya* are usually dismantled, taken apart, and buried to recall the burial at Karbala. On the coast, celebrants may send their *ta'ziya* out to sea after the festival.

The two most popular colors used on *ta'ziya* are red, for Husain, and green, for his brother Hasan. Often red and green scarves and streamers are hung from the *ta'ziya* structure or are carried on standards during the procession. Other sculptural forms are also carried during the procession and are often set up inside the shrine until the completion of the festival.

Aside from the *ta'ziya*, perhaps the most important replica is the *alam*, a standard with a crest and embroidered banner, a copy of the one carried by Husain and his companions at Karbala. Frequently these feature gold and silver embroidery, tassels, fringe, and occasionally even streamers. In many cases a replica of

the silver crest section of the *alam* appears in celebrations, commonly made from embossed tin or aluminum. The heart-shaped form has an open hand projecting from the top, and the central section is connected to a pole or a stick so it can be carried.[15] The embossed crest may include an image of the tomb at Karbala or the names of Husain and his family.

Besides the *ta'ziya* and the *alam*, participants in the procession may carry other iconographic emblems. The open hand, the *panjtan*, symbolizes the five pure members of the Prophet's family: Muhammed, his son Ali, Ali's wife Fatima, and their sons Husain and Hasan. A depiction of twelve hands represents the twelve Imams. The *qadam-i-rasu* is the footprint of the Prophet, often carried in a coffin-shaped box. The *nal sahib* is a horseshoe from Ali's horse, associated with a large, crescent-shaped object. In fact, the horse is an important and popular motif of these festivals. A horse made from bamboo, covered with paper, and carrying an empty saddle is recognized as Duldul, Husain's steed who returned to the people to announce his master's death. Often Duldul's forehead is smeared with blood. Observers have also seen live horses in military garb parading during Muharram. Another horse image, Buraq, the mystical winged horse of the Prophet, is sometimes included in this repertoire. Yet a third horse image carrying a sort of palanquin or house-like structure is also seen from time to time. Inside the palanquin there may be images of Husain's wife and children, or the structure may be empty, for everyone who sees it understands its symbolism.[16]

Finally there is the *menhdi*, in Delhi a one-tiered *ta'ziya*, in Lucknow "a boat-shaped wooden structure in which bride and groom used to sit in the past while riding a camel. One such structure with a house-like construction in the middle, decorated with paper flowers and paper creepers, was kept by the side of the tazia."[17] Not only did the festival in honor of Imam Husain find a place in the Caribbean, but many of the motifs associated with it have become part of creole aesthetics wherever it is practiced.

Jamaica

Martha Warren Beckwith first researched the Hosay festival in Jamaica, publishing her findings in 1924, just one year after her research on Jamaican Christmas festivals. One man to whom she spoke had come to Jamaica from Lucknow, India, and though he had been a Muslim in India, he was converted to Christianity in Jamaica. As in India, participating in Muharram festivities and paying homage to Husain has less to do with one's specific religious descent than with an ethnic identity that became vital to cultural survival. Beckwith noted that Muslims, Hindus, and East Indian Christians participated in the festival for Husain, and the songs she recorded were all in Hindi. During this time, the festival was under strict local control, and in fact had been banned in Kingston and Savanna la Mar because the competing processions often clashed over territorial right of way.

The most important part of the celebration and procession in Jamaica was the building and parading of the structure commemorating Husain, "the tajeah which is modeled like a temple."[18] Nearly eight feet tall, the *taziyah* was built in three sections and was set on a platform and carried by four men *(Figure 95)*. The lowest section was enclosed, and behind a small door was a model of the graves of two ancestors. Beckwith's informants all agreed that the procession with Hosay struc-

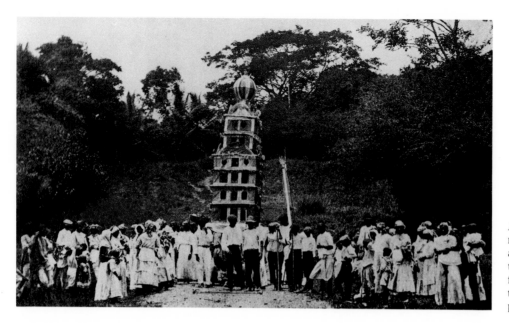

Figure 95 This Hosay procession near Annotto Bay, Jamaica, c. 1922, shows East Indians parading a *taziyah* or a model of the tomb of Imam Husain. In mother India, the festival is part of Muharram celebrations; in the Caribbean, East Indians of many faiths participate as a gesture to ethnic solidarity.

tures occurred on the ninth night after a new moon, but that the month of the festival varied around the island. After an all-night ritual the *taziyah* was paraded on the tenth day to the homes of wealthy patrons, who gave the participants money. "Special pageants are borne in the processions such as a hand on the end of a long pole, a symbol which may also be seen painted upon the side of the Hussay," Beckwith wrote.[19]

Dr. Ajai Mansingh recalled that the first Hosay festival he attended in Jamaica was in 1974. There were in this festival about six *taziyah* all made in the parish of Clarendon,[20] and one was constructed and owned by a black man who appeared to be about seventy years old. Mansingh interviewed an elderly black woman who was there selling sweets. She said she had set up a booth at this same location for every festival since about the turn of the century.

Today in Jamaica, on the first day of Muharram a *chauk* is built, a sacred square of earth where Hindus pray.[21] A prayer is said when the soil is first cut. This area is treated with a sacred paste, and on the Wednesday before the Friday night procession a clay image representing Husain and his brother Hasan is set on the center of the *chauk*. The participants circle the *chauk* five times and place banana leaves on the four corners.[22] While the *taziyah* is being built and the *chauk* consecrated, the male participants must not eat meat, drink alcohol or engage in sexual relations. On the Thursday prior to the large Friday procession, coal and incense are burnt on the *chauk*.

It is on Thursday night that the small, personal *taziyah* are brought out. This outing is called the *manuit*, or individual Hosay, while the Friday celebration is the *panchayati*, or community Hosay. Sometimes, the personal *taziyah* are small enough to be carried on the head, usually protected by a turban. These small *taziyah* often have a conical top and resemble the traditional wedding hats worn by both East Indian Hindus and Muslims. Other Thursday night *taziyah* are fastened to bamboo sticks and carried by hand while illuminated, like the *menhdi* in India.

The Friday night *taziyah* are most often quite large, and are carried by six to ten men, or else they are rolled on a platform. Before this final procession, the participants are offered *malida,* a fried combination of burnt sugar, flour dough, and molasses. Both coal and incense are burned, and the procession departs to the beat of the *dhol,* a *tassa* drum, and a set of *jhanj,* or metal cymbals.

124

As part of the Hosay performance during Carifesta 1976 celebrations in Westmoreland, Jamaica, a man and a woman in street clothes performed a stick fight. Formerly during the ten-day festival before the Friday night procession, there was singing and reading from the Koran. Today, since there is rarely a devout Muslim who can read the Koran, men and women gather to sing songs of praise for the dead. Dr. Mansingh commented that many Jamaican participants no longer knew the historical origins of the celebrations, but that they take part because it is something that East Indians do or something that they enjoy. At the end of the Friday night procession the *taziyah* are destroyed or sent out to sea on a nearby river.

In Jamaica today the Hosay festival is enjoying a renaissance. One important reason may well be the Seaga government's promotion of cultural pluralism, giving greater recognition to ethnic minorities of which the East Indian population is the nation's largest.

Guyana

Tadja has been outlawed in Guyana since the 1930s, on the grounds that it "did not encourage good public order."[23] It does not exist today as a major festival. It is, however, of historical importance.

In 1883, H. V. P. Bronkhurst published the most extensive report on Hosay festivals in Guyana. By then the festival was regularly observed on almost every estate. Bronkhurst's descriptions of the *tadja* resemble ones from India and the Caribbean, for he said they were made from "precious metals and bamboo, and are papered inside and out with costly and tinselled paper . . ."[24] *(Figure 96)*. He also described other paraphernalia used in the celebration. This is the only nineteenth-century report of the festival in the Americas discovered to date. In Guyana it seems the participants carried the *alams* in the processions, as well as the *nal sahib*, the *Rast-hath* [sic], or hand with five fingers, and the *Purmesht-ug* [sic], or symbolic handful of sand.

In Guyana, Hindus and Muslims often clashed, especially when Muharram coincided with the Hindu celebration of Dasserah or Durga Pujah. Then the two groups of festival participants vied for control of major streets, and passersby would get caught up in the conflict. Even *tadja* groups from different estates competed with one another for the right of way. As was the case in other Caribbean nations, the conflict was not directed by one ethnic group specifically at another; rather the competitive spirit permeated the festival itself. By 1883 Bronkhurst could write that, "The black native population on the different plantations seem to be getting as fond of the annual show as the Coolies themselves are, and they follow the gaudily-dressed temples in thousands . . ."[25]

He also documented several Afro-Guyanese-originated *tadja* and creole processions. The festival was so popular that "respectable Creoles and European planters not only countenance these festivals by their presence, but also give the immigrants large presents and then encourage them in their wickedness."[26] The abolition of slavery, the arrival of indentured laborers, and the increasingly centralized government in Guyana brought greater regulation of street festivals. From 1892 on, the celebration of *tadja* on the estates could only occur with permission from and the supervision of a local magistrate. In 1925 the law was changed so that local police, rather than a magistrate, might give permission for the celebration. By the

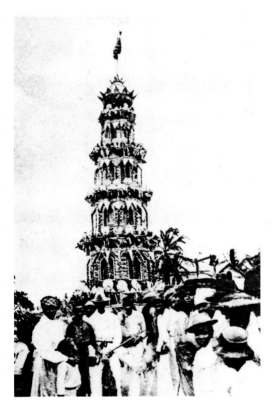

Figure 96 A Hosay procession, with both Blacks and East Indians, in Georgetown, Guyana, 1907. This particular *tadja* is decorated with tinsel, foil, and colored paper.

1920s the *tadja* festival had become so secularized that even rum shop owners became patrons with the aim of stimulating business.[27] In light of the still growing East Indian population in Guyana, the possibility of a renaissance of the *tadja* festival must not be ruled out.

Figure 97 Indian migrants in late nineteenth-century Trinidad dressed in accordance with native traditions. Their determination to maintain cultural traditions ensured the survival of Hosay in the West Indies.

Trinidad

The celebration of Hosay began in Trinidad during the 1850s. Indentured East Indians who first made the voyage worked the great sugar plantations of southern Trinidad, called the Deep South *(Figure 97)*. The status of the new laborers was hardly better than that of the black slaves who had preceded them, but by the terms of indentureship, the newly landed laborer could anticipate his freedom from the plantation and the opportunity to start his own life and business.

Though work hours on the Trinidadian plantations were fixed by law, production quotas could be raised to force laborers to work faster in the same period of time. Initially, the recruitment of male laborers was preferred, and in many instances, women stayed behind and waited for their husbands to return with riches.[28] Men either married outside the East Indian community, which they rarely did, or waited in the hope that more women would arrive. Robert Guppy, a lawyer who settled in Diego Martin, Trinidad and who once owned a plantation, wrote of living conditions there in 1888:

> The barrack is a long, wooden building 11 or 12 feet wide, containing perhaps 8 or 10 small rooms divided from each other by wooden partitions not reaching to the roof . . . All noises and talking and smell pass through the open space, from one end of the barrack to the other. There are no places for cooking, no latrines. The men and women, boys and girls go together into the canes or bush when nature requires. Comfort, privacy and decency are impossible.[29]

The first Hosay procession most likely was held in 1850, on the Philipine Estate south of San Fernando.[30] The spectacle of the *tadjah*, fueled by the powerful staccato sound of the sun-dried clay *tassa* drums, the low slapping blows of the large, wooden bass drums and the holy chants mourning Husain and Hasan, lifted participants to ecstatic states, an experience that contrasted sharply to their daily lives. Once the Hosay processions began in Trinidad, stopping them was beyond the power of the British colonial authority. In 1859, there were boisterous parades in Port of Spain, and competitions took place between estates in which not only East Indians, but also "Creoles and Chinese went to the help of their workmates; loyalties to the estate transcended those of race in the fighting."[31] By the late 1850s Afro-Trinidadians began to participate in the processions as drummers or as *tadjah* bearers.

The sacrifice of Husain and Hasan paralleled the experiences of the East Indian laborers in Trinidad, who saw their brothers die on board the ships or on the plantations. The hardships they endured brought these men to an undeniable conviction: in the midst of their religious and caste differences, they were all East Indians. The festival became a national statement in a land of many nationalities.

The early Hosay celebrations in Trinidad also required economic sacrifices to build festival objects, many of which were twice the size of present-day versions *(Figure 98)*. To cover expenses estate owners often took up collections on payday.[32] Then a few craftsmen and helpers purchased colored paper, tinsel, and pieces of glass to embellish the objects.

During the 1870s, increasing ethnic rivalries, declining sugar prices, and a continuing influx of East Indians to Trinidad strained the relationship between the British and their subjects to the point of actual rebellion. By 1881, about one third of the nation's population was of East Indian origin. Symbolizing as it did the ethnic voice of the East Indians, the Hosay festival became the focus of white colonialists' fears. At the approach of each celebration the colonialists grew anxious, for they believed that the festival could threaten law and order and colonial rule itself. Finally an ordinance passed in July of 1884 banned Hosay from public roads. A Hindu leader named Sookoo responded by quickly assembling twenty-one Hindus and eleven Muslims from twenty-six estates to prepare a petition for repealing the restrictions. When the petition was denied, Sookoo exclaimed, "I can only die once, I cannot die twice. Mutiny, there will be mutiny."[33]

Anticipating the worst, the government ordered the police in Port of Spain at the St. James barracks to prepare for trouble, besides alerting police in the towns of San Fernando, Couva and St. Joseph. In addition, the H.M.S. Dido was anchored off the coast of San Fernando and marines from the ship prepared to go on duty at Princetown. Meanwhile, Hosay participants and what British authorities called "Carnival thugs," who were armed with knives and sticks, carried their *tadjah* towards San Fernando, the *tassa* drums booming out the rhythm of solidarity. On the last day of the festival, October 30, 1884, the Justice of the Peace, Arthur Child, met the crowds outside San Fernando and asked them to return to their estates. In defiance, they shouted Hosay! Hosay! At Child's order, the police fired. The stunned celebrants threw down the *tadjah* and fled, leaving four dead and fifty wounded. A later confrontation at the Mon Repos entrance to San Fernando resulted in the deaths of twelve and wounding of one hundred.[34]

The 1884 rebellion was too weak to withstand British force; Hosay festivals were successfully contained without incident from 1885 to 1900. Despite this suppres-

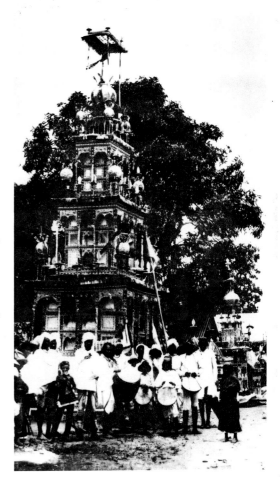

Figure 98 The Hosay Festival celebrated on a sugar estate in Trinidad in the 1880s. Before the very tall *tadjah* in the foreground stand the *tassa* drummers. This object is stylistically similar to its Indian prototype. With the advent of electrical wires, these structures had to be shortened.

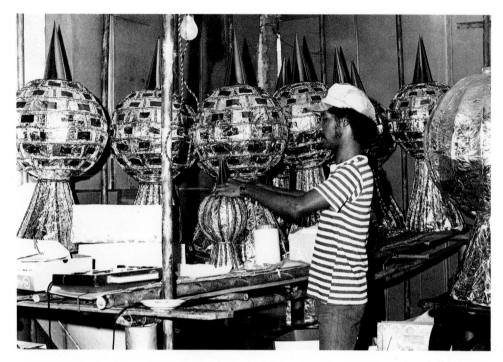

Figure 99 A *tadjah* member from the St. James community in Port of Spain, 1976 adds finishing touches to several domes. The team approach and assembly line techniques used here resemble construction processes at the *mas* camps.

sion, Hosay became a powerful festival wherein the sacrifice of the martyred brothers was acted out and mirrored by the real sacrifice of East Indian protesters. Here ritual and reality met, and men were transformed.

Hosay thrives in Trinidad today. Each year in the St. James neighborhood of Port of Spain, the festival is celebrated by the building of four *tadjah* and the Husain and Hasan moons, each by a separate building crew. A few months before the festival, designers submit drawings of *tadjah* to the building crews. Each of the four *tadjah* crews meets and approves the plans, though they may insist on modifications. Once the designs for the *tadjah* for the 1986 celebration were accepted, a carpenter and a few helpers within an enclosure built the foundation of the *tadjah* of bamboo or cut wood beams. Only the crews were allowed inside the temporary shelters, heightening suspense in the community *(Figure 99)*. Each night prayers were said and ritual food was shared among the builders and invited guests. Everyone worked quietly and precisely in a hushed atmosphere.

Joey Muller, director of one *tadjah* crew, oversaw both the construction and the ritual, incorporating fifteen minutes of evening prayer into the work routine for ten days. Facing toward Mecca, before an altar crowned by a jar of flowers, the participants gathered on the *chauk,* grieving for the martyred brothers. The water in the jar symbolized the thirst of the dying Husain. Nearby burning incense drove away evil spirits. Now neighbors and pedestrians could literally smell the approaching festival.

A few blocks away, the *tadjah* built at Mathura and Carlton Streets was the object of prayers and *tassa* music. When the drums deviated from the proper pitch one *tassa* group performed while another heated their skin-headed drums at a fire *(Figure 100)*. The festival procession began late Friday night, led by large hand-pulled carts decorated with flags, some of which were crowned by the *panjtan*. The street lights and neon signs of local shops colored these large banners while the silvery surface of the hands reflected the ambient light.

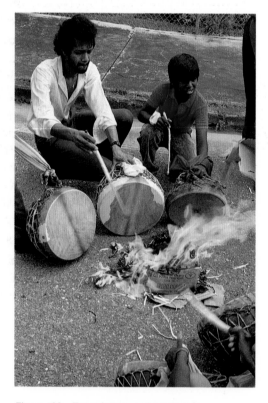

Figure 100 *Tassa* drummers heat their instruments at fires built with pieces of paper, straw, and cardboard found on the streets of Port of Spain, 1986. The heat tightens the goatskin drum heads, adjusting the instruments to the correct pitch.

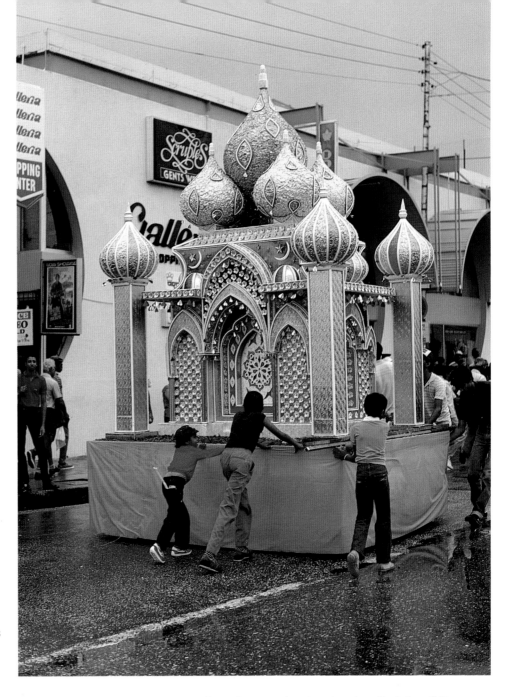

Figure 101 The 1986 *tadjah* from St. James exhibits fine craftsmanship and detailed work. Its four corner turrets and central cluster of domes recall Indian *ta'ziya*.

The moons were brought out Saturday evening in what is called Small Hosay to celebrate the death of the younger brother. This performance ended at 3 a.m. the next day. That evening, the Hasan Moon was carried out of the enclosure and attached to bamboo tubing. The crew who would carry it prayed on the *chauk* with an Imam from a neighborhood mosque. Then Joey Muller lifted the moon onto his shoulders, placed the shaft in a holster at his waist and spun the object in perfect balance. Others followed Muller to the street to take their turn in the ancient dance. Members of the moon camp threw coins and rice for good luck. Shouts of Hosay! Hosay! filled the air.

To the beat of the *tassa* drums participants pushed their *tadjah* into the streets. At about 1 a.m. on Monday, the two moons, symbols of Husain and Hasan, met, touching in a symbolic kiss, thereby joining together in the holy mission. The two moons then led the way to music heard in the far reaches of the city.

On the morning of September 15th, the four *tadjah* appeared one by one on the main route *(Figure 101)*. Ahead waited the Hasan Moon, its supporters dressed in

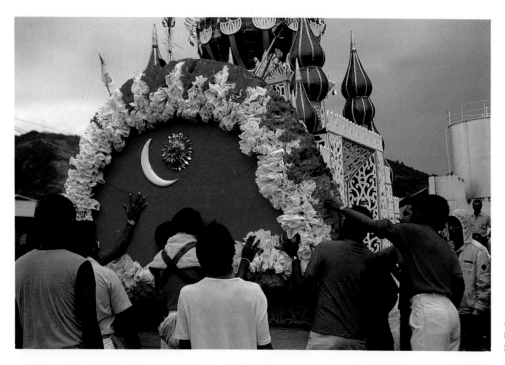

Figure 102 In a brief moment, the Husain moon touches a *tadjah* in a symbolic kiss, releasing the spirits of the brothers.

white pants and blue-green shirts. Rain fell, each drop adding to the moon's weight. When the *tadjah* lined the western Main Road, the Husain Moon made its triumphal appearance at the back of the procession. Before passing the waiting *tadjah*, this gleaming white and red object stopped parallel to each tomb and touched it in a symbolic kiss, releasing the spirits of Husain and Hasan into unbounded space. In this fashion, the brothers met and kissed for the last time *(Figure 102)*. The crescendos of the *tassa* drums urged the procession onward and called forth the followers.

Mr. Buchan, a *tassa* drummer and maker for forty years, explained that the drums dictate the motion of the dancing, inspiring each moon to jump. "Everybody

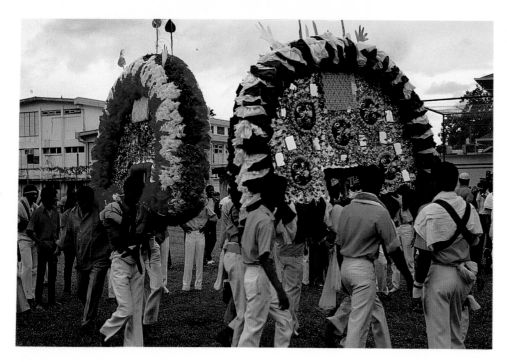

Figure 103 The Husain and Hasan moons circle on the grounds of the Queens Royal College, Port of Spain, 1986, in preparation for the long procession back to St. James. The athletic dance heartens participants weakened by a ten-day fast.

playing, body hot," he said. "If the drums are not respected, their straps might strangle you."[35] The polished cymbals are believed to cause lightning; and indeed, on that dark gray morning fingers of light leaped across the horizon. At certain points drummers tuned their instruments against the escaping heat of the fires.

Near the Queen's Royal College, the procession slowed, as the men tired of the great weight of the festival objects. Fellow dancers gathered round to catch the moons should the bearers collapse. The moons were carried onto the Queen's Royal College ground at 3 p.m. and were set on bamboo stands. The *tadjah* pulled onto Hays Street. Facing toward Mecca, the participants prayed to Allah. Thirty minutes later, dancers again lifted their moons onto their shoulders to shouts of Hosay, Hosay! Hosay, Hosay! The dancers circled in triumph and sped off to the road for the long return *(Figure 103)*. By nightfall, Hosay ended. The celebrants broke their ten-day fast with meat, curries and rice.

Near dusk on Wednesday, the moons and *tadjah,* worn from sunlight and wind-driven dust, were cut to pieces with machetes, placed in trucks and transported to the Caribbean shore. There the fragments were placed in the water where they drifted into the current *(Figure 104)*.

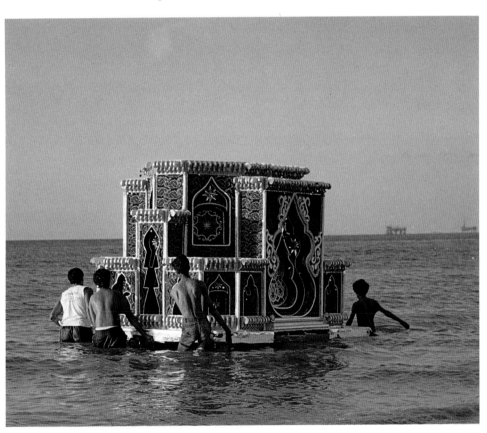

Figure 104 A *tadjah* from St. James community of Port of Spain being placed in the Gulf of Paria as an offering to the Supreme Being on the 15th day of Muharram, in 1987.

The principal objects of the East Indian festival are the *ta'ziya* and the *alams*. In Trinidad, however, the moon shape is probably derived from the Indian *alam*, judging from the crescent shape of a particular *alam* associated with the *nal sahib*, or sacred horseshoe, as well as the crescent moon of Islam itself. Thus the two Trinidadian moons derive from a number of East Indian festival objects and practices. As such they are a fascinating part of Hosay, visually as well as in performance and symbolic terms.

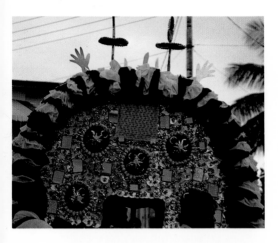

Figure 105 The Hasan moon is green and white, symbolizing the color of Hasan's skin after he was poisoned. This side of the moon is heavily decorated with mirrors, rosettes and thin circular disks of foil, sustaining the abstract aesthetic characteristic of Islamic art.

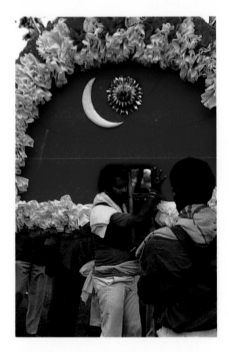

Figure 106 The 1986 Husain moon, pre-dominately red and white, has, like the moon of Hasan, one side with little decoration, in this case only a crescent moon and rosette.

The two moons are similarly built with bamboo armatures decorated with cloth, tinsel paper, and mirrors. In the Husain structure, red stands for the martyr's blood, and the green of the Hasan moon refers to the poisoned brother's skin, which turned green. Three peacock feathers, a *panjtan,* and a knife blade, symbolic of the battle of Karbala, surmount the Husain moon. Correspondingly, from the crescent portion of the Hasan construction protrude twenty-three knives, the two hands and the *culce,* the green shamrock-shaped objects at the top of the crescent *(Figure 105).* Each object has a sack suspended on the top of the heavily decorated side; the sacks are said to be filled with sacred material. Each of the heavily decorated sides also has five large rosettes interspersed among the mirrors. On the less decorated side of the Hasan and Husain Moons are depicted respectively the crescent moon of Islam and a five-pointed star, and the crescent moon and a large rosette *(Figure 106).*

Answering the needs of Muslims and Hindus, the *alams* of India play a central role in the festival. The strong animistic side of Hinduism has relegated certain *alams* to the status of spiritual objects. This is particularly true of the horseshoe-shaped crescent in Hyderabad, India, described thus: "A silver or iron rod, two to three feet long, ending in a massive crescent or horseshoe and covered on all sides with peacock tail feathers, is for a considerable time set before some burning incense."[36]

> If many Sunnis have come to share in the Muharram celebration, much more have Hindus, and with them there is no inhibition from their religion. The celebration appeals to them as also the story; the horse-shoe celebration, the finding of the crest of Husain's banner, the *qadam-i-rasul,* and a stone impression of Ali's hand, the making of vows, etc.—all these savour more of Hinduism than they do of Islam, but through the years they have been accepted by Sunni Muslims also.[37]

The crescent shape, and the peacock feather decoration of this horseshoe *alam,* as well as the fact that incense is burned before it, all link it to the Trinidadian moon with respect to shape, materials, and ritual use.

Like Trinidadian moons, East Indian *alams* are often decorated with gold and silver embroidery, tassels and fringes, and the open hand, while some feature swords emblematic of the weapons carried by Ali.[38] During one Indian celebration, an amazingly large *alam* representing Fatima was made of gold and suspended from each side were three green bags, said to contain diamonds; it was carried by an elephant. Brought out on the tenth day of the festival, this object was preceded by another that was shaped like an open mouth with a hand over it. Such *alams* can be linked to the Trinidadian moons by the symbolic kiss, which implies the presence of a mouth, though no such motif actually appears upon them.

The horseshoe shape of the Trinidadian moons suggests that these objects symbolize horses. Furthermore, both moons are decorated with bridle-like cords suspended from the sides, and the *culce* surmounting the Hasan moon resembles the ears of the horse. Considering that the image of the horse, Duldul, appears in Husain in India, and in African versions of Husain at Ramadan, it is difficult to account for its absence; but the horseshoe shape may be a substitution for the equine image. Furthermore, the moon dance is reminiscent of the movements of a bucking horse; as the two moons meet in the procession, they prance in a circle like horses. One can imagine that the moons represent the brothers on horseback, mounting an attack with outstretched hands and bared knives. This is a symbolic

Figure 107 This detail from a 1986 *tadjah* made by the Mathura and Carlton community shows the color and textured surfaces.

Figure 108 The *tadjah* made by the Cocorite community being drawn down the Western Main Road on its way to the Queens Royal College, Port of Spain, 1986.

Figure 109 The recessed ojival arches in the 1986 Mathura and Carlton *tadjah* broke up the surface's reflection by creating shadows in the niches.

Figure 110 The hands on the *tadjah* from the Mathura neighborhood symbolize the five martyrs whose sacrifice served as a foundation for the Muslim world.

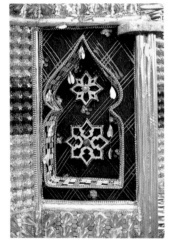

play, marking the return of the dead for revenge. In this context, the moons have become a powerful symbol in Hosay in Trinidad, synthesizing many aspects of the East Indian tradition.

Though Trinidad *tadjah* vary, most conform to certain general rules. In 1986, the four St. James *tadjah* rested on platform bases and consisted of two primary sections, the walls of the tombs and the upper section decorated with turrets, finials and domes. The wall sections were surfaced with many colors of tinsel paper, glass bulbs, flowers, and cloth to compose a complex all-over pattern, in accordance with the Islamic preference for rich texture and complicated abstract design *(Figure 107)*. The exception to the polychrome schemes was the Cocorite neighborhood *tadjah (Figure 108)*; its black and white colors signified mourning for a member of the group who had died in an automobile accident earlier in the year. The tombs were approximately ten square feet at their bases, with the walls extending to five feet, and the dome section reaching five or more feet.

The design of wall sections ranged from simple to complicated. The Mathura and Carlton Street *tadjah* consisted of recessed ojival-shaped niches and hundreds of conical ornaments *(Figure 109)*. In artificial light at night, or in ambient daylight, the niches broke up the light, further varying the surface of the objects and attracting the eye.

The upper portions of the *tadjah* may feature the sacred hands, sometimes supporting a turret or a dome *(Figure 110)*. The crescent moon, with or without the five-pointed star, is also commonly displayed. In Cedros, south of Port of Spain, the upper part of *tadjah* are decorated with birds that carry the souls of the deceased to heaven. Large rosettes, floral motifs, and other geometric patterns are reproduced in colored paper to enhance both upper and lower sections.

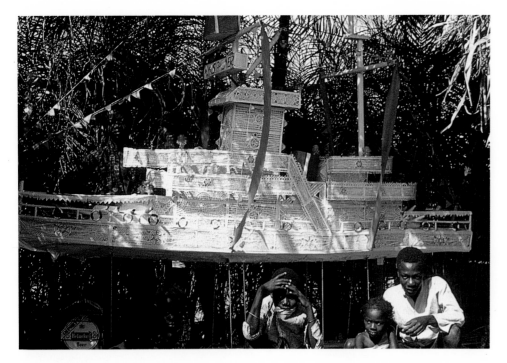

Figure 111 A lantern, or *fanal*, used during a Lantern celebration at Christmas 1970 in Banjul, the Gambia. This lantern is made from paper cut in fine filigree to represent the *H.M.S. Palmer*.

Observations

The questions of convergences, diffusion, and independent development have always intrigued scholars of multifarious cultural traditions in the Americas. The model tomb-like house is not found only in the Hosay festivals of the Caribbean; as a matter of fact, this motif, worn as a headdress, carried in the hands, or built large enough to require a moveable platform, appears in festivals on both sides of the Atlantic. The structure and iconography of the Hosay festival in Jamaica parallels other Jamaican celebrations, as well as other Afro-Caribbean and West African festivals, in intriguing ways. Such similarities are worthy of notice.

Although in Jamaica Jonkonnu has a longer history than the Hosay festival, many Jamaicans speak knowledgeably of both. From the early 1970s through the 80s, Mr. Walsh was performing with a Kingston-area Jonkonnu band; he had been a Jonkonnu player for almost fifty years. He recalled that while he was living in St. Mary's Parish in the 1930s and 40s he saw "Coolie masqueraders who paraded wearing a house on their heads."[39] Other Jamaicans concurred. "The Indian people do a Jonkonnu thing with a house," one from Westmoreland remarked. "It's wonderful! It has things inside . . . snakes, birds, crabs, like that."[40]

Another observer from Westmoreland elaborated: "They did it once a year, twenty to thirty people. Each estate would sponsor their own. They [the structures] would be fifteen to twenty feet in the air. Most were carried on people's shoulders; the largest ones had wheels. They all would meet in town and have a sword play. They all would put the Husay things in the sea. We used to follow them around the streets of Savanna la Mar."[41]

Ranny Williams, the late Jamaican folklorist, also compared the "house-head" Jonkonnu style headdress with the "house" carried by East Indians for Hosay. Williams recalled that when he was a boy in the 1930s, he used to see a lot of bamboo houses carried on the head, but that the tradition had died out.

These similar iconographies are verified by historical accounts. In 1816 at the port of Black River, St. Elizabeth, M. G. "Monk" Lewis described a Jamaican

Figure 112 A lantern used during a Ramadan celebration in Rokupr, Sierra Leone in 1967. Although the celebrations in Senegambia and Sierra Leone are connected with Ramadan or Christmas-New Years, rather than Muharram or the commemoration of Husain, this particular lantern is very similar to the *ta'ziya* built for Husain in India and the Caribbean.

Figure 113 A *tajiya* from Surinam used during Husain celebrations in the late 1970s. After the parade to commemorate Husain and Hasan, these model tombs are either buried or put out to sea.

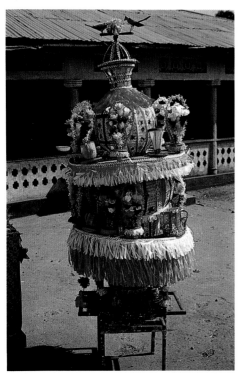

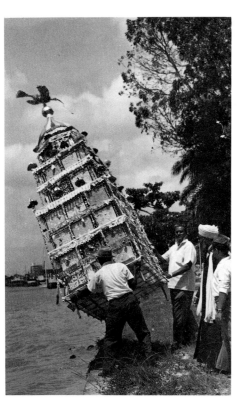

Jonkonnu performer who wore a "paste-board house-boat, filled with puppets."[42] A little more than one hundred years later, Martha Beckwith wrote, "In 1921 he [Frederick Swabe, the John Canoe dancer] wore a cap shaped like an ordinary cottage with a porch at the side; when I saw him again two years later, he had changed to a box-shaped pattern small enough to fit squarely on the head while he danced."[43] It is entirely possible that in parishes with many East Indian residents, like Westmoreland, St. Elizabeth and St. Mary, the Hosay tradition reinforced an existing Jonkonnu practice of wearing a house-headdress.

There are similar descriptions of such objects from individuals living in Bermuda during the 1860s. Furthermore, the Cuban anthropologist Fernando Ortiz has determined that the same motif appeared in nineteenth and early twentieth-century Cuban *comparsas,* and became the first to link those structures to similar ones in African festivals. They are specifically related to the *Fanal* Festival (the Lantern Festival) of the Wolof in Senegambia,[44] which is still celebrated in parts of West Africa.

Lanterns from Banjul, in the Gambia, were brought to Sierra Leone during the 1930s.[45] The Sierra Leone celebration always takes place during Ramadan, the Muslim holy ninth month. In Senegambia, the celebration of Lanterns either happens during the period between Christmas and New Year's or else at Ramadan *(Figure 111).* In neither of these places is the celebration or the model of the tomb-like house connected with Muharram, nor does it specifically commemorate the death of Imam Husain, though the festivals share important iconographic motifs. The actual celebration incorporating the house/tomb motif varies; only the motif remains constant.

An illustration from 1877 shows a Tabaski celebration in Saint Louis de Senegal, which included a large, decorated masted ship, hand-held lanterns resembling houses that were mounted on long poles, banners, and a large house-like structure with doorways, windows, cut-out decorations, and a cupola-like top crowned with the Muslim crescent moon. The large house is almost identical to the *tajiya* used in Hosay celebrations in Surinam and one used during Ramadan in Sierra Leone in 1967 *(Figures 112 & 113).* The article confirms that in 1877 both Tabaski and Fanal celebrations coincided on December 24. The objects were all made "en papier de couleurs variées et decoupé à jour," and illuminated as they are in Senegambia and Sierra Leone to this day.[46] Cut-out paper lanterns still are used in Senegambia. Clearly the blending of cultures has changed the meaning of the festivals and their arts. In Freetown, for example, "Lanterns is neither sacred, secular, Islamic, nor traditional African, but rather a combination of the four."[47]

Indeed, this mix of attributes has sustained the appeal of the Hosay festival in Asia, Africa, and the Caribbean. That Hindus, Muslims, people of African descent and other religions participate in the festival affirms its aesthetic appeal and ability to survive in a world where every little piece of difference counts.

In degree of beauty, the aesthetics of Hosay equal the horror of the decapitation of Husain, the poisoning of his brother, and the massacre at Karbala; it is the wonder of that heroic sacrifice that translates into the beautiful. The vigor of this aesthetic has further enlivened the memories of its devoted followers so that shouts of Hosay! Hosay! triumphantly echo in the realm where the imagined sacrifices of the brothers and those of all participants converge in the arts of Hosay.

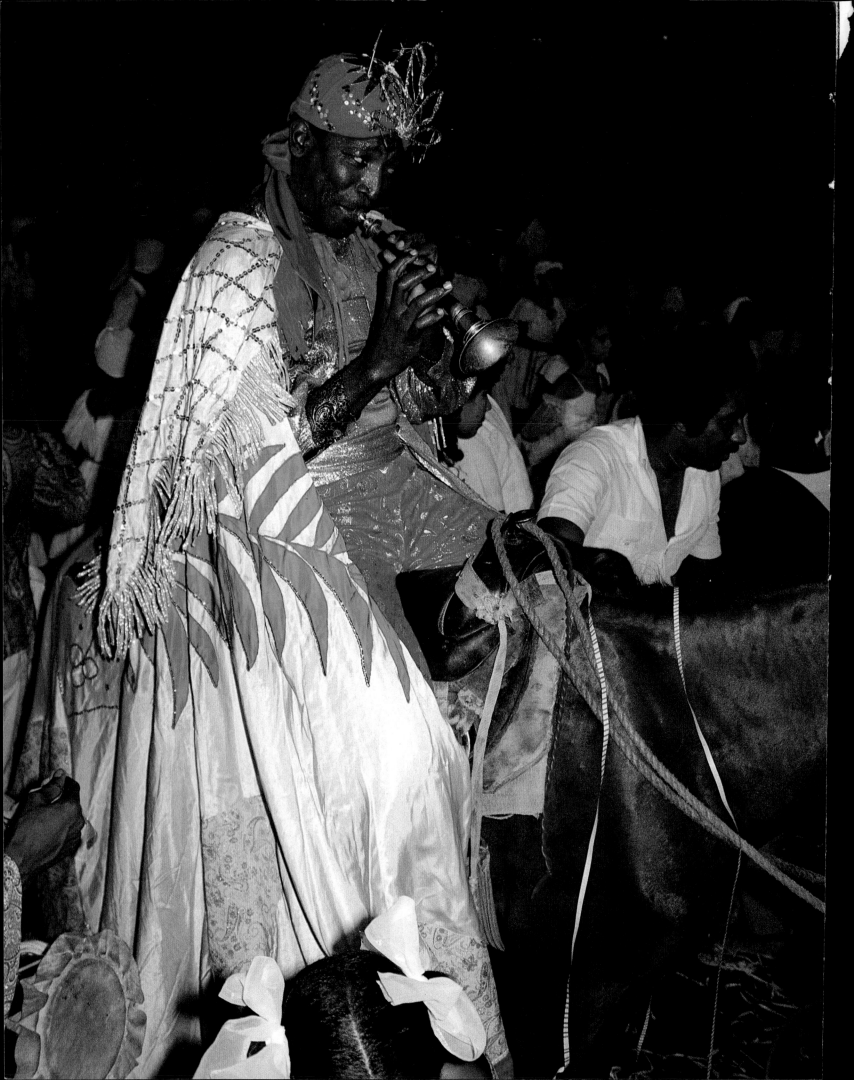

Judith Bettelheim
Barbara Bridges
Dolores Yonker

5

Festivals in Cuba, Haiti, and New Orleans

Carnaval and Festivals in Cuba

Judith Bettelheim

The rumba style *comparsa* group advanced slowly down the grand seaside Avenue Malecon toward the jurors and the bandstand set up below the Hotel Nacional. It was an hour before midnight on July 18, 1987, and Havana was celebrating Carnaval. The male and female paired dancers wore coordinated red and white outfits and executed a marching step in intricate choreographic formations. Accompanying the groups were five men twirling glittering *farolas*, large decorated lantern-like structures, on long poles that they held in holsters. Some *farolas* were tiered globes covered in colored paper and glitter *(see Figure 116)*. One consisted of triangular tiers with doors and windows painted on them.

At the very top of one of the swaying *farolas* reigned a small female figure in red. Amid the dancers with routines derived from the Tropicana, Havana's famous nightclub, was this emblem of more traditional celebrations that paid homage to the history of the dance of the *anaquillé*, first documented by the brilliant Cuban ethnographer Fernando Ortiz.[1] During the nineteenth century these carved female figures atop long poles acted as guardian figures for *cabildo* groups, who paraded in public celebrations for saints or at Christmastime.[2]

Ortiz asserted the African origins of this motif, observing that only black Cubans respected this tradition. He further noted the parallel tradition observed by the *maracatus* and *xangos* of Brazil. Ortiz's observations are underscored by the ethnomusicologist Odilio Urfé, who also has researched Kongo influence in Cuba, noting that the *macuta* is a special rhythm, as well as the name of a drum and a dance step.[3] *Maracatu* and *macuta* seem to derive from the same Kongo source.

As this special emblem of Afro-Cuban culture subtly presided over Havana's Carnaval in 1987, other *comparsas* groups, each with coordinated costumes, floats,

Figure 114 Walfrido Ballerino, the leader of the Conga San Pedrito, during Carnaval, July 1987, in Santiago de Cuba. Playing the *corneta china*, this magnificent masquerader, dressed in lamé, sequins, and bright pink pants, led a drum ensemble and hundreds of dancers. Although *congas* traditionally do not include a choreographed performance, this particular group incorporated elements of the *comparsa*, or paired dancers, into their repertoire.

Figure 115 A member of the percussion ensemble for Conga Los Hoyos playing for Carnaval, July 1987, Santiago de Cuba. Three to four varieties of drums and brake drum players are the traditional Conga musicians. The large circular drum is a *conga*.

137

and *farolas*, paraded down the Malecon. A *comparsa* is a larger group of *conga* musicians accompanied by paired male and female dancers as well as by smaller groups of line dancers performing a specific choreographed routine. A *conga* consists of a small group of musicians who all play the same rhythm and are followed by neighborhood residents, who dance through the streets with identifying flags or banners. The *comparsa* often includes elements of the *cabildo*, a mutual aid organization with direct African precedent, such as a King and Queen and decorated banners and *farolas* with specific, identifiable iconography. In Santiago de Cuba the older traditional Carnaval groups are known as *comparsas*, while newer groups are called *paseos*. *Comparsas* are traditionally organized by neighborhood and are united by ancestral ties. In addition to subsuming the *cabildo*, *comparsas* in Havana also included the neighborhood *parranda*, or groups of musicians and singers, and the *charanga*, or neighborhood party group, a small but festive gathering. Toward the end of the nineteenth century the *parranderos* in various neighborhoods of Havana were competitively decorating church facades and, by 1900, they were carrying small floats in the streets on Christmas Eve. A *paseo* is a special sub-category of *comparsa*. Usually produced and directed by an individual, the *paseo's* name is "owned" by the individual director/producer who can alter its organization, hire different musicians, and manage its income.

In July 1987, along with the traditional *comparsas*—known as Las Bolleras, La Jardinera, Los Guaracheros de Regla, and Los Payasos—there appeared dancers

Figure 116 Accoutrements of a neighborhood *comparsa* group that performed during Festival in Santiago de Cuba, April 1984. The large decorated *farola,* or lantern, is twirled above the dancers's heads. The *caballito,* or hobbyhorse, is ridden by a dancer. In the center foreground are a circular *conga* drum and a *bocú* lying horizontally. To the right are three *tumbadoras.*

dressed as karate fighters and strange ethereal-looking ninja. And on Sunday morning, July 19, thousands of children paraded, danced, and clowned during Carnaval Infantil. Carnaval in Havana, Matanzas, and Santiago de Cuba is celebrated during the last two weeks of July, with a special parade coinciding with the anniversary of the assault on the Moncada barracks of the Revolution.[4] This attack was specifically planned during Carnaval because so much of the population was occupied. July 26 remains the most important date of the Revolution. In 1987 in Santiago de Cuba, beginning at 8 p.m. on July 25 and ending at 5 a.m. on July 26, a complete parade of all Carnaval groups was held. At least twenty different *comparsas*, *congas*, and *paseos* performed. The largest, the Textilera Comparsa, included two hundred and fifty dancers whose performances of choreographed cabaret routines was accompanied by a live drum ensemble and recorded popular music.

Carnaval in Cuba today incorporates a broad spectrum of traditions, ranging from cabaret dancers to sacred emblems of religious ritual. The history of these festival traditions parallels the rich and overlapping history of the Cuban people themselves. During the nineteenth century around Havana and Matanzas, Carnaval celebrations were linked to the bourgeois tradition of ballroom dances (*salón de baile*). In *piezas de cuadro*, friends formed groups of couple-dances, sometimes masked, and performed publicly.[5] Their popularity led to the creation of new ballrooms and orchestras.

In Matanzas a rival dance tradition developed among economically stable Blacks and mulattoes, the *danzon*. According to the ethnographer Israel Moliner Castañeda, in February 1857 at the Main Theatre in Matanzas, a *danzon* was performed which began that particular tradition.[6] The tradition of public couple-dances was one factor in the development of the *comparsas*; another was the demise of the *cabildo de nación*. As Moliner Castañeda has pointed out, in Matanzas the *comparsa* was not the invention of black urban groups, but of whites. In Matanzas during the Carnaval of 1867, the first white *comparsa* of eight couples performed, sponsored by the Spanish Club House Prince Alfonso.[7]

The Matanzas Carnaval of 1871 featured a *comparsa* of eight couples directed by the mulattoes Cayetano Velardes and Anselmo Calle, while the most popular *comparsa* of 1875 was organized by the mulatto Andres Solis. Called Los Negros Congos, it consisted of twenty couples accompanied by eight percussionists.

In eastern Cuba, particularly in Santiago de Cuba, public festivities during Corpus Christi in June and Santiago in July combined as part of *comparsas*. A description from 1800 underscores the differences between public festivals in eastern and western Cuba. Describing a Corpus Christi celebration in Santiago de Cuba, José M. Perez wrote:

> In the month of June the solemn Corpus procession was most noticeable . . .
> There were several masks or figures representing angels, devils, gypsies, lions, tigers, and especially the huge serpent called Tarasca, which was the boy's favorite entertainment . . . All these comparsas had their dances and analogous emotions which preceded the cross.[8]

By 1852 in Santiago de Cuba, neighborhood groups of "colored men and women" paraded the streets in June to celebrate St. John's Day (Juan). These groups featured both solo and chorus singing, and by the celebration for St. James (Santiago) in July "more than a hundred groups would celebrate." The musical

accompaniment consisted of drums (*congas*), pans, and other metal percussion instruments. Thus, *comparsas* featuring paired dancers dominated nineteenth-century celebrations in western Cuba, while in the east large groups of neighborhood participants followed musicians through the streets, forming groups that became known as *congas*.

The history of Carnaval in Havana is intimately connected with Dia de Reyes celebrations, the *cabildos de nación*, and the power of the Abakuá Society.[9] Dia de Reyes (Day of the Kings) or Epiphany is celebrated on January 6, but has not been celebrated in Cuba since 1884. There are many published nineteenth-century accounts of Dia de Reyes celebrations. Two written by Americans provide a descriptive though prejudiced view of these celebrations. John George F. Wurdemann, a physician and author, who went to Cuba in 1842, wrote the following account:

> The next day being "el dia de los Reyes," twelfth day, almost unlimited liberty was given to the negroes. Each tribe, having elected its king and queen, paraded the streets with a flag, having its name, and the words "viva Isabella," with the arms of Spain, painted on it. Their majesties were dressed in the extreme of the fashion, and were very ceremoniously waited on by the ladies and gentlemen of the court, one of the ladies holding an umbrella over the head of the queen . . . The whole gang was under the command of a negro marshal, who with a drawn sword . . . was continually on the move to preserve order in the ranks.

> But the chief object in the group was an athletic negro, with a fantastic straw helmet, an immensely thick girdle of strips of palm-leaves around his waist, and other uncouth articles of dress.[10]

Another traveler to Cuba, Maturin M. Ballou, who visited the island in 1845, described Dia de Reyes as follows:

> On January 6th, the day of Epiphany, the negroes of Havana, as well as in other cities of the island, make a grand public demonstration; indeed, the occasion may be said to be given up to them as a holiday for their race. They march about the principal streets in bands, each with its leader got up like a tambor major, and accompanied by rude African drum notes and songs. They are dressed in the most fantastic and barbarous disguises, some wearing the cow's horns, others masks representing the heads of wild beasts, and some are seen prancing on dummy horses. All wear the most gorgeous colors, and go from point to point on the plazas and paseos, asking for donations from everyone they meet.[11]

Black public participation in Dia de Reyes was organized by *cabildos de nación* according to neighborhood and ethnicity, i.e., the African nation of origin. Even freed Blacks and Creoles formed their own *cabildos* with government permission. The colonial government sponsored them in an attempt to split up the free black population and diffuse its power. The Dia de Reyes celebration, also called "Black Carnaval," developed at a time when the *cabildos* celebrated publicly after permission for public performances was granted in 1823. Thus, their external purpose was to visually demonstrate their solidarity and power through a public performance, while their internal purpose was mutual aid. As Odilio Urfé points out, the Day of the Kings "was used by the colonial government as a deliberate catharsis for the oppressed."[12]

The Abakuá Society, an association or brotherhood, was originally established by Efik and Ejagham (Ekoi) slaves from the region of Calabar and the Cross River of Nigeria-Cameroon. By 1844 an Abakuá group had formed an official *cabildo* and

established a formidable reputation in Havana.[13] Shortly thereafter a creole group established its own Abakuá Society, the Efí Acabaton. With the help of the "colored" Andres Petit in 1857, mulattoes and whites were admitted into Abakuá. The noted ethnologist Lydia Cabrera reports that the survival of Abakuá was greatly aided by Petit, who died in 1889, as the white membership temporarily abetted official persecution.[14]

The *cabildos* and the Abakuá gained more and more power and became separatist organizations which threatened official government. Slave emancipation in Cuba was a slow process, beginning in the 1870s and extending through the 1880s. By official decree on December 19, 1884, public Dia de Reyes celebrations were prohibited and the *cabildos* slowly lost whatever power they had accumulated. Throughout the period of slavery, official alternative support and persecution of the *cabildos* had kept them subordinate, but after emancipation Blacks' renewed identification with their African heritage became threatening to the government. By 1887 the *cabildos* were officially changed to organizations that were forced to adopt a Catholic designation under direct control of local authorities. These decrees were aimed at eroding the power of the *cabildos*, especially those with Abakuá membership, and lessening their participation in the War of 1895 on the side of independence. Yet *cabildo* power continued, if somewhat underground. Even during the War, the *cabildo* drums of the Izuama of Santiago de Cuba[15] were used to carry illicit weapons and medicine to the freedom fighters, as well as to transmit coded messages by their beats. These warnings were probably related to the coded secret script of the Abakuá Society. Although by the end of the nineteenth century the *cabildos* were no longer official or a true public presence, many black Cubans maintained membership in them.

The *cabildos* developed into and integrated with other social groups to form *comparsas*, which gained popularity in the area of Havana and Matanzas during the period 1870–1920, but especially after the Ten Years War which lasted from 1868–1878. Both *comparsas* and *cabildos* were organized through strong neighborhood and ethnic ties that also extended into labor relations. By the end of the nineteenth century, politicians and merchants used these relationships to develop patronage networks, furthering extant neighborhood rivalries, or as Argeliers León calls it, a "neighborhood conscience." León reports that around Havana the power of the Abakuá Society was so strong that members affiliated with various *comparsas*, in lieu of outlawed *cabildos*, and aggravated neighborhood competitions. In the February 1894 Havana celebrations, these rivalries resulted in what police records call "bloody Carnaval."[16] Provoked by continued police harassment and deportations designed to keep their power divided, *comparsa* rivalries accelerated. Political tensions during this period were already extreme when the War of Independence began in 1895. *Comparsas* were placed under strict government control, and Carnaval celebrations in the early 1900s were dominated by the *paseos* of the "Creole artistocracy."[17] These wealthier participants introduced a new motif into Havana celebrations. By 1908 floats were imported from the United States decorated with "allegorical figures" and featuring "dancing ladies." Shortly thereafter decorated automobiles were integrated into the *paseos*.[18]

Yet the alternative tradition of "*comparsas cabilderas*" (*cabildo* dominated *comparsas*) persisted in Havana and Matanzas, despite severe government restrictions. As both León and Moliner Castañeda make clear, these were controlled by leaders of different Abakuá Societies and were distinguished by membership of

anywhere from 20 to 100 individuals organized by their own resources and supported by the collection of donations during their public performances (like the old *cabildos*). Their organization centered on social satire/caricature or on atavistic topics which could change annually.

Argeliers León relates the following account of the Havana 1912 Carnaval that underscores the importance of a covert authority within certain *comparsas*. First prize that year was awarded to the Comparsa Alacrán, which was dominated by the *potencia* or subgroup Ekerewa of the Abakuá Society. Second prize was given to the Comparsa Chinos Buenos, while the Comparsa Gavilon, dominated by the *potencia* Ebión Eté, was awarded third place. In retaliation the Comparsa Gavilon stole the *alacrán*, or sculpted scorpion, of the *comparsa* that had been awarded first place. (The *alacrán* was made from wire, painted cardboard, and paper.) The Comparsa Alacrán stole back its sculpted scorpion and during the battle several people were killed, causing renewed restrictions against *comparsa* outings in the capital. From 1912 to 1930 authorities prohibited participation of certain neighborhood *comparsas*, especially those made up of Blacks and mulattoes, from celebrations in Havana itself.[19]

Much of the social unrest during this period can be attributed to the military presence of the United States. The initial occupation dated to 1899–1902, when the Platt Amendment gave the United States the right to intervene in Cuban affairs and to establish a naval station at Guantanamo Bay in Oriente Province. The second U.S. intervention lasted from 1906 to 1909. In 1912 demonstrations by Afro-Cubans in Oriente led to the death of at least 8,000 Blacks.[20]

In the 1930s restrictions against *comparsa* outings were lifted in order to effect a transformation in *comparsa* organization which highlighted themes pleasing to the tourism that flourished during this period. The choreographic schemes became more complicated, and the number of participants, at times up to 150, increased. As Moliner Castañeda points out, this newer *gran comparsa* organization resulted from a "de-Africanization" of traditional groups together with changes in names, as for example, Los Lucumies became Las Bolleras. (The Yoruba in Cuba are known as *Lucumi*, from a Yoruba phrase "aluku mi," meaning my friend.) The African elements that were retained, such as *ireme* dancers, were considered "picturesque" rather than ethnically powerful.[21] Moliner Castañeda considers the appearance of Abakuá Society *ireme* characters in contemporary Cuban folklore performances to be a form of "folkloric propaganda," a superficial reflection of a historical phenomena. Perhaps there is some validity to his appraisal, as miniature Abakuá *iremes* are sold in tourist stores as memorabilia of Cuban folklore *(see Figure 117)*, and the once sacred and secret Abakuá *nsibidi* script, called *anaforuanas*, is replicated on banners and flags adorning conference halls and cultural centers.[22]

On a clear day, from eastern Cuba one can see both Haiti and Jamaica. Today the Haitian-Cuban community is being "rediscovered" by ethnographers and anthropologists; Casa del Caribe, part of the Ministry of Culture, promotes a renaissance of traditional culture, just as the Jamaican Cultural Development Commission and the Trinidad Carnival Development Commission are doing. All such organizations are involved in facilitating the development of popular culture. Santiago de Cuba manifests a particularly strong and distinct festival tradition, evident in their powerful neighborhood *congas,* Los Hoyos, El Tivoli, San Agustin, and San Pedrito. Conga Los Hoyos is perhaps the most popular and powerful of Santiago de Cuba's *conga* groups.

Figure 117 Doll representing Abakuá Society *ireme* spirit, purchased in Cuba, ca. 1985. Among the most powerful of traditional black Cuban masqueraders, Abakuá Society *ireme* are impersonated in many contemporary performances.

Los Hoyos is a distinct neighborhood and holds the reputation for toughness and solidarity. Sebastian "Chan" Herrera has been the leader of Los Hoyos since 1946 and for the 1986 Festival de la Cultura de Origen Caribêño organized a *conga* march which extended for two city blocks and included hundreds of dancing followers. Led by brake drum percussionists, drummers, and the classic corneta china,[23] Los Hoyos typifies neighborhood participation in both Festival and Carnaval. For Santiago Carnaval 1987, the leader of Los Hoyos and Conga San Pedrito, Walfrido Ballerino, played his corneta china while on horseback, incorporating the Spanish tradition of the *mamarrachos (see Figure 114)*. A magnificent sight, he wore a turban-style crown, a fringed and sequined cape, and skin-tight pink pants, offset by a gold lamé shirt with blousy sleeves and appliqued flowers, and a fringed waist sash. The accompanying musicians wore matching paisley or striped shirts and head-ties *(see Figure 115)*.

Congas are the essence of performance in Santiago de Cuba, and are also known as "santiagueras." Their origin can be traced to Corpus Christi processions, although their most powerful presence was always seen and heard on the day of St. James (Santiago) on July 25, a date that today coincides with both Carnaval and the anniversary of the assault on Moncada. The *conga* groups usually do not include dancing couples or costumed performers, but rather accumulate power and prestige by gathering a crowd of dancing followers as they march throughout the city.

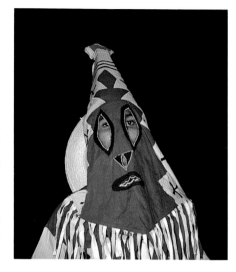

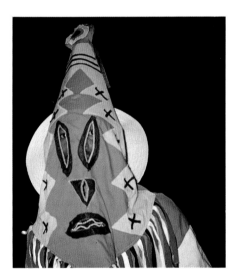

Figures 118 & 119 Ireme headdresses worn by members of the Paseo Sueño during Carnaval, July 1987, Santiago de Cuba. Although traditionally Abakuá Society *ireme* performed publicly for Dia de Reyes in January, they have infrequently taken part in public celebrations since the turn of the century.

In Oriente Province, where Santiago de Cuba is located in the eastern part of the island, *comparsas*-type groups paraded publicly throughout the 1800s. By 1836 these santiaguero-type *comparsas* came out in full force on July 25, the day of the Saint James (Santiago) celebration.

From the mid-nineteenth century on, many Santiago *conga-comparsas* developed a separatist character. The predominantly Afro-Cuban population strengthened their neighborhood organizations, especially during the political turmoil of the Ten Years War, the War of Independence, and the U.S. interventions. These strong Afro-Cuban *comparsas* satirized political personalities and commented on contemporary events through their costumes and songs. The Cabildo Izuama of Santiago de Cuba, which worked "underground" during the War of Independence, developed from a *cabildo de nación*, and is now part of the Conga Los Hoyos. By the early 1920s and climaxing in the 1940s, a concerted effort to commercialize *comparsas* in Santiago began, but the traditional groups protested. The newer groups were thus called *paseos* to distinguish them from the traditional neighborhood *comparsas* or *congas* such as Los Hoyos and El Tivoli.

In Oriente Province there are many traditional groups, only some of whom perform in Carnaval. A few of these groups now perform in the "Festival de la Cultura de Origen Caribêño" under the aegis of Casa del Caribe, an intellectual arm of the Ministry of Culture in Santiago de Cuba, the most Caribbean of all Cuban cities. Every spring since 1982, Casa has sponsored round-table discussions, investigative presentations, and a festival celebration of Caribbean culture.

Many festival groups performed in Santiago de Cuba during Carnaval 1987. Some of these groups incorporated elements from traditional Afro-Cuban culture, while others included motifs more directly reminiscent of Spanish celebrations. A small group, the Cabildo Carabali Izuama, with ten elderly members dressed in nineteenth-century costumes in imitation of a king, queen, and attendants, marched slowly down the parade route.[24] The Paseo Sueño performed a choreographed routine entitled "Imagen Caribêna," and incorporated traditional charac-

ters from other Cuban celebrations into its repertoire. A Shango character derived from the Yoruba-based Santería religion, dressed in red, black, and white, and carrying a hatchet instead of a double-headed axe, led a trio of beautifully attired *iremes* complete with tall pointed headdresses *(Figures 118 & 119)* and fringed and appliquéd jumpsuit-like costumes. Even though the tradition of the Abakuá Society and its *ireme* spirits existed only in the area of Havana and Matanzas, Carnaval in Santiago de Cuba today incorporates traditional folklore from the entire country.

The Paseo Comercio featured male rumba dancers wearing high hats, sequinned jumpsuits, and carrying batons. Members of another group, the Conga Guayabito, distinguished themselves by wearing the traditional male costume of Santiago de Cuba Carnaval: huge capes, painted, stitched, sequinned, and appliqued with various scenes, and held in an open half-circle by as many as four attendants. The principal dancers and their attendants wore sequinned and glittery fringed loosely fitted blouses and trousers, matching sequinned and furred sombreros, and a sequinned scarf attached to their hats *(Figure 120)*. A special feature of these capes was their reversability; one side showed a rooftop scene of the narrow, hilly streets so typical of Santiago de Cuba on one side, and on the other was stitched the name of the group and the title "Carnaval, Santiago de Cuba, 1987."

A similar huge cape was included in the Carnaval performance of the Cabildo Teatral Santiago, a theater group specializing in western dramatic theater and folklórico dramas. Their presentation incorporated many characters from a broad variety of Cuban traditions. A papier-mâché bull's head was worn by the dancer carrying a colorfully painted cape with a depiction of a rooster. The rooster is most frequently associated with the Santería religion and embodies the essence of Osanyin, god of herbalist medicine, whose African associative emblems are birds. In the Americas, however, the bird image is often replaced by a rooster.[25] All informants in Santiago de Cuba repeatedly stated that this rooster was the powerful Santería god Shango, who controls thunder, lightning, the skies and who awakens the world with his crowing.[26]

Other characters derived from Afro-Cuban traditions included two *iremes* of the Abakuá Society wearing patchwork pants *(Figure 121)*, and a hooped and fringed skirted character whose feathered headdress was adorned with the once-sacred script of the Abakuá Society, the *nsibidi*.[27] This later costume reflects the contemporary penchant for historicity, as it is copied from an illustration in a Fernando Ortiz publication.[28] In addition, there appeared a burlap bag figure, two *peludos* with costumes made from multi-colored strips of cloth (one on stilts and the other a smaller childlike figure), a señora and a captain, and miscellaneous *muñecones* or characters wearing huge papier-mâché heads in imitation of a variety of children's fantasy characters: birds, old men, and Disney favorites.

Another traditional group from the mountains surrounding Santiago de Cuba, Pilon del Cauto, appears only at Festival. Pilon del Cauto is a group comprised of descendants of Haitians, and accordingly exhibits strong Kongo influence.[29] In 1791 French immigrants and their slaves first arrived from Haiti, fleeing the upheavals of what was to become the Haitian Revolution. There has been a steady trickling of immigrants ever since, with another large influx in the early twentieth century brought as labor for the expanded sugar plantations. Pilon del Cauto also performed publicly during the formal parade as part of Festival 1986. They executed a variety of secularized ritual dances and "sports," which attests to the equal borrow-

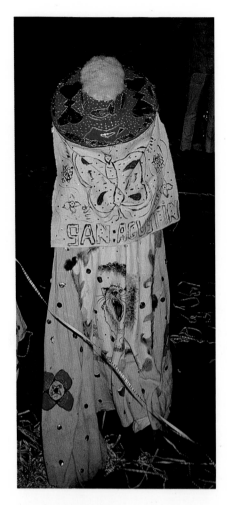

Figure 120 A member of the Comparsa San Agustin performing at Carnaval, July 1987, Santiago de Cuba. This dancer assisted a lead dancer who wore the traditional costume of Santiago Carnaval, a huge cape held open in a half circle.

Figure 121 An Abakuá Society *ireme* danced by a member of the Cabildo Teatral Santiago during Carnaval, July 1987, Santiago de Cuba. The Abakuá Society was introduced to Cuba by Ejagham from the Cross River area of Nigeria, and, until at least the early 1900s, was a powerful social force. Today even the popularized image of the *ireme* maintains a special significance in Cuban society.

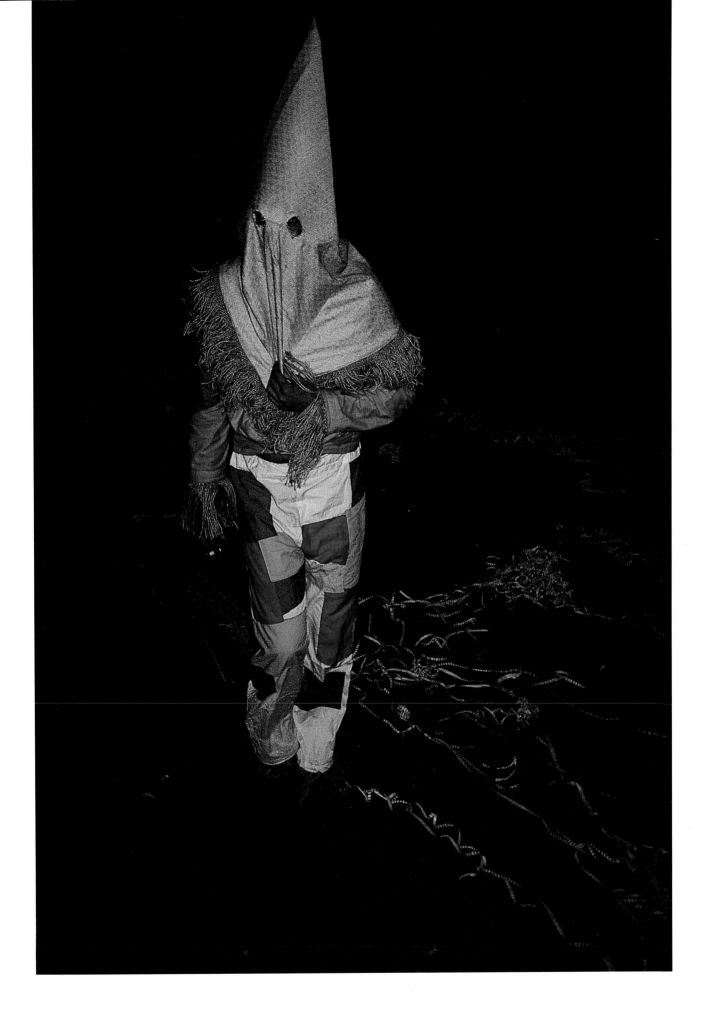

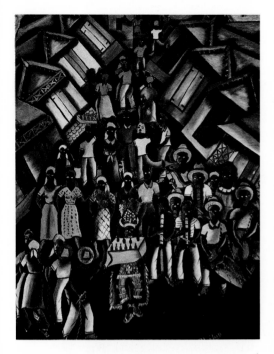

ing of rituals among significant and distinct traditional cultures, rather than the appropriation of traditional forms by a dominant group.

For example, underscoring their Haitian heritage, Pilon del Cauto members incorporated feats most often associated with Rara groups in Haiti into their performance. (Rara is known as Gaga in both Cuba and the Dominican Republic). A young girl clenched a corner of a wooden table in her teeth and lifted it off the ground *(Figure 123)*. Although Dolores Yonker reports that this feat is no longer part of Rara ritual in Haiti, Harold Courlander documented such acts during his extensive fieldwork there between 1937 and 1955 *(Figure 122)*.[30] Pilon del Cauto also incorporated performances by Rara *major joncs*, as well as acrobats. Their participation in the Festival celebrations was directed by members of Casa del Caribe, and undoubtedly this academic historicizing input influenced the content of the performance.

Today, throughout Cuba many elements of traditional culture exist side by side with contemporary thematic, choreographic, and costume innovations. As some less traditional *comparsas* and *paseos* thrive with aesthetic innovations, other *comparsas*, *congas*, and cultural communities are recognized for their contribution to Cuban culture and also participate in Carnaval and Festival.

Figure 122 A detail of a painting by G. Abélard depicting a Rara group in Haiti in the 1950s. The center figure, with his horned cap, cape, and fringed knee-length pants, balances a table in his teeth.

Figure 123 Members of Pilon del Cauto, a traditional Cuban group whose members are of Haitian descent, performing during the Festival de la Cultura de Origen Caribêño, April 1986, Santiago de Cuba. A young girl is clenching the corner of a table in her teeth and lifting it off the ground. Such feats are most commonly associated with Rara rituals in Haiti and are being revived by the Cuban-Haitian community.

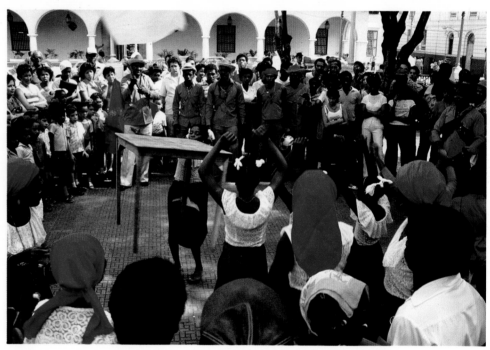

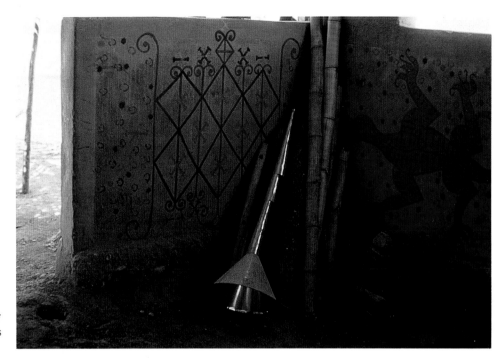

Figure 124 Rara musical instruments "put to sleep" in a corner of a 1984 *vodoun* peristyle at Croix de Bouquets. The quad-rated *vévé* against which the *vaccines* and the aerophones lean refers to Zaka, the *loa* of agriculture, an association appropriate to this farming community.

Rara in Haiti

Dolores Yonker

Haiti occupies the mountainous western third of the Caribbean island that was claimed for Spain as Hispaniola in 1492 by Columbus, who described it enthusi-astically as fertile and abundantly watered. Ceded to the French as St. Domingue in 1697 by the Treaty of Ryswick, it soon became France's richest colony. To provide labor for the sugar, coffee, indigo, and cotton plantations, African slaves were imported in large numbers from the very beginning of colonization. In 1791, a revolution inspired by descendants of these slaves destroyed the colonial enter-prise, and in just thirteen years succeeded in establishing the first independent black republic in the western hemisphere. Sweeping from their mountain refuges, the *maroons* led the insurrection under the crimson banner of Ogun, a militant Yoruba deity adopted from their African heritage. The first flag bore Ogun's colors, red and blue, as does the national banner today. The fledgling republic was renamed Haiti, from an Amerindian word meaning "mountainous land." The African traditions so courageously defended are commemorated in Rara, a unique festival celebrated in the Haitian countryside during Lent.

Rising from the embers of Carnival, Rara gains impetus during each weekend of Lent, exploding in noisy and colorful processions during Easter's holiest four days. As Christian mourners quietly observe the most solemn forty days of their calen-dar, many of Haiti's people "make Rara" on the streets and roads of town and countryside. Urged along by shrill whistles, hooting bamboo *vaccines*, thumping drums, and raucous songs, hundreds of participants clog highways and solicit contributions for performances of hip-twisting dances and nimble acrobatics. Rara has been suppressed at times, but the bands have always emerged with renewed enthusiasm to dance for miles, enduring sleepless nights and sweltering days in

Figure 125 Artist-*houngan* André Pierre painting a banner with an image of Bosu for a social service group sponsoring a Rara band in the Cul-de-Sac region outside Port-au-Prince, Haiti, 1984.

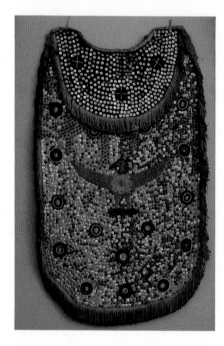

Figure 126 Sequinned major jonc's cape, bordered by the traditional gold fringe. It bears the phoenix emblem associated with the themes of death and rebirth celebrated in Rara. The body of the bird embraces a pentacle, symbolic of the magical power of regeneration. The shoulders of the cape bear three circled crosses which denote the dangerous but crucial site of the crossroads and the *loa* who is guardian of the crossroads, Legba. The sign has also been identified by Robert Thompson as a Kongo cosmogram referring to the eternal cycle of life and death.

Figure 127 Major joncs from the area of Archaie, Haiti dressed for the culminating *sortie* of Rara on Good Friday morning, 1985.

choking dust and snarled traffic. For the hard-working Haitians, Rara is release, an abandon to their spirits, natural and supernatural. Flashing tinsel, mirrors, sequins, multi-colored scarves, and strips of cloth transform their clothing, just as Rara transforms ordinary life for a few precious days.

In the streets, the Rara band falls into the following order: the flag-bearers; the master or chief of the band and the avant-garde; two or more *major joncs*, who twirl the *jonc* in a series of symbolic and magical maneuvers; the queen and her attendants; the musical ensemble; the women's choir; women vendors of refreshments; and finally, the rear guard. Towards Holy Week, the emblem of the group, a banner or a symbolic object, will appear revealing the chosen name. The banner is usually elaborately decorated with tinsel, chromolithographs of saints, ribbons, and cut colored paper. The legendary artist André Pierre, who is also *houngan* (priest of *vodoun*), painted such a banner, in this instance a wooden plaque, for a group associated with social services in the Cul-de-Sac region in 1984. It bore as symbolic of the group an image of Bosu (*Figure 125*), a taurine *loa* of Kongo derivation that figures in the Petro ranks of *vodoun*, one of several branches of the African-based religion practiced by most of the Haitian people.[31] It was Moreau St. Méry who recorded the founding of a sect in 1768 by one Don Petro of Petit Goâve. This Petro sect was infamous for its violent ceremonies and magical "superstitions."[32] Rara participants most often select Petro deities, or *loa*, as protectors during the exhausting, sometimes dangerous, processions.

The bands are ruled by a hierarchy of officials, who have royal or military titles. The president or colonel is chief of the band and directs its activities with a whip.[33] His garb is varied but it reflects his prestigious role as master of ceremonies. Female officiants, most often referred to as queens, wear long, brightly colored dresses of taffeta or rayon, resembling those used by their counterparts in secret society assemblies. They wear elaborate, jeweled headwraps or broadbrimmed hats, decorated with vari-colored cloth strips. Gloved, and adorned with many baubles, the women wear skirts that are slit to reveal ruffled petticoats.

Each band has from two to six *major joncs*, clad in vivid assemblages of paper, cloth, mirrors, and sequins (*Figure 127*); they recruit adherents and attract donors as they protect the group from magical attacks. The *major jonc* is the most visible member of the band, wearing a bright ensemble of short pants, stockings, and shirt, topped by a sequinned, gilt-fringed tunic, and occasionally a cape bearing the insignia of a *loa*. The materials and emblems on the tunics and capes relate them to the sequinned ritual flags used in *vodoun* ceremonies. A stylized bird, identified as a phoenix, is a recurrent element (*Figure 126*). In myth, the phoenix represents periodic destruction and recreation. Christians interpret it as symbolic of the triumph of eternal life over death; vodouisants connect the image with Legba, a *loa* of Yoruba origin, as embodiment of resurrection and transfiguration.[34] Another favorite motif is the star, a *garde* or protective sign.

Major joncs usually wear sunglasses, a reference to the *Guédés*, a class of *vodoun loa*, and especially to their underworld boss Baron Samedi. Tucked into their belts are embroidered scarves, like those worn by penitents during the massive annual pilgrimages to *vodoun* sites. Their colors are symbolic of the *loa* served by the wearer. The *jonc* is a baton of wood about a yard to a yard-and-a-half long, covered with embossed metal and terminating in conical tips that are filled with materials that rattle. The *jonc's* center is clearly marked on the metal, and is sometimes

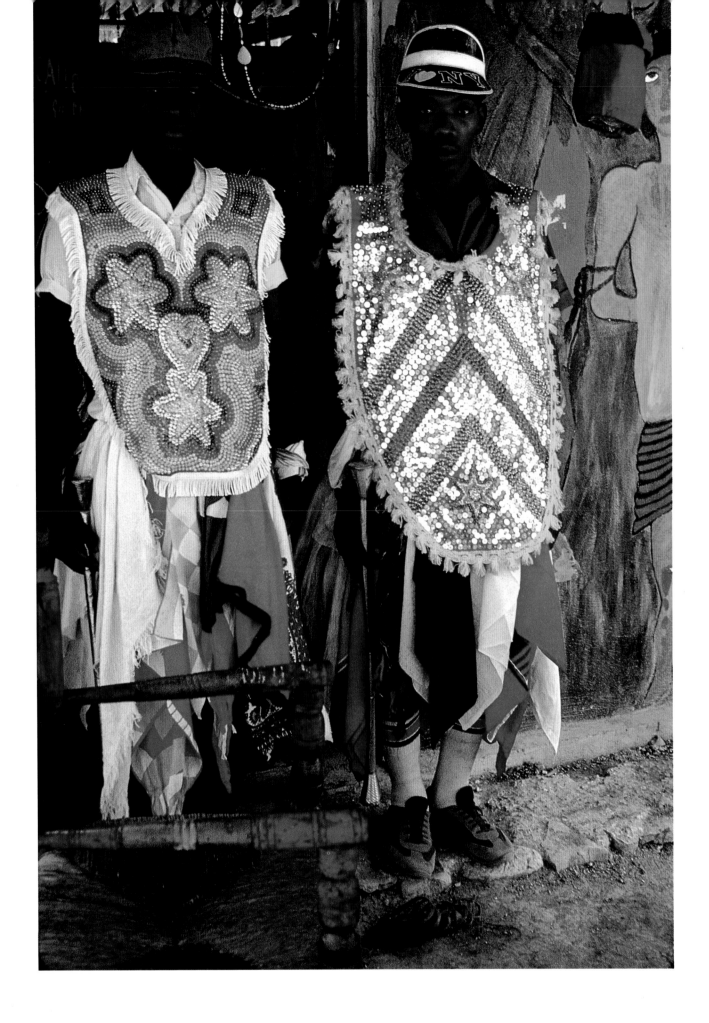

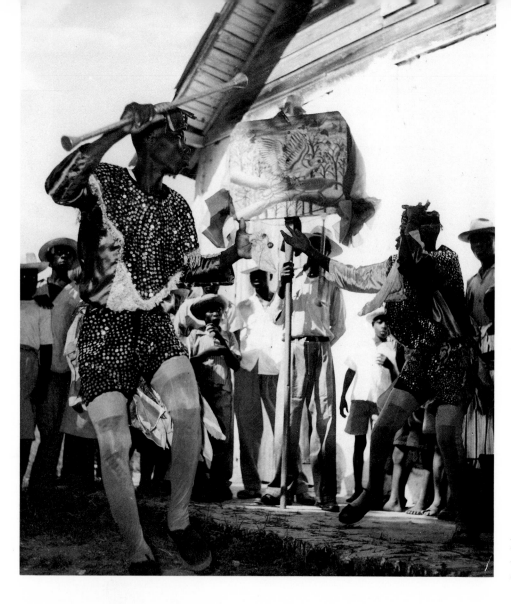

Figure 128 A Rara group from Léogane in the 1950s. Two major joncs dance before their group's banner, which depicts a bird catching a lizard.

referred to as a *point* or a locus of magical power. In addition to the virtuosity of his performance, the *major jonc* is believed to wield supernatural powers. The *jonc* is ritually prepared before its use, and like the musical instruments, it may be left overnight to sleep in the cemetery or *houmfort* (the temple or shrine of *vodoun* religion) to restore its power *(see Figure 124)*.

The *major jonc* executes maneuvers familiar to and anticipated by his audience. The *zéclair* or *trois limié* involves rapid passes about the body as the baton is twirled between the fingers. Everyone knows of the famed *major jonc* who could toss his baton into the sky, go into his house for a drink, and catch the falling *jonc* when he emerged some minutes later. During processions, the *jonc* is often passed around the body of a contributor to the band, or to an honored guest, as a salute and gesture of incorporation *(Figure 128)*.

Flag-bearers head the band, and announce the identity and intentions of the band at the orders of the leader. They play an important role in signaling friendly or hostile action toward an approaching group. Flanking the whip-bearer, just as they flank the machete-bearer, who is the assistant to the *houngan*, the flag-bearers signal events with their flags, by dipping, twirling, or touching an object or person as a salute. As in a military operation, the capture of a flag denotes the defeat of the group, which may even lead to its dissolution; it is an emblem to be defended at all costs. Colors and motifs are selected carefully by the band's proprietor.[35] The

favored color red alludes to the Yoruba deity, Ogun, and his Christian counterpart, St. Jacques Majeure, both warriors who signify metal, weapons, and aggressive action. One group called "Hivernal" carried a white flag with a sheep embroidered in its center. The members chose this reference to the Haitian sea deity Agouwé and the animal sacrifice belonging to him. It was a public avowal of the peaceful intentions of the band, which was founded on the feast day of St. Innocent.

Early mentions of Rara-like celebrations suggest an African derivation for many elements. The word "rara" probably derives from a Yoruba adverb meaning noisily or loudly. It may at one time have been assigned derogatorily to the rowdy processions led by an unappreciative Yoruba speaker. References to the religion and mythology, music, and dance of the Congo/Angolan regions recur in Rara celebrations. During the eighteenth century, probably the formative period of Rara, Africans from the kingdoms of the Congo basin outnumbered other arrivals.[36] At least 1,500 slaves a year were shipped from the Congolese ports of Cabinda, Malemba, and Loango. Many of them were distinguished for achievements or authority, but were exiled and enslaved as members of rival factions grappled for power. Cultures of the Congo region also dominate the Petro cult of *vodoun*.

Rara emphasizes movement in space rather than observances at fixed locations. Bands move from the village into the countryside; economic transactions and rituals take place at crucial sites. At intervals, baths and other treatments are administered as rites of magical protection and purification. A strict code of rules stipulates specific punishments for misconduct, particularly fighting and thievery. The bands' disciplinary functions, as well as their elaborate hierarchy, relate them to the secret societies—known as the *shanpwels* or *sans poils*—many of which sponsor large Rara bands. One of the most powerful societies in Léogane, *Société Decembré*, dispatches the oldest and largest Rara bands of the area, Chien Mechant (Wicked Dog). Both Rara groups and the secret societies execute rituals permeated with Petro symbolism[37] at crossroads or entrances to villages.

Records of Rara-like festivals have existed since the colonial period, when colorfully dressed groups of celebrants roamed the countryside, singing and dancing.[38] A female in each group carried a long-handled ribboned basket to receive offerings, much as the *reine corbeille* (queen of the basket) does in Rara groups today. On New Year's Eve, a group of slaves would appear before the master, singing and dancing to solicit gifts with such a basket. When retribution for an injustice was sought, the inhabitants would pour out of households or *lakous* (compounds), each bearing some kind of noise-making instrument. The group would proceed to the house of the owner to express their dissatisfaction.[39] It was a means by which relatively powerless people could challenge authority.

Moreau St. Méry's description of *vodoun* celebrants in 1789 is strikingly similar to the appearance and performances of Rara bands today. Dances he called *chica* or *calenda* are today's sensuous *banda*. The many bright-colored handkerchiefs tucked into the waist, with red always the dominant color, were worn then as now *(Figure 129)*. The rich garb of the king and queen he described resemble what is worn today. Moreau presciently warned of the potential militarism of such groups. Military titles figure in the hierarchy of Rara groups today. Rara periodically has been suspected, not without reason, of harboring a militant patriotism.[40]

Petro symbolism dominates Rara. The central meeting place of the best-known Rara bands is the southwestern region between Petit Goâve and Léogane. Vigorous

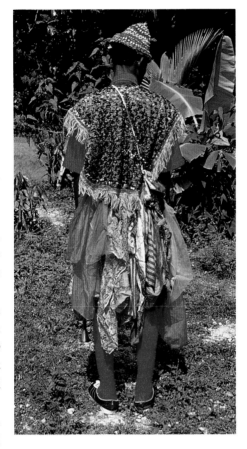

Figure 129 Major jonc of Groupe Modele Numéro Un from Carrefour du Fort near Léogane, Haiti, 1985. The vari-colored scarves tucked into his belt refer to the multitude of spirits called upon to protect the band and to the theme of penitence underlying the physical ordeal which is Rara.

Petro rhythms dominate the music. In his classic study of *vodoun*, Louis Maximilien has clearly identified Rara with the Petro rites, particularly in its evocation of magic and its use of whips, fire, and gunpowder.[41]

The differences between Rara and pre-Lenten Carnival have intensified in this century. Carnival at one time brought everyone to the streets, bridging the chasm that splits Haitian society in terms of language, wealth, and ethnic identity. Their emphatic separation reflected the devalued status of the African components of the Haitian heritage, particularly in relation to *vodoun*. The suppression of *vodoun* that began during the American Occupation from 1915 to 1934, continued into the 1940s as an "anti-superstition" campaign. Carnival was supported by authorities, while Rara was denigrated in a neo-colonial revival of class distinctions. Traditional bands found streets closed to them. Their money-gathering activities were denounced as thievery. In fact, the bands during the later years of the Occupation had become increasingly nationalistic and hostile to any foreign presence.

In contrast to Carnival's loosely organized revelry, which often incorporates individual masqueraders, Rara groups are collective and highly disciplined. Masquerade is restricted to certain officials of the band. The most elaborate appear only during the final days before Easter. Rara is an ordeal, with participants traveling miles across the countryside by foot. Music and dance are prescribed by the leader, and follow certain patterns that show the strong bond with Petro. Most of the instruments are handmade with ritual observances and restrictions. Money collected from performances is held for the common good. Most bands emerge from the *houmfort*, the *vodoun* temple. References to *vodoun* spirits are ubiquitous in both music and dance.

The break between Carnival and Rara is dramatized by a custom called *brûler Carnival*. Late on Tuesday night Rara bands set fire to objects used in Carnival—bits of cloth or masks. Then the band members dance and sing around the fire, performing ritual acts such as pouring libations of *clairin*, a raw local rum, in the cardinal directions, in a gesture commonly used in *vodoun* ceremonies. After the flames die out, each member, in order of his importance in the group, plunges a finger into the ashes and draws a cross on his forehead. An echo of the Catholic custom of Ash Wednesday, the act alludes to the limitations of the profane and the certainty of human mortality.[42]

Rara begins at once. The initial exercise is called *balancer Rara*, an acting out of the potential perils faced by the bands. Typically, Legba is invoked first. He appears as Carrefour, guardian of crossroads and thresholds, who must be placated in order to assure a safe passage. The chief of the association solicits his protection using libations of fresh water and cracking a long whip of sisal fibers. The use of the whip is as frequent in Rara as it is in the Petro rite of *vodoun* and the meetings of secret societies *(Figure 130)*.[43] The whip is cracked at entrances and exits to deflect potentially malevolent forces.[44] In 1984, several of the more important whip-bearers wore elaborately assembled necklaces of leaves, apparently as protection in their vulnerable front-ranked position.

In Carrefour, a suburb of Port-au-Prince, a small band prepared for an early *sortie*. In the roofed outdoor portion or peristyle of the *houmfort*, the official circled the center post, the *poteau-mitan*, that is believed to be the pathway down which the spirits descend to possess the faithful. A few false starts, or feints, are designed to confuse any spirits who might obstruct the band's itinerary. At such a ceremony at Beudet in 1984, a fire was lit, within the peristyle, upon ritual stones that were

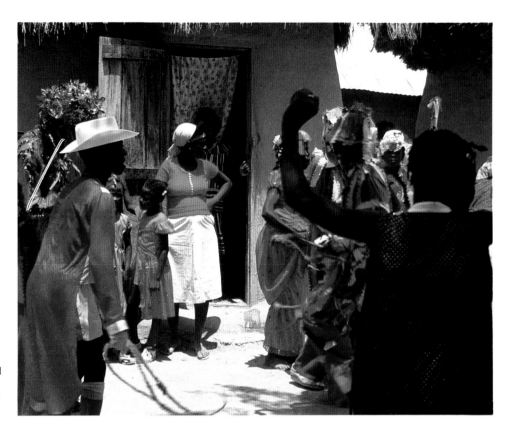

placed over a hole in the earthen floor. Blue flames were nourished by repeated libations of *clairin*. Kneeling over the depression, the leader, the Maître Rara, spoke in the secret language known only to *vodoun* adepts. All participants ran over the flame three times, circling the center post, while the whip cracked repeatedly. The Maître explained that the maneuver's purpose was to give strength and protection for the ordeal ahead. Further, he said, the ceremony was intended to "raise the participants to a higher level of being and action," in effect, to sacramentalize the activity to come.

The music of Rara is dominated by the *vaccines*,[45] which consist of three or four bamboo tubes of varying dimensions called Maman, Foula or Seconde, and Petite. They are often painted, as are the drums. It is believed that their durability and effectiveness depend upon proper ritual preparation. The cutting of the bamboo, which must occur five days before the new moon or three to five days after a full moon,[46] is accompanied by libations, prayers, and singing. Courlander has suggested that the word *vaccine* derives from a word for cow horn, which is played as a musical instrument in some parts of the southern peninsula of Haiti, and also is used to apply medicine through a hole pierced in the tip. The magical-medical preparation was called *vaccine*—the name transferred to the horn applicator, and finally to the bamboo trumpet.[47]

The *lambi*, or conch shell, is another aerophone used by the bands. Blown as a signal horn by the *maroons* who led the revolution for Haitian independence, it has been associated with Haitian nationalism. Beyond its use in rituals performed for the sea deity Agouwé, it signals mourning at funeral wakes and sounds the alarm in public emergencies. A variety of tin horns, some with bizarrely twisted tubing, completes the traditional ensemble of wind instruments. Most are homemade. One type, resembling a large trumpet, is called a *clairon*.

Drums are of the Congo or Petro type, made of light wood and compactly tuned with tightened cords or hoops, in contrast to the bulkier peg-tuned Rada drums that do not leave the *houmfort (Figure 131)*. Their use is another link to the Petro rite of *vodoun*.[48] A flat circular drum called *basse*, with circular metal disks mounted in the rim, resembles the American tambourine. The smallest drum is the *cata* or *petite*. Although the drummer plays a less important role in Rara than in the *houmfort*, he is always singled out as ritually significant. At Gonaive, the band Aimable meets at the crossroads of Vieux Chapelle on the eve of the first *sortie*. There, a goat is sacrificed and the ceremonial meal of rice prepared with the goat's blood is consumed by all participants. The dead animal is passed over the shoulders of the drummer, affiliating him with the value and meaning of the sacrifice.[49]

Figure 131 A battery of Petro and Congo drums "put to sleep" in a peristyle in Archaie, Haiti, 1985. Identifiable by the way in which the bindings secure the drumhead, the instruments are gathering the necessary force to lead the Rara procession the following day.

Scrapers used in the Rara celebration have both African and Amerindian prototypes. The most spectacular is a tin cylinder with conical tips, a *grage*; this is perforated like a common kitchen grater and played by rubbing a stick across its roughened surface. The *tchancy*, a cylindrical rattle filled with dried seeds, is used in the peristyle section of the *vodoun* temple by the song leader. The *tchatcha*, a dried gourd attached to a wooden handle, also appears in the peristyle, as well as in Rara. The unusual *joucoujou* is a cross of sticks terminating in three seed-filled gourds, with one arm piercing a fourth gourd that is elongated to form a handle. Courlander attributes its symbolism to a Cuban rattle-cross, used there by the Abakuá Society; others assign African origins.[50] The *ogan*, a metal gong, derives indisputably from African prototypes. Other pieces of metal and glass are struck, as well, to accentuate the principal rhythm.

Although there are no dances reserved exclusively for Rara, the *banda* is a favorite, as is the *chairo-pié* or *charges-au-pieds*, a dance observed most frequently in the Léogane region. Its constant halt-run movement, echoing the feints of *balancer-rara*, is useful for covering the considerable distances of Rara trajectories. The *banda* is also a funeral dance, its sexually suggestive hip-thrusting movements showing that life emerges from death.

New Rara songs are composed each year, some of the more popular and obscene carried over from Carnival. Selected and directed by the *reine chanterelle* (song queen) or *samba*, they are sung by the chorus of women. The content of songs is crucial to the movement and performance of the band. Some, referred to as *chanter point* (singing a point), chastise some individuals for bad behavior, especially the sexual misbehavior of women. *Loa* are often invoked—most frequently Zaka, connected with cultivation and fertility; Loko, related to trees, vegetation, and healing; and Legba, as guardian of dangerous crossroads. All these deities are related to the countryside, its landmarks, its products, and its people.

Music and dance not only contribute to the atmosphere of gay abandon characterizing Rara, but are also peaceful outlets for competition. But beneath the surface is the threat of violence and vengeance controlled by military discipline, suggested by the emphasis bands place on protective devices and strategies. The "combative compulsion," the motivation to compete violently for dominance, is preeminent in Rara. Most of the strategic planning in terms of decoration, maneuvers, routes, and rituals serves one end—to *krasé Rara*—to crush or dominate the opponent, or to protect oneself or the band from attack.[51] The leader directs the route of the band to maximize friendly encounters (when songs of greeting and gestures of salutation express amity with another group) and minimize hostile ones (when a veritable arsenal of natural and supernatural weapons may be employed). Toxic powders

fabricated to confuse, fatigue, or even paralyze or kill an opponent are as effective as the daggers, machetes, and slingshots that are often carried. Haitian scholar Gerson Alexi names several of these potions: *poudre tousse, poudre chaut-frait, poudres zombis* or *poudres morts*, the latter being used to call upon the powers of the dead.[52] A pouch containing such materials is part of the regalia of the leader; its use is controlled by him.

Magic and mysticism pervade Rara. Talismans are sold on the streets, as they are at the pilgrimages which occur at various times during the year in Haiti. The comparison of Rara with these pilgrimages is not inapt. A number of *houngans* interviewed claimed that dancing for Rara was a sacred obligation. According to André Pierre, Rara is not for pleasure but for exhaustion. It is a duty, commanded by the *loa*. *Houngan* Jean-Luc Beaubrun at Beudet affirmed that, "The mysteries [*loa*] demand Rara. My father passed the secrets to me before he died. Rara is a mystic obligation with an ancient meaning."[53] According to Max Beauvoir, a *houngan* and theologian of *vodoun* who was Director of Carnival in 1982, all Rara bands come out of the *houmfort*. All of them, he insists, are Petro and all are strongly linked to Congo rites.[54]

Rara, like *vodoun*, is a dynamic institution, incorporating change and regional variations. It serves as a cohesive and identifying force in smaller communities. At the same time, it stimulates a healthy competition among them. Rivalries are particularly strong when leaders of bands come from the same communities and compete for the same adherents. The uncertainties of the Haitian economy and interclass tensions have had marked effects upon Rara. Rising real estate values have pushed the poor into the ravines and crowded sections around the capital. It is from these areas that many Rara bands emerge. Dwindling funds have stifled some of the artistry, such as that of the elaborate headgear in the forms of European crowns and military caps, confections of tinsel, cloth, and paper, elaborately sequinned caps, and feathered straw hats in fanciful shapes, all of which older observers recall having seen. Nevertheless, cheap colorful cloth and simple objects purchased from street vendors or in the Iron Market of Port-au-Prince are used to make original and striking assemblages *(Figure 132)*. Small mirrors, combs, discarded packaging, buttons, and hardware items are affixed to panels and strips of brightly colored fabric, which are then attached to everyday garments. Funds collected on the rounds of the bands are now sorely needed by their members, the band forming a kind of ad hoc mutual aid society. All of the leaders emphasize that their obligations to participants are taken very seriously.

Formation and continuity of the bands help consolidate and stabilize local authority. In this sense they provide governmental functions parallel to those of the secret societies. The band itself forms a miniature government and recognizes specific supporters, many of them political figures. It has been, and continues to be, a reservoir of potential assistance during times of political instability. The general defection from countryside into the capital, however, has reduced the number of bands in the smaller centers where the traditions were observed most faithfully. Urban celebrants who have little understanding of the significance underlying Rara tend to profane the authentic observance. The mobs of youths who clog the streets of Léogane on Holy Friday evening, whooping it up with generous swigs of *clairin*, have more immediate pleasures in mind than celebrating ancestral ties or venerating the *loa*.

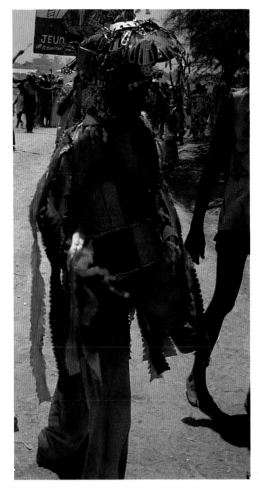

Figure 132 Rara celebrants wearing unique and original assemblages of cloth and decorative objects on the road during Good Friday processions in the Artibonite Valley.

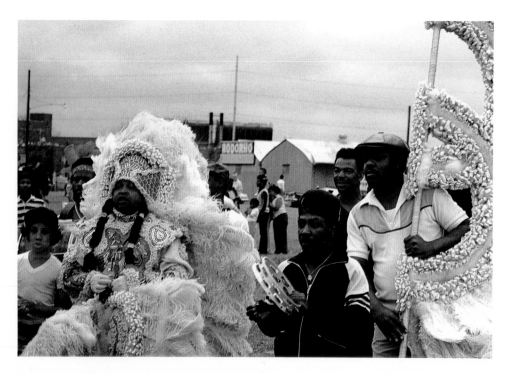

Figure 133 Chief Gerald "Jake" Millon of the White Eagles leads a chanting "second line" on Mardi Gras Day, New Orleans, 1979.

Black Indian Mardi Gras in New Orleans

Barbara Bridges

> . . . The next time you see an Indian, ask him to "open up." If his mood allows, you will see "the prettiest thing you're gonna see all day."[55]

Unlike festivals in Brooklyn, Toronto, and London, the festivities in New Orleans did not emerge in the twentieth century from enclaves of Caribbean immigrants. Rather, Mardi Gras celebrations in New Orleans are almost as old as the city itself. Like Junkanoo, Wild Indian Masquerade, John Canoe, and Rara, New Orleans's pre-Lenten Carnival celebrations are variations of Afro-Caribbean festivals that underwent further creolization in North America. Mardi Gras combines the European, African, and Caribbean influences of West Indian festivals and their variants, and, like a tasty Callaloo, adds more spicy ingredients from another continent.

The city of New Orleans developed much like the Caribbean islands. Amidst native Amerindian tribes like the Natchez, Choctaw, and Chickasaw, New Orleans from the late 1600s onward hosted peoples of French, Spanish, British, African, Afro-Caribbean, German, and Canadian parentage. With the major presence of Roman Catholicism, along with strong commercial ties between Louisiana and the West Indies,[56] many people practiced pre-Lenten traditions, while slaves congregated on Sunday afternoons to sing and dance. The development of pre-Lenten festivities from these early practices parallels that of some West Indian celebrations, which were characterized by episodes of racial segregation, violence, prohibition, and integration.

The pre-Lenten Carnival of New Orleans retains two distinct traditions of aesthetic significance. One, born of French Catholic roots in the seventeenth century, consists of a street parade with decorated floats and masked revelers in the French Quarter. Participants dress as characters from classical mythology, harlequins,

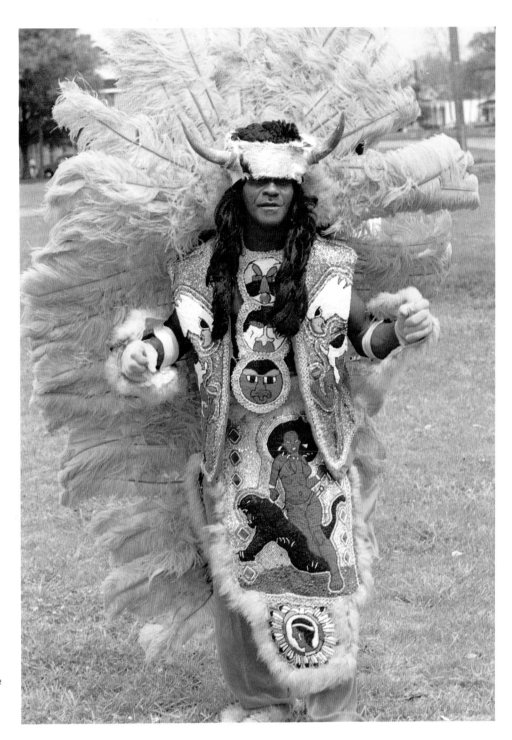

Figure 134 Wild Man Lionel Robichon sports a horned headdress with his Mardi Gras suit. The features of Plains Indian-style dress have been heavily incorporated into contemporary New Orleans Mardi Gras designs.

dragons, cartoons, whatever their imaginations conjure. This celebration begins on the Twelfth Night after Christmas and culminates on the day before Lent, Shrove Tuesday or Mardi Gras. Initially a celebration of the white gentry who organized themselves into elite Carnival clubs called *krewes*, this Mardi Gras celebration consists of by-invitation-only masquerade balls, street parades with commercially-produced floats, and the selection of a King, Queen, and Court for each *krewe*.

In the 1860s and 1870s the free black population of New Orleans formed their own Carnival clubs and began to participate in Mardi Gras.[57] Because of the city's racial schism, however, a second pre-Lenten masquerade may have emerged, a

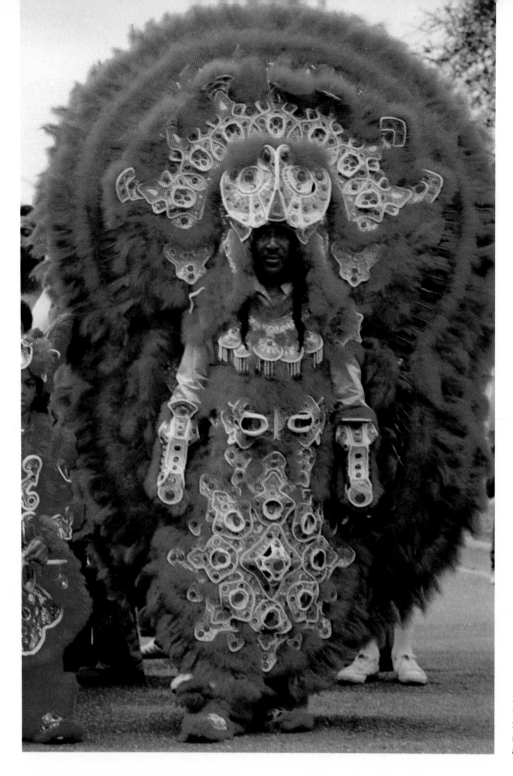

Figure 135 Big Chief Allison "Tuddy" Montana of the Yellow Pocahontas wears his 1979 rhinestone costume. His designs have been setting Downtown-style trends for four decades.

celebration exclusively for working-class Blacks who drew on African rhythms and native Amerindian motifs to create a celebration that is unique to New Orleans, but still akin to Gombey celebrations in Bermuda, Junkanoo in the Bahamas, and masquerades in West Africa.[58]

Called the Black Indians or the Mardi Gras Indians, these neighborhood "tribes" display their dazzling, colorful artistry each year on Mardi Gras, and two to three Sundays later on St. Joseph's Day. They emerge Mardi Gras morning, bedecked in vividly colored costumes. Beneath one hundred pounds of canvas, feathers, plumage, rhinestones, beads, sequins, and velvet, they assume their tribal positions as Scout, Flagboy, Wildman, Second or Third Chief, Queen, Big Chief, Young

Blood, or Trail Chief, and they move through their neighborhoods, adding tribesmen and an entourage called Second Liners *(see Figure 133)*.

In a call-and-response chant punctuated by tambourines, the tribes move from house to house and bar to bar in informal competition. When opposing tribes meet, there is dancing and showing off, a formal display of costumes, hand signals and tribal gestures, and a shared pride in "being Indian." At one time there was violence in these confrontations. Anything dropped on the ground meant "spreadin' the table for blood."[59] Today, the competition is for aesthetic stakes. Says Chief of the Yellow Pocahontas, Allison Montana, "They used to carry hatchets, razor sharp, and real shotguns. Now it's all changed. They fight with their costumes . . . they try to outdress one another."[60]

The accompanying music reflects tribal pride as well as Afro-Caribbean roots. The song "Xango Mongo Lo Ha," popular between 1915 and 1925, referred to the Yoruba diety, Shango. It also used North American Indian words and intonations, and Haitian *vodoun* language to convey a theme of pride.[61] Today, the chorus, "Oh the golden crown, oh the golden crown/Big Chief Tuddy got the golden crown/Big Chief Tuddy gonna take 'em down,"[62] reiterates the theme of tribal pride and acknowledges the stature of Chief Montana who, with four decades of masquerading to his credit, is considered the "Big Chief of the City."[63] The song "Meet the Boys on the Battlefront," refers to tougher, more violent times when tribal confrontations ended in bloodshed.[64]

Constructed in sections or pieces, the costumes have the same overall form. There is a radiating feather or plume headdress, or crown, that often trails the ground. Pants, shirts, aprons, vests, tunics, or chest panels are used, along with assorted arm patches, boots, braids, and perhaps a staff or shield. The crowns are stylistically like the headdresses worn by North American Plains Indians, only highly embellished and quite large, often approaching six feet in diameter. Depending on one's tribal position, the headpieces may show differences. A Wildman, for example, might wear a fur helmet with horns, similar to that of a Mandan warrior *(see Figure 134)*.

Each costume is handmade by the wearer; each sequin or rhinestone is painstakingly sewn on by hand. The materials differ with each individual. Chief "Tuddy" Montana has been masquerading since 1947. Now in his sixties, Montana's creations are considered among the best *(Figure 135)*.[65] He builds three-dimensional abstract patterns in sequins, studded with stones of different colors, and attaches them to vests and aprons. His crowns are huge, often containing as many as 350 feathers. With bold color and symmetry, Montana's suits take on the markings of a butterfly. He says abstract, sequin designs are "more artistic, demand more creativity" than rhinestone or beaded mosaics. For Montana, "That's where the contest is . . . me, fighting myself . . . being different each year."[66] He claims to be a trendsetter whose designs are copied by others in subsequent years. Artistic individuality is at the heart of the Mardi Gras Indian costumes, and innovation is encouraged.

Black Indian tribes are divided into two very general stylistic factions: the Downtown tribes, who prefer sequins; and the Uptown tribes, who use rhinestones and beads in pictorial patches. Larry Bannock, Chief of the Golden Stars and formerly of the White Eagles, creates his suits in the Uptown style, using a rhinestone background highlighted by beaded patches with Indian themes. For

Bannock, the choice of colors is very important and his favorites of red, gold, and blue appear frequently in his carefully planned themes. Bannock's vest panels on his 1985 winning costume show an Indian with spread eagle wings emerging from flames, a large bald eagle, and a seated Indian medicine man. Both front and back panels are set against the backdrop of a crescent-shaped moon, referring to New Orleans's sobriquet, "The Crescent City," while the other images suggest prowess, power, and Shango. Bannock's work speaks of strength, pride, and independence.

Bannock changes his panels each year and he often gets his ideas from illustrations, although, he says, "Different ones are getting so hard to find."[67] Common Mardi Gras Indian motifs include eagles, horses, Indian portraits, snakes, butterflies, cowboys, stage coaches, and even totem poles. Indians of many tribal nations in North America appear in the works.

Bannock claims proudly that working in rhinestones and creating figural costumes necessitate more work and provide more design challenges than abstract, sequin suits *(Figure 136)*. In executing his patches on canvas, Bannock starts from the top center of the panel and builds his design outwardly and symmetrically.[68] His special techniques achieve a look that sets him apart from beginning artists. His 1985 tunic, for example, is convex in front. To achieve that shape, the Chief used silk thread coated in beeswax. When he finished sewing, he set the piece on top of his television where the heat melted the wax, tightened the canvas, and puffed up the patch so that no padding was necessary.[69]

In spite of the Black Indians' claims that one style demands more skill or design sense than another, each artist spends many hours creating a single costume. After spending anywhere from $1,000 to $3,000 on materials, an artist may get started sewing in August or September for the February Mardi Gras. Tribal rehearsals take place throughout the year in neighborhood bars, parks, or houses, and gain momentum on the Sundays prior to Mardi Gras.

True to the assemblage aesthetic of pan-Caribbean festivals, Mardi Gras Indians use glass beads, velvet, rhinestones, ribbons, sequins, canvas, feathers, and ostrich plumes, compiled in layers of fragments. The layering of the costumes allows the opposing Chiefs to "undress" one another, displaying artistry to an admiring audience.[70] Before the use of synthetic materials, costumes were made of egg shells, turkey feathers, and broken glass.[71]

As in so many festivals, the Mardi Gras Indian costumes are eventually destroyed. Some patches may be saved and integrated into future costumes, but crowns and color schemes change each year. Larry Bannock claims his own superstition leads him to always make a new rhinestone patch for the front of his costumes.[72]

The expense of masquerading, as well as the changing neighborhood alliances, cause the number of active tribes and tribal members to fluctuate from year to year. While some tribes vanish, others are resurrected. Creole Wild West is an old tribal name resurrected by young, talented members. Under the leadership of Chief "Little" Walter Cook, the tribe is one of a few that has taken to performing on stage at the annual New Orleans Jazz and Heritage Festival *(Figure 137)*. Such performances, as well as recorded albums of Mardi Gras Indian music, have increased public awareness of Black Indian artistry. Tribes seem committed to furthering the Mardi Gras Indian tradition. Montana teaches younger Blacks about costume making, and Bannock gives pieces of his cast-off costumes "to other members 'cause they can't always afford to make their own and this keeps their interest."[73]

Figure 136 The Uptown-style of Larry Bannock incorporates carefully sewn beads and rhinestones depicting traditional American Indian motifs in New Orleans Mardi Gras of 1986.

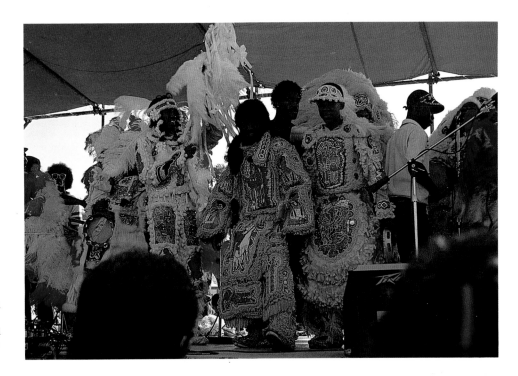

Figure 137 Creole Wild West performs on stage at the 1985 New Orleans Jazz and Heritage Festival. Public performances and record albums have helped perpetuate the Black Indian tradition in New Orleans.

It is believed the New Orleans Mardi Gras Indian tradition started on a Mardi Gras day in the 1880s when a leader named Becate Batiste and a group of young men dressed as Indians proclaimed themselves the Creole Wild West. Becate, the great uncle of Chief Montana, was a descendant of Africans and North American Indians.[74] Maurice Martinez, scholar on the Black Indians, has said, "This cross-fertilization of two of America's most repressed cultural groups has resulted in a powerful expression."[75]

Indeed, there is much speculation about which converging African, Afro-Caribbean and American Indian cultural and aesthetic forces led to the creation of the Mardi Gras Indians. New Orleans's black slaves had been congregating since about 1805 on an open field called Congo Square, an area previously used by the Oumas Indians to celebrate their sacred Corn Festival.[76] The slaves would sing and dance their African favorites.[77] In 1814, such gatherings were restricted to Sundays. Twenty years later, they were prohibited altogether. In 1845 they resumed, and after the Civil War and the abolition of slavery, some Blacks continued to meet away from Congo Square.[78] At these gatherings men wore the cast-off finery of their masters, women had brightly colored Madras kerchiefs on their heads, and the plain garments of children were "relieved by bright feathers or bits of gay ribbon."[79]

Other black costumed dances or processions in New Orleans included the masked quadroon balls, to which upper-class white men escorted mulatto women;[80] *vodoun* ceremonies, very popular among Haitian emigres;[81] and costumed processions such as that observed by Reverend Timothy Flint in 1824–25:

> Some hundreds of negroes, male and female, follow the king of the wake . . . For a crown he has a series of oblong, gilt-paper boxes on his head, tapering upwards, like a pyramid. From the ends of these boxes hang two huge tassels, like those on epaulets . . . All the characters that follow him, of leading estimation, have their own peculiar dress, and their own contortions.[82]

Each of these must have helped maintain African and Afro-Caribbean rhythms, masquerade traditions, and spiritual beliefs among the black population of New Orleans, which eventually came in contact with cultural traditions of North American Indians.

Blacks and Amerindians had contact with one another as early as the eighteenth century.[83] The potential for intermarriage and cultural exchange continued in the nineteenth century. Great numbers of Haitians, including free mulattoes, black slaves and white planters, fled to New Orleans in the early 1800s to escape the Haitian revolution.[84] They brought *vodoun* religious practices to New Orleans, converging on the city at the same time native southeastern tribes such as the Creeks, Choctaws, Cherokees, Chickasaws, and Seminoles were trying to accommodate themselves to a rapidly expanding white civilization. Both Blacks and Amerindians met strong resistance from a colonial regime that restricted their movements and treated Blacks as subhuman and Indians as savages. Although the United States government pressured the Indians to move west, not all left. They continued to intermarry with Blacks, and together the groups led underground lives, hiding out in New Orleans or in nearby bayous and canals.[85]

There was much to draw Indians and Blacks together spiritually: the Indians' conception of themselves as nations and the Africans' as kingdoms; tribal hierarchies led by chiefs; a bond to nature, the land, and their ancestors; drum-based musical ceremonies; and oppression by white colonialists who feared them.[86] These factors fostered a kindred spirit between the two ethnic groups that resulted not only in creolized offspring, but in a creolized festival aesthetic that may have given birth to the Mardi Gras Indians in an Afro-Caribbean people who were already committed to carrying on their ancient music and masquerade traditions.

The specific aesthetic development of the Mardi Gras Indians is more difficult to assess. Today costumes most resemble Amerindian Plains style dress, such as that of the Sioux tribe. Both costume types incorporate an assemblage aesthetic that includes decorated moccasins, leggings, arm ornaments, staffs, shields, braids, and long feather and horn headdresses. Still, Plains dress was not native to the Amerindians of the southeast. Indeed, with the exception of sparse feather ornaments and vertically projecting headbands, eighteenth and nineteenth-century illustrations of regional Natchez, Chickasaw, Creek, Choctaw, Cherokee, and Seminole dress bear little resemblance to the highly embellished Black Indian suits worn today, suggesting that aesthetic influences were provided by other sources.

Little visual documentation exists for Mardi Gras Indian costumes prior to the 1920s, but it is believed that the earliest Black Indian crowns were short headdresses made with turkey feathers that did not reach the ground, and that the long drop-crown was first used by the Mardi Gras Indians in the 1920s, with the use of ostrich plumes following shortly thereafter.[87] The earlier crown, a more austere headdress, would have been in keeping with southeastern Amerindian styles as well as Amerindian costumes from Puerto Rico, St. Kitts-Nevis and the Dominican Republic. Likewise, the early use of discarded materials such as egg shells and broken glass is reminiscent of Amerindian costumes from Bermuda and Jamaica.[88]

While it is difficult to delineate the aesthetic history of contemporary Black Indian costumes, a number of possible sources for the aesthetic in New Orleans exists. In addition to contact with native southeastern tribes and Caribbean immigrants to the city, residents of New Orleans were exposed to Amerindian culture through publications of the 1700s and 1800s, as well as through popular culture.

Magazines and newspapers ran stories, political cartoons, and illustrations depicting Indian tribes encountered in America.[89] Indian costumes with both long and short crowns are seen amid the crowds of street revelers in New Orleans Mardi Gras in illustrations dated April 6, 1867; 1873; March 23, 1878; February 24, 1883 *(Figures 138 & 139)*. Even *The Illusrated London News* of December 31, 1881 shows an Amerindian costume among British Christmas masquerade fashions.[90] Amerindian images were part of late nineteenth-century culture in Europe and in the United States.

As the Indian nations of the United States were subdued through political and military efforts, the romance of the Wild West and its characters became further entrenched in popular culture through traveling shows. William F. Cody, or Buffalo Bill, began his touring stage show in 1876. Widely viewed and popular, Cody's show included actual Sioux, Pawnee, and Arapaho Indians wearing their Plains costumes. In December 1884, the Wild West Show traveled to New Orleans, staying on through early February, the beginning of the Carnival season.[91] Though dated to the 1880s, the specific date for the first masking of the Black New Orleans tribe Creole Wild West is unknown. The similar tribal titles and costume styles suggest that Cody's Wild West tour, with its fancifully-dressed but politically-vanquished Amerindians, may have focused new attention on shared spiritual concerns of Blacks and Amerindians, and possibly influenced the aesthetic development of the already powerful black performance expression.

The Mardi Gras Indians exemplify the creolization at the heart of the pan-Caribbean aesthetic. African, Caribbean, and North American influences converging to create a fresh aesthetic is similar to what occurred in the West Indies. And although the Amerindian form appears with variations in Toronto, Brooklyn, London, Trinidad, St. Kitts-Nevis, Brazil, Cuba, Jamaica, Bermuda, and the Bahamas, nowhere else is it accompanied by quite the same musical refrains, aesthetic form, and artistic technique that characterize New Orleans's Black Indians. Their century-old tradition and powerful history are seasoned with lots of ingredients, like a good Callaloo soup.

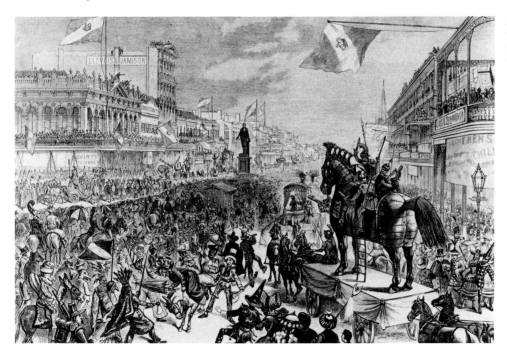

Figures 138 & 139 Depictions of Mardi Gras festivities from the late nineteenth century show Indian costumes with both long and short crowns.

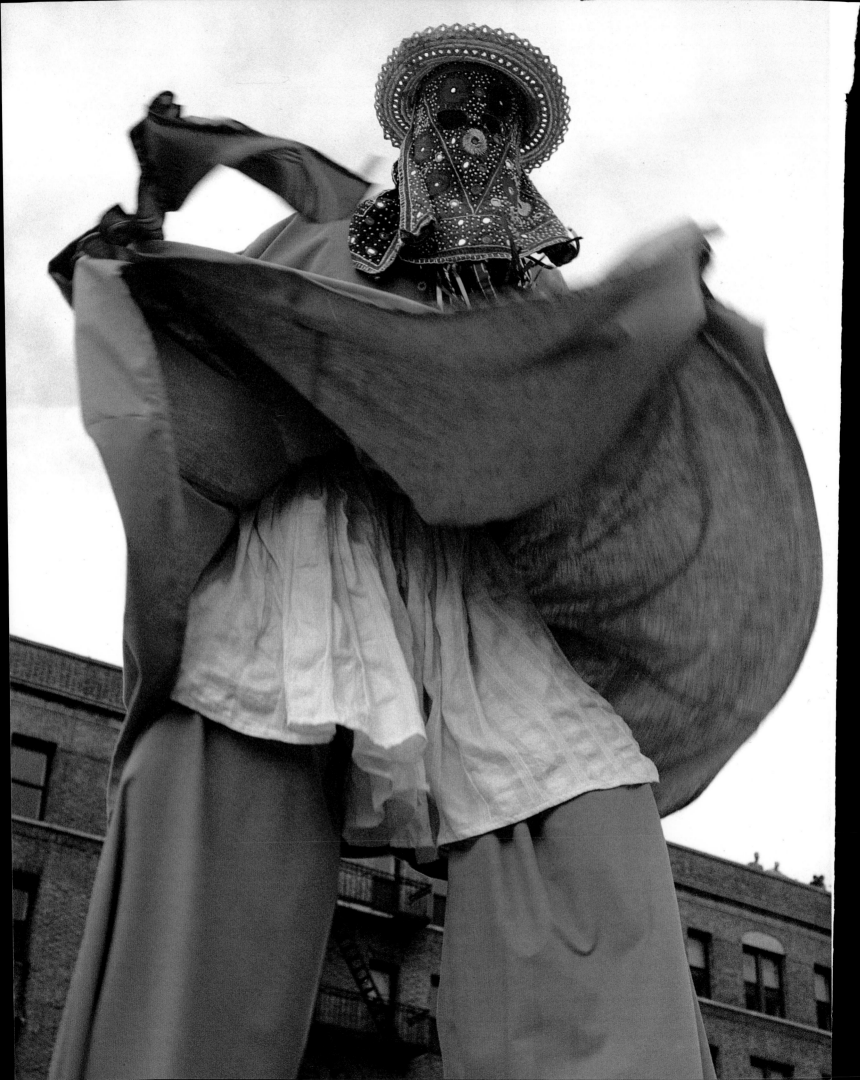

John Nunley

6

Festival Diffusion into the Metropole

The people of the Caribbean have always been on the move. Before Europeans came to the New World, Carib and Arawak Indians migrated continually from island to island. Later, slaves were shuttled to and fro as British, French, and Spanish settlers sought their fortunes there. Free Blacks, soldiers, and sailors also moved about the region, settling in Africa, Asia and the Caribbean after they retired. Considering this nomadic heritage, it is not surprising that Caribbean peoples and their festivals have become established in some of the great cities of Europe and North America. Presently, festivals are held in London, Amsterdam, Toronto, New York City, Miami, Los Angeles, Boston, Philadelphia, and Detroit *(Figure 140)*. Many citizens and expatriates of Caribbean countries travel widely to participate in these new festivals.

> The Virgin Islands are three islands and each island carry a different day for their Carnival. St. Croix Carnival is New Year's Day. Then you comin' on to St. Thomas. Then later on in the year you get St. John. Everybody shares the same part of the pie. And you get the people from one island going to the other islands.[1]

Figure 140 This Moco Jumbie from the 1987 Brooklyn Labor Day Festival played by David Robeson reveals the intricate detail of the face piece and the beaded and sequinned hat, features which tie it to Africa.

This crisscrossing from island to island and city to city diversifies the festivals, resulting in a Callaloo of global proportions. Because the traditions of Caribbean festivals are carried to new places by word of mouth, information about their origins varies. Three of the festivals, however, can be traced to their beginnings. The Brooklyn Labor Day Carnival, the Notting Hill Gate Carnival in London, and the Toronto Caribana festival were all formally organized in the 1960s, when migrations from the Caribbean began to have significant impact on the demographics of these cities.

Brooklyn Carnival

New York equalize you
Bajan,[2] Grenadian, Jamaican, tut mun
Drinking they rum
Beating they bottle and spoon
Nobody could watch me and honestly say
They don't like to be in Brooklyn on Labor Day[3]

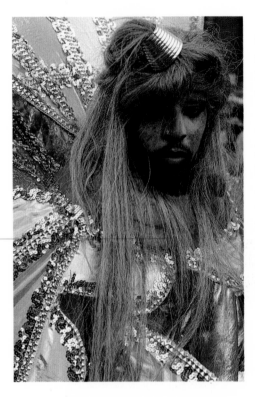

Figure 141 A Trinidadian-style costume with sequinned wings radiating from the shoulders appeared in the 1987 Brooklyn Labor Day Festival.

Figure 142 The flowers on this traditional costume from the 1987 Brooklyn Labor Day Festival symbolize fertility, renewal, and beauty.

An estimated 500,000 West Indians in Brooklyn have each added a little piece of the Caribbean to the celebration. Hot roti, barbecued goat, Jamaican and Trinidadian beer, and even Callaloo made with fresh dasheen are sold along Eastern Parkway throughout Labor Day. On this day Brooklyn is a Caribbean outpost transformed by *mas (Figures 141 & 142)*.

Caribbean peoples began migrating to New York at the beginning of the twentieth century. As more West Indians settled there, great Calypsonian musicians like Lionel Belasco found it convenient to record their music in the city. Small calypso revues together with masquerading appeared in Harlem in the 1920s.[4] These soirées were held in the Renaissance Ball Room during the pre-Lenten season. The event became so popular it had to be moved to a larger area; but because of the cold winter weather, the celebration was moved to the Labor Day holiday and onto the street.[5] A Trinidadian named Jessie Wardle (sometimes spelled Wattle) organized the first Labor Day celebration in 1947 to remind her of Carnival in her birth place. She obtained a permit from City Hall to parade on Lenox Avenue from 110th to 140th streets.[6] The festival grew until 1964, when the dissident elements in the Black Power movement deemed the event detrimental to their interests and provoked young Blacks to pelt paraders with stones, cans, and bottles. Such disruptions contributed to the cancellation of the Harlem festival.

Across the Brooklyn Bridge, a West Indian community was growing rapidly. There Rufus Goring organized the West Indian Day Development Association to coordinate festival programs and to obtain a permit to hold the masquerade on the side streets of the borough. Yet during the late '60s, King and Queen competitions and Sunday music revues were held in Manhattan at Madison Square Garden; and a parade lasting a few hours followed on Monday in Brooklyn. After Goring's death, the leadership of the festival passed to a Venezuelan-born New York City transit worker named Carlos Lezama, who molded the festival into its present form.[7]

This new leader took charge at a time when young people were demonstrating against everything from racism to the Viet Nam War. As a street phenomenon, Carnival was vulnerable, a potential target of political activists, even though it was confined to the St. Johns neighborhood on Washington Avenue and Dean Street. To accommodate the growing number of participants, a larger arena was necessary. It seemed to Lezama that the solution was to give the festival a clearer structure and identity. Rather than begin at the bottom to affect this change, he sought out Mayor John Lindsay and Governor Nelson Rockefeller. Lindsay concurred with Lezama's intention to incorporate the festival, directing him to the attorney general's office for legal advice. The governor encouraged Lezama to include the word "American" in the new organizing committee's title, to give the festival broader appeal. The Brooklyn Carnival was thereafter organized by the West Indian-American Day Carnival Association, Incorporated. Drawing on his experiences of Carnival in Port of Spain, Lezama moved the Dimanche Gras show to Brooklyn, fittingly on the

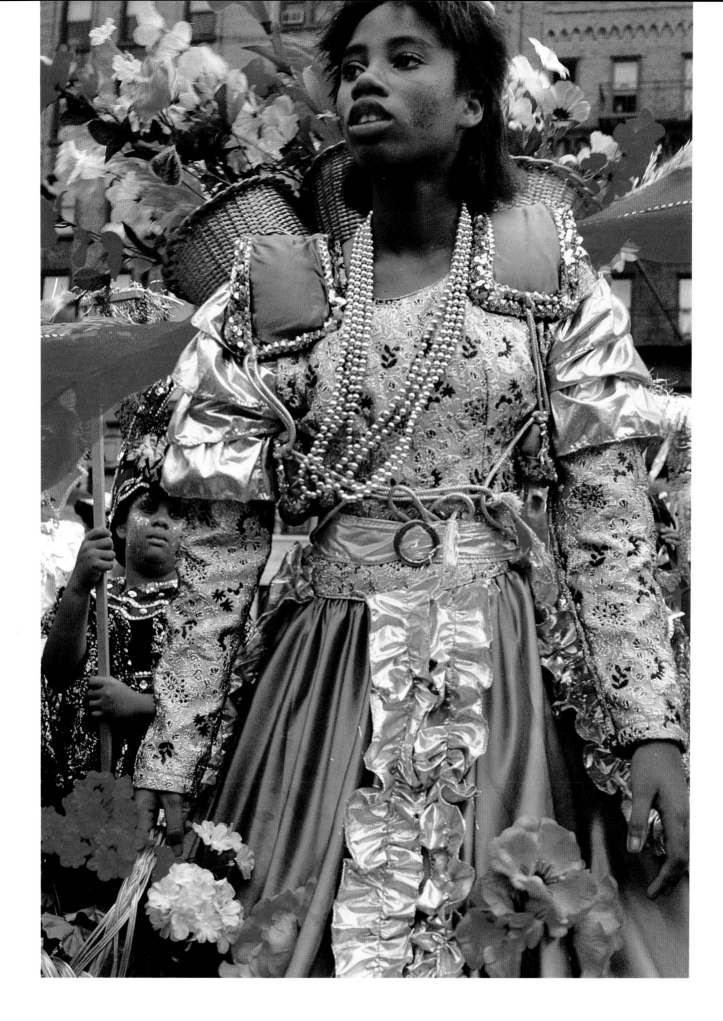

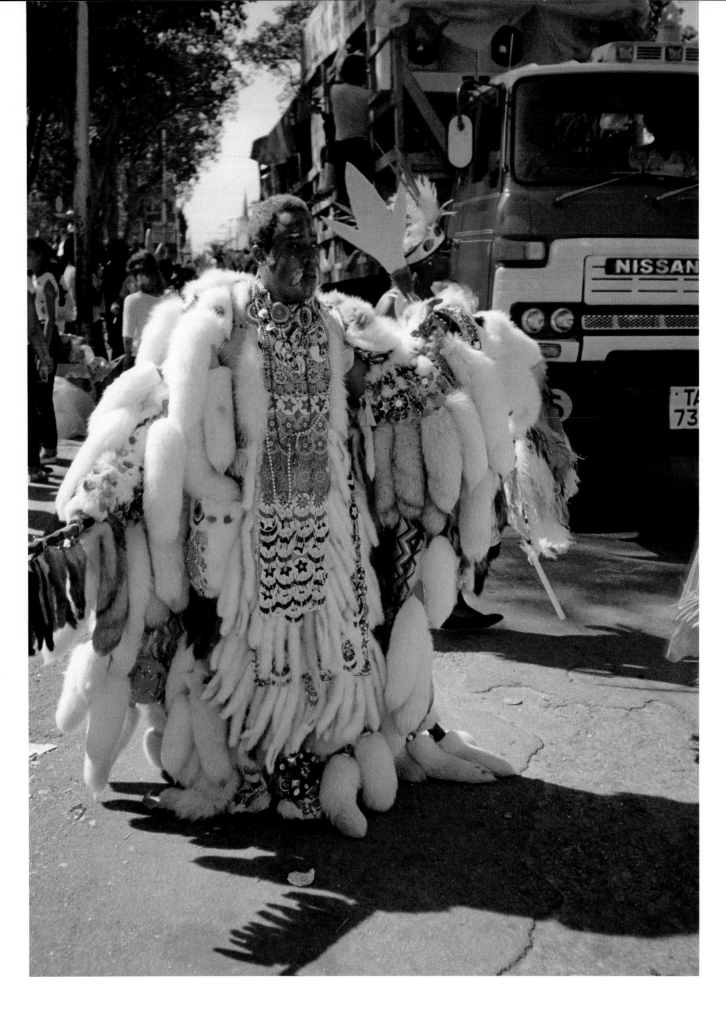

grounds of The Brooklyn Museum where it could be formally judged. The Monday parade, moved onto Eastern Parkway in 1969, was now an integral part of the festival, since it passed by the Museum grounds.[8]

In 1973, Trinidadian band leader and designer Mervin Johnson won the King competition with Maboya, and Morris Stewart won Band of the Year award with Oriental Fantasy. Since then, Trinidadian band leaders have played *mas* in Brooklyn, and Brooklyn designers have played in Trinidad. Yet it remains a Brooklyn affair: "And then now in New York, Mervin and Stevie together, double trouble."[9] Combining Caribbean and expatriate talent, Brooklyn *mas* has grown each year.

Under Lezama's direction, the festival begins with a Calypso revue on the Thursday night before Labor Day. Friday is devoted to reggae music for the large Jamaican population. Steel band and calypso competitions are held together with the presentation of Queens and individual characters of each band on Saturday night. On both Saturday and Sunday afternoons, Kiddies Carnival is held from noon until four. The Dimanche Gras show opens with Calypso and closes with the King costume competition. As at the Savannah in Port of Spain, admission is charged for seats on the Museum grounds, but in both places young people enter at no charge and stand in the wings or at the back. The Monday parade begins about 10 a.m. on Eastern Parkway and the bands dance by the stands in front of the Brooklyn Museum, the last one passing by at 6 p.m.

Over two million people watch this festival; first-time visitors often watch in dismay. Even police officers have asked more than once what this was all about. Unlike Port of Spain, security is extremely tight in Brooklyn, with forty or more officers at every intersection of the parkway, and unlike Trinidad police, this security force is armed. Despite the enormous crowds drinking and dancing, the festival has remained relatively peaceful and safe.

Tuesday after the festival is over, band designers and organizers turn to Trinidad and the grand *mas*, which has inspired the present Brooklyn version. They carefully watch developments in the *mas* camps during the fall to find new expressions for the next parkway parade.

Born in 1944 in Port of Spain, mask maker Neil Arthur Hodge moved to the Bronx in 1970, where he made costumes for five years, winning competitions each of the three times he entered the Brooklyn festival. He joined Mervin Johnson in 1986 in the Brooklyn band Feather Explosion. The band also won first place in the Boston carnival.

Mas was always on Hodge's mind; although each costume is destroyed, lost or given away, the challenge remained to create an even better one. When the *mas* feeling arrived, Hodge explained, he felt compelled to drop everything and return to the costumes.

Like other artists, Hodge enjoyed designing Amerindian costumes because of the popularity of that mask type in Trinidad and because it allows for an imaginative use of feathers and rhinestones. At $6 per twenty-four inch plume, $2.50 for a single rhinestone, and $20 for foxtail, his costumes consumed a major part of his income. Cash prizes only begin to cover the expense. For his 1987 costume, he planned to further explore the Indian theme using a cow skull from a craft shop in Texas. He purchased most of his materials at a shop near 23rd Street and 6th Avenue. Because materials are cheaper and easier to find in New York, many artists from the Caribbean come there to buy materials, as do men who play Black Indians in New Orleans Mardi Gras.[10]

Figure 143 Fur, beads, and rhinestones are the primary materials Neil Arthur Hodge used in this 1986 Fantasy Indian costume for Brooklyn Carnival.

Figures 144 & 145 In this 1985 Labor Day costume by Neil Arthur Hodge, the artist layered reflective materials to produce rich textures like that of the right cuff. The mirrors reflect the surface as well as the ambient light, amplifying the dancer's movements. Peacock feathers, beads, and sequins contrast lavishly with the gold painted boots. These hidden details increase the power of the masqueraders in the eyes of competing dancers.

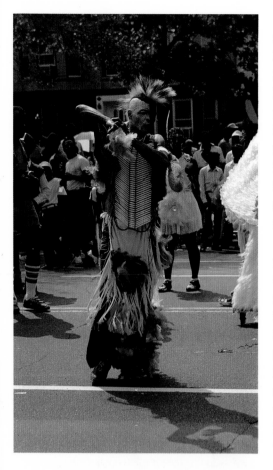

Carnival *mas* has affected others besides Caribbean expatriates. One person moved by Caribbean festival arts is David Robeson, grandson of actor Paul Robeson. Robeson first saw the *Moco Jumbie* dance groups in New York in the early 1970s. Visiting St. Thomas, he saw another version of the stilt masker. Since then he has learned the art of mask making and dancing this particular character and has performed *Jumbies* in Belize, Trinidad, St. Thomas, and other locations in the Caribbean and North America.[11] Robeson has carefully researched the costume and distinguishes between the African, Caribbean, and North American versions in his performances. At summer's end in New York, he participates in Brazilian Carnival, Caribbean Carnival, and the Brooklyn festival (Figure 140). With such artists as Hodge and Robeson, *mas* in Brooklyn has become a colorful and indeed a spectacular event.

The 1985 festival began with the Dimanche Gras show, the pinnacle of all the pre-parade celebrations. Calypsonians such as Crazy, David Rudder and his band Charles Roots, and The Shadow played to the audiences. As in Trinidad, the celebration continued late into the night. For the last time each costumed contestant joined the others at the flanks of the stage, waiting to perform. Fantasy Indians, Sailors, Dragons and masqueraders adopting African motifs paraded to steel band and *soca* down Eastern Parkway in the hot, humid Labor Day afternoon. In the fair-like atmosphere, vendors distributed political literature on city politics and the U.S. stand on South African apartheid. Local handicrafts as well as goods from Africa were sold, including carvings, beads, cloth and leatherwork. As is the custom in the Brooklyn festival, food was abundant, sating the appetites of the two million or so who watched Brooklyn *mas* with the Callaloo mix.

Figure 146 The body costume of this 1985 Brooklyn Indian combines the roach head crest, bone frontlet, and fringed skirt of the Plains Indian.

Figure 147 This costume, King of the band Sea Dreams, was produced in Toronto in 1985 and traveled to Brooklyn the same year. The sea horses and tridents portray the oceanic world envisioned by producer Russel Charter.

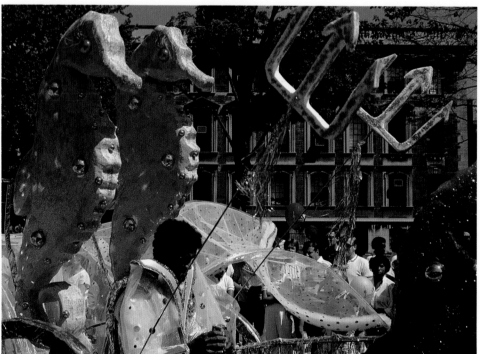

A group of fancy sailors joined masqueraders with rocket ship headdresses, while others wore large multiple collars or headpieces with long phallic nosepieces. In the fantasy category was a beautifully crafted costume from the Toronto band Sea Dreams, consisting of two large gold sea horses with a pair of tridents

projecting in front *(Figure 147)*. The King, who balanced this costume on wheels, danced the entire length of the roadway. Another King depicted two large birds fighting for a snake. One band was proceeded by a bright yellow banner with images of two black arms linked by a shattered chain. The banner read, "Free South Africa, U. S. Get Out". Most ingeniously, an Amerindian King carried his own teepee in the *soca* dance. The teepee flared into an abstract version of a Sioux full-feathered headdress. The King wore a body costume in the Plains style with simulated bone breast doublet and buckskin pants. His painted face was crowned by a roach of Indian design *(Figure 146)*.

Strongly reminiscent of Trinidad was a band called Devils. Like the Jouvay band that inspired them, Devil members wore horned headdresses and simple costumes. Many of the group were covered with reddish oil and dirt, as in Jouvay. Devils jammed to the steel drums of Golden Stars, and occasionally male and female members joined, female in front and males behind, grinding into their partner's backsides or "wining," as it is called in Trinidad. A Back-to-Africa theme band featured a masked character stylized after the Baga fertility goddess mask *Nimba*, from Guinea Bissau *(Figure 148)*. The costume builder, no doubt, found the design in an art book. Noel Audain, a visiting Canadian artist, danced in a King Neptune costume, a dragon-like character with green wings. Neil Arthur Hodge's Amerindian costume that year was heavily decorated with rhinestones and beadwork prominently displayed on the front apron *(see Figure 144)*. The decorated gold boots were matched by the large plumed crown of ostrich feathers *(see Figure 145)*.

Though Brooklyn *mas* lasts only a day, it has made a great impression, particularly since the major newspapers, radio and television networks cover it. Competing groups have emerged in the New York area, but they hold their festivals around Brooklyn *mas*. Brazil Independence Day Celebration, for instance, is held the weekend after Labor Day. Another competing Caribbean festival, Black Day, occurs on the second Sunday after Labor Day. Its organizers frequently invite *mas* bands and steel bands to participate. The Caribbean Cultural Center in Manhattan also sponsors a Caribbean Carnival and invites twenty or more groups to parade to Lincoln Center on the second weekend in August. Though competition can be divisive, in this instance it reveals the importance of the Caribbean and Afro-American community in the cultural milieu of New York. There are substantial pieces of difference in this city, each one sweetening the changing American character.

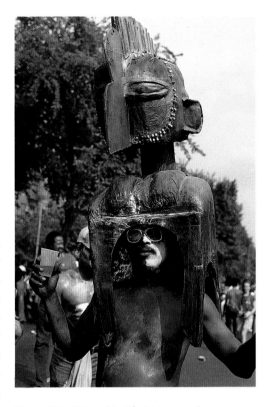

Figure 148 This unidentified masquerader appeared in 1984 and 1985 Brooklyn Carnival wearing a cardboard rendition of the Nimba mask made by the Baga peoples of Guinea Bissau. The artist has faithfully reproduced the parallel rows of beads on the face, representing the rows of brass tacks or studs used by the Baga themselves.

Notting Hill Gate

The origins of the Caribbean-based Notting Hill Gate Carnival are difficult to trace. Major migrations of West Indians to the United Kingdom occurred after their countrymen came to Britain to work in the wartime industries. Initially the large Jamaican population established the West Indian presence in the metropolitan center, and with it came West Indian cultural expressions. Vivian Comma sums up the origin problem: "No one person or group could be said to have brought Carnival Caribbean-style to England. It would be right to say that every Trinidadian or West Indian who came to England brought a bit of it in himself."[12] The Caribbean population brought music, dance and traditional food to its new environment. In the

1940s West Indian culture was promoted with calypsos like "Rum and Coca Cola" and "Nora Nora." In the 1950s, Edmundo Ross's renditions of "Brown Skin Gal" and "All Day All Night Miss Mary Anne" kept it alive. The Festival of Britain booked a Trinidadian steel band in 1951 which was a great success.

From this time, migrations to London escalated. The Walter/McCarran Act, passed in 1952, was partly responsible for encouraging the new migrations, and from 1955 until 1959, from 20,000 to 33,000 West Indians settled in Britain each year.[13] Another 168,000 arrived between 1960 and 1962, before the Commonwealth Immigration Act of that year in effect slammed the door. The new arrivals were received by their friends and families at Paddington Station with "Boat Train Receptions," lavish with Caribbean food, music, and dance, and culminating in what might be called a proto-Carnival. These cultural expressions underlined the West Indians' need to promote their identity and solidarity.

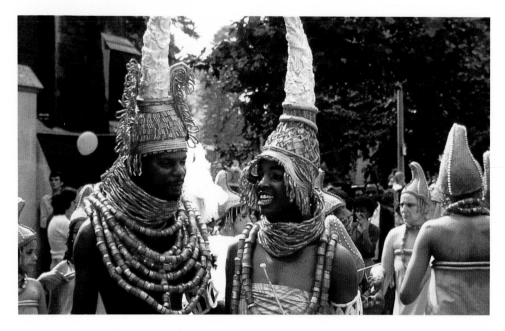

Figure 149 This masquerading pair from the band African Heritage, Notting Hill Gate Carnival, 1985, displayed multiple strands of red, coral-like beads, ivory-colored armlets and beaded caps surmounted by tusk-like forms, an imitation of the royal costumes of the Obas (Kings) of the Benin peoples of Nigeria who have been monarchs since the thirteenth century.

A key personality in the beginnings of Carnival was Rhaune Lazlett, a London-born woman whose mother was an Amerindian and whose father was Russian. Lazlett established the Community Neighborhood Service in the 1960s to respond to the needs of migrants. In May 1965, she had a vision of a parade in Notting Hill Gate, a festival whose participants included Jamaicans, people from other Caribbean nations, and rebellious elements from society, like radical students and middle-class dropouts. The first procession Lazlett organized included cultural dancers from the Ukraine, Cyprus, and India.[14] Later, backed by the North Kensington Amenity Trust in Notting Hill, Lazlett and Anthony Perry promoted a Carnival emphasizing black cultural expression of the West Indies.[15] Under the leadership of Vernon Fellows, Russell Henderson, and Junior Telfer, the festival took on a decidedly Trinidadian character, with steel bands forming the backbone of the event. These bands brought with them the masquerades of Carnival.[16]

> we living in another country and we attempt to put the pan on the road—is the same feeling we looking to get for man to feel free with himself and get in tune with them rhythms that come through the bamboo and forge demself in steel clashing steel to shock you into the rhythmic excellence of blackness that does make your hair stand up when the tune-bum call from Africa[17] *[Figure 149]*.

172

A Trinidadian iconography prevailed amid a primarily Jamaican population because of the need for solidarity among Caribbean peoples. In 1970, as the Black Power movement grew within the expanding London black population, Lazlett canceled the festival, but the celebration continued, led by steel bands.[18]

Steel band director Malcolm Thomas and other pan groups organized mask sections throughout the 1970s under the leadership of Selwyn Baptiste, a musician from Trinidad, and his newly formed Carnival Development Committee established in 1975. Designers and masquerade band leaders brought out large bands illustrating African Fantasy, Flora and Fauna, Sailors, and Jonkonnu, and other West Indian masquerade traditions. The visual arts of the festival took on a decidedly Trinidadian character.

Like Caribbean festivals in the nineteenth century, where police used weapons to thwart masqueraders, the Notting Hill celebration has been marred by violence. In 1976, some 250,000 disillusioned West Indian youths, encouraged by the revolutionary lyrics of reggae, rioted against 1,500 police. Until the end of the 1970s, the festival was characterized by tension, even though the sounds of reggae, steel and calypso were becoming more popular.[19] The tension was evident in the structure of Carnival itself with the rivalry between the Carnival Development Committee and the Carnival and Arts Committee, the latter having been founded by disaffected CDC members with strong political views which they believed should be expressed in Carnival.[20]

Figure 150 Chief Pow Wow, designed by Nicki Lyons, from the 1984 Notting Hill Gate Carnival.

Figure 151 Players from the band Grenada Shortney from 1985 Notting Hill Gate Carnival. This masking tradition derives from St. Patrick's on the northern side of Grenada. Knee-length pants, colorful clothes with mirrors attached, and wire screen mask are characteristics of this costume. Similar masqueraders also perform at Toronto's Caribana.

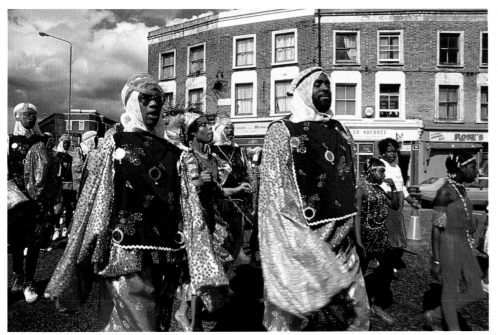

Formally organized by the Carnival and Arts Committee, Notting Hill Gate Carnival is now one of the largest festivals in Europe, attracting over half a million people. Two weeks before the Bank Holiday on which Carnival falls, designers and volunteers at the *mas* camps work around the clock to prepare for the formal competitions one week before the bands parade. At West London Stadium judges award first, second, and third prizes for the best costumes and bands on the road. Prize money ranges from £100 sterling to about £1,500.

In 1984, the band Cocoyea portrayed Fantasy Wild Indian, designed by Nicky Lyons, who on occasion joins Peter Minshall's *mas* camp in Trinidad. Her King, Great Chief Pow Wow, won first place that year *(see Figure 150)*. The body costume featured bead and rhinestone embroidery in the Trinidadian style of Bomparte and Lionel Jagessar. The superstructure of the costume displayed three large plastic molded headpieces representing the spirits of chiefs. The Queen of the band, also designed by Lyons, represented the elements Earth, Wind, Water and Fire. Led by Bertrand Delandro, the Carnival Ebony came out with the band China Through the Ages. Pagoda headpieces, oriental costumes, and fantasy emperors marched in this band. The members of Grenada Shortney, a band of African-descended people who live on the north end of Grenada, wore wire screen masks, costumes of brightly colored cloth hung with mirrors, and pantaloons or knee-length pants. These masqueraders stylistically resembled the old Jonkonnu maskers of Jamaica, St. Kitts-Nevis, Belize, and Bermuda *(see Figure 151)*.

London Carnival has adapted many Caribbean traditions, but judging from its short history and taking into account the patterns of cross-fertilization and creolization, it will evolve in its own peculiar shape, as West Indians continue to settle in Great Britain, and as the second and third generations mature. As individuals of different origins participate, a new source of creativity will strengthen the festival. Each year, London Carnival leaders return to Trinidad to learn the latest in design and band organization; each year, costume designers from the Caribbean visit Notting Hill Gate. The cross-fertilization further nourishes what is likely to emerge as a very significant festival in Europe.

Toronto's Caribana

"When you see June come. When you see July come. When you see a lot o' strange faces on the landscape . . . When you start seeing the women wearing clothes that you could sometimes see through, if yuh looking in that direction. When you see life and light, gait and gaiety, when you see a fellow that you didn't see for the winter stop and talk to you for one hour concerning something that he could tell you in a minute, when you see a car full o' Wessindians stop at a traffic light, and you hear Sparrow coming through the speakers; when you start hearing the colours o' the Wessindians and seeing the spirits in their bodies, when a fellow raise his voice above the pollution and the noise and the screech o' hardships in this place call Ontario, Canada, then you know the time here, Caribana coming, boy!"[21]

Figures 152 & 153 The 1986 band Out of Africa from Toronto Caribana included this (right) outstanding costume inspired by Dan masqueraders in Liberia and the Ivory Coast. The glistening black surface of the face mask (above) compares to the highly glossed patina of African carvings. A black and white-striped cloth, a referral to African country cloth, completed the costume.

Each year since 1968, Caribana has grown in numbers and complexity. Beyond their Canadian citizenship, West Indian immigrants have clung to their cultural traditions, as well as their point of view.

Share, Canada's largest black newspaper, *Ind. Caribbean News, Indo Caribbean World, Contrast,* and *Pride* extensively cover Caribana, but articles on the Hindu Vedas by the Dalai Lama and advertisements for classes that teach Muslims how to prepare for the *Hajj* (pilgrimage to Mecca) also abound in these tabloids. The Caribbean community is diverse, but it comes together on both the printed page and in the festival. The masquerade parade is held the first Saturday of August. Participating in the event are the Dominica Association of Ontario, The Jamaican Caribana Participation Committee, The Association of the Bahamas in Canada, and the Calypso Association of Canada. The Expatriates of Guyana sponsor a Guyana

Night prior to the parade. Ironically, this city of bitter sub-arctic winters now has a hot, vital mix of West Indians.

Toronto is a cosmopolitan city; besides its Caribbean constituency, it has substantial Chinese, German, and Italian communities. Buttressed by an open immigration policy initiated in Canada in the 1960s, and the xenophobia of French Montreal, Toronto has grown rapidly. In recognition of its cultural complexity, the 1967 celebration of the Canadian Centennial invited ethnic groups to parade.

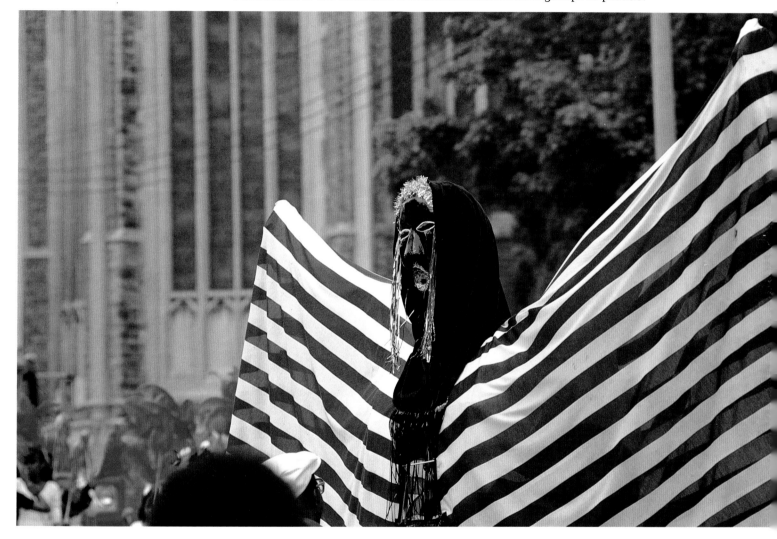

Ken Shaw, a young Trinidadian taking a degree in chemistry at Ottawa University, was asked to participate in this parade and to bring costumes that would represent the Caribbean, particularly Trinidad. There was only one band that year, Psychedelic Fantasy, which had some large individual costumes. Two musical bands played a tribute to the festival, The Guiness Cavaliers and The Trade Winds. The Trinidadian *mas* was a hit and people began to jump into the procession. "There is too much fire for *mas* among these band leaders to resist the call of the blood," one reporter concluded.[22] Designers Whitfield Belasco, Peter Marcellin, and Elmo Daisey met in a basement near Bathurst and Bloor to establish what would become the Caribbean Cultural Committee. Initially the group received support from British West Indies Airways (BWI) and the Ontario Provincial government which hoped to promote tourism in Toronto. Currently, Caribana attracts half a million people and

Figure 154 This Junior Carnival costume Eagle Fan Dancer, Toronto, 1986, was made of molded plastic, a technique pioneered in Trinidad.

Figure 155 In 1986 Noel Audain designed a King costume with the image of the feathered serpent, Quetzalcoatl, as the primary motif. Against a lime-green flaring bonnet with mylar feathers, three heads of the mythical plumed serpent project. A detail of one of the serpent heads shows the inventive way the artist has depicted the animal spewing feathers, alluding to his dragon costume of the previous year.

Figure 156 King Neptune, King of Toronto Caribana for 1985, was designed and constructed by Noel Audain, once assistant to George Bailey, a master Trinidadian artist of the 1960s. Audain became a consummate wire bender under Bailey's tutelage.

draws nearly $30 million in revenue, while the Caribbean Cultural Committee receives about $200,000 from the city to sponsor its events. Because of the Canadian multiethnic policy which promotes cultural pluralism, funding has been available for such "ethnic" events.

On the Sunday before the parade, nightly dances are staged on the ferries that cruise Lake Ontario. Thousands of people line up at the quays below University Avenue to board the ferries. A mile or so away from shore, the music bands from Trinidad, Dominica, and Jamaica begin to play. After a few songs, the bands play favorites for which dancers have developed stylized gestures. At the start of such a tune everyone executes that gesture, reaffirming group identity and purpose. The ship literally *socas* out to sea.

The King and Queen competitions are held on Thursday at the Varsity Arena of the University of Toronto. The ice hockey rink is converted into a mini-Savannah where, from 7:30 p.m. to 2 or 3 a.m., audiences enjoy Calypso, West Indian food, and the competitions of Kings, Queens, male and female individuals, and junior *mas*.

A section of the band Fans to See, organized by Nip Davis and Ken Shaw, assembled on the eighteenth floor of a luxury apartment on the harbor front in 1986. Rum and music, provided early, prepared the group for its foray on the city.[23] Over 6,000 participants emerged from the underground and assembled around the Queen's Park above University Avenue. At 10:50 a.m., the first band was on the crowd-lined road.

The contemporary landscape was transformed by sixteen-foot wings, bats, dragons, and dancing flowers, all challenging the sturdy perpendicular lines of the urban park setting. The cool lake breeze and the downward slope of University Avenue assisted masqueraders as they danced along the four-mile strip. By 1 p.m. all the bands were on the road and movement slowed to a snail's pace. Leaving their sections for food and cold sodas, members often had to dance back through several bands to find their own. When they returned, fellow members cheered and asked for reports about the other bands.

The Fans to See section was headquartered near the end point of the parade, so it was simple to walk back to where the fête would begin. After having danced on paved surfaces for eight hours, it was difficult to imagine more dancing. Nevertheless, the volume of the recorded music was turned up and the fun began once more.

The 1985 and 1986 Caribana festivals each presented over 6,000 *mas* participants in twenty and twenty-one bands, respectively. Although Trinidad Carnival is the primary inspiration, West Indian groups from Dominica, Jamaica, the Bahamas, St. Vincent, the Grenadines, Montserrat, and St. Kitts-Nevis organize their own costume bands *(see Figure 159)*. Eddie Merchant & Associates produced a seven section band entitled A Vision of Loveliness, with the Queen and King of the band in costumes over thirteen feet high, portraying butterflies reminiscent of Peter Minshall's 1982 Papillon band from Trinidad *(Figure 157)*. Ken Shaw organized a 1985 band called Ship to Shore, in which costumes depicted sailors from Hawaii and China, as well as King sailors. A sailor section from Washington, D. C. joined the group, to play *mas,* meet friends, and conduct business. The individually decorated shirts and pants of these sailors derived from sources in Port of Spain, in particular in the costumes of Jason Griffith. Another prominent band produced by Russell

Charter, Sea Dreams, depicted coral reefs, sea horses, King Neptune God of the Sea, and a Queen pulled along by two shark escorts. The King of the band, played by Noel Audain, placed first in Caribana and second in Brooklyn *(see Figure 156)*, where the Queen and the sea horses played *mas* as well *(see Figure 147)*. Crepe paper costumes in the band called Children of the Sun, produced by The Association of Bahamians, featured the Arawak Indians in bush skirts in the same style that Philip Miller creates in Nassau, the Bahamas *(Figure 158)*.

Further tying the Caribana *mas* to Trinidad was a 1986 band called From Sally with Love. Sam Malcolm and Russell Charter paid tribute to Harold "Sally" Saldenha, a great band leader of Trinidad who died in 1985. The musicians of the steel band Afropan accompanying another band played "How Many More Must Die,"

Figure 157 The butterfly motif of this Toronto band was influenced by Peter Minshall's Papillon band of 1982. Consisting of seven sections, the Toronto band entitled A Vision of Loveliness was striking against the cobalt blue sky and dazzling sunlight.

Figure 158 A costume from a band of Bahamians, some of whom are living in Canada and some of whom are visiting from the Caribbean. Flowers are a major motif which Bahamian artists treat. This 1986 Toronto costume is made of gessoed cardboard covered with small strips of fringed crepe paper.

protesting South African apartheid. Among the Junior Carnival costumes was the outstanding male individual called Eagle Fan Dancer, played by Michael Sheppard. Sheppard, like Peter Minshall, also has adopted the technique of molding the plastic headpiece *(see Figure 154)*.

In 1985, the band Island to Island, produced by Shadowland, a repertory company, and The Bamboo Club included sections of trees, houses, birds and sailboats. The 1986 version called The Late Great Lakes, in Minshall protest style, illustrated the good and the bad, the unpolluted and the polluted. The destruction of the lakes was indicated by dancing fish scarred by industrial waste.

Two important artists living in Toronto have spurred the success and growth of Caribana; both were born in Trinidad and both studied under George Bailey. Consummate wire benders, Noel Audain and Wallace Alexander have built costumes and led bands for many years. At the age of nineteen, Audain began making *mas* for George Bailey. The last band he played for Bailey was Bright Africa in 1969; shortly after, he left for Canada. With wire bending skills and an appreciation for Bailey's adherence to historical accuracy, Audain made and played a King costume at the 1969 Caribana for Earnest Castillo's band Afro Fantasy of Colors and won first place. During this time he studied graphic design at George Brown College in Toronto and later was employed as a screen printer. His Queen and King from his first band, Excerpts from Central America, in 1970 placed first and second respectively. Notably, his individual male and female, Sun God and Serpent Goddess, both placed first. The artist's interest in Pre-Columbian imagery, snakes and dragons developed during this period.[24] By 1984, Audain produced six bands and worked for band leaders designing and building costumes.[25] His Kings and Queens regularly place either first or second, as did his bands in the early years. After 1986, the artist stopped producing his own bands, but he continues to make Kings, Queens, individuals and junior costumes for Louis Saldenha, Eddie Merchant, and Russell Charter.

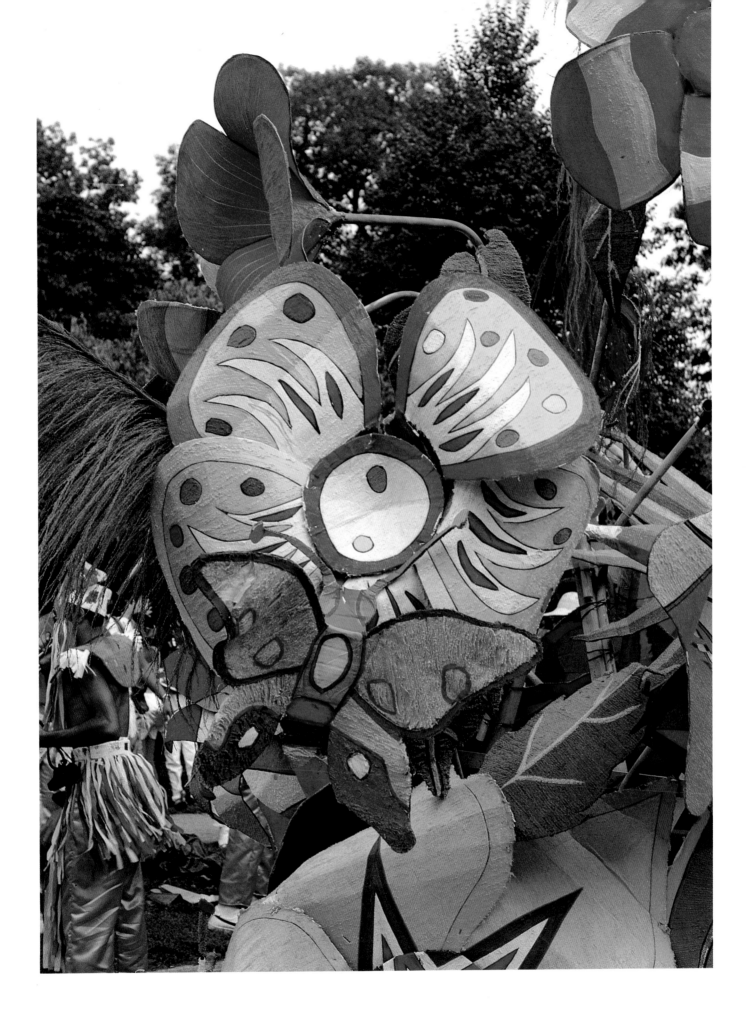

Russell Charter, a Trinidadian, organized the band From Sally with Love in 1986, and hired Audain to design the King's and Queen's costumes.[26] That Audain had worked with Saldenha's son in past Caribana competitions made this particularly appropriate. The band had its launching at 1545 Eglinton Avenue West, an unusual part of the city for a *mas* camp. To introduce the group to the community, Charter invited the local police chief and the health inspector to visit the camp at its opening, and he obtained sponsorship from local merchants after the launching. As *mas* in Trinidad has served as a principal unit of social organization, so it finds a similar function in Toronto, where Trinidadians use it to move into new neighborhoods. The studio, located behind a beauty salon, was rented for the whole year.

As a tribute to Saldenha's favorite historical themes, Audain designed the costume, Quetzalcoatl, the Plumed Serpent Goddess, which was portrayed by Charter's daughter, Karen. The King, also representing a Pre-Columbian theme, was based on illustrations from *Mexican and Central American Mythology* by Irene Nicholson. The twelve-foot high curving neck of the plumed serpent Queen, made of gold, red and green crackle paper with dyed ostrich feathers crowning the serpent's head, resembled that of the serpent on the facades of the pyramid of Quetzalcoatl at Teotihuacan *(see Figure 155)*. Aluminum, fiberglass rods, and a galvanized wire frame held together with nuts, bolts, and plastic strapping tape has replaced wire bending in larger costumes. Two paper-molded images of a Pre-Columbian Peruvian Moche deity were located at the base of the costume. In this instance, the artist fused motifs of different cultures, times, and places. Another costume portraying the plumed serpent employed a radial design with green vinyl and plastic feathers, establishing a circle with the dancer's head below the center of the costume. Recalling the fantasy Indian costumes made in Trinidad, this feather arrangement ties the Pre-Columbian image to that of the late nineteenth-century Sioux Indian feather bonnets. Flanking the costume in gentle s-curves were two images of the plumed serpent with feather-flames issuing from their mouths. Directly above the head of the dancer, another serpent head established the center point of the costume.

Another Toronto designer, Wallace Alexander, learned wire bending in Trinidad. In the Bailey tradition, his 1986 band highlighted Africa. Like Audain, Alexander drew upon the illustrations in an art history book to design his costumes. His band Out of Africa included a wonderful interpretation of a Dan mask of Liberia. The Toronto object was reproduced in papier-mâché with a large black and white garment completing the costume *(Figures 152 & 153)*. Fascinated by the sturdy geometrical designs of Bwa masks of Borkino Faso, Alexander incorporated several Bwa motifs in his costumes.[27] His King, entitled Oba, was based on another type of Bwa mask with a tall superstructure. Though the African word *Oba* derives from the name given the Benin kings from a region far away from the Bwa people, Alexander freely incorporated these separate African traditions in one work of art, sustaining creolization in North America. Also represented from Borkino Faso was the Korumba mask. Many Caribbean peoples now freely incorporate African motifs in their masquerades. Black Canadians, and Americans as well, have been receptive to this, adopting Afro-styled hair and dress. The magnitude of Caribbean peoples borrowing from African cultures in masquerade is fascinating to non-Caribbean Blacks, who can appreciate the use of African artistic motifs in the context of dance and masking—quintessentially African performance media.

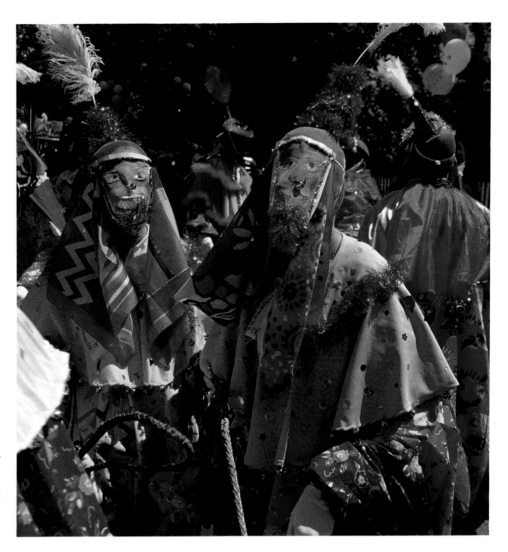

Figure 159 One large masquerade band that took part in Caribana 1987 featured *mas*, derived from St. Kittitian clown characters. The Toronto version, virtually indistinguishable from the St. Kittitian prototype, consists of baggy pants, loose-fitting shirts decorated with sequins, and painted wire screen masks. The dancers wield rope whips.

Observations

It is not by coincidence that the festivals in London, Brooklyn, and Toronto found their present form immediately after most Caribbean countries of the English-speaking Caribbean became independent, when a new spirit of Caribbean nationalism emerged. In large metropolitan cities where migrants had settled, this new status gave Caribbean expatriates confidence to assert their cultural forms overtly in foreign countries, albeit adapting them to the peculiarities of each new environment. In this respect, the masquerade is a liberating experience.

The success of this process has encouraged Caribbean people to establish festivals in other North American cities. The West Indian Independence Celebration Committee hosts its annual West Indian Independence Day in Hartford, Connecticut. A similar group sponsors such an event in Delaware, and the Boston Carnival Association holds its annual festival in August. The New York Moharram Observation Committee hosts a Hosay festival in DeWitts Park in September.[28] Once the liberating forces of *mas* are felt by citizens of these cities, they may learn to play *mas* as well. The influx of Caribbean peoples into North America, with every little piece of difference, will have long-term implications, but the cultural changes it brings to the European-based cultures of northern cities are only beginning.

181

7

Implications for Caribbean Development

The organization of social life in traditional societies gives a special place to the festival, for there is a general consciousness of its potentials as a vehicle for communicating or affirming the values of a society and for strengthening the bonds that bring its members. The traditional concept of a festival, therefore, is that of a communal celebration of life in which the members of a society participate on different levels in a number of structured and unstructured but significant events. When the circumstances of a community change, consideration may be given to the revision of the schedule of festivals . . .[1]

J.H. Kwabena Nketiah, a distinguished musicologist, was speaking of Ghana, his native country. He could have been speaking of the Commonwealth Caribbean, where Great Britain once held sway, as well as of Haiti, long liberated from French overlordship, and of Cuba and Santo Domingo, which achieved political independence at the end of the last century after centuries under Spanish rule.

In all these cases the circumstances of the communities have changed, and consideration indeed has been given not only to the schedule of each festival, but in some places also to the nature and function of the event *(Figure 160)*. In the Commonwealth Caribbean, the idea of festival remains a vehicle for communicating *and* affirming values and for strengthening the bonds in the new society, but it has changed somewhat through a protracted transformation from colonial fiefs to independent modern politics.[2] The task of nation-building looms large, and the manipulation of symbols, festivals included, has become part of the action. Harnessing deeper social forces becomes a continuing challenge in shaping the new society in which values of freedom, equality, opportunities for self-actualization, and rehumanization of a policy that had known only slavery and imperialist subjugation for most of its existence are priorities.

Figure 160 Western metropoles which host Caribbean festival frequently feature costumes from many of the islands. These Grenada Shortney Characters played in the 1987 Brooklyn Labor Day Festival. Such characters also perform in London and Toronto.

It stands to reason that, in the quest for place and purpose, the new post-colonial dispensation should wish to draw on the experience and energy of its own people—especially the mass of the population who not only vote for those seeking political power, but who participated in the struggle for liberation that put power into native hands. The use of what the mass of the population, "the people from below," have created out of their collective realities can be less an indulgence in populist exploitation and more an attempt to legitimate the new authority devolving in societies no longer dancing to the echoes of distant pipers.

The resourcefulness of people in exercising their creative imagination, even in bondage, is a common theme in the human story. The Caribbean is no exception. Under slavery, the mass of the population uprooted from West and Central Africa guaranteed to themselves cultural continuities as salve for the suffering caused by the severance. They adapted and adjusted, creating in the end expressions appropriate to their new circumstances by way of encounters with the Europeans acting as economic masters or colonial overlords, with others of their ilk, first aboard ship and later on the plantation, and with indigenous Amerindians, Arawaks, and Caribs, who were already decimated by the onslaught of alien diseases and imposed overwork.

The survival of that horde of involuntary workers in new lands became their priority. And all means within their command were found to protect themselves in their vulnerable capacities as chattel and dehumanized zombies at the beck and call of callow, callous men and the brutal systems they operated. Flight and guerrilla assault against plantations and oppressors were not their only options. Alternatives which manifested world-views and protection from the obscene violations of vile and venal predators were more readily at hand. The festival was one such means.

A few days rest from labor was critical to the operations of the festivals that emerged throughout the region in the eighteenth and nineteenth centuries as variations on a theme. But the sustaining lifeblood of these events was the creation by the participants of masks to disguise, of music to affirm, of dances to celebrate, as well as the germination of ideas beyond the reach of those who brutishly supervised them for the rest of the year.

As with the "Africans" in slavery, so with the new wave of East Indian migrants in indenture, the form of contract labor which continued the tradition of labor exploitation after slavery was abolished. Hosay is a later manifestation of that process. The Caribbean in the twentieth century has turned to the very process and its products to meet the demands of contemporary existence and to shape a future to call its own. All mechanisms of affirmation become part of the quest for appropriate designs for social living. The still-developing notion of an emergent Caribbean civilization, defining itself on its own terms, serves to inform the practical program of nation-building and the challenging strategies of development.

I

Caribbean festival arts in their overt and covert ways now act as catalyst to different dimensions of Caribbean post-colonial development. Whether in nurturing the creative arts, in planning strategies for social and economic development, in sharpening the articulation of political nationalism in independence, they promote regional unity, not only among the anglophone Caribbean, but also in communities outside that can be regarded as part of the Caribbean Basin.

Festival Arts and the Contemporary Arts

Since the late 1930s, the Caribbean has brought forth such world-class practitioners of literature, music, dance and the plastic arts as writers Derek Walcott, Vidia Naipaul, Edward Brathwaite, and George Lamming, and composers and performers of Trinidad calypso and Jamaica reggae, Lord Kitchener, the Mighty Sparrow, Bob Marley, Jimmy Cliff, and Peter Tosh. Within the region itself there is an implosion of energy in the performing arts. Jamaica's National Dance Theatre Company has become a pace-setter in the exploration of Caribbean dance-theater following on the great pioneering work of Beryl McBurnie of Trinidad, Ivy Baxter of Jamaica and Katherine Dunham and Lavinia Williams, the two Americans who have adopted Haiti. The Walcott brothers of St. Lucia and Trevor Rhone of Jamaica are among those who have become prime movers in developing a Caribbean theater in the recent past. Jamaica's Edna Manley and a fresh school of "intuitive painters" join the renowned Haitian school to complete the network of Caribbean creative artists, confirming the texture of artistic life in the region. Significantly, none of these forms have been able to avoid the impact of the festival arts as a source of energy.

The Trinidadian dramatist, playwright, and theater scholar Errol Hill once called for the Trinidad Carnival to be a mandate for a national theater of Trinidad and Tobago.[3] He shared with Guyanese-born theater critic Slade Hopkinson the view that "Until there is a theatre based on drama rooted in Trinidad, the theatre and drama in Trinidad will remain essentially artificial, colonial things, interesting chiefly as symptoms of the psychological sickness of a fragmented confused people—a people who contain the possibility of a unique cultural synthesis and inventiveness, but who prevent the fulfillment of this possibility by not having the courage or the intelligence to become what they in fact are."[4]

Hill insists—and he is right—that Carnival is a most authentic source, since it "has achieved a synthesis between old and new, between folkforms and art forms, between native and alien traditions."[5] He goes on to "enunciate principles" rooted in Carnival that "for the establishment of a national theatre will truly represent the cultural attitudes, expressions and aspirations of the people of Trinidad and Tobago."

A not dissimilar vision guided the efforts of dance-theater in Jamaica, where the National Dance Theatre Company (NDTC) emerged at Jamaica's Independence in 1962 and has since explored movement, music, and traditional lore in forging a vocabulary, techniques, and style now generally regarded as "Jamaican."[6] Movement, music, drama, speech patterns are all integrated in Caribbean festival arts

and are central to Jamaican dance-theater. Some of the work of Danza Nacional, the Jamaican NDTC's Cuban counterpart, reflects a similar base in traditional Cuban festival arts.

All Caribbean theater, when it chooses, takes on amazing authenticity and authority as long as it employs these Caribbean gifts of artistic expression. Hill's plays and certainly those of Derek Walcott in the Eastern Caribbean, as well as the pantomimes and some of the farces of an admittedly more solemn Jamaica, utilize much verbal imagery and metaphor for communicating their message. In *costuming* and *stage scenery*, Hill is right in claiming for Trinidad a wealth of talent, ideas, and innovativeness all evident in Carnival and reflected in much that is Caribbean theater today, even at the risk of jeopardizing the centrality of dialogue in a drama. Jamaican dance-theater is known for its excellent costuming, which does not subvert the integrity of the movement patterns: the influence of Trinidad on cabaret, drama, musicals, and dance theater in the rest of the region comes through in costuming and design.

Hill stresses as well *audience involvement,* a feature of Trinidad Carnival. The more reserved Jamaicans have always stood and watched the Jonkonnu bands parade and perform, throwing them money to spur on antics and reward the inventive. Efforts to introduce street dancing in the annual Independence festival celebrations have yet to succeed totally in Jamaica. Most people stand and watch while a few uninhibited revelers "jump up" (a Trinidadian Carnival term) to recorded music in the plazas of Kingston. The Trinidad Carnival is made for participation despite the now-established Savannah "march-past" before a paying audience and judges who award prizes to the parading bands.

But this merely emphasizes another element which Hill points out about Trinidad Carnival—"the *procession as a choreographic form* and the frequent use of ceremony evident in coronations."[7] The same is true of Jonkonnu and of Hosay. Jamaican dance theater has drawn heavily on "the procession as a choreographic form." It is a device often missed or misunderstood by metropolitan critics who have neither that sense of space nor openness which is a luxury in crowded cities. Mobilizing masses of people in marches, with their feet keeping a basic rhythm while the upper parts of the body in polyrhythmic counterpoint carve myriad designs in space, produces a different kinesthetic quality and visual impact than that of the American Modern Dance or the European classical ballet, both of which are rooted in the cultural realities of their respective habitats.

Thus the hankering after cultural definition on the Caribbean's own terms sent Caribbean creative arts to their own sources. As such, festivals like Jonkonnu and Carnival and the sources from which they have drawn over centuries take on new meanings in contemporary life. Even when Europe's all-pervasive influence persists in the artistic activity and manifestos of the region, the force of these indigenous forms fights back in dialectical defiance. The results are sometimes the better for the confrontation. A production of Shakespeare's *The Tempest* is set in one of the islands of the Caribbean. The noises of that isle are those of the steelpan and the voices of Carnival bands.[8] It works! One of the finest plays to be produced on the Jamaican stage is Sylvia Wynter's original television script, *Maskarade,* transformed into a full-length play by Jim Nelson.[9] It deals with the lives of Jonkonnu players in the nineteenth century.[10]

Artists have indeed studied these festivals, dragging scholars in their train, to discover the ontologies of those who have given form and purpose to cultural life in the region. Studies on calypso and on Carnival are in the catalogues of university and national libraries, as are those on Jonkonnu.[11] More is yet to be done!

Festival Arts in Economic Development

Such studies serve another purpose. They can inform public policy. Cultural tourism is after all important to several Caribbean governments, for whom it is a major source of national income. The Bahamas sells "Goombay" as a tourist attraction. Jonkonnu was never as deliberately mobilized for tourist consumption in Jamaica. But in 1987 "Bruckins," an expertly packaged show based on the Jamaica Jonkonnu and related festivals was exhibited all over the north coast of Jamaica under the auspices of the Jamaica Tourist Board.

The idea of festival is, however, given practical expression in the Independence Festival events in July and August each year. In mid-August there is also the latter-day Reggae Sunsplash Festival, a genuine tourist attraction modeled more on the Woodstock rock festival than on the traditional indigenous festival arts of Jamaica. The affirmation of the cultural authenticity of Jamaican reggae by Sunsplash is not lost on the Government of Jamaica in its search for genuine national expressions. But hard currency comes with the tens of thousands of reggae revelers from all over the world; and that is regarded as good for an economy starved of foreign currency.

Now that the price of oil has declined and the foreign exchange reserves are greatly depleted, there is growing interest in tourism and in the growing role of Carnival in oil-producing Trinidad. Trinidad Carnival becomes a prime target for cultural tourism as a potential foreign exchange earner in the planning strategies of a new government.

Festival arts, in traditional terms, may not be regarded as profitable or tenured sources of employment—a factor high on the Caribbean's agenda of national concerns. But Trinidad Carnival becomes a year-round occupation for a chosen few who coordinate bands and conceptualize the next year's display. By-products come in the form of curios for the tourist trade. Dolls, miniature steel-pans, plaques of brass and copper with figures in bas relief, and carnival masks are some of the merchandise. Jonkonnu dolls were once popular in the Jamaican tourist trade and could become so again. *Ireme* dolls can be purchased in Havana. And in both Trinidad and Jamaica music is the raw material for a thriving recording industry which provides employment for many long after the brief duration of the festivals. The market for recordings of calypsos and reggae has definitely grown throughout the region and beyond.

None of these possibilities—cultural tourism, a budding craft industry, a recording industry, a facilitating bureaucracy for cultural administration—escape the more aggressive politicians who must find every means possible to maximize the benefits by careful husbanding of rather limited resources. A cultural policy is formally a part of development plans for Jamaica and more recently for Barbados and St. Lucia.

Festival Arts and Political Articulation in Independence

Much of this takes place within the parameters of political action. The accredited representatives of the people must embrace the aspirations of the mass of the population who vote them in. Independence has meant more about controlling the instruments of political decision-making rather than the economic mobilization of resources. This last dimension of power is still seen as being possible only after the political kingdom has been sought and won, most by democratic participation of the people through free, for the most part fair, and quite frequent elections.

The redistribution of power has affected just about every activity pursued by the people at large. Problems of class, race, and ethnicity loom large in post-Independence. The question of whose festivals should form the mandate for national expression graduated from topic for muted speculation to one for open study and debate. The controversy over Peter Minshall's "two Act" spectacle "River" in 1983 turned, it was felt, not only on the fact that he was a white Trinidadian attempting to change a black traditional popular genre with his Eurocentric innovations, but that he used East Indian *tassa* drums to accompany his band.[12] Carnival is Trinidadian (read Black West Indian). Hosay is still seen as East Indian! Trinidad, like Guyana, where over fifty percent of the population is East Indian, is deemed to be West Indian. The recency of East Indian migration to the region, and the seeming persistence of authentic elements from Mother India, combined with innovations like the appearance of moons in Trinidad, the continuing disappearance of *alams* in Jamaica and increased numbers of African descendants playing *tassa* drums all point to the authentic reconstruction of the festival in the West Indies. With the further creolization of Hosay, this phenomenon is likely to change even more.

"People power" means then not only numerical majorities but cultural legitimacy in Caribbean terms. Politicians have not been slow to use such popular traditions as festivals to their own ends, as well as to minimize the marginalization of the mass of the population.

Jamaica established a Festival Commission (later, the Jamaica Cultural Development Commission) in 1963 to give national focus to the many village and parish festivals which dated to the turn of the century. Today the Independence Festival includes competitions in music, dance and drama, displays of traditional dance and music, a festival song contest, street dancing, festivities specially designed to celebrate the coming of Independence, and beauty contests. All the ingredients of traditional Caribbean festival arts were incorporated by a Government anxious to provide unity and cultural focus for a new nation with a disparate social order. Trinidad on the eve of Independence had established a Carnival Development Committee, drawing into its official orbit activities that were the remit of private individuals and groups of citizens. It was necessary not only to ensure order in the hitherto sometimes contentious proceedings, but also to harness a popular pastime into national channels. Barbados with its Crop-over festival did likewise in the 1970s with the establishment of a National Cultural Foundation responsible for the National Independence Festival of Creative Arts (NIFCA). That these official organizations take pains to project themselves as facilitators rather than stiflers of popular artistic spontaneity and creativity reveals the extent to which the authenticity of the festival arts is jealously guarded. In any case, political directorates would aver that they are merely incorporating the "people's expressions" in order to affirm their legitimacy in and centrality to the new political dispensation in which the mass of

the population are expected to participate not only through their votes, but through the active ongoing exercise of their creativity in giving form and purpose to the new society in Independence.

At worst such political "interventions" are dismissed as bread-and-circus appropriations of the people's creativity. Thus there is no shortage of adverse criticism of officialdom's dominating too much of the Trinidad Carnival, Bermudian Gombey, Bahamian Junkanoo, and Jamaican post-colonial national festival. Some people see the phenomenon as a means of social control through the politicization of art, ethics, and the creative imagination.

Others see the intervention by government into festival arts activities as one of the surest guarantees of social cohesion, as provision for needed patronage either through direct money assistance or through such institutional and operational frameworks as the Jamaica Festival and Cultural Development Commission (JCDC), the Trinidad and Tobago Carnival Development Committee (CDC) and the Barbados National Cultural Foundation (NCF).

Still, cynicism abounds. In certain quarters it is felt that governments, in an effort to control the initiative of the masses, feel it more expedient to join than to alienate them. So they exact loyalties by obligating the people to officialdom rather than leaving them to take their innovations into directions that may not be "in the national interest" (as perceived by the new power-wielders), or may be construed to constitute a crime against the social order. In any case, the history of bannings throughout the region by the old colonial power did nothing to stop the growth and development of such festivals. Rather, the "oppression" served as soil for nurturing such festivals, which grew in proportions to haunt the frightened governors. Small wonder that post-colonial native politicians decided to avoid this.

The spartan Dr. Eric Williams, former Prime Minister of Trinidad and Tobago, soon gave up the idea of discounting Carnival. He realized early enough in his twenty-five-year reign that to his countrymen Carnival is serious business. Was not a colonial governor forced to retreat from his attempts to ban Hosay earlier in the century? All over the region the dependence of the popular vote by private ballot dictates official indulgence, if not outright support, of such popular expressions.

That government patronage can be a means of social control there is no doubt in the minds of many grass-roots leaders in the country. They repeatedly assert their independence from the Kingston-based Jamaica Cultural Development Commission through the voluntary Festival Committees spread all over the country. Trinidad's Best Village "festival" type competitions betray similar independence of spirit from the very government quarters responsible for their existence.

Festival Arts in Search of Regional Unity

As with individual countries of the Commonwealth Caribbean, so with the territories of the Caribbean which have collectively attempted to utilize the "festival" mechanism to forge a cultural unity. All else had failed, or so it seemed by the early sixties. Political federation lasted three uncertain years (1958–1961) until Jamaica pulled out by referendum, and the remaining territories disintegrated into now independent states and one or two colonies tied still to Mother Britain. The sixties saw feverish activity in economic integration. Out of that came the Caribbean Community (CARICOM) as successor to a Caribbean Free Trade Area (CARIFTA). The persistent cultural realities of countries that most readily identify with each

other through music, dance, the plastic arts, and literature emerge from time to time to remind the five or six million inhabitants of their common history and the shared consequence of slavery, the plantation, and the creolization process over the past half a millennium. The identification with each other in the wider Caribbean, wherever Africa met Europe on American soil, comes naturally through the responses of the marginalized mass to their oppression in new and hostile environments.

Festival arts, then, provide variations on a common theme. The ingredients throughout share common feeling and intent, even if the forms are different. Masquerade, to disguise and affirm, is everywhere—in Jonkonnu, Carnival and the religious rituals which themselves are a form of festivals sharing common practices, correspondences (symbolic systems), and similar exegeses whether it is Cuban Santería, Jamaican Pukkumina, Guyanese Cumfah, Trinidadian Shango, Haitian Vodoun, or the more Christian-oriented revivalism now modernizing itself all over the region with the generous help of American televangelists.

Caribbean economic integrationist aspirations followed cultural reality; and relations with Santo Domingo, Haiti, Surinam, the Netherlands Antilles and even Cuba (before the fall of Grenada) still inform the CARICOM vision. Such wider Caribbean integration takes on an urgency in the final decades of the century in light of latter-day hegemonic perception on the part of the United States that the so-called Caribbean Basin is to be penetrated, controlled, and directed along lines dictated by that Superpower.

Part of the resistance to this is the assertion of the cultural distinctiveness of the region. One such assertion is through the Caribbean Festival of Arts (CARIFESTA).[13] Preceding its inception in 1972 was the Caribbean festival held in San Juan, Puerto Rico in 1952 and the anglophone festival of arts in 1958 at the launching of the ill-fated West Indian Federation in Port of Spain, the federal capital. It took all of eight years to rekindle enthusiasm after the breakup of the federation. In the meantime, the steelpan ping-ponged its way into the Eastern Caribbean. One of the region's most distinguished bands—Brute Force—came from Antigua. "Carnival" as a popular festival spread to all the territories, with some linking it not to the traditional pre-Lenten period but to times of significant national celebrations. Even far-away Jamaica could not escape. The leading *soca* band is Jamaica's Byron Lee and the Dragonaires. Trinidadian students on the Jamaica (Mona) campus of the University had introduced Carnival to the campus in the early 1950s in any case. There were calypso hours on Jamaican radio and by the mid-seventies Jamaica was to answer by penetrating the entire region with reggae.

A conference of writers and artists in Guyana in 1965, coupled with the UNESCO conference on Culture and Conservation held in Jamaica in 1970, took place in an ambience of growing recognition for the importance of things artistic to regional unity. The Conservation Conference recommended appropriately that "Governments of the territories of the Caribbean be asked to support any action that might be initiated, especially periodical inter-Caribbean Festivals including films, art and tourist promotion in the region. . . ."[14] By 1972 Forbes Burnham, the Prime Minister of Guyana, was ready to host the first Carifesta, featuring "Guyanese and Caribbean artists whose work in poetry, painting, and sculpture project our dreams and visions and help to foster and develop a Caribbean personality. . . ."[15]

Criticisms came from distinguished quarters. Derek Walcott, the well-known St. Lucia-born poet/playwright, dismissed it as a "cynical exploitation" of West Indian

artists for two weeks by West Indian governments who ignore them for the other fifty weeks of the year. Writers George Lamming and John Wickham were far more positive. Lamming saw Carifesta giving the region a chance to "heal and restore the rhythm and beauty of that battered black body which it argued, and continues to argue, is ugly, graceless and without history."[16]

Since 1981 the region has been beleaguered by all the afflictions of the developing condition—debt burden, balance of payments difficulties, foreign exchange shortage, decline in bauxite and oil revenues, violence within states, military invasion as a part of the entrapment within the hegemonic combat between the two Superpowers, unemployment, drug abuse, and drug-related criminality. The reggae continues to flourish in Jamaica and beyond. Carnival remains vibrant; Jonkonnu struggles to stay alive; but the theater arts, especially dance which it in part inspires, continue to thrive.

Carifesta has faded somewhat into the background, even while conservative politicians promote Caribbean unity through political parties pledged to saving the region from Leftism or anything that could take another island along the route that Maurice Bishop's People's Revolutionary Government journeyed in Grenada. Against this background, the Prime Minister of Jamaica, himself not known to be a passionate Caribbean integrationist, offered to host Carifesta in 1988 at a meeting of the CARICOM Heads of Government in 1983. The old commitment to Caribbean unity and to political self-determination once again reared its head. Festival arts, political partisan linkages, and intra-regional trade completed the trilogy of collaborative devices dictated by the commonalities of the region. Whatever is common to the historical experience and existential reality of the people of the region, cutting across geographical boundaries and time-span, is bound to be important to those who advocate unity or regional co-operation in grappling with development issues.

Festivals are one such manifestation of regional commonalities. These festivals speak holistically to the ordinary folk's world-views, self-perception, values about economic activity (i.e., in their choice of consumer goods, priority on time utilization and work ethic) as well as to political and social organization (as in their collaborative work on the design and execution of costumes and on festivities under a leader and on the basis of division of labor). Many question the value of all this as a guide in a modern society which requires more sustained application than the three-day "indulgence" of Carnival and Jonkonnu. Advocates of festival arts in national development argue that the level of professionalism and depth of concentration given these festivals in fact suggest a capacity for self-discipline and sustained work toward excellence.

The Caribbean community clearly concurs. A Cultural Desk installed in the CARICOM Secretariat in Georgetown, Guyana had as one of its major tasks the organization and promotion of the Caribbean Festival of Arts (Carifesta). The Jamaican organizers of the second Carifesta held in 1976 were at pains to declare that "Carifesta '76 continues to demonstrate the positive connection between cultural expression and the struggle for political and economic self-determination."[17] The one that followed took place in Cuba in 1979 when Cuba made assertive attempts to enter the Caribbean family, since identification with the arts was one sure guarantee of the linkages Fidel Castro sought with his neighbors. Then in 1981 the fourth Carifesta was held in Barbados. The event received mixed reviews from the participants, due largely to inadequate infrastructural resources to ensure smooth operations.[18] The time lapse between the first event, held in Barbados in

1981 and the planned Festival for 1988 in Jamaica was not lost on Caribbean Ministers of Culture, who instructed the Secretariat in 1987 to convene a meeting of cultural agents from all over the region to advise CARICOM on a regional cultural policy.

The meeting held in Port of Spain in August 1987 discussed Carifesta and focused on problems of cost and the lack of facilities in most CARICOM countries. The idea of mini-festivals re-emerged from its Barbados Carifesta origins.[19] Despite reservations about large, multi-disciplinary single location Carifestas, the idea of regional festivals remained a binding commitment in the interest of regional unity. A tentative schedule was recommended for the 1990s with smaller scale festivals alternating every two years with major multi-disciplinary events to start in 1991.

Yet there is as strong a view that festival arts are yet to inform in any serious way public policy within Caribbean nations or regionally. The 1988 Carifesta plans were, at the very outset, dogged by questions of cost. An estimate of $25 million dollars (Jamaican) for the event would be naturally prohibitive in a country barely managing to balance its national budget. Among many planners festival arts are still seen as something divorced from serious everyday life. Matters are clearly not helped when a modern commentator on the Trinidad Carnival assesses Peter Minshall's seriousness of purpose in his concepts and designs as possibly "inappropriate to the medium, *mas,* in which he seeks to deliver his message; since our Carnival is all about life, an annual celebration that defies death's dominion, a freeing of the spirit rather than a shackling of the soul. And mas, for the majority of us, is the opportunity to embrace hedonism, certainly not the time to agonize over the inevitability of death."[20] The economic planner may have no wish to facilitate the embrace of hedonism in the face of the intractable problems of low productivity, negative growth, and international debt.

Many see these festivals as indulgences of the lower classes or entertainments of the minstrelsy genre designed as respite from months of hardships. The work of enthnographers, social anthropologists, and cultural historians notwithstanding, the economic variables of GDP and GNP remain the acceptable indicators of progress.

Lip-service is indeed given to the investment in human resources as an imperative for development, but the centrality of human creativity and the reality of the cultural context still take second place to notions of getting hordes of people "trained" to manage the technology being transferred from the North Atlantic. Peter Minshall, the *bête blanc* of Trinidad Carnival arts, challenged his peers to face the implications of some of this with a magnificent Mancrab, which won the title of King of Carnival for 1983. He made his statement, having technology rape the River (the environment?). His detractors were suitably confused, but he played *mas* in the spirit of Carnival dating back well over a century and a half.[21]

For the festival arts, like other innovations of the people from below, have long demonstrated the ability of Caribbean people to assimilate, adapt, adjust, and finally to innovate—in short to be the creative agents of their destiny, to be the subjects rather than the objects in the complex process of cross-fertilization. And Peter Minshall, as the consummate Carnival artist, is the epitome of this spirit of Caribbean survival and development. Most Trinidadians who care about Carnival (and a great many of them are "the ordinary folk") grasp this fact instinctively.

II

It is in this sense that Caribbean festival arts in their traditional or transmuted forms are likely to sustain their relevance to Caribbean society. They are, after all, manifestations of many of the key elements in the dynamics of Caribbean existence, even bringing into focus some of the deeper social forces that determine and define the Caribbean contemporary reality.

The Creolization Process

All great civilizations are the result of cross-fertilization. No exaggerated claims need to be made, then, for the Caribbean on this most fundamental of social and cultural formation among human beings anywhere on the planet.

Different peoples torn from old civilizations of Africa, Europe, and Asia met on foreign soil in the Americas, where indigenous civilizations were to be found as well. Their encounters created creolized forms of social living still sorting themselves out. The Caribbean as a distinct part of that historical experience developed its own variations of this "American phenomenon" in the complex relationships that developed between enslaved Africans and European overlords, both of whom displaced in most islands the indigenous Amerindians by the sheer weight of numbers and by consolidating their social structures into a dialectical (some would say schizophrenic) co-existence that persists to this day.

By the time the latecomer East Indians, Chinese and Lebanese from the Levantine Coast entered the region, the rules of the game had been made; not even the overwhelming majority East Indian population in Guyana and the sizeable minority of the same group in Trinidad has jerked those countries out of their historical Euro-African or Afro-Creole realities. Carnival and Jonkonnu are unashamedly Afro-Creole or Euro-African expressions, claiming a particular authenticity over Divali (Festival of Lights) and Hosay as genuine ancestral Caribbean expressions.

The reality expresses itself in politics no less where the political culture is rooted in Westminster democracy in principle but expected to function, in practice, by rules forged by the people of African ancestry. Only time can determine whether the influence of Hosay and Divali will transform in a deeply organic way the Euro-African or Afro-Creole nature of festivals and, by implication, of Caribbean life itself.

The African Presence at the Center of Caribbean Ethos

For the African presence is yet to be universally acknowledged as central to the Caribbean ethos. The disparate elements have indeed been creolized over time into native-born and native-bred entities that are no longer the clones of their separate origins. There is no surprise, then, that Jonkonnu should have flourished, having found form and identity, after the long period between 1807 when the slave trade was abolished and 1834–1838, the period of Emancipation. An entire new generation of West Indian slaves had in fact grown up without encountering new arrivals

from the Guinea Coast. Much that became "West Indian" or "Caribbean" was actually forged in the crucible of the African experience in the Americas. The Africanization of the European was no less important to the creolization process than the Europeanization of the African.

In any case, the African slave could not return home as his European masters could. And without the capacity, right, or opportunity to determine the values of the governing group, the African devised rules, customs, values for his survival. Europe governed while Africa ruled. And so the history of the region has meant nothing outside of the history of its early common people, the Africans, who brought to economic activity and to social and cultural life all the energy and creativity by which Caribbean slave society existed.

Resistance to the authority of the Crown by the slaves themselves or by their masters in pursuit of total hegemony over their human property, sometimes even in defiance of the enlightened and liberal views of their colonial colleagues in the cities, was continuous and unrelenting. This persisted after Emancipation in the English-speaking countries and much later in no less a place than Cuba, where slave resistance and the struggles of black Cubans in Oriente Province figure prominently in the historical struggle that was to make Castro's revolution possible and meaningful.

Today Castro not only insists that he is a Caribbean man and his Cuba a Caribbean nation, but he also is demanding that the leadership profile of the Cuban Communist Party reflect more faithfully the ethnic realities of Cuba.[22] The African presence continues to be understated in Cuba's politics, though not in its *comparsas*, *cabildos*, and the Santería religion, regarded as the heartland of the Cuban cultural reality.

Jamaica is black and Cuba is mulatto, said the Cuban poet laureate Nicolás Guillén in the 1930s.[23] It was a poetic assertion of the power of the African presence in two of the more populous countries of the region. The implications for politics and economics should be self evident. But this is not necessarily so to decision-makers concerned with development, except in times when political leaders who, hoping to impress visiting potentates or tourists, showcase the black population's capacities for singing, dancing, dressing-up in fancy costumes and acrobatics, which the festivals have frequently been mistaken merely to be.

Masking Device

But to the ordinary people, festival arts are more than minstrelsy; they affirm the use of the mask, literally and metaphorically, in coming to terms or coping with an environment that has yet to work in their interest, a society that is yet to be mastered and controlled by them, despite the coming of Independence. The ambush of the society under the cover of masquerades in festival has been one way of attempting control, if only a temporary one. Three days of satirical comment on a boorish society by those who suffered most was a safety valve wisely left open in the steaming cauldron.

Contemporary existence still employs such devices as allegory, double entendre, code-switching in speech to manage the contradictions of a groping society. Politicians are the butt of the calypsonian savage wit and ribald humor to this day.

Figure 161 This raised ithyphallic mask appeared in Jason Griffith's 1988 sailor band in Port of Spain. Earlier in the nineteenth century, another masker called Actor Boy (see p. 1) also posed with his mask raised above the face. At this position, the individual occupies the threshold leading into the ritual of masquerade or out of that ritual. The faces of culture and of individual human beings appear to us now and as they did when Caribbean festival arts first emerged. It is the individual and his play with the masks of culture which drive Caribbean festival arts. Through social confrontation and reaffirmation, the play of masks ensures the vitality of these festivals and the welfare of participants who, by the nature of being, negotiate a personal space in the matrix of social and cultural living.

Throughout colonial West Indian history, sailors were looked upon with ambivalence; in one respect their perceived good life was envied yet their intrusion into local culture was resented. Uniforms of French, English, American, and Dutch sailors sparked the creativity of festival designers who freely interpreted sailor designs while adhering to his essential character. Sailors explored the world and have so for centuries. They are boundless in time and space. Likewise in festivals, sailors explore the planets, distant continents, and times future and past, searching out every little piece of difference in the universe. The sailor, once perceived as an extension of colonial control, has become cultural liberator. Dancing down the streets of Port of Spain, Brooklyn, Toronto, and London, sailors celebrate the great accomplishments and failures of humanity.

As everyman, this masker obtains a global personality ever prepared to move in a rapidly changing world. These conditions were present when Actor Boy first appeared in the Caribbean world and declared his right to play with culture.

194

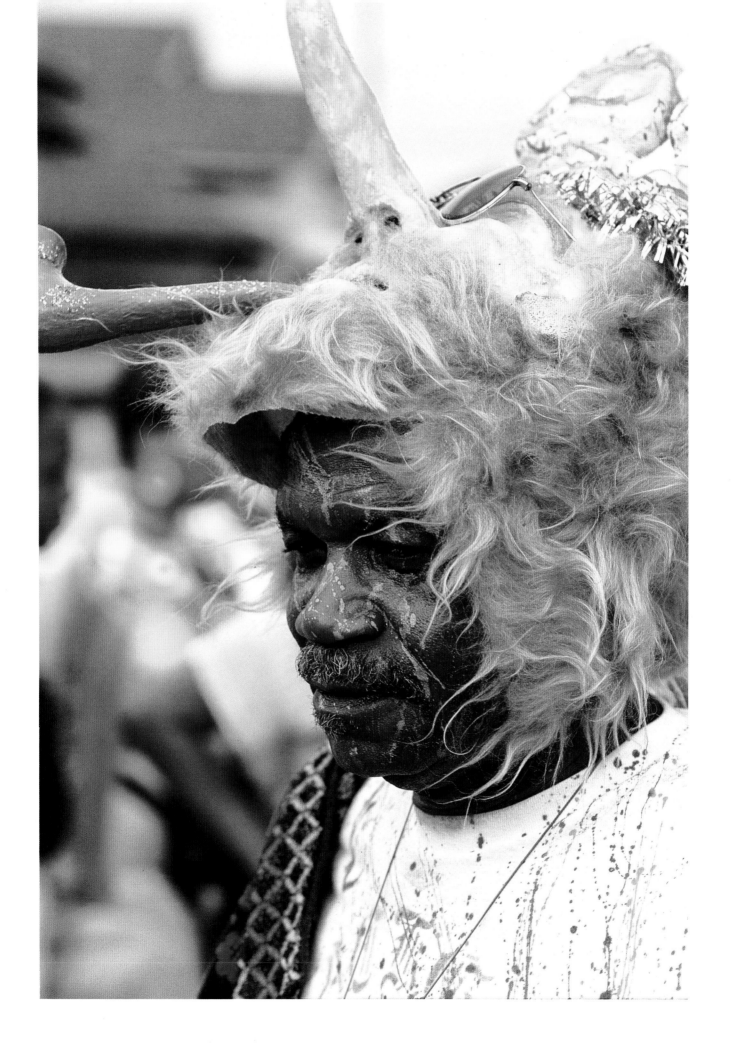

Establishment heartlessness comes in for its share of trenchant criticism in the lyrics of reggae. "Masking" has extended from the festivals to everyday life which had been the source of festival arts originally. Opportunities for this natural outlet are consciously subjected to remarkably little official censorship, even though a few calypsos and reggae pieces have been banned in modern times.

Many students of Caribbean society past and present see the festival as a temporary respite from a world of drudgery, hardship, and toil, whether under slavery, during colonialism, or in post-Independence. But it is also a positive expression of people's world-views and sense of self *(Figure 161)*. To be a King or a Queen for a day or two may well speak to a deep aspiration for recognition and status that elude the denigrated African in exile, the alienated worker, the jobless citizen with little sense of hope otherwise. Among the Jamaican Rastafarian the masks are dropped. The Rastafarian believer needs no festival as prop for his claims to the kingness of his personhood. He crowns his woman, "queen." She attends him in the Court of Jah. Judith Bettelheim rightly attributes the decline of Jonkonnu among the younger generation throughout the sixties and seventies to the super-cession of that ancestral imagery by the contemporary unequivocating Rastafarian movement.[24]

In Trinidad Carnival, there are Kings and Queens aplenty, receiving recognition and status from an adoring populace as well as from officialdom. Calypsonians take on royal titles with or without the benefit of Carnival coronation. The society in independence increasingly understands the significance of all this. National honors go to calypsonians and other exponents of festival arts. The Mighty Sparrow, the calypso king, is in private life Dr. Slinger Francisco, D. Litt (*honoris causa*) of the University of the West Indies.

Hosay no doubt does for the East Indians what Carnival and Jonkonnu did for the migrant Africans in demarginalizing them in a society not of their making. Trinidad, Jamaica, Surinam, and Guyana where Hosay is to be found are not regarded as "East Indian" societies. The Muslim and Hindu religio-cultural factor remains secondary to the ideals long rooted in Christian culture challenged albeit by the "insolent" and sometimes disguised defiance of African belief-systems, some of which may lie dormant but are by no means dead.

The masking devices of the exiled African in the Caribbean find parallels among the exiled East Indians of Trinidad, Guyana and Jamaica in Hosay. The product may indeed be different but the process is similar. For both sets of marginalized souls, metaphor, the mask, and masquerading are among the tools of liberation from the uncertainties consequent on uprooting.

Diasporic Diffusion

The continuous scattering of Caribbean people in the waves of twentieth-century migration to metropolitan centers has diffused festival arts weaned in the Caribbean to places like London, New York, and Toronto. The festival arts again act as means of cultural expression, survival, and social demarginalization in a hostile environment.

The phenomenon should not surprise. Within the Caribbean region itself such diffusion had been apace. In earlier times, if the records are to be trusted, Jamaican

Jonkonnu apparently spread to Belize and the Bahamas. Masquerade in the Leeward Islands of Antigua, St. Kitts and Montserrat benefited from the cross-fertilizing; Cuba was enriched with the waves of slaves who accompanied masters to that country after the Haitian revolution; and London now boasts more texture in August for having to struggle with the Notting Hill Carnival which is developing characteristics different to its parent in Port of Spain.

Brooklyn, New York does "catch afire" each summer, ignited by the Caribbean festival, and Toronto can no longer deny the presence of a sizeable West Indian population, reaffirmed by the annual Caribbean Festival mounted there, if by nothing else *(see Figure 160)*.

Common items of cultural engagement within the Caribbean crop up at these events staged by migrant citizens with yearnings for psychic, if not physical, return. The consequences are far-reaching for the region "back home." As a mobilizing force, such festivals have not failed to convince home governments of the need to find a place for millions of diasporic Caribbean people in the region's plans for its own development. Attracting investment by expatriates is not the least of the region's designs on them, hungry as they are for cultural certitude in a situation where a steady job, the ownership of a house, and access to consumer durables provide little compensation for the racial and cultural hostility meted out by the host society.

Caribbean festival arts, far away from source, continue to provide for Caribbean people, as Kwabena Nketiah remarked, "a vehicle for communication [*and*] affirming the values of the society [they leave behind] and for strengthening the cultural bonds that binds them."[25] They can also guarantee the migrant's psychic survival and existence beyond survival. In the changed circumstances of diasporic existence, the festivals are appropriately revised and re-scheduled. Carnival in Protestant and often-times cold London, as well as in ecumenical Brooklyn, is held in the heat of summer rather than in pre-Lenten February or March. They will long continue—these festivals—to have a special place in the organization of social life in Caribbean society at home and abroad.

Notes

Introduction

1. Colin MacInnes, *City of Spades* (New York: Macmillan, 1958), p. 43.

2. MacInnes, *City of Spades*, p. 39.

3. MacInnes, *City of Spades*, p. 83.

4. For figures on West Indian migration to the United Kingdom, see Stephen Davis and Peter Simon, *Reggae International* (New York: R&B, 1982), p. 156. For remarks on reggae by Sting, see the same source, p. 171.

5. Jane Kramer, "Letter from Europe," *The New Yorker*, Vol. LXII, No. 13 (May 19, 1986), p. 106.

6. For brief discussion of the style of these three leading New York painters of the '80s, see Robert Farris Thompson, "Activating Heaven: The Incantatory Art of Jean Michel Basquiat," *Jean Michael Basquiat* (New York: Mary Boone/Michael Werner Gallery, 1985), n.p.

7. Classic accounts of these traits include Richard Alan Waterman, "African Influence on the Music of the America," *Acculturation In The America*, ed. Sol Tax (Chicago: University of Chicago Press, 1952), and Marshall W. Sterns, *The Story of Jazz* (New York: Oxford, 1956), Chapter 1.

8. From a series of interviews with Dejo Afolayan, winter 1985. All further citations of Yoruba proverbs and data relating to other aspects of Yoruba traditional music and music criticism stem from Afolayan's profound knowledge of the traditional culture of the Oyo and Ijesha Yoruba. I am very much indebted to him.

9. I am grateful to the Alafin of Oyo for graciously allowing me to film the running of the Alakoro mask before his palace on New Year's Day, 1964, in Oyo.

10. Victor Turner, "Carnival, Ritual, and Play in Rio de Janeiro," *Time Out of Time: Essays on the Festival*, ed. Alessandro Falassi (Albuquerque: University of New Mexico Press, 1987), p. 74.

11. Turner, "Carnival, Ritual, and Play," p. 83.

12. Interviews with Fu-Kiau Bunseki, winter 1985, summer 1986, and summer 1987. All vernacular renderings of terms for Kongo masking art and music stem from Fu-Kiau, who is without question one of the foremost aestheticians of the Bakongo.

13. Adolf Bastian, *Die Deutsche Expedition an der Loango-Kuste*, Volume II (Jena, Germany: Hermann Costenoble, 1875), p. 183.

14. From a conversation with John Nunley, New York City, November 1987.

15. I am extremely grateful to Judith Bettelheim for graciously sharing photographs of Jonkonnu masks and the Rosicrucian altar from her fieldwork in Port Antonio, Jamaica.

16. I am grateful to Tom Steinberg for sharing his photographs of John Wesley performing in a Junkanoo festival in 1978, during fieldwork on the island of Eleuthera in the Bahamas.

17. *Carnival Masks from Trinidad* [1971], Photograph Collection, Art Library, Yale University. Two maskers with apparently Yorubaizing multi-lappeted costumes with plumes are documented in this interesting photograph. The wearing of a bright flashing blue "eye" over the heart of one of the maskers may well have been influenced by the image of the nineteenth century *batonnier*/stickfighter in the Trinidad Carnival. The latter, as Ms. Pamela Franco, a student of Afro-Trinidadian art history, has informed me, traditionally wore "a heart on the chest with mirrors placed inside." See illustration in Errol Hill, *Trinidad Carnival: Mandate for a National Theatre* (Austin: University of Texas Press, 1972), p. 96.

Chapter 1

1. Peter Minshall, *Callaloo an de Crab* (Trinidad and Tobago, 1984), p. 19.

2. Nelson Graburn, *Ethnic and Tourist Arts: Cultural Expressions from the Fourth World* (Berkeley: University of California Press, 1976), p. 4.

3. Interview by Judith Bettelheim, November 27, 1976, Port Antonio, Portland, Jamaica.

4. Sidney Mintz, "Africa of Latin America, An Unguarded Reflection," *Africa in Latin America, Essays on History, Culture, and Socialization*, ed. Manuel Moreno Fraginals (New York: Holmes & Meier Publishers, Inc., 1984), p. 292.

5. For a good review of Caribbean musical forms including a brief overview of festival music, see Kenneth M. Bilby, "The Caribbean as a Musical Region," ed. Sidney Mintz and Sally Price, *Caribbean Contours* (Baltimore: Johns Hopkins Press, 1985), pp. 181–215.

6. The type of British folk theater closest to Caribbean masquerades is generically known as mumming, and comprises Doctor plays, Hero/Combat plays, and Morris dances. Mummers and Morris dancers generally appear at Christmas, whereas similar performers like the Jack-in-the-Green and his entourage entertain at May Day. Morris dancers may also appear at a spring festival.

Mummers often perform sword dances (mock battles) and include among their repertoire characters such as a hobbyhorse, a clown, a king, a queen, a Betty (a man/woman), and a doctor. A sweeper who purges the area of evil often precedes the entourage and the sword play. A Hero/Combat play, often simply another term for a mumming, is usually divided into the presentation, the combat, the cure, and the collection. Doctor plays, in turn, could simply be a subcategory of a Hero/Combat play, although at times they were performed alone. Roger Abrahams, who writes about mumming in the Caribbean, terms all such plays "ritual renewal in combat

form." (Roger Abrahams, "Pull Out Your Purse and Pay: A St. George Mumming from The British West Indies," *Folk-lore*, Vol. 79 [Autumn 1968], p. 200).

7. For an excellent discussion of the term creole and a concise historiography of its usage, see Edward Brathwaite, *The Development of Creole Society in Jamaica* (Oxford: Clarendon Press, 1971), pp. xiv–xvi. Rex Nettleford gives further insight in his discussion of the importance of creolization for today's Caribbean culture. He includes different types of Africans and Europeans, and the "latter-day arrivants and the interplay that followed on this between the established groups and the new East Indians, Chinese, Arabs, and even the more recent transitory North American visitor. The creolising process in fact continues" (*Caribbean Cultural Identity: The Case of Jamaica* [Kingston, Jamaica: The Institute of Jamaica, 1978], p. 185).

8. John Thomas Smith, *Vagabondiana, or anecdotes of mendicant wanderers through the streets of London; with portraits of the most remarkable* (Piccadilly: Chatto & Windus, 1874), n.p.

9. The shortage of luxury raw materials has seriously affected many festivals. Certain costumes and sculptures can no longer be fabricated and certain symbolic motifs or ingredients have all but disappeared for lack of materials. If they can afford it, some Jamaicans fly to New York or Miami to purchase materials, but this is unusual. Individual Jonkonnu performers most often no longer create their own new costumes and consequently, for lack of the appropriate paraphernalia, no longer parade the streets. In Cuba the supply of cowrie shells is virtually depleted and the Conjunto Folklorico is finding it increasingly difficult to construct the costumes for the Afro-Cuban saints who require cowries as part of their sacred insignia.

10. *After Africa: Extracts from British Travel Accounts and Journals of the Seventeenth, Eighteenth, and Nineteenth Centuries concerning the Slaves, their Manners, and Customs in the British West Indies,* ed. Roger D. Abrahams and John F. Szwed (New Haven and London: Yale University Press, 1983). A reading of the forty-eight page introduction to this volume is essential for any student of African culture in the Americas.

11. *The Celebration of Society: Perspectives on Contemporary Cultural Performance,* ed. Frank E. Manning (Bowling Green, Ohio: Bowling Green University Popular Press, 1983), p. 6.

12. Sidney W. Mintz and Richard Price, *An Anthropological Approach to the Afro-American Past: A Caribbean Perspective* (Philadelphia: Institute for the Study of Human Issues, Occasional Papers in Social Change, 1976), No. 2.

Chapter 2

1. The most elaborate eighteenth-century description of Jamaican festivals, and the first specific mention of Jonkonnu, may be found in the *History of Jamaica,* published in 1774, by Edward Long, an English planter-politician. Long gives the name "John Connu" to the central figure in these festivals and goes on to explain that both the parade and the main dancer are an honorable memorial to John Conny, an active, successful merchant at Tres Puntas, in Axim (modern day Ghana) around 1720. Other writers copied Long's account, varying the spelling. British-influenced writers spell the name *John Canoe,* while in contemporary Jamaica, its spelling more closely reflects its pronunciation, *Jonkonnu.* The phonetic transformation of the name *John Conny* to *Jonkonnu* is still the source of dispute, but it is certain that since at least the late eighteenth century the Christmas parade has been known as Jonkonnu. For a thorough discussion of the various suggestions for the source of the name *Jonkonnu,* see Frederick G. Cassidy, *Jamaica Talk* (New York: MacMillan, 1961), pp. 256–262, and Judith Bettelheim, *The Afro-Jamaican Jonkonnu Festival: Playing the Forces and Operating the Cloth* (Ph.D. diss., Yale University, 1979).

2. For a discussion of neo-African, see Cheryl Ryman, "Jonkonnu, a Neo-African Form," *Jamaica Journal,* Vol. 17, No. 1 (February 1984).

3. See Orlando Patterson, *The Sociology of Slavery* (1967; reprint ed., London: Granada Publishing, 1973), pp. 244–246. Patterson's

theories have been accepted unquestioningly by many authors, although his African sources are at best generalized interpretations of African ritual, unsubstantiated by historical data. One such author, Sylvia Wynter, in "Jonkonnu in Jamaica: Toward an Interpretation of Folk Dance as a Cultural Process," *Jamaica Journal,* Vol. 4, No. 2 (1970), pp. 34–48, accepts Patterson's information and goes on to speculate on both a secularized and a religious element within Jonkonnu. Perhaps the religious qualities she proposes may have been personally viable for certain participants in the nineteenth century, but they were not strong or organized enough to endure as a consistent theme within Jonkonnu in the twentieth century.

4. All interviews in this chapter were conducted by Judith Bettelheim in the mid-1970s and '80s. This particular interview took place in Port Antonio, on November 27, 1976.

5. Carifesta is modeled on national regional festivals of arts, similar to those sponsored by the Jamaican Cultural Development Commission (JCDC). It brings together performers from all around the Caribbean, in entertainments that vary from folk theater to popular songs to the performances of modern dance companies. Carifesta was established as a means for cultural cooperation, and "as a way of investing historical tendencies with positive force and as a device to forge the solidarity of the Caribbean collective consciousness." Its organizers stated that "Carifesta 1976 con-

tinues to demonstrate the positive connection between cultural expression and the struggle for political and economic self-determination." Rex M. Nettleford, *Caribbean Cultural Identity: The Case of Jamaica* (Kingston, Jamaica: The Institute of Jamaica, 1978), pp. 152–154. The first Carifesta had been held in Guyana in 1972. Carifesta 1988 is scheduled to take place in Jamaica.

6. Since Judith Bettelheim's research in the 1970s, and the publication of articles relating to Jamaican Jonkonnu, the festival has undergone changes reflecting the political climate of the 1980s. During subsequent research, Bettelheim has revised aspects of her thesis regarding Jonkonnu, as the following discussion will demonstrate. Comparative analysis can be found in her previously published article, "The Jonkonnu Festival," *The Journal of Ethnic Studies,* Vol. 13, No. 3 (Fall 1985), pp. 85–105.

7. Winston A. Van Horne, "Jamaica: Problems of Manley's Politics of Change 1972–80," *Journal of Caribbean Studies,* Vol. 2, Nos. 2 and 3 (Autumn/Winter 1981), p. 7.

8. Interview with Zeek Gordon, who had been playing Cowhead for at least twenty years, Port Antonio, November, 1976.

9. In 1984 the Jamaican National Museum curated a small dynamic exhibition of Nyapingi-inspired art. Clinton Brown's 1975 drum and Everald Brown's 1976 dove harp are exquisitely rendered tributes to their faith, while Brown's paintings present a mystical world of hope and collective endeavor.

10. Interviews, Kingston, July 22 and August 25, 1976.

11. This information was supplied by Trinidadian art historian Pamela Franco.

12. Isaac Mendes Belisario was born in Jamaica and was perhaps the grandson of the Rabbi of the same name, who died in 1791. He was probably born c. 1791–1800, one of the six children of Abraham Mendes Belisario and Ester Lindo. He was schooled in England and exhibited landscapes at the Royal Academy in 1815, 1816, 1818, and 1831. On four occasions, he also exhibited at the Old Water-Colour Society. Returning to Jamaica around 1833, he set up his studio in central Kingston, at the southeast corner of the Parade. Obviously, as can be discerned from his sketches, Belisario was trained in the Beaux Arts tradition. The color sketches under consideration were "drawn from life" on Christmas 1836, lithographed in 1837 by Duperly, and published in Kingston. The series of twelve is on permanent exhibition at the Institute of Jamaica, and four have been issued as color reproductions. This biographical information on Belisario is summarized from notes in the Institute of Jamaica's clipping file and from an entry in *The Jewish Historical Society of England,* Transactions, No. 14 (London, 1935–1939).

13. Bettelheim, *The Afro-Jamaican Jonkonnu Festival,* p. 78.

14. Interview with Valentine "Willy" Best, Port Antonio, November 27, 1976.

15. Reverend Hope Masterson Waddell, *Twenty-Nine Years in the West Indies and Central Africa, 1829–1859* (London: T. Nelson & Sons, 1863), p. 16.

16. Patterson, *The Sociology of Slavery,* pp. 238–79.

17. Sidney W. Mintz and Richard Price, *An Anthropological Approach to the Afro-American Past: A Caribbean Perspective* (Philadelphia: Institute for the Study of Human Issues, Occasional Papers in Social Change, No. 2, 1976), p. 3.

18. Edward Brathwaite, *The Development of Creole Society in Jamaica 1770–1820* (Oxford: Clarendon Press, 1971), p. 231.

19. Sir Hans Sloane, *A Voyage to the Islands of Madera, Barbados, and Jamaica,* Vol. 1 (London: B.M., 1707), pp. 46–48.

20. Edward Long, *The History of Jamaica* (London: T. Lowndes, 1774), p. 424.

21. Lady Maria Nugent, *Lady Nugent's Journal* (1839; reprint ed., London and Kingston: Institute of Jamaica, 1966), p. 48.

22. Tippo Sultan of Mysore was encouraged by Napoleon to oppose the British in India; he was killed in 1777.

23. Matthew Gregory Lewis, *Journal of a West Indian Proprietor Kept during a Residence in the Island of Jamaica 1815–1817* (1829; reprint of 1834 edition, New York: Negro Universities Press, 1969), p. 53.

24. Lewis, *Journal of a West Indian Proprietor,* p. 56–57.

25. Cynric R. Williams, *A Tour through the Island of Jamaica in Year 1823* (London: Hurst & Chance, 1827), p. 86.

26. Alexander Barclay, *A Practical View of the Present State of Slavery in the West Indies* (London: Smith, Elder & Co., 1826), p. 10.

27. Waddell, *Twenty Nine Years,* p. 18.

28. Michael Scott, *Tom Cringle's Log* (1836; reprint ed., New York: E. P. Dutton, 1915), pp. 261, 264–65.

29. I. M. Belisario, *Sketches of Character in Illustration of the Habits of the Negro Population of Jamaica* (Kingston, 1837), n.p. Zoe Annis-Perkins, textile conservator and costume historian at The Saint Louis Art Museum, has determined that the House John Canoe costume closely resembles a popular eighteenth-century English masquerade, that of the Hussar, based on a Hungarian military uniform. The Hungarian Hussar regiments were formed at the end of the seventeenth century to defend their frontier against Turkish forces and the uniform/costume owes much to a Turkish influence. The tunic top is fastened across the front with braid loops or cords and has long tight-fitting sleeves with cuffs. The uniform also includes a sash, or a *sabre tache.* In a 1752 painting by Thomas Worlidge entitled *Garrick as Tancred,* the pants worn by Garrick are piped on the outside seam with what appear to be tufts of fabric (Aileen Ribero, *The Masquerades in England, 1730–1790, and its Relation to Fancy Dress in Portraiture* [New York: Garland Publishing, 1984], plate 7). Belisario has replaced these with cloth flowers in his Jamaican House John Canoe. Masquerade pattern books often carried designs for the Hussar uniform. The official uniform of the West India Regiment included a "short red coat with lapels to the waist and collars, cuffs, and lapels in the distinctive regimental facing." (Roger Norman Buckley, *Slaves in Red Coats, the British West India Regiments 1795–1815,* [New Haven, Connecticut: Yale University Press, 1979], p. 83.) Perhaps Belisario was also influenced by illustrations of these uniforms.

30. Belisario, *Sketches of Character.*

31. *Marly: or a Planter's Life in Jamaica* (Glasgow: Richard Griffin, 1828), p. 292.

32. Barclay, *A Practical View,* p. 10.

33. Rosamond Bayne-Powell, *Eighteenth-Century London Life* (London: J. Murray, 1937), pp. 303–04. Popular magazines often carried stories about the Jack; see *The Illustrated London News,* May 27, 1843.

34. J. F. Caine, "How to Make a Jack in the Green," *English Dance and Song,* Vol. 2, No. 5 (May 1938), pp. 79–80.

35. John T. Hayes, *Catalogue of the Oil Paintings in the London Museum with an Introduction on Painters and the London Scene from the Fifteenth Century* (London: H. M. S. O., 1970), p. 54.

36. Margaret Dean-Smith, "Disguise in English Folk-Drama," *Folk Life* 1 (1963), p. 98.

37. Robert Farris Thompson, personal communication, March 1976.

38. Monica Schuler, *"Alas, Alas, Kongo," A Social History of Indentured African Immigration into Jamaica, 1841–1865* (Baltimore, Maryland: The Johns Hopkins University Press, 1980), p. 71.

39. This concept of complementary sets is basically a simplistic but not invaluable structuralist approach as evidenced in, for example, *African Arts as Philosophy,* Douglas Fraser, ed. (New York: Interbook, 1974). Rural/urban, as a complementary set, parallels such sets as nature/culture, animal/vegetal and dynamic/static, according to Fraser; and each set concentrates on the patterns formed by the parts, whatever the subject of investigation.

40. Interview, Kingston, August 13, 1976.

41. The best-known Horn Dancers came from Staffordshire. The characters in their masquerade included a clown or fool, a hobby horse, a musician, and a Maid Marian.

42. Angelina Pollak-Eltz, "The Devil Dances in Venezuela," *Caribbean Studies* 8, No. 2 (July 1968), p. 71. Pollak-Eltz states that "the masks of the 'devils' of Curiepe were made of calabashes. The dancers wore fancy garments made of raffia or corn straw, carrying long cowhorns on their heads, painted in vivid colors." These "devils" were, during the nineteenth century, sponsored by "a religious fraternity organized only by people of African descent." Similar processions took place in Lima, Peru, during the eighteenth century. Among the most famous were those of "Our Lady of the Negroes;" see Jean Descola, *Daily Life in Colonial Peru, 1710–1820* (London: Allen & Unwin, 1968), p. 157. For other references to black masquerades in Peru, see Fernando Ortiz, "La fiesta Afrocubana de Dia de Reyes," *Archivos del Folklore Cubano,* 1 (1924), pp. 23–24. Ortiz also documents a Cowhead character that appeared during Cuban Dia de Reyes celebrations. Other chroniclers of Dia de Reyes celebrations in nineteenth-century Cuba also described the black masqueraders: "They are dressed in the most fantastic and barbarous disguises, some wearing cow's horns, other masks representing the heads of wild beasts, and some are seen prancing on dummy horses." (Maturin M. Ballou, *Due South or Cuba Past and Present* [New York: Houghton, Mifflin and Co., 1885], p. 198.) Another character in Haitian Rara wears a Devil headdress, but the Cowhead may even

be more powerful than the Devil. One informant stated, "The cow in Rara is the strongest; he can scare away the Devil with his horns." (Emmanuel C. Paul, "Notes sur le folk-lore d'Haiti," *Bulletin de Bureau d'Ethnologie,* Port au Prince, 1956.) See also "Le Rara à Léogane," manuscript in the library of the Faculté d'Ethnologie, Port au Prince.

43. Historical accounts of horned headdresses in West Africa include: Francois Froger, *Relation d'un voyage fait en 1695–97 au côtes d'Afrique* (Paris: 1698), discussed in Frank Willet, *African Art* (New York: Praeger, 1971), p. 98; Jean Labat, *Nouvelle relation de l'Afrique occidental,* Volume IV (Paris: Chez G. Lavelier, 1728), p. 288 (for Gambia, 1728); and Louis Gustave Binger, *Du Niger au Golfe du Guinea,* Volume I (Paris: Hachette et Cie, 1892), p. 378.

44. A Horsehead collected by Martha Beckwith in Lacovia, St. Elizabeth, Jamaica in the 1920s is in the American Museum of Natural History in New York. The Horsehead is made of a real skull attached to a wooden frame, which extends below the skull as a support the player can hold. The head is embellished with bits of cloth and tinsel, and looks as if it had once been totally covered with silver paper, since much of its surface still has paper attached to it. The eyes are filled in with iron scraps and woven twine, and the skull is fitted with a metal bit. The ears are made of wire loops covered with silver paper and bits of red and gray cloth; the hinged jaws can be made to open and close by means of a rope.

45. Zora Neale Hurston, *Tell My Horse* (New York: J. B. Lippincott Company, 1938), pp. 39–41.

46. Dominique Zahan, *Sociétés d'initiation Bambara* (Paris: Mouton, 1960), pp. 156, 176–187.

47. Zahan, *Sociétés d'initiation Bambara,* p. 156. The art historian Anita Glaze writes that a horse costume is also used by the graduating class of the Poro Society among the Senufo (personal communication, March 1978). The honor graduates have the right to perform on a sculpted hobbyhorse in dances held in their honor during the dry season following their graduation.

48. Violet Alford, "The Hobby Horse and Other Animal Masks," *Folk-lore* 79 (Summer 1968).

49. Violet Alford, "Some Hobby Horses of Great Britain," *Journal of the English Folk Dance and Song Society* (1939).

50. Margaret Dean-Smith claims that "this type of hobby-horse is not English" (personal communication, December 17, 1976). It is first documented in England in a series of painted glass windows in Bentley Hall, Staffordshire, which date to the reign of Edward IV in the fifteenth century. In the several panels are characters interpreted as "Morris dancers" with a hobbyhorse in the center. Another interesting hobbyhorse representation is found in a painting by D. Vinckboons (1578–1629) in the collection of the Fitzwilliam Museum, Cambridge, attributed by them to the "Flemish School," early seventeenth century (Colonel Maurice Harold Grand, *Old English Landscape Painters,* Vol. 1 [London: 1957], p. 6). It includes "morris dancers, a fool collecting money, and a hobby-horse." Five nineteenth-century prints made of this particular painting attest to the popularity of its subject.

51. In the Tyrol, Carnival is celebrated from New Year or Epiphany until Ash Wednesday. The season is divided into special masquerades. The Schleicherlaufen, or the running of the masks, takes place at regular intervals, once every five years. The most famous group of masks are the Schleicher, or sneakers, and the most famous masquerade is held at Telfs. The masks worn by the Schleicher are identical to the whiteface wire screen masks worn in the Caribbean, especially the older commercially produced type.

The masks worn by the Telfer Schleicherlaufen in Tyrol are made of wire screen. During the latter half of the nineteenth century the Thuringer Production Co. sold these masks in Germany, France, and Spain and "exported them to South America." By 1925 they were being manufactured for export by the Pischl coppersmiths in Telfer (Robert Wildhaber, "Gesichtsmaske. Bemerkungen zur Typologie und Verbreitung im europäischen Raum," *Volksleben,* Band 18 [Reutlingen, 1967]). I would like to thank Dr. Klaus Beitl, Director of the Österreichisches Museum Für Volkskunde, Vienna, for this information.

52. Bruce Procope, "The Dragon Band or Devil Band," *Caribbean Quarterly,* Vol. 4–5, Nos. 3 and 4 (1956), p. 275.

53. Personal communication, December 16, 1975. I am assuming for this argument that many Caribbean people do not distinguish between Austria and Germany when discussing sources for this mask type. I have not located documentation of a whiteface wire screen mask from Germany.

54. Procope, "The Dragon Band," p. 275. Also personal communication, from Daniel and Pearl Crowley, December 18, 1982.

55. Interview with Aston Spence, Savanna la Mar, August 16, 1976.

56. The analysis of Jonkonnu choreography was accomplished in 1976 by Judith Bettelheim in collaboration with Cheryl Ryman, then an associate of the African Caribbean Institute, Kingston, and a performing member of the Jamaica National Dance Company, and Sheila Barnett, Director of the Jamaica School of Dance. Over a period of one year, they separately recorded the breakdown of Jonkonnu choreography, leaving out elements left to individuals, improvisations, and spontaneous performance patterns. Each analyzed at least six separate performances and three distinct Jonkonnu bands. As a result, this choreographic analysis is based on approximately fifteen performances by six different bands. For a complete dance analysis, see Bettelheim, "The Jonkonnu Festival," *The Journal of Ethnic Studies,* Vol. 13, No. 3 (Fall 1985).

All the Jonkonnu performances documented were officially sponsored, either by a local Tourist Board, by the Jamaican Cultural Development Commission, or by the Jamaica School of Dance. Although some bands may voice objections to the input and control of the JCDC, most bands have been able to improvise under its influence. Some bands have appointed and/or acquired patron-managers with innovative, non-traditional formulae for survival. For example, the band from Port Antonio now incorporates the singing of folksongs along with their choreographed performances during visits by cruise liners. The Three Mile Kingston band has added new characters, such as the very popular North American Indian, whose aggressive and athletic performance has led certain bands to distinguish between Tame Indian, Red Indian, and Wild Indian, so as to provide additional performance possibilities. Only one of the performances incorporated a street procession and house to house visitation. The descriptions incorporate information from both rehearsals and performances.

57. Mintz and Price, *An Anthropological Approach,* pp. 27–28.

58. Mintz and Price, *An Anthropological Approach,* p. 27.

59. Also called the Cut-Out or Open Cut-Out.

60. Belisario, *Sketches of Character,* n.p.

61. With acknowledgement to Robert Venturi.

62. Interview with the fifeman, Duheney Pen, July 26, 1976.

63. Interview with the Devil, Kingston, August, 1984.

64. The information in this section is based on archival research and communications with scholars who have done fieldwork in Belize. Actually, the original Black Caribs from St. Vincent were settled at Trujillo, Republic of Honduras, in 1800. They used to be called Black Caribs to distinguish them from Red Carib Amerindians. The ethnic group, Black Caribs, was first established on St. Vincent when rebellious slaves joined forces with indigenous Amerindians. By 1804 on the Central American Coast they began to disperse both north and south. In that year the Carib Marco Diaz and his followers founded a settlement at Livingston, Guatemala, and also settled on

both sides of Stann Creek. In 1825 a larger migration of Black Caribs occurred. They supported the losing political side in the quest for national rule and fled both north to British Honduras, now Belize, and south to the Mosquito Shore. The most important Garifuna communities in Belize are Stann Creek, Punta Gorda, Hopkins, and Seine Bight. The recent history of the Black Caribs in Nicaragua is even more complicated. (Ruy Galvao de Andrade Coelho, *The Black Carib of Honduras* [Ph.d. diss., Northwestern University, 1955], pp. 42–45.)

65. According to Mrs. Nancy Merz, Associate Archivist, Jesuit Missouri Province Archives, the image is from a glass lantern slide on the frame of which is written the identification. It presumably belonged to Father Louis G. Fusz, who was in Punta Gorda Town from 1907–1914 as part of the British Honduras Mission. Communication dated June 19, 1987.

66. The following account is summarized from six reports. One is from Livingston, Guatemala (Nancie L. Solien [Gonzales], "West Indian Characteristics of the Black Carib," *Peoples and Cultures of the Caribbean*, ed. Michael Horowitz [Garden City, New York: Natural History Press, 1971], p. 133–131). One is from Trujillo, Honduras (Ruy Galvao de Andrade Coelho, *The Black Carib*, pp. 179–232.) Peter May, a personal friend, who lived in Tela, Honduras in 1974–75 and danced Yanhanu [sic] with the Garifuna there on Christmas, related his experiences. One is from Seine Bight Village, Belize (Robert Dirks, "John Canoe: Ethnohistorical and Comparative Analysis of a Carib Dance," *Actes du XLIIe Congrès International Des Américanistes VI*, Septembre 2–9, 1976, p. 489). And two are from the area of Punta Gorda Town, Belize (Margaret Shedd, "Carib Dance Patterns," *Theatre Arts Monthly*, 17 (1933), pp. 65–77; and Emory C. Whipple, December 16, 1975).

67. Douglas MaCrae Taylor, *The Black Carib of British Honduras* (New York: Werner-Gren Foundation for Anthropological Research, 1951), p. 20.

68. The characters include the Devil, an old man, a pregnant woman, the doctor, a policeman, and a number of extra men and women. All the characters are played by men. The Devil wears a red robe and a papier-mâché mask with "goat's" horns. He also may wear a red headwrap. The doctor dresses by combining a woman's skirt with a bustle, a man's shirt, and a necktie. He carries a shopping bag filled with pillboxes, knives for operations, and a ball point pen to be used as a syringe. In Jamaica, the ultimate joke in a Doctor play is listening with the stethoscope, whereas in Belize the greatest hilarity is produced by giving an injection.

The action of *Pia Manadi* commences as the Devil clears the path and the others dance in a circle. The Devil touches the pregnant woman; she becomes ill and falls on the ground twitching. The doctor gives her an injection; she recovers and jumps up to perform a solo. The other characters interact, perform solos, and as the performance terminates the Devil is caught, tied up, receives an offering, and the troupe moves to the next house.

69. In a personal communication, historian Monica Schuler has suggested that Belize, having been a dependency of Jamaica, was a recipient of Jamaican cultural traditions during the 1841–1884 period. See also Bonham C. Richardson, *Caribbean Migrants: Environment and Human Survival on St. Kitts and Nevis* (Knoxville: University of Tennessee Press, 1983), p. 110.

70. Thomas Young, *Narrative of a Residence on the Mosquito Shore During 1839, 1840, 1841* (London: 1842), p. 135.

71. Margaret Shedd, "Carib Dance Patterns," *Theatre Arts Monthly*, Vol. 17 (1933), p. 74.

72. Robert Dirks, *John Canoe: Ethnohistorical and Comparative Analysis of a Carib Dance* (1976), pp. 5–6.

73. Belisario, *Sketches of Character*, n.p.

74. Although Bettelheim had concluded that the earliest report dated from December 24, 1894, an earlier report of Christmas season festivities has been found. Dr. G. Gail Saunders, Director of the Archives Section of the Public Records Office, writes that the *Nassau Guardian* for December 26, 1849 carried an article on Christmas Day amusements at the market place on Bay Street (personal communication, August 3, 1976). This article is worth quoting in part, for it now seems the first reference to "John Canoe" in Nassau:

> several prize oxen, decked out in ribbons, were led over the town previous to falling a sacrafice, and "John Canoe" came forth on stilts in style, much to the gratification of his numerous train of followers

The appellation "John Canoe" does not seem to be appropriate for, or indigenous to, nineteenth-century Christmas celebrations in the Bahamas. No other Bahamian references to Christmas amusements from the 1850s through the first decade of the twentieth century used the term "John Canoe." Why it appears at this early date, and why it appears in quotation marks, are two essential questions. Perhaps the author has borrowed the term from the well-known Jamaican tradition.

75. Louis Diston Powles, *The Land of the Pink Pearl* (London: 1888), p. 147.

76. The Yoruba and Yoruba subgroup, the Egba; and the Igbo and Kongo.

77. Alan Parsons, *A Winter in Paradise* (London: A. M. Philpot, 1926), pp. 102–104.

78. Robert A. Curry, *Bahamian Lore* (Paris: Lelram Press, 1928), n.p.

79. Amelia Dorothy Defries, *The Fortunate Islands* (London: C. Palmer, 1929), pp. 41–50.

80. Defries, *The Fortunate Islands*, p. 50.

81. Interview with Charles Storr, Jr., Nassau, the Bahamas, October 27, 1976.

82. Interview with Charles Storr, Nassau, the Bahamas, October 27, 1976.

83. Interview with Charles Storr, Nassau, the Bahamas, October 27, 1976.

84. Interview with Percy Francis, Kingston, Jamaica, July 27, 1976.

85. Interview with Chippy Chipman, Kingston, Jamaica, July 27, 1976.

86. Interview with A. B. Malcolm, Nassau, the Bahamas, October 27, 1976.

87. Interview, with A. B. Malcolm, Nassau, the Bahamas, October 27, 1976. Another Nassau resident, Charles Storr, also expressed regret at the new Junkanoo regulations.

> In my days you'd find yourself and wear something on your head, like a house, and you'd go and do your own thing. You'd go in line and rush. But now you can't do it today. If you're not in a group or something, you'd better stay on the sidelines.

88. Percy Francis has been leading the Junkanoo group, The Saxons, since the early 1960s. He explained how most of the contemporary groups are organized.

> See, my area of the city, we've been Junkanoo inclined for a long time. It's the East Street area; there has always been Junkanoo there. A friend of mine about fourteen years ago . . . well we were brothers on the same block. And one or two other brothers were with another group, but they decided to form their own group. So we all got together. I'm mostly interested in art. I do all the drawing. In 1965, we depicted the Saxons and that's how we got our name.
>
> Interview July 27, 1976.

Another group leader, Gus Cooper, tells a similar story. He joined a group in the mid-1950s but was disappointed with its organization, so he formed his own group in 1958. In 1958, the average age of the members was seventeen years. Cooper had an older friend, Leonard Bartlett, who had been involved with Junkanoo for thirty years. Bartlett became Cooper's consultant and the group members were Cooper's high school friends. Cooper's group is known as the Valley Boys, named after a neighborhood "east of over the hill." From an interview with Cooper, Nassau, the Bahamas, October, 28, 1976.

89. John Nunley attended Junkanoo in Nassau in 1986; the eyewitness accounts are based on his fieldwork.

90. Alfred M. Williams, "A Miracle-Play in the West Indies," *Journal of American Folk-lore*, Vol. 9, No. 33 (1896), p. 120.

91. Antonia Williams, *A Tour Through the West Indies 1908–1909*, p. 52. Williams's handwritten diary is available only in the Rare Book Room of the University of the West Indies, Mona, Kingston, Jamaica.

92. Antonia Williams, *A Tour*, p. 52.

93. Ralston Williams explains "Negra Business" thus: "The naughtiest of the now tired groups are those who call themselves Negra Business. About a dozen in number the usual size of a troupe, they would use a string band for music. They were the walking newspapers of those days. No gossip, embarrassing incident or family feuding escaped their attention. They were even known to 'play' persons or incidents in the very yard of the people they were 'taking off';" ("Christmases Past in Nevis," a booklet edited by David Robinson, U. S. Peace Corps Volunteer, [Nevis: Nevis Historical and Conservation Society, 1985], p. 21).

94. R. Williams, "Christmases Past," p. 21.

95. Richard Gaugert, "Masquerade in St. Kitts and Nevis," unpublished manuscript, 1987, p.

12. Richard Gaugert, Manager, Special Events, The Saint Louis Art Museum, kindly shared his fieldwork.

96. Gaugert, "Masquerade in St. Kitts and Nevis," pp. 27–28.

97. Bonham C. Richardson, *Caribbean Migrants*, p. 123. Between 1900 and 1930, the "overwhelming majority of Kittitians and Nevisians went to Santo Domingo to work on American-owned cane plantations in the southeastern portion of the Dominican Republic," like the La Romana sugar estate.

Bonham C. Richardson substantiates the oral reports of a St. Kitts-Nevis masquerade tradition rooting in Bermuda. With the installation of a dry dock in the main harbor of Hamilton, Bermuda, and the construction of improved fortifications and barracks, some thousands of black Caribbean workers migrated to Bermuda for work between 1898 and 1904. By 1904 there were 3,000 black West Indians in Bermuda, a sizeable minority in the Atlantic colony whose native population was only 17,535 in 1901." An overwhelming percentage of

these were from St. Kitts-Nevis: "Of the roughly £40,000 remitted to the West Indies from the Bermuda post office from 1901 to 1905, however, almost £30,000 ended up in St. Kitts and Nevis." Perhaps as many as 1,000 Kittitians and Nevisians stayed on in Bermuda.

98. Personal communication with Fradrique Lizardo, November 7, 1977.

99. Interview with Charles Place, Hamilton, Bermuda, October 23, 1976.

100. Interview with Charles Place, Hamilton, Bermuda, October 24, 1976.

101. Cup Match is a two-day legal holiday in August. It commemorates emancipation on August 1, 1834 and is the occasion of an all-star cricket match between the island's eastern and western parishes. See Frank E. Manning, "Cup Match and Carnival: Secular Rites of Revitalization in Decolonizing Tourist-Oriented Societies," *Secular Ritual*, eds. Sally F. Moore and Barbara G. Myerhoff (Assen/Amsterdam: Van Gorcum, 1977).

102. Interview with Charles Place, Hamilton, Bermuda, October 23, 1976.

Chapter 3

1. Neil Arthur Hodge to John Nunley, personal communication, March 1987.

2. "Repatriated Africans" were African slaves who were rescued by the British from slave vessels crossing the Atlantic; they were then returned to Africa.

3. Pegi Adam, "Trinidad's Carnival Celebrates Life." Press release of M. Siver Associates, Inc., p. 1, 1983. Mr. Holder elaborated on this concept in an interview with John Nunley in New York City, February 24, 1984.

4. Alec Waugh, *Island in the Sun* (New York: Farrar, Strauss and Cudahy, 1955), p. 131.

5. Interview with Elsie Lee Heung, by Dr. Karen Morell, Port of Spain, Trinidad, March 3, 1984.

6. Interview with Elsie Lee Heung by Dr. Karen Morell.

7. Historical information on these characters was supplied by Judith Bettelheim. Sir William Young, "A Tour Through the Islands of Barbados, St. Vincent, Antigua, Tabago and Grenada in 1791 and 1792" in Bryan Edwards, *A History of the West Indies*, (London: 1793; reprint ed., original III, 1807), III, p. 258. Young saw a stilt dancer on St. Vincent on Christmas 1791 and called him "Moco-Jumbo," noting that the phrase was derived from "Mumbo-Jumbo of the Mendengoes."

8. "Moko" refers to a curer, especially when it is used in conjunction with "nganga," as in

"Nganga a moko," referring to a doctor who has been called in to treat a specific illness. In this case the word is not associated with stilt dancing. Reverend W. Holman Bentley, *Dictionary and Grammar of the Kongo Language, as spoken at San Salvador* (1887; reprint ed., Farnborough, Hants, England: Gregg Press Limited, 1967), pp. 350, 371.

9. Daniel J. Crowley, "Traditional Masques of Carnival," *Caribbean Quarterly*, Vol. 4, Nos. 3 and 4 (March and June 1956), p. 198.

10. Andrew T. Carr, "Pierrot Grenade," *Caribbean Quarterly* Vol. 4, Nos. 3 and 4 (March and June 1956), p. 283.

11. Carr, "Pierrot Grenade," p. 282–283.

12. Donald Wood, *Trinidad in Transition* (London: Oxford University Press, 1968), p. 244.

13. Errol Hill, *Trinidad Carnival: Mandate for a National Theatre* (Austin: University of Texas Press, 1972), p. 38.

14. Information supplied by Pamela Franco, who interviewed masquerade participant and former Port of Spain resident, Keto, in Brooklyn, New York, October 1987.

15. The information on the evolution of the Indian bands of Trinidad was supplied by Karen Morell, personal communication to Judith Bettelheim, December 1, 1987.

16. Hill, *Trinidad Carnival*, p. 19.

17. Hill, *Trinidad Carnival*, p. 96.

18. Hill, *Trinidad Carnival*, p. 97.

19. *Trinidad Carnival, 1981*, ed. Roy Boyke (Port of Spain: Key Caribbean Publications, 1981), p. 58.

20. *Trinidad Carnival, 1986*, ed. Roy Boyke (Port of Spain: Key Caribbean Publications, 1986), p. 95.

21. Keith Lovelace to Nunley, personal communication, Port of Spain, September 21, 1986.

22. Interview with Elsie Lee Heung by Dr. Karen Morell.

23. *Trinidad Carnival, 1976*, ed. Roy Boyke (Port of Spain: Key Caribbean Publications, 1976), p. 84.

24. *Trinidad Carnival, 1974*, ed. Roy Boyke (Port of Spain: Key Caribbean Publications, 1974), pp. 10–11.

25. *Trinidad Carnival, 1977*, ed. Roy Boyke (Port of Spain: Key Caribbean Publications, 1977), p. 84.

26. Andrew Pearse, "Carnival in Nineteenth Century Trinidad," *Caribbean Quarterly*, Vol. 4, Nos. 3 & 4, 1956, p. 175.

27. Wood, *Trinidad in Transition*, p. 39.

28. Wood, *Trinidad in Transition*, p. 70.

29. Wood, *Trinidad in Transition*, p. 80.

30. Wood, *Trinidad in Transition*, p. 80.

31. Wood, *Trinidad in Transition*, p. 244.

32. Bridget Brereton, "The Trinidad Carnival 1870–1900," *Savacou: Journal of Caribbean Studies*, Vols. 11 & 12 (September 1975), p. 47.

33. Brereton, "The Trinidad Carnival," p. 47.

34. John W. Nunley, *Moving with the Face of the Devil: Art and Politics in Urban West Africa* (Champaign, Illinois: University of Illinois Press, 1987), p. 45.

35. Brereton, "The Trinidad Carnival," p. 48.

36. Wood, *Trinidad in Transition*, p. 241.

37. Nunley, *Moving with the Face of the Devil*, p. 46.

38. Brereton, "The Trinidad Carnival," p. 50.

39. Brereton, "The Trinidad Carnival," p. 52.

40. Fr. Anthony de Verteuil, C. S. Sp., *The Years of Revolt. Trinidad 1881–1888* (Port of Spain, Trinidad: Paria Publishing Co. Ltd., 1984), p. 80.

41. de Verteuil, *The Years of Revolt*, pp. 82–3.

42. Brereton, "The Trinidad Carnival," p. 55.

43. Wood, *Trinidad in Transition*, p. 243.

44. Brereton, "The Trinidad Carnival," p. 56.

45. Roy Boyke, ed., *Trinidad Carnival 1983* (Port of Spain: Key Caribbean Publications, 1983), p. 33.

46. Interview with David Rudder by John Nunley, Port of Spain, Trinidad, September 1986.

47. Hill, *The Trinidad Carnival*, pp. 45–47.

48. Hill, *The Trinidad Carnival*, p. 51.

49. Adam, "Trinidad's Carnival Celebrates Life," p. 3.

Chapter 4

1. The eyewitness accounts of Hosay in Port of Spain, Trinidad were recorded by John Nunley during September, 1986 and 1987.

2. One individual of the first twelve generations of direct descendants of the Prophet Mohammed is an *Imam*.

3. Bennett Bronson, "An Industrial Miracle in a Golden Age: The 17th Century Cloth Exports of India," *Field Museum of Natural History Bulletin*, Vol. 54, No. 1 (January 1983), pp. 16–18.

4. Lukshmi Mansingh and Ajai Mansingh, "Indian Heritage in Jamaica," *Jamaica Journal*, Vol. 10, Nos. 2, 3, and 4 (December 1976), p. 10.

5. The language of nineteenth-century Northern India was Hindustani, which 'combines Hindi and Urdu. As there is no standardized transliteration of Hindustani into English, the various sources used for reference in this chapter vary the spelling of key words. As the immigrants to the Caribbean were East Indian Muslims, not Muslims from the Middle East, East Indian orthography is used whenever possible. As most immigrants arrived in the nineteenth century, we have relied on early sources when discussing the traditions in India, rather than updated ones. In discussions of Hosay in the Americas, the spelling of the word as it appears in Trinidad will be used, since the most significant celebration of the festival occurs there. Primary sources for this information are: Thomas Patrick Hughes, *A Dictionary of Islam* (1885; reprint ed., Delhi: Oriental Publishers, 1973) and *The Encyclopedia of Islam* (Leyden: E. J. Brill, 1934).

6. Noor Kumar Mahabir, *The Still Cry: Personal Accounts of East Indians in Trinidad and Tobago during Indentureship 1845–1917* (Trinidad and New York: Calaloux Publications, 1985), p. 18.

7. Interview conducted by Judith Bettelheim in Jamaica, August, 1984.

8. *Ta'ziya* in India refers to the architectural structures built to replicate the tomb at Karbala. Structures derived from Indian *ta'ziya* that appear in the Caribbean are usually spelled *taziyah* in Jamaica; *tadja* in Guyana; *tadjah* in Trinidad; and *tajiya* in Surinam.

9. Keith Guy Hjortshoj, *Kerbala in Context: A Study of Muharram in Lucknow, India* (Ph.D. diss., Cornell University, 1977), p. 181.

10. Donald Wood, *Trinidad in Transition* (New York and London: Oxford University Press, 1968), p. 151.

11. Hjortshoj, *Kerbala in Context*, p. 140.

12. *Census of India, 1961, Monograph #3*, Office of the Registrar General India, "Moharram in Two Cities (Lucknow and Delhi)," plate 50.

13. John Norman Hollister, *The Shi'a of India* (London: Luzsc and Company, Ltd., 1953), p. 167.

14. Hjortshoj, *Kerbala in Context*, p. 140.

15. See illustrations in *The Census of India*. The hand motif refers to both the *panjtan* and the severed hand of Husain. According to tradition, the original silver crest from Husain's standard is kept in Lucknow, India.

16. Syed Husain Ali Jaffri, "Muharram Ceremonies in India," *Ta'ziyeh, Ritual and Drama in Iran*, ed. Peter J. Chelowski (New York: New York University Press, 1979), p. 241.

17. *Census of India*, p. 3.

18. Martha Warren Beckwith, *The Hussay Festival in Jamaica* (Poughkeepsie, New York: Vassar College Folk-Lore Foundation, 1924), No. 4, p. 4.

19. Beckwith, *The Hussay Festival in Jamaica*, p. 7.

20. In Clarendon since at least the turn of the century there has been a yearly Hosay festival of differing proportions, depending on the ruling government's recognition and patronage. For the festival of 1984 the Festival Commission donated the raw material from which the participants made their *taziyah*.

21. Interview with Dr. Mansingh and Mr. Albert Girdharisingh by Judith Bettelheim, Halesfield District, Race Course, Clarendon, August 6, 1984. It is important to recall that Dr. Mansingh arrived in Jamaica in the 1970s and that both men are Hindu, although Hindus do substantially outnumber Muslims in Jamaica.

22. The significance of the banana leaves was explained thus: "They are something that grows out of the ground, and the *taziyah* go back to the soil too."

23. Personal communication to Judith Bettelheim from Joel Benjamin, Deputy University Librarian, University of Guyana, October 10, 1983.

24. H. V. P. Bronkhurst, *The Colony of British Guiana and Its Labouring Population* (London: Woolmer, 1883), p. 357.

25. Bronkhurst, *The Colony of British Guiana*, p. 362.

26. Bronkhurst, *The Colony of British Guiana*, p. 364.

27. Dale A. Bunauth, *The East Indian Immigrant Society in British Guiana 1891–1930*, (Ph.D. diss., University of the West Indies, 1977), pp. 274–276.

28. Mansingh and Mansingh, "Indian Heritage in Jamaica," p. 10.

29. Fr. Anthony de Verteuil, C.S. Sp., *The Years of Revolt: Trinidad 1881–1888* (Port of Spain, Trinidad: Paria Publishing Co. Ltd., 1984), p. 121.

30. Gertrude Carmichael, *History of the West Indian Islands of Trinidad and Tobago, 1498–1900* (London: 1901), p. 273.

31. Wood, *Trinidad in Transition*, p. 152.

32. de Verteuil, *The Years of Revolt*, p. 140.

33. de Verteuil, *The Years of Revolt*, p. 164.

34. de Verteuil, *The Years of Revolt*, pp. 163–187.

35. Interview by John Nunley with Mr. Buchan, Freeport, Trinidad, September 1986.

36. Hollister, *The Shi'a of India*, p. 176.

37. Hollister, *The Shi'a of India*, p. 178.

38. Hollister, *The Shi'a of India*, p. 169.

39. Interview by Judith Bettelheim, Kingston, August 16, 1976.

40. Interview by Judith Bettelheim, Savanna la Mar, Westmoreland, August 1976.

41. Interview by Judith Bettelheim with H. P. Hylton, Mandeville, August 24, 1976.

42. Matthew Gregory Lewis, *Journal of a West Indian Proprietor During a Residence in the Island of Jamaica, 1815–1817* (1829; reprint of 1834 ed., New York: Negro Universities Press, 1969), p. 51.

43. Martha Warren Beckwith, *Christmas Mummings in Jamaica* (Poughkeepsie, New York: Vassar College, 1923), p. 8.

44. Fernando Ortiz, "Los Cabildos Afro-Cubans," *Revista Bimestre Cubana*, Vol. 16, No. 1 (January/February 1921), pp. 32–34.

45. John Nunley, "The Lantern Festival in Sierra Leone," *African Arts*, Vol. XVIII, No. 2 (February 1985), p. 45.

46. The illustration originally appeared in the *Journal Illustré*, Paris, April 15, 1877 and is reproduced in William H. Schneider, *An Empire for the Masses: The French Popular Image of Africa, 1870–1900* (Westport, Connecticut: Greenwood Press, 1982), p. 98. Bettelheim thanks Professor René Bravmann for sending this illustration and Professor David Gamble for locating the text of this article.

47. Nunley, "The Lantern Festival," p. 97.

Chapter 5

1. Fernando Ortiz (1881–1969), one of Cuba's most erudite and prolific writers, dedicated much of his scholarship to the understanding of African-Cuban culture. He published *Hampa Afrocubana: Los Negros Brujos* in 1906 and its sequel *Hampa Afrocubana: Los Negros Esclavos* in 1916. "La Fiesta Afrocubana del Dia de Reyes" first appeared in 1920 [*Revista Bimestre Cubana*, 15], and was revised several times until the final version, "La Antiqua Fiesta Afrocubana del Dia de Reyes," was published in 1960 by the Ministerio de Relaciones Exteriores, Departamento de Asuntos Culturales, Habaña. The most complete bibliography in English for Ortiz's publications, and for all material relating to the Caribbean, remains John F. Szwed and Roger D. Abrahams, ed., *Afro-American Folk Culture: An Annotated Bibliography of Materials from North, Central and South America and the West Indies*, I and II, (Philadelphia: Institute for the Study of Human Issues, 1978).

2. Ortiz documents a "Cabildo Congo," which paraded on each October 4, dedicating their celebration to San Francisco (St. Francis), who controlled hurricanes. The Cabildo Congo dancers held *muñecos*, or small carved dolls, on long poles dancing above the crowds. Ortiz also documents Carnaval *comparsas* that represented different neighborhoods, who paraded during Christmas, each carrying their special female emblem (*Los Bailes y el Teatro de los Negros en el Folklore de Cuba*, [Habana: Ediciones Cardenas y Cia, Ministerio de Educación, 1951], pp. 411–415). Accompanying this section is an illustration of a black woman holding a carved female figure on a pole and labeled: "'Mulata de rumbo' bailando el anaquillé." Judith Bettelheim and Dr. Jean Stubbs are currently working on an annotated translation of the 1960 version of "*La Antiqua Fiesta*" to appear in a volume, along with other articles, on Cuban Carnaval.

3. Odilio Urfé, "Music and Dance in Cuba," *Africa in Latin America, Essays on History, Culture, and Socialization*, ed. Manuel Moreno Fraginals (New York: Holmes & Meier Publishers, 1984), p. 177.

4. This attack reflects a strong Caribbean tradition. A festival or holiday celebration often has led to, or has been used as, camouflage for revolutionary activity. Robert Dirks has noted that one-quarter to one-half of the rebellions of emancipation in the British Caribbean can be dated to the Christmas-New Year season (Robert Dirks, "Slaves' Holiday," *Natural History*, 84, no. 10 [December 1975]).

5. Dr. Argeliers León, "La Fiesta del Carnaval en su Proyección Folklórica," Special collections (Habaña: Ministerio de Cultura, 1984), p. 27.

6. This and subsequent material directly related to the development of *comparsas* is taken from Israel Moliner Castañeda, *Las Comparsas* (unpublished manuscript, 1986), p. 3. Moliner Castañeda is the Especialista en Estudias Culturales de la Provincia de Matanzas. He has been most generous, sharing his research and knowledge of traditional Cuban culture. I am enormously grateful.

7. In other Cuban cities, Carnaval-type celebrations occurred at different times of the year: in Trinidad and Camaguey in June during St. John and St. Peter festivals; and in Santiago de Cuba in July in honor of St. James and St. Anne.

8. Emilio Moreau Bacardi, *Cronicas de Santiago de Cuba* II (Barcelona: 1908), p. 31, quoted in Moliner Castañeda, *Las Comparsas*, 1986.

9. The Abakuá Society, an association or brotherhood, was originally established by Efik and Ejagham (Ekoi) slaves from the region of Calabar and the Cross River area of Nigeria-Cameroon. Members of the Abakuá Society in Cuba formed a Cabildo Carabali. The phrase *carabali* refers to African peoples from the region of Nigeria-Cameroon. According to Cuban records, this group includes Ibo, Ekoi (Ejagham), Efik, Icuama, Briche, Ibibio, and Rio de Rey peoples. (Romulo Lachatañere, "Tipos Etnicos Africanos que concarrieron en la Amalgama cubana, *Actas del Folklore*, #1, #3 [Marzo 1961], Habaña [originally published in 1939 in *Estudios Afrocubanos*].) The first Abakuá Society was founded in 1836. By 1863, whites were being admitted into the Abakuá Society. The term Abakuá is derived from Abakpa, a creole name for the Ejagham. Dia de Reyes festivals included a vast assortment of costumed performers and musicians and predated the organization of the first Abakuá Society, "Efike Buton," in the town of Regla across Havana's harbor in 1836 by over one hundred years.

This history of the Abakuá Society in Cuba is condensed from two major sources: Lydia Cabrera, *La Sociedad Secreta Abakuá: Narrada por Viejos Adeptos* (Miami: Ediciones C.R., 1970); and Robert Farris Thompson, *Flash of the Spirit: African and Afro-American Art and Philosophy* (New York: Random House, 1983). Other information is gleaned from Israel Moliner Castañeda's notes included in "Matanzas en el VII Festival de la Cultura Caribēña," a brochure published by the Casa del Caribe, Santiago de Cuba, Mayo–Junio 1987, and Dr. Argeliers León's "La Fiesta del Carnaval."

10. Wurdemann first published his account in a serialized form in *The Magnolia* magazine, and then in the 1844 anonymous publication, *Notes on Cuba, by a Physician* (1844; reprint ed., Salem, New Hampshire: Arno Press, 1971), pp. 83–84.

11. Maturin M. Ballou, *Due South or Cuba Past and Present* (New York: Houghton, Mifflin and Co., 1885), p. 198.

12. Odilio Urfé, "Music and Dance in Cuba," p. 171.

13. The publications of Fernando Ortiz first popularized the image of the *ireme* and its association with the Abakuá Society and Dia de Reyes celebrations in the early 1900s. He reproduced several late nineteenth-century depictions of *iremes*, including Miale's "Dia de Reyes" lithograph and the oil paintings, *El Dia de Reyes* and *Diabolito* by Victor Patricio Landaluze. Landaluze's *Album pintoresco de la Isla de Cuba* was published in Berlin in 1850. Landaluze also illustrated *Tipos y Costumbres de la Isla de Cuba* published in 1881 with a

prologue by Antonio Bachiller y Motomo. Many nineteenth-century chroniclers were also captivated by the social and visual power of Dia de Reyes celebrations.

Today in Cuba there is some academic controversy about the actual extent of the official participation of Abakuá Societies in Dia de Reyes celebrations. The debate centers on elements of fantasy and/or realism in nineteenth-century works, including those of Landaluze.

14. Lydia Cabrera, *El Monte: Igbo Finda, Ewe Orcha, Vititi Nfinda (Notas sobre las Religiones, la Magia, las Supersticiones y el Folklore de los Negros Criollos y del Pueblo de Cuba)* (Habaña: Ediciones C.R., 1954; revised edition, Miami: Rema Press, 1968), pp. 196–197. Today throughout Cuba, Abakuá *iremes* join other *comparsas* personages to celebrate Carnaval. Yet the *iremes* maintain a special significance; for many even their popularized image embodies what Fernando Ortiz has called "ñañiguismo." The *ñañigos*, the generic name given to all members of the Abakuá Society, embody a particular black presence and heritage.

Nañigo is the generic name used to identify members of the Abakuá Society. Robert Farris Thompson believes that the term *ñañigo* is derived from a Kongo source: "nan" meaning false, and "igo" meaning leopard. Individual named *ñañigos* are known as Ireme Embema, Ireme Mosungo, Ireme Erikundi, etc. *Ireme* is thus a ritual name. *Diabolito*, or "little devil," is the Spanish term originally applied to all Blacks who masqueraded in costume. Now in Cuba, the term *diabolito* is often applied to the costumed *iremes* of the brotherhood of the *ñañigos*. Not all scholars agree on the interpretation of the phrase *ireme*. Odilio Urfé defines *iremes* as the "little Abakuá devils whose dances are the original core of the Cuban rumba and whose music is Congolese in origin" ("Music and Dance in Cuba," p. 176). Moliner Castañeda, meanwhile, states that to be an *ireme* was a secret lodge within Abakuá and not all *ñañigos* were *iremes*; interview in Havana, July 21, 1987.

15. The "Cabildo Carabali Izuama" is today part of the powerful Los Hoyos neighborhood of Santiago de Cuba. Odilio Urfé reports that their songs include lyrics derived from Spanish, Carabali, Congolese, and Yoruba ("Music and Dance in Cuba," p. 179).

16. Argeliers León, "La Fiesta del Carnaval," p. 30.

17. Licenciado Carlos Alberto Cruz-Gomez, "El Carnaval en la Plástica Cubaña," in the papers of the Ministerio de Cultura, Habaña, [n.p.] April, 1985.

18. Carlos Alberto Cruz-Gomez, "El Carnaval en la Plástica Cubaña."

19. Argeliers León, "La Fiesta del Carnaval," p. 31.

20. Franklin W. Knight, *The Caribbean: The Genesis of a Fragmented Nationalism* (New York: Oxford University Press, 1978).

21. Although Fernando Ortiz in the 1960 edition of his "Dia de Reyes" article states:

> Nañiguismo can still be found in Cuba and it is to this that is to be attributed the survival of the *diabolito*, who can be seen in public in *comparsas* and burials. In the presidium of the Republic even, prisoners tell of *ñañigo* dancing, complete with *diabolito* and all. (translation by Dr. Jean Stubbs)

He did document the last *ñañigo* burial with a full liturgy as taking place in Regla in 1926. Dr. Guillermo Gonzalez, called Iyamba Okereré, died at the age of 114 and was the chief of *iyamba* of the *potencia* (or lodge) Efi Abakuá, which was founded on December 5, 1845 (Ortiz, *Los Bailes y El Teatro*, p. 399).

22. Moliner Castañeda's comments were made during conversations in Havana on July 21, 1987 and in Matanzas on July 30, 1987; see Moliner Castañeda, *Las Comparsas*. Moliner based parts of this report on material located in the historical archives of the Province of Matanzas.

23. The influence of Chinese laborers, who entered Cuba beginning in 1844 and numbered about 150,000 by the end of the nineteenth century, is evident in the popular instrument the "chinese cornet," or "corneta china," the insignia of the powerful neighborhood *congas* of Santiago de Cuba (Urfé, "Music and Dance in Cuba," pp. 184–185).

24. This *cabildo* originated in the very black and very powerful neighborhood of El Tivoli.

25. For a complete discussion of Santería iconography, see Robert Farris Thompson, *Flash of the Spirit* (New York: Random House, 1984). Lydia Cabrera illustrates a rooster altar assembled for Orisha Osu in *El Monte*.

26. Certain "Cabildo Teatral" members stated that this rooster had a dual identity. He not only represented Shango, but also was the heraldic insignia of the Montague family of Romeo and Juliet, a favorite drama of the "Cabildo Teatral."

27. This character is actually derived from a combination of illustrations. One is found in Fernando Ortiz's *Los Bailes y el Teatro* (Fig. 85, p. 343), and the other in Lydia Cabrera, *La Sociedad Secreta Abakuá: Narrada por Viejos Adeptos* (Miami: Ediciones C.R., 1970). Although the technical name *nsibidi* has been lost in Cuba today, there is ample evidence for the survival of the sacred script itself.

28. Historical evidence indicates that Abakuá Societies were limited to the provinces of Matanzas and Havana in western Cuba, yet today the image of the *ireme* is a national insignia; *ireme* masqueraders appear as official entertainment during Carnaval, and major folklórico presentations include *ireme* dancers in their repertoire.

29. Within the spectrum of African Haitian culture, these groups are known as *Petro*, a term used in Haiti to identify religious belief and ritual derived from the Kongo culture of Central Africa. In Cuba, Kongo cultural influence is evident in *kimbisa* and *mayombé* musical liturgy, and in rituals such as *palo-mambo*, *palo-monte* and *yuka*. Members of this Kongo-Cuban community celebrated a lengthy religious rite for a special group of invited guests (including Judith Bettelheim) during Festival 1986. Other French-influenced Afro-Haitian groups in Cuba formed their own *cabildos* in Oriente. Known as Tumba Francesa (french drum) Societies, these groups became famous for a special musical rhythm and often joined in Carnaval in Santiago de Cuba as distinct *conga* groups, accompanied by a female chorus. The Tumba Francesa performs two special dances, *el masón* and *el yubá*. At the triumph of the Revolution in 1959, only two Tumba groups were extant, one in Santiago and the other in the neighboring Guantánamo. Today in Santiago de Cuba Tumba groups are being supported by the Ministry of Culture; see Odilio Urfé, "Music and Dance in Cuba," p. 178, and album notes for "Anthologia de la Musica Afrocubana: Tumba Francesa," vol. VII, 1976 (text written by Dr. Olavo Alén, Director del CIDMUC).

There are two sources to the name "Pilon del Cauto"; *Cauto* is the name of the largest river in Cuba, and a *pilon* is a large mortar and pestle manipulated while standing. Thus metaphorically, this group captures the energies of mighty forces of the mountains where many traditional people still reside.

30. See Harold Courlander, *The Drum and the Hoe* (Berkeley: University of California Press, 1960; reprinted 1985).

31. The *vodoun* pantheon is divided into several groups, or "nations" of spirits, the two most important being the Rada nation, deriving largely from the Dahomean region of Africa, and the Petro nation, which derives largely from the Congo cultures. The former are of a more benign temperament, the latter fierce and aggressive.

32. In a work published in 1803 in Parma, "De la Dance," Moreau St. Méry noted that dancing Don Petro was severely prohibited in his time, because it was accused of causing great disorder and spreading ideas injurious to the public peace. For this reason, Petro was limited to the south and west of Haiti where it is strongest today. Quoted in Jean Price-Mars, "Lemba-Petro, un culte secret," *Revue de la société d'histoire et de geographie d'Haiti*, Vol. 9, No. 28 (1958), p. 19.

33. Gerson Alexi, "Notes sur la Rara," *Bulletin de Bureau d'Ethnologie*, Serie III, No. 27 (April, 1961, Port-au-Prince), p. 42. When he cracks the whip, he is identified as Legba. Then it is Legba who guides, who warns of danger, discovers *ouangas* (malevolent charms) likely to be found at road sides and crossroads. In this function, the whip and *jonc* share the task of magical *gardes* (protective talismans) for the band.

A noisemaker formerly used by the bands was called a *rara* in Creole. Disrupting the normally tranquil tropical nights, cracking whips, the rhythmic rasp of tin graters or *grages*, drumbeats and the resonant tones of the *vaccines* reverberate for blocks. J. B. Romain proposes an African derivation for Rara, comparing it to the Afro-Cuban Comparsa and the Afro-Brazilian Walwadi. In fact, in some parts of Haiti, Rara is still called *loualouadi*. This could be a corruption of *la loi dit* (the law decrees). In Creole, the word Rara has unpleasant connotations. A proverb *tombé nan Rara* (fall on Rara) means to suffer misfortune; a *voix Rara* (Rara voice) is loud and harsh. The expression *fé Rara* (make Rara) means to cause a row.

34. In observations made in the 1950s, Emmanuel Paul has noted that the elaborate costume of the king of the pre-Lenten carnival has tended to be transferred to Rara's *major jonc*. (Emmanuel Paul, *Panorama du Folklore Haïtien* [Port-au-Prince, Haiti: Imprimerie de l'Etat, 1962]).

35. Color symbolism plays an important role in the iconography of *vodoun*. Each *loa*, and families of *loa*, are associated with a color and a devotee who, when possessed, immediately receives scarves or other apparel in an appropriate hue.

36. Kongo is the name given by the BaKongo to the land they occupy, which was the Kingdom of the Kongo until 1702. The entire surrounding area is the modern Congo (Brazzaville), Zaire, and Angola.

37. Rachel Beauvoir, from an unpublished manuscript (Tufts University, 1986). Having done extensive fieldwork on the subject, she concludes: "The shanpwel, finally, are the greatest dispatchers of Rara bands." *Sans poil* literally means hairless. Members are reputed to shed their skins and fly. These secret societies function as tribunals and enforcers, resembling that of African predecessors.

38. Harold Courlander, *The Drum and the Hoe* (Berkeley: University of California Press, 1960), p. 107. As slaves, skilled musicians were highly valued in the colonial habitation. Such individuals commanded a high price. Music lightened the oppressive labor, and improved the standard of workmanship. Rara instruments accompany the labors of cooperative work bands called *coumbites* (Henock Trouillot, *Introduction à une histoire de vaudou* [Port-au-Prince, Haiti: Les Editions Fardion, 1983], pp. 151–152).

39. Jean-Baptiste Romain, *Africanismes Haïtiens* (Port-au-Prince, Haiti: Imprimerie M. Rodriguez, 1978), p. 65. Eugene Aubin, *En Haiti* (Paris: A. Colin, 1910), pp. 42f. Aubin described Holy Week processions remembered at the turn of the century. At the end of the week, a masquerading group dressed in tinseled garments moved across the countryside re-enacting the search by the soldiers of Christ. Each habitation formed its group. Organization and preparations had begun on New Year's Eve. At noon on Holy Thursday, the king emerged, accompanied by his suite, with flags and drums. Night and day until Easter, the processions and dances proceeded uninterrupted. Often, he continued, these "debaucheries" had deplorable consequences, particularly for the young people participating in these "excesses of 'loiloidi.'"

40. Moreau St. Méry, *Description topographique, physique, civile, politique et historique de la partie française de l'î'le S. Dominque*, Nouvelle edition, ed. Blanche Maurel and Etienne Taillemitte (Paris: Société de l'historie de la Colonie français, 1958), pp. 65–68.

41. Louis Maximilien, *Le Vodou Haitien* (Port-au-Prince, Haiti: Imprimerie l'Etat, 1955), p. 151. The other principal *vodoun* rite, called Rada, adheres to the deities and rituals deriving largely from the Dahomean cultures. Its expressions are more restrained, its spirits of a more benevolent nature, its music softer and symbolic colors cooler.

42. Emmanuel Paul, *Panorama du Folklore Haïtien*, pp. 164f. Paul describes the many regional differences in the ceremonies of *brûler Carnival*.

43. Katherine Dunham noticed that between the studies she made in 1947 and 1981, a larger number of whips was in evidence, with a corresponding increase in violence. She withdrew her earlier prediction of Rara's imminent eclipse, adding that, to the contrary, the number of bands had increased. (Katherine Dunham, *Dances of Haiti* [Los Angeles: Center for African-American Studies, University of California at Los Angeles, 1983], p. 35.)

44. Gerson Alexi has analyzed the symbology of whip cracking, as memorializing the whipping of the slaves, the lashing of the Saviour on the way to the cross, or the whipping of "zombies," spirits of the dead who could threaten the band. (Gerson Alexi, "Monographie des Danses Rara," *Lecture en Anthropologie Haitenne* [Port-au-Prince, Haiti: Presses Nationales, 1970], p. 104.)

45. Robert Farris Thompson has noted the use of similar bamboo trumpets called *disoso* by the Kongo. As each plays only one or two notes, the tune is played by hocketing in series, a technique used by the pygmies who live close to the Kongo in northern Zaire (Robert Farris Thompson and Joseph Cornet, *The Four Moments of the Sun: Kongo Art in Two Worlds* [Washington, D.C.: National Gallery of Art, 1981], p. 172). Thompson further concludes that the originators of Rara had to be strongly influenced by persons of Kongo heritage. A certain pose favored by the *major jonc* recurs in Kongo ritual in the *Gilka mambu*, left hand on hip, right hand raised. The same conformation occurs in staff-heads of *vodoun* flags, which Thompson compares with the handle of the Kongolese royal executioner's sword. Women dancing in Rara groups typically lift and swirl their skirts, in a gesture similar to the Kongo custom of *nikusa minpa*, waving or agitating pieces of cloth as a sign of mediation between the worlds of the dead and the living (Thompson and Cornet, *The Four Moments of the Sun*, p. 189). The expression of dynamic progress, controlled by discipline, as embodied in the Kongo pose, is certainly central to the function and meaning of Rara. André Pierre has explained to me the meaning of the pose; the left hand on hip is to anchor the force, the right hand pointing upward to signify the triumphant resurrection of Christ. Interview with André Pierre by Dolores Yonker, 1984.

46. Lorimer Denis and Emmanuel C. Paul, *Essai d'Organographie Haitienne* (Port-au-Prince, Haiti: Bureau d'Ethnologie, 1980), p. 85.

47. Courlander, *The Drum and the Hoe*, pp. 197–198.

48. Thompson has noted the derivation of Haitian Pétro drums from those used by the Kongo called *tu'utila* (Ute Stebeich, *Haitian Art*, [Brooklyn: Brooklyn Museum, 1978], p. 28).

49. Paul, *Panorama du Folklore Haïtien*, p. 200. Paul suggests that the goat served as surrogate for the drummer himself, representing the sacrifice of the individual whom they valued most highly.

50. Courlander, *The Drum and the Hoe*, p. 199. The Cuban, Fernando Ortiz, indicated to Emmanuel Paul that this was a uniquely Haitian instrument. But this instrument was one of the most important among the Abakuá in Cuba and is used in folklórico performances there today. Perhaps Ortiz was implying that it was introduced into Cuba by Haitians. Paul suggested its resemblance to a rattle used by the Bembe of Congo in funeral ceremonies. In Congo ceremonies in Jacmel, on Haiti's southern coast, the object is called *i'asson wangol*, relating it to a priest's ritual gourd rattle called an *asson*. Wangol, of course, refers to Angola. It also symbolized, according to Rigaud, the sun as a spiritual force, fertility and the levels of *vodoun* initiation (Milo Rigaud, *La Tradition Voudoo et le voudoo Haitiën*, [Paris: Editions Niclaus, 1953], p. 257f).

51. Ernst Mirville, *Considerations Ethno-*

Psychoanalytiques sur le Carnival Haitian, (Port-au-Prince, Haiti: Collection Coucouille, 1978), p. 52. Haitian history is replete with the exploits of small warrior bands, from the pre-revolutionary forays of *maroon* groups, to revolutionary armies, to a succession of rebel bands culminating in the *cacos*, guerilla opponents of the American Occupation forces. It is tempting to relate these to Rara's militant aspects.

52. Alexi, "Monographie des Danses Rara," p. 194. Loosely translated, they are powders for coughing, hot-cool powders, zombi powders or powders of the dead.

53. Interview with Jean-Luc Beaubrun, by Dolores Yonker, Beudet, Haiti, April, 1984.

54. Interview with Max Beauvoir, by Dolores Yonker, April, 1984, Peristyle de Mariani, Haiti.

55. Maurice Martinez, "The Plume and the Feather," *Black New Orleans*, Vol. 1, No. 2 (February 1982), p. 23.

56. Lynne Fauley Emery, *Black Dance in the United States from 1619 to 1970* (Palo Alto: National Press Books, 1972), p. 148.

57. John W. Blassingame, *Black New Orleans 1860–1880* (Chicago: The University of Chicago Press, 1973), p. 145.

58. Harper Barnes, "Mardi Gras Indians: Once They Fought—Now They Dance and Sing," *The St. Louis Post-Dispatch Sunday Magazine*, June 23, 1985, pp. 18–19.

59. Interview with Larry Bannock, Chief of the Golden Stars, New Orleans, Louisiana, May 1985. All interviews in this section were conducted by Barbara Bridges.

60. Allison Montana, Chief of the Yellow Pocahontas, in Maurice Martinez, "Delight in Repetition: The Black Indians," *Wavelength*, Vol. 16 (February 1982), p. 4.

61. Martinez, "Delight in Repetition," *Wavelength*, p. 4; Maurice Martinez, "Tué or Tu es? Creolization of Black Indian Culture," a paper presented at the 28th Annual Meeting of the African Studies Association, November 26, 1985, New Orleans, Louisiana, p. 14.

62. Maurice Martinez, "Two Islands: The Black Indians of Haiti and New Orleans," *New Orleans Museum of Art—Arts Quarterly*, Vol. 1, No. 7 (June 1979), p. 7.

63. Interview with Allison Montana, New Orleans, Louisiana, May 1985.

64. Barnes, "Mardi Gras Indians," p. 8.

65. Interview with Montana, New Orleans, Louisiana, May 1985; interview with Gerald Millon, New Orleans, Louisiana, May 1985; personal communication with Maurice Martinez, November 1984.

66. Interview with Montana, May 1985.

67. Interview with Bannock, May 1985.

68. Interview with Bannock, May 1985.

69. Interview with Bannock, May 1985.

70. Interview with Bannock, May 1985.

71. Andy Kaslow and Bunny Matthews, "The Indians," *Wavelength*, Vol. 1, No. 4 (February 1981), p. 9; Allison Miner, Collection notes 1971.37, Louisiana State Museum.

72. Interview with Bannock, May 1985.

73. Interview with Bannock, May 1985.

74. Martinez, "Delight in Repetition," p. 3; Maurice Martinez, "Black Indians Carry On," *The Louisiana Weekly*, Section 1 (February 16, 1985), p. 2; Jason Berry, "The Caribbean Connection: A Link in the Chain of New Orleans Culture," *New Orleans Magazine*, Vol. 19, No. 8 (May 1985), p. 66.

75. Martinez, "Black Indians Carry On," p. 2.

76. Herbert Asbury, *The French Quarter* (New York: Capricorn Books, 1968), p. 240.

77. In *Black Dance in the U.S.* Lynne Emery discusses dances and musical instruments, and notes observed similarities between those of Congo Square and Jamaica (p. 157–158).

78. Asbury, *The French Quarter*, pp. 240, 242, 252; Emery, *Black Dance in the U.S.*, pp. 156–157.

79. Asbury, *The French Quarter*, p. 242.

80. Emery, *Black Dance in the U.S.*, p. 150.

81. Emery, *Black Dance in the U.S.*, pp. 166–172; Berry, "The Caribbean Connection," pp. 65–67.

82. Jason Berry, "The Caribbean Connection," p. 66; Emery, *Black Dance in the U.S.*, p. 172; Timothy Flint, *Recollections of the Last Ten Years on the Valley of the Mississippi*, ed. George R. Brooks (1826; reprint ed., Carbondale: Southern Illinois University Press, 1968), p. 103.

83. The French made an unsuccessful attempt to enslave Indians on their plantations; they quickly fell back to depending on Africans for slave labor. There also are reports of Indians hiding runaway slaves. Indeed, in 1730, slaves hiding among the Chickasaw tribe returned to slave quarters and organized an unsuccessful rebellion (Jason Berry, "The Caribbean Connection," 1985, p. 65). The Natchez Indians waged war with the French in 1716, 1722, and 1729 until they were finally subdued and forced to move toward Creek and Cherokee territory. Some 450 Natchez, however, were captured and sold into slavery in Haiti in 1731, where they may have introduced a North American Indian aesthetic to the Caribbean (Barbara A. Leitch, *A Concise Dictionary of Indian Tribes of North America* [Michigan: Reference Publications, Inc., 1979], p. 297).

84. Jason Berry, "The Caribbean Connection," p. 65; Emery, *Black Dance in The U.S.*, p. 148.

85. Kalamu ya Salaam, "Spirit Red," *Wavelength*, Vol. 28 (February 1983), p. 27; Martinez, "Black Indians Carry On," p. 2.

86. Berry, "The Caribbean Connection," p. 65.

87. Martinez, "Two Islands," p. 8.

88. Discussion of Amerindian styles found in the Caribbean appears in Judith Bettelheim's chapter "Jonkonnu and Other Christmas Masquerades."

89. *Harper's Weekly* of the 1880s shows dozens of sketches, political cartoons, and stories dealing with Indian themes and images. Apache, Cheyenne, Natchez, Yamacraw, and other tribes are depicted, along with cigar-shop Indian figures and white political leaders in Amerindian dress. The illustrations of George Catlin and Karl Bodmer further depicted peoples from North America.

90. *Harper's Weekly*, Vol. 27, No. 1366 (February 24, 1883), pp. 120–121; *The Illustrated London News*, Vol. 19, No. 2226 (December 31, 1881), p. 640; *Frank Leslie's Illustrated Newspaper*, Vol. 45, (March 23, 1878); Vol. 24, No. 601 (April 6, 1867); Vol. 25, No. 634 (November 23, 1867), p. 153.

91. Henry Sell and Victor Weybright, *Buffalo Bill and the Wild West* (New York: Oxford University Press, 1955), pp. 125–145; personal communication, Paul Fees, Curator, Buffalo Bill Museum, November 1986.

Chapter 6

1. Interview with Stephen Derek and Alvin Knock by Dr. Karen Morell, Port of Spain, Trinidad, March 14, 1987.

2. A *bajan* is a person from Barbados.

3. Lyrics from "Mas in Brooklyn" by The Mighty Sparrow, Recording Artists Productions.

4. Donald R. Hill and Robert Abramson, "West Indian Carnival in Brooklyn," *National History*, Vol. 88, No. 7 (August/September 1979), p. 77.

5. Interview with Carlos Lezama, Brooklyn, New York, September 1987.

6. Hill and Abramson, "West Indian Carnival," p. 83. The name "Wardle" is spelled a variety of ways by writers and oral historians.

7. Interview with Lezama, September 1987.

8. Interview with Lezama, September 1987.

9. Interview with Derek and Knock by Dr. Karen Morell.

10. Interview with Neil Arthur Hodge, New York, New York, March 1987.

11. Interview with David Robeson, New York, New York, September 1986.

12. Vivian Comma, "Carnival in London," *Masquerading: The Art of the Notting Hill Gate Carnival* (London: Arts Council of Great Britain, 1986), pp. 24–27.

13. Dawn Marshall, "A History of West Indian Migrations: Overseers Opportunities and 'Safety-Valve' Policies," *The Caribbean Exodus,* ed. Barry B. Levine (New York: Praeger, 1987), pp. 26–27.

14. Abner Cohen, "Drama and Politics in the Development of a London Carnival," *Man,* Vol. 10, March 1980, p. 65–87.

15. Everton A. Pryce, *The Notting Hill Gate Carnival—Black Politics, Resistance and Leadership 1976–1978,* unpublished manuscript, University of the West Indies, Jamaica, 1985, p. 2.

16. *Notting Hill Gate Carnival 1984,* Carnival Arts Committee program, unpaginated.

17. Leslie Palmer, "Memories of Notting Hill Gate Carnival," *Masquerading: The Art of the Notting Hill Gate Carnival* (London: Arts Council of Great Britain, 1986), p. 21.

18. Cohen, "Drama and Politics," p. 68.

19. Cohen, "Drama and Politics," p. 68.

20. Pryce, *The Notting Hill Gate Carnival,* p. 12.

21. William Doyle-Marshall, "From Humble Beginnings to Mammoth Success," *Share,* Vol. 3, No. 3 (July 30, 1985), p. 1 of supplement.

22. M. Bissoon, "Caribana: Fancy Sailor," *Ind. Caribbean News,* Vol. 1, No. 718 (July/August, 1985), p. 1.

23. John Nunley would like to thank band members Christine Galt and Joan Patience for inviting him to play *mas* in Fans to See.

24. Audain's 1982 Junior King, called A Dragon Fly, and his individual male, also called A Dragon Fly, placed first in Montreal and Toronto and second respectively in Toronto. The following year his Junior King, called Kulculcan Maya God of War, placed first in both Montreal and Toronto.

25. Biographical sketch of Noel Audain, from a letter to John Nunley, 1986.

26. Russell Charter, personal communication, July 31, 1986.

27. Wallace Alexander, personal communication, Toronto, August 1986.

28. William Doyle-Marshall, "Caribbean Festivals Blossom in America," *Trinidad Guardian* (July 16, 1984), p. 1B.

Chapter 7

1. J. H. Kwabena Nketiah, "Traditional Festivals in Ghana and Community Life," *Cultures,* Vol. III, No. 2 (UNESCO Press & 1a Baconniere), p. 33.

2. The independent countries of the Commonwealth (anglophone) Caribbean are Jamaica, Trinidad, Guyana, Barbados, St. Lucia, St. Vincent, Grenada, Antigua & Barbuda, St. Christopher (St. Kitts) & Nevis, Belize, the Bahamas, Dominica. The Cayman Islands, Anguila, Turks, Caicos and Montserrat are still colonies of Great Britain, as is Bermuda which does not normally regard itself as a member of the Commonwealth Caribbean.

3. Errol Hill, *The Trinidad Carnival: Mandate for a National Theatre* (Austin: University of Texas Press, 1972).

4. Hill, *The Trinidad Carnival,* p. 114. Mr. Hopkinson's statement from his "Theatre and Drama," in *This Country of Ours: Independence Brochure on the Nation* is quoted by Dr. Hill.

5. Hill, *The Trinidad Carnival,* p. 115.

6. Rex Nettleford, *Dance Jamaica: Cultural Definition and Artistic Discovery* (New York: Grove Press, 1986), especially Chapter 2.

7. Hill, *The Trinidad Carnival,* p. 117.

8. The production was directed by Rawle Gibbons at the Jamaica School of Drama, and was attended by many Jamaican school children, text in hand, since the play was a set-book assignment for that year's General Certificate Examinations (GCE).

9. *Maskarade* was directed in 1978 by co-author Jim Nelson at the Creative Arts Centre of the University of the West Indies (Mona Campus), and won high critical acclaim. It utilized music and dance, but had a very strong dramatic line.

10. Sylvia Wynter, "Jonkonnu in Jamaica," *Jamaica Journal,* Vol. 4, No. 2 (1970). Ms. Wynter, a noted Jamaican woman of letters and scholar, had herself done extensive research on Jonkonnu and published her analysis in a rich and stimulating article in *Jamaica Journal.*

11. Two unpublished master's theses should be added to the list. They are Sheila Barnett's "Jonkonnu and the Creolisation Process in Jamaica: A Study in Cultural Dynamics" (1977) and Cheryl Ryman's "Dance as a Major Source and Stimulus for Communicating Africanisms in Order to Effect A Process of Self-Actualization" (1983). Both authors collaborated with Judith Bettelheim when she conducted field research in Jamaica.

12. Therese Mills, "River: Band of the People's Choice," *Trinidad Carnival* (Port of Spain, Trinidad: Key Caribbean Publications, 1983), p. 94.

13. Rex Nettleford, *Caribbean Cultural Identity: The Case of Jamaica* (Los Angeles: UCLA, Center for Afro-American Studies and Latin American Publications, 1979), pp. 152–154.

14. *Report of the Cultural and Conservation Conference,* July 29 to August 2, 1970 (mimeographed).

15. Nettleford, *Caribbean Cultural Identity,* p. 152.

16. See *Caribbean Contact,* September 1981, pp. 9–12.

17. Nettleford, *Caribbean Cultural Identity,* p. 154.

18. The first incumbent of the CARICOM Cultural Desk was Frank Pilgrim, the Guyanese journalist and playwright who with Lynette Dolphin was one of the coordinators of the first Carifesta held in Guyana in 1972. He was subsequently loaned to the government of Nigeria to help in the organization of the Festival of African Culture (FESTAC) in 1976, and was a major help in the mounting of Carifestas 2 and 3 in Jamaica and Cuba respectively.

19. See *Caribbean Contact,* September 1981, especially Victor Questel, "Two Weeks on Mourning Ground," 99, pp. 10–11.

20. Roy Boyke, "This Centenary Year," *Trinidad Carnival* (Port of Spain, Trinidad: Key Caribbean Publications, 1983), p. 6.

21. Mills, "River: Band of the People's Choice," p. 104.

22. Fidel Castro also called for representation of the youth and women in Party Leadership at the December 1985 conference of the Cuban Communist Party.

23. See Roberto Marquéz, "Zombie to Synthesis—Notes on the Negro in Spanish American Literature," *Jamaica Journal,* Vol. II, Nos. 1, 7, 2 (1977), p. 28.

24. For more on the Rastafarian movement, see M. G. Smith, F. R. Augier, Rex Nettleford, *Report on the Rastafari Movement in Kingston* (USER, Kingston, Jamaica, 1960).

25. Nketiah, "Traditional Festivals in Ghana."

Glossary of Terms

Abakuá Society an association or brotherhood in Cuba whose constituency originally consisted of Efik and Ejagham (Ekoi) slaves. Founded in 1836 in Regla, across the harbor from Havana, Abakuá members also formed the important Cabildo Carabali.

aggogoo double gong found in many West African cultures

alam replica of the crest and embroidered banner carried by Husain and his companions at Karbala. In India it is often heart-shaped and includes an image of the tomb at Karbala or an open hand, symbolizing the first five members of the Prophet's family.

Bajan a person from Barbados

balancer Rara initial ceremonies preceding Rara street processions in Haiti

banda a sensually suggestive dance step favored in Rara performances

basse a flat circular drum with circular metal disks mounted in the rim resembling the American tambourine; used in Haitian Rara

Bruckins step a dance step used in the opening procession of Jamaican Jonkonnu; the Bruckins dance party originated in a celebration of Emancipation on the first of August 1834. The performance consists of animated dance rivalry between two teams who originally mimicked their masters, both in dancing style and in dress. A special section involves the election of a chairman or "cheerman" who makes a speech to urge the dancers on.

brûler Carnival ritual occurring between Carnival and Rara when Rara bands set fire to bits of cloth or masks used in Carnival. The band members then dance and sing around the fire, performing such acts as pouring libations of ritual rum in the cardinal directions. After the flames die, each member, plunges a finger into the ashes and draws a cross on his forehead.

Buraq The Prophet Mohammed's mythical winged horse

cabildo a mutual aid organization in Cuba, often with direct African precedent

canboulay slaves extinguishing fires on the cane plantations carried torches, sang, and marched to the fields in what became known as the burning of the cane or Cannes Brulées

chica or calenda traditional dance steps described as early as the eighteenth century which resemble today's hip-twisting *banda* in Haiti

clairin raw Haitian rum used both ceremonially and as a beverage

comparsas a Cuban dance or group of dancers, traditionally organized by neighborhood, made up of paired male and female dancers performing a specific choreographed routine to the accompaniment of live or recorded music

conga a small group of musicians in Cuba who all play the same rhythm and are followed by neighborhood residents carrying identifying flags or banners; also the name of a drum

culce green shamrock-shaped objects at the top of the moon crescent carried in Hosay festivals

Cup Match two-day legal holiday in Bermuda that commemorates Emancipation on August 1, 1834 and is the occasion of an all-star cricket match between Bermuda's eastern and western parishes

dhol a double-headed skin-covered drum of East Indian origin

Dimanche Gras Sunday evening performance during Trinidad Carnival that features the final competition of Kings and Queens; from the French, meaning Fat Sunday

Duldul Husain's horse

Fanal West African festival, called by its English name Lanterns in Sierra Leone and the Gambia. Participants carry decorated and illuminated paper lanterns of varying sizes and shapes. In Senegambia, model ships decorated in intricate cut paper are made for Fanal. It is celebrated either during Christmas-New Year or Islamic Ramadan.

fara-kankurang costume of the Mandinka of the Gambia made from shredded or torn bark; worn in ceremony presiding over circumcision; once called Mumbo Jumbo

farolas large decorated lantern-like constructions atop long poles held in holsters; used in Cuban Carnaval

fetes In Trinidad, fete describes a party with music, dance, and food; from the French word *fête*, literally meaning festival.

fita-kankurang costume of Mandinka of the Gambia made from leaves; see *fara-kankurang*

Ganesha a Hindu diety represented by an elephant

garde protective device, such as a talisman, used in Haitian Rara and *vodoun*

grage an instrument featured in Haitian Rara processions, made of a metal cylinder with roughened surface which produces a rasping sound when rubbed rhythmically with a stick

gumbay (gombe, goumbeh, gombey) the name of a drum in many Caribbean nations. In Jamaica it has a box-like shape and is played with the hands. In the Bahamas it is called *goombay* and is conical in shape.

hajj the pilgrimage to Mecca

houmfort *vodoun* temple

houngan a priest of *vodoun*

Imam an individual in the first twelve generations of direct descendants of the Prophet Mohammed

Imambara a Muslim shrine, ranging in size from household to major architectural monument, in honor of the Imams

ireme individually named *ñañigos* within the Abakuá Society in Cuba

Jamettes a Trinidadian term derived from the French word *diamêtre*, it refers to people who are outside the circle of respectability. In Trinidad Carnival it refers to masqueraders who represent these individuals.

jhanj set of metal cymbals of East Indian origin

jonc zinc baton which is twirled in admirable displays of skill during Rara processions by the *major jonc*. It is associated in esoteric lore with Legba, *loa* of the crossroads and sacred thresholds.

Jonkonnu an all-male entourage in Jamaica of masked and costumed dancers, performing mimed variations on an established repertoire of dance steps and accompanied by small musical corps; the festival that features the Jonkonnu entourage

joucoujou a traditional Haitian instrument of gourd rattles mounted on the three tips of crossed poles

jouvay the first day of Pre-Lenten Trinidad Carnival; the term derives from the French *jour overt* (opening day); participants in *jouvay* bands often cover themselves with mud or ash, soot, and oil, while others dress in old worn clothes or dilapidated costumes.

kanzo a level in *vodoun* initiation; literally, bonded by fire

kore duga among the Bamana of Mali in Africa, *kore* is a society made up of various brotherhoods, among which the *duga* wears a horse costume

krewes carnival clubs participating in New Orleans festival which begins on Twelfth Night after Christmas and ends on Shrove Tuesday

lakou traditional complex of houses and *houmfort* in the Haitian countryside

lambi conch shell once blown as a signal by the *maroons* which today symbolizes revolutionary freedom in Haitian historic legend. It is blown to celebrate an offering to the deity of the sea, Agouwé.

Legba *loa* deriving from the Eshu-Elegba trickster of the Yoruba of West Africa. One of his manifestations in Haiti is Carrefour, guardian of crossroads.

liming a Trinidadian word which describes a social gathering involving food and drink

loa a Haitian *vodoun* spirit or deity often of Yoruba derivation. *Vodoun* ceremonies celebrate an extensive pantheon of spirits.

Lucumi people of Yoruba descent in Cuba

major jonc Rara performer distinguished by elaborate sequinned costume who manipulates a zinc baton called a *jonc*. Each Rara band has two or more of these individuals whose skill attracts adherents to the band.

malida an East Indian delicacy made from fried burnt sugar, flour dough, and molasses

manuit the portion of the Hosay festival in Jamaica when individual small *taziyah* are marched

maroons word evidently deriving from the Spanish "cimarron," meaning wild cattle, but referring to runaway slaves who sought refuge in the wilderness and built enclaves there

mas a Trinidadian term denoting the masquerade costumes of individual Carnival participants, as well as Carnival itself

menhdi small, one-tier, hand-held *ta'ziya* popular in Delhi, India

Moco Jumbie the Caribbean name for a stilt dancer. The character and the name are derived from various African sources.

mumming a kind of British folk theater comprised of Doctor plays, Hero-Combat plays, and Morris dances. Mummers and Morris dancers generally appear at Christmas.

muñecones characters in Cuban Carnaval wearing huge oversize papier-mâché heads in imitation of children's fantasy characters

ñañigo a generic name given to all members of the Abakuá Society in Cuba

nal sahib a replica of a horseshoe from Ali's horse

negre jardin a Carnival masquerade character whose costume refers to the clothing of black slaves who worked with the Great House

nsibidi the once sacred script of the Abakuá Society which is now used on banners and posters to signify Cuba's African heritage

Oba the name given the Benin kings of Nigeria

obeah widespread medicinal system in the Caribbean based on traditional therapeutic practices in West Africa

Ole Mas type of Trinidadian masquerade where performers wear ragged costumes and act out skits which are socially and politically satirical

panchayati the Friday celebration or community Hosay, when large *taziyah* are paraded in Jamaica

panjtan iconographic emblem of the open hand, symbolizing the five pure members of the Prophet's family: Mohammed; his son Ali; Ali's wife, Fatima; and their sons Husain and Hasan

Papa Bois the spirit of the forest often portrayed in masquerade costumes

parranda a Cuban neighborhood group which decorated church facades and paraded decorated floats on Christmas Eve, especially in Havana

paseos a newer sub-category of a Cuban Carnaval comparsa in which an individual director/producer can hire dancers and musicians and choose a theme

peludos a Spanish word used to describe Cuban Carnaval characters dressed in bush costumes or multi-layered strips of cloth

peristyle the roofed outdoor portion of the *vodoun houmfort*

pétro a term used in Haiti to identify a *nanchon* or nation of spirits with fierce temperaments; believed to derive largely from Congo traditions

pisse en lit nineteenth-century Trinidad Carnival band whose members wore transparent nightgowns and carried menstrual cloths stained with blood, or feigned urinating on sheets

poteau-mitan the center post of the *peristyle*, the roofed dance arena adjoining the shrines in the *vodoun houmfort* in Haiti. It is believed to be the pathway down which the *loa* descend.

potencia a sub-group within the Abakuá Society in Cuba, sometimes a lodge with specific membership

qadam-i-rasu the footprint of the Prophet Mohammed, often carried in a coffin-shaped box during Hosay festivals

Ramlil Hindu festival celebrated in Trinidad

reine corbeille literally, queen of the basket. She bears a ribboned, long-handled basket to receive offerings from appreciative Rara audiences.

roots Jamaican vernacular, emphasizing a strong black presence; neo-African to some

roti a creole food originating in Trinidad with East Indian migrants; a thin, delicate, large, and round crepe-like pastry filled with curried vegetables and meats and then folded into many layers, eaten like a sandwich.

Schleicher Austrian Tyrolean Carnival performers featuring a group of costumed men whose wire screen masks may be the prototype of those originally exported to the Caribbean

shak shak (shakers, shakka, maracas) gravel or seed-filled gourds or tin boxes used to provide percussion in a musical ensemble

Shango (Xango, Chango) the Yoruba deity who was the fourth king of the Old Oyo and whose powers are manifested in thunder and lightning; a powerful force in the Yoruba-based Santería religion in the Americas

shanpwels Haitian word designating a type of secret society which enforces community morality. They often sponsor Rara bands.

soca Trinidadian soul-calypso music or rhythm

tadja the name for the Hosay celebration in Guyana. *Tadja* is derived from *ta'ziya*, which in India refers to the architectural structures built to replicate the tomb at Karbala.

tassa circular in form, single-headed, and often made from clay, these drums of East Indian origin are played with the hands and carried on a shoulder strap

ta'ziya (tadjah, tadja, taziyah, tajiya) part of the Islamic Muharram celebrations. In the Middle East the *ta'ziya* constitute ritual theatrical performances which recount the story of Imam Husain and his brother Hasan. In the Caribbean, this variously spelled word serves as the name for architectural structures which replicate the domed tomb of Imam Husain at Karbala.

tchancy a cylindrical metal rattle from Haiti

tchatcha gourd rattle from Haiti

tea meetings formerly held in anglophone islands, a special concert or performance in which the black actors would construct topical songs or theatrical bits, charge admission, and often travel around the district giving performances

vaccines Haitian musical instruments of bamboo tubes in varied dimensions, played in hocketing sequence

Vodoun religion with African roots practiced by the majority of Haitians. The term derives from the Fon word for "spirit."

zareeh in India, permanent smaller *ta'ziya* which are kept in shrines and can be made from wood, ivory, glass, silver, brass and ornamented with an assortment of materials

zéclair a Haitian name given to a certain "pass" or maneuver of the *jonc*

Suggested Readings

Abrahams, Roger D. and John F. Szwed, ed. *Afro-American Folk Culture: An Annotated Bibliography of Materials from North, Central and South America and the West Indies*, I and II. Philadelphia: Institute for the Study of Human Issues, 1978.

Abrahams, Roger D. and John F. Szwed, ed. *After Africa: Extracts from British Travel Accounts and Journals of the Seventeenth, Eighteenth, and Nineteenth Centuries concerning the Slaves, their Manners, and Customs in the British West Indies*. New Haven & London: Yale University Press, 1983.

Alexi, Gerson. "Notes sur la Rara." *Bulletin de Bureau d'Ethnologie*, Serie III, No. 27, April 1961.

Berry, Jason. "The Caribbean Connection: A Link in the Chain of New Orleans Culture." *New Orleans Magazine*, May 1985.

Bettelheim, Judith. "The Jonkonnu Festival." *The Journal of Ethnic Studies*, Vol. 13, No. 3, Fall 1985.

Bettelheim, Judith. *The Afro-Jamaican Jonkonnu Festival: Playing the Forces and Operating the Cloth*. Ph.D. diss., Yale University, 1979.

Blassingame, John W. *Black New Orleans 1860–1880*. Chicago: The University of Chicago Press, 1973.

Boyke, Roy, ed. *Trinidad Carnival 1983*. Port of Spain: Key Caribbean Publications, 1983.

Brereton, Bridget. "The Trinidad Carnival 1870–1900." *Savacou: Journal of Caribbean Studies*, Vols. 11 & 12, September 1975.

Cabrera, Lydia. *La Sociedad Secreta Abakuá: Narrada por Viejos Adeptos*. 1959. Reprint. Miami: Ediciones C.R., 1970.

Caribbean Quarterly, Vol. 4, Nos. 3 and 4 (1956).

Carmichael, Gertrude. *History of the West Indian Islands of Trinidad and Tobago, 1498–1900*. London: 1901.

Census of India, 1961, Monograph #3. "Moharram in Two Cities (Lucknow and Delhi)." Office of the Registrar General India.

Cohen, Abner. "Drama and Politics in the Development of a London Carnival," *Man*, Vol. 10, March 1980.

Comma, Vivian. "Carnival in London." *Masquerading: The Art of the Notting Hill Gate Carnival*. London: Arts Council of Great Britain, 1986.

Courlander, Harold. *The Drum and the Hoe*. Berkeley: University of California Press, 1960, reprinted 1985.

Denis, Lorimer and Emmanuel C. Paul. *Essai d'Organographie Haitienne*, Port-au-Prince, Haiti: Bureau d'Ethnologie, 1980.

Dunham, Katherine, *Dances of Haiti*. Los Angeles: University of California at Los Angeles, Center for African-American Studies, 1983.

Emery, Lynne. *Black Dance in the U.S. from 1619–1970*. Palo Alto: National Press Books, 1972.

Fouchard, Jean. *The Haitian Maroons*. New York: Blyden Press, 1981.

Graburn, Nelson. *Ethnic and Tourist Arts: Cultural Expressions from the Fourth World*. Berkeley: University of California Press, 1976.

Hill, Donald R. and Robert Abramson. "West India Carnival in Brooklyn." *National History*, Vol. 88, No. 7, August/September, 1979.

Hill, Errol. *Trinidad Carnival: Mandate for a National Theatre*. Austin: University of Texas Press, 1972.

Hjortshoj, Keith Guy. *Kerbala in Context: A Study of Muharram in Lucknow, India*. Ph.D. diss., Cornell University, 1977.

Hollister, John Norman. *The Shi'a of India*. London: Luzsc and Company, Ltd., 1953.

Martinez, Maurice. "Delight in Repetition: The Black Indians," *Wavelength*, February 1982.

Maximilien, Louis. *Le Vodou Haitien*. Port-au-Prince, Haiti: Imprimerie l'Etat, 1955.

Minshall, Peter. *Callaloo an de Crab*. Trinidad and Tobago: 1984.

Mintz, Sidney W. and Richard Price. *An Anthropological Approach to the Afro-American Past: A Caribbean Perspective*. Philadelphia: Institute for the Study of Human Issues, Occasional Papers in Social Change, No. 2, 1976.

Mintz, Sidney W. and Sally Price. *Caribbean Contours*. Baltimore: Johns Hopkins Press, 1985.

Mirville, Ernst. *Considerations Ethno-Psychoanalytiques sur le Carnival Haitian*. Port-au-Prince, Haiti: Collection Coucouille, 1978.

Nettleford, Rex M. *Caribbean Cultural Identity: The Case of Jamaica*. Kingston, Jamaica: The Institute of Jamaica, 1978.

Nettleford, Rex M. *Dance Jamaica: Cultural Definition and Artistic Discovery*. New York: Grove Press, 1986.

Nketiah, J. H. Kwabena. "Traditional Festivals in Ghana and Community Life." *Cultures*, Vol. III, No. 2, UNESCO Press & la Baconniere.

Nunley, John. "The Lantern Festival in Sierra Leone." *African Arts*, Vol. XVIII, No. 2, February 1985.

Nunley, John. *Moving with the Face of the Devil: Art and Politics in Urban West Africa*. Champaign, Illinois: University of Illinois Press, 1987.

Ortiz, Fernando. "La fiesta Afrocubana de Dia de Reyes." *Archivos del Folklore Cubano*, 1, 1924.

Ortiz, Fernando. *Los Bailes y el Teatro de los Negros en el Folklore de Cuba*. Havana: Ediciones Cardenas y Cia, Ministerio de Educación, 1951.

Palmer, Leslie. "Memories of Notting Hill Gate Carnival." *Masquerading: The Art of the Notting Hill Gate Carnival*. London: The Arts Council of Great Britain, 1986.

Paul, Emmanuel. *Panorama du Folklore Haitien*. Port-au-Prince, Haiti: Imprimerie de l'Etat, 1962.

Rigaud, Milo. *La Tradition Voudoo et le voudoo Haitiën*. Paris: Editions Niclaus, 1953.

Romain, Jean-Baptiste. *Africanismes Haïtiens*. Port-au-Prince, Haiti: Imprimerie M. Rodriguez, 1978.

Ryman, Cheryl. "Jonkonnu, a Neo-African Form." *Jamaica Journal*, Vol. 17, No. 1, February 1984.

de St. Méry, Moreau. *Description topographique, physique, civile, politique et historique de la partie française de l'Ile S. Dominque*. 1797. Nouvelle edition 1798. Blanche Maurel and Etienne Taillemitte, ed. Paris: Société de l'historie de la Colonie français, 1958.

Schuler, Monica. *"Alas, Alas, Kongo," A Social History of Indentured African Immigration into Jamaica, 1841–1865*. Baltimore, Maryland: The Johns Hopkins University Press, 1980.

Stebeich, Ute. *Haitian Art*. Brooklyn: Brooklyn Museum, 1978.

Thompson, Robert Farris. *Flash of the Spirit: African and Afro-American Art and Philosophy*. New York: Random House, 1983.

Thompson, Robert Farris and Joseph Cornet, *The Four Moments of the Sun: Kongo Art in Two Worlds*. Washington, D.C.: National Gallery of Art, 1981.

Urfé, Odilio. "Music and Dance in Cuba." *Africa in Latin America, Essays on History, Culture, and Socialization*. Manuel Moreno Fraginals, ed. New York: Holmes & Meier Publishers, 1984.

de Verteuil, Fr. Anthony, C. S. Sp. *The Years of Revolt. Trinidad 1881–1888*. Trinidad: Paria Publishing Co. Ltd., 1984.

Wood, Donald. *Trinidad in Transition*. London: Oxford University Press, 1968.

Photography Credits

(photographs are cited by figure number unless otherwise indicated.)

Martha Warren Beckwith, Courtesy The National Library of Jamaica, 95; Zoe Annis-Perkins, 150; Judith Bettelheim, 10, 14, 15, 16, 17, 18, 23, 24, 25, 27, 28, 29, 30, 31, 32, 33, 35, 38, 40, 43, 114, 115, 123, 126; Barbara Bridges; 136, 137; Alex Castro, pp. 6–7, 1, 3, 5, 6, 61, 62, 64, 65, 67, 69, 78, 91, 140, 141, 142, 160, 161; Robert Dirks, 41; Henry John Drewal, 148; Gregor Duruty, Courtesy Paria Publishing Company, 85, 87, 88, 97, 98; Benjamin Bettelheim Edwards, 118, 119, 120, 121; Ruby Finlayson, Courtesy Paria Publishing Company, 68, 84, 93; David Gamble, 112; Sunil Gupta, Courtesy Arts Council of Great Britain, 149, 151; Doranne Jacobson, 94; Roderic Knight, 111; Bob Kolbrener, 44, 48, 50, 52, 117; Francis Lau, Courtesy Trinidad Express Newspapers Limited, 99; David Levy, 13; Fradrique Lizardo, 56; Maurice Martinez, 133, 134, 135; Martin Mordecai, Courtesy The Library, University of West Indies, Mona, 21, 22; Karen Morell, 4, 104; John Nunley, 8, 9, 49, 51, 59, 60, 63, 70, 71, 72, 77, 79, 80, 82, 83, 90, 92, 100, 101, 102, 103, 105, 106, 107, 108, 109, 110, 143, 144, 145, 146, 147, 152, 153, 154, 155, 156, 157, 158, 159; Odette Mennesson Rigaud, Courtesy Harold Courlander, 122, 128; David Ulmer, 36, 117; Leroy Willett, pp. 4–5, 53; Antonia Williams, Courtesy The Library, University of West Indies, Mona, 54, 55; Dolores Yonker, 124, 125, 127, 129, 130, 131, 132; Courtesy British Honduras Mission Collection, the Jesuit Missouri Province Archives, St. Louis, 42; Courtesy Bob Burns, St. Georges, Bermuda, 58; Courtesy Galerie de Arte, Santiago de Cuba, 116; Courtesy Errol Hill and Carlisle Chang, 66; Courtesy Errol Hill, 89; Courtesy Historic New Orleans Collection/Research Center, 138, 139; Courtesy Historical Pictures Service, Chicago, 86; Courtesy Musée National de Blerancourt, 11; Courtesy Norton Studios, 2, 7, 74; Courtesy Roy Boyke, Key Publications, 73, 75, 76, 81; Courtesy Surinaams Museum, Paramaribo, 113; Courtesy The Bermuda Magazine, Hamilton, 57; Courtesy Department of Archives, Nassau, The Bahamas, 45, 46, 47; Courtesy The National Library of Jamaica (from *The Gleaner*), 19, 20, 34, 39; Courtesy Museum of London, 26; Courtesy University of Guyana Library, 96; Courtesy Yale University Library (from John Thomas Smith, *Vagabondia or Anecdotes of Mendicant Wanderers Through The Streets of London: With Portraits of the Most Remarkable,* Chatto & Windus, Picadilly 1874), 12; Photographer Unknown, Courtesy Pamela Franco, 37.